100 YEARS OF
GRAND OLE
OPRY

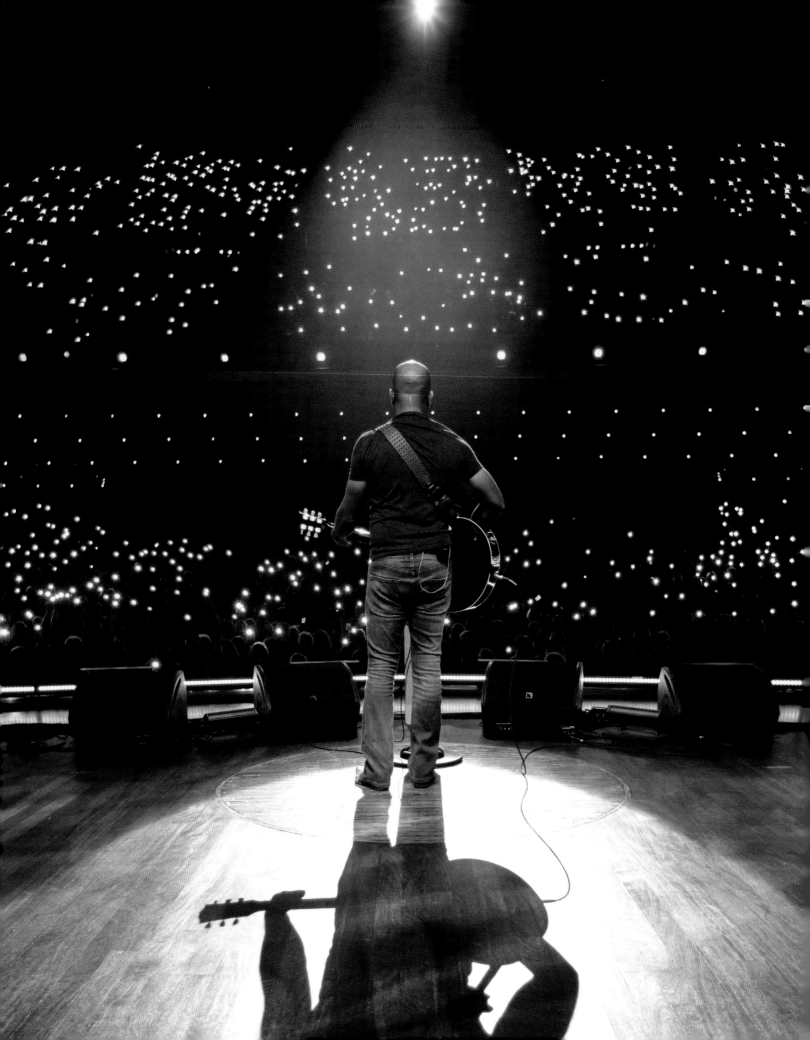

100 YEARS OF

GRAND OLE OPRY

A CELEBRATION OF THE ARTISTS, THE FANS, AND THE HOME OF COUNTRY MUSIC

**BY CRAIG SHELBURNE &
THE MEMBERS OF THE GRAND OLE OPRY**

WITH BRENDA COLLADAY

ABRAMS, NEW YORK

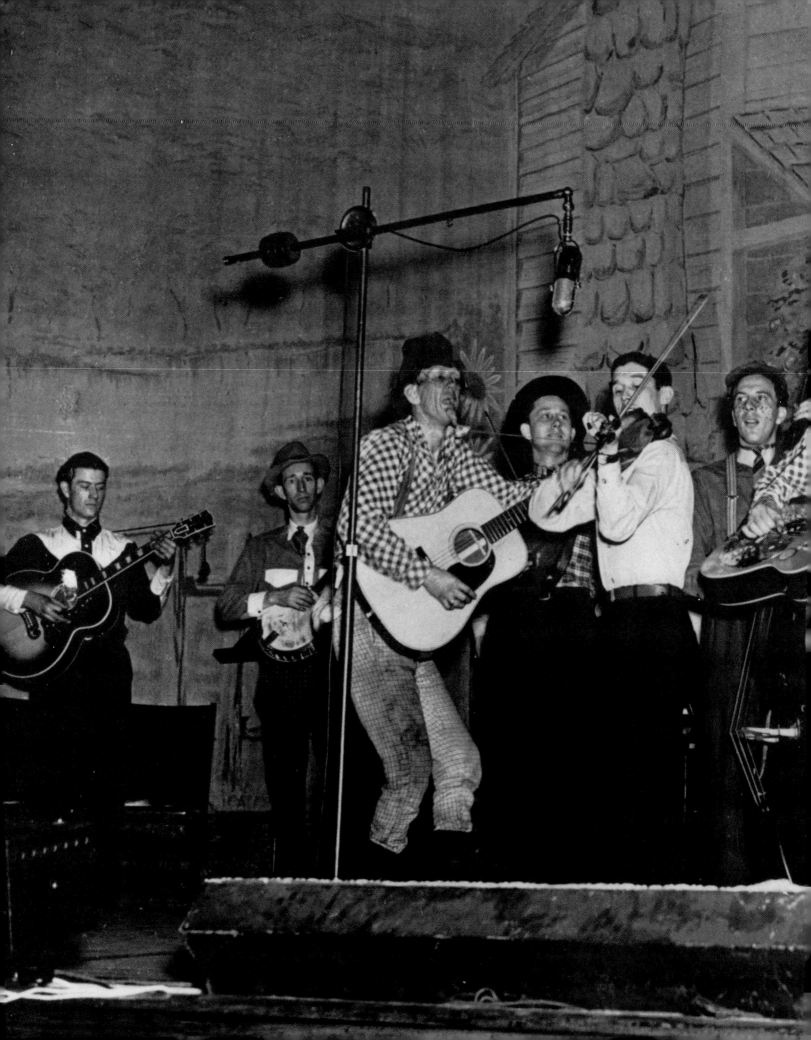

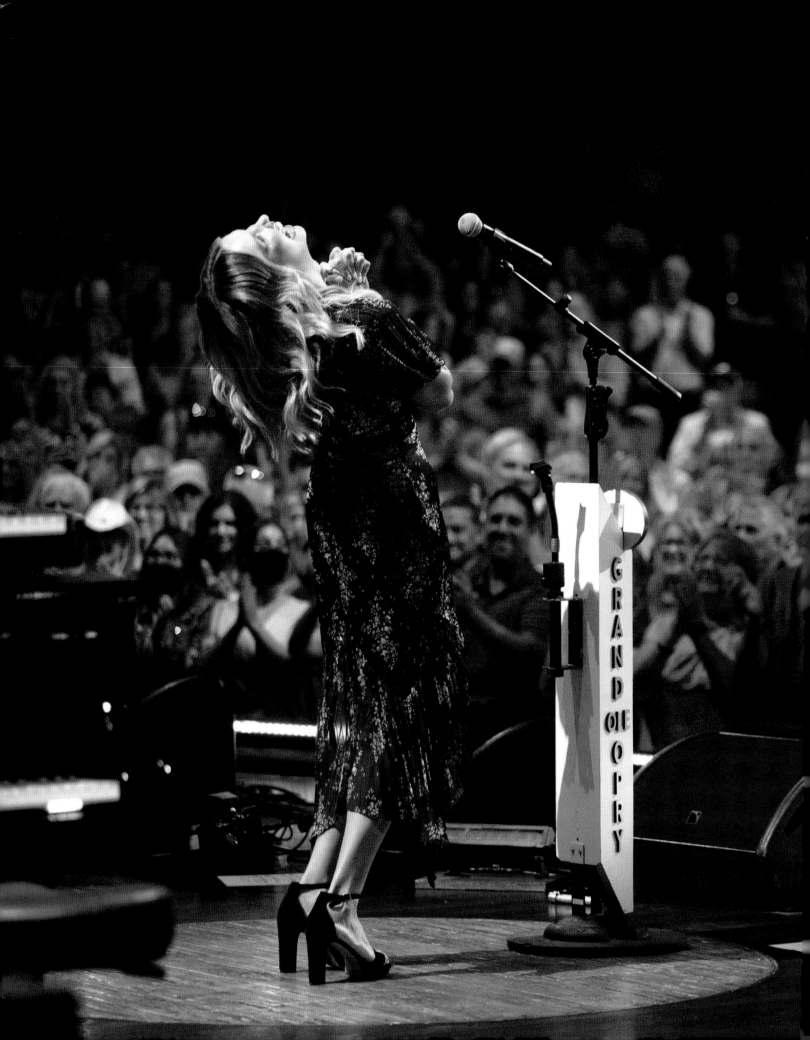

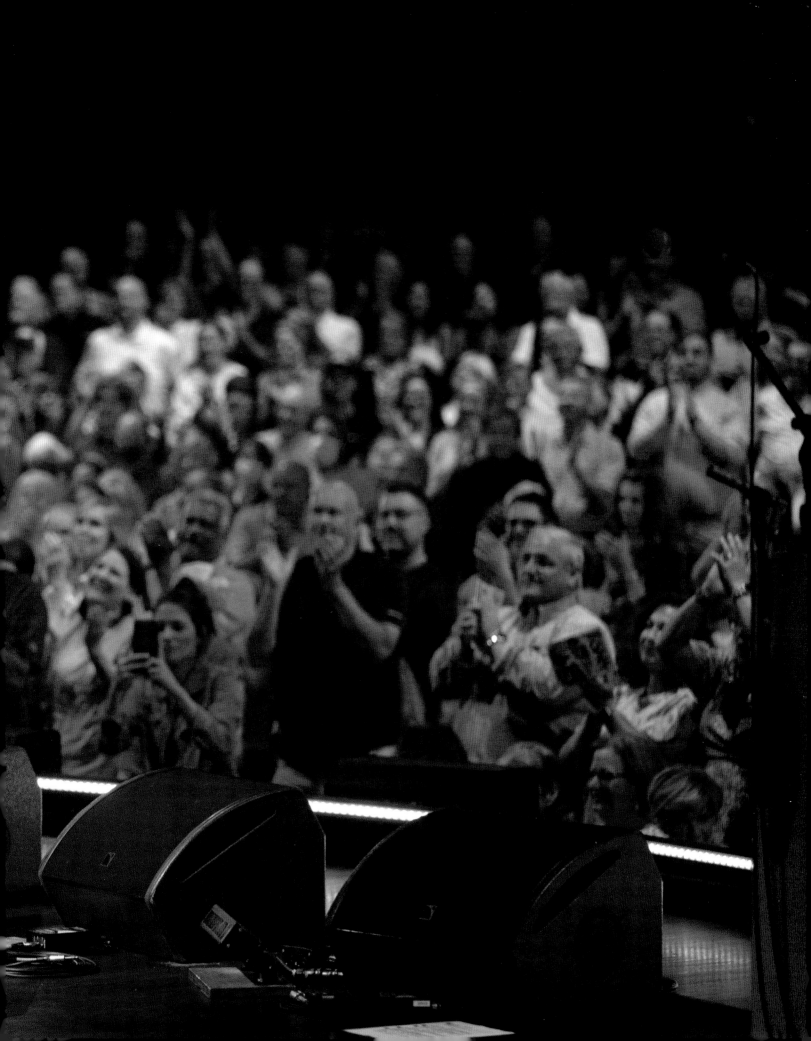

SOUVENIR
PROGRAM

THE
GRAND OLE OPRY
THE MOTHER CHURCH OF COUNTRY MUSIC ®

CONTENTS

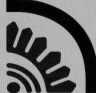

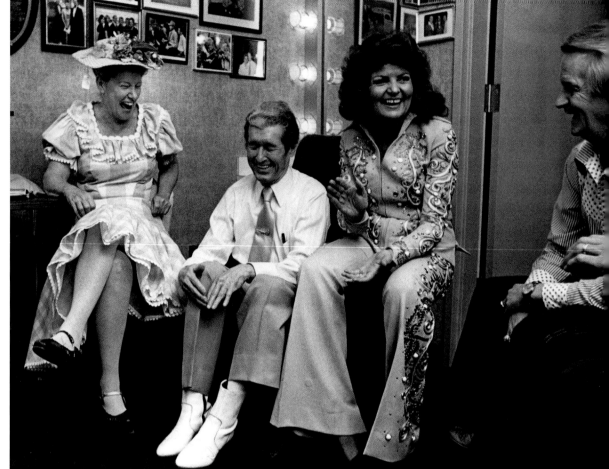

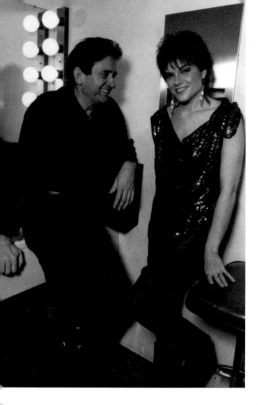

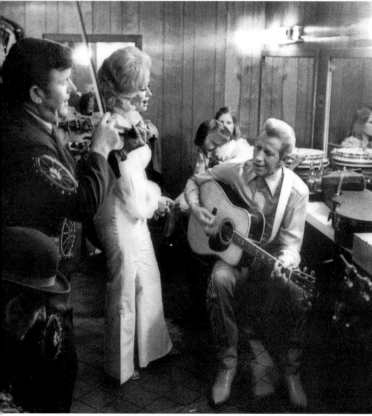

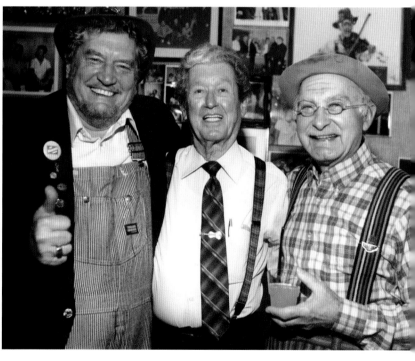

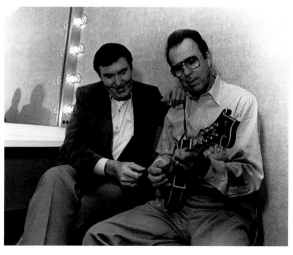

CLOCKWISE FROM TOP LEFT: Loretta Lynn and Merle Haggard, May 13, 1967; Minnie Pearl, Roy Acuff, Jeanne Pruett, and Ben Smathers, February 17, 1979; Johnny Cash and Rosanne Cash, November 22, 1982; Charles Esten, Darius Rucker, and Chris Janson, August 28, 2018; Boxcar Willie, Roy Acuff, and Grandpa Jones; Billy Walker and Buck White, January 10, 1991; Mack Magaha, Dolly Parton, and Porter Wagoner, March 1974; Josh Turner, Randy Travis, and Scotty McCreery, April 20, 2024; Kelsea Ballerini, May 17, 2019

FOREWORD BY

GARTH BROOKS & TRISHA YEARWOOD

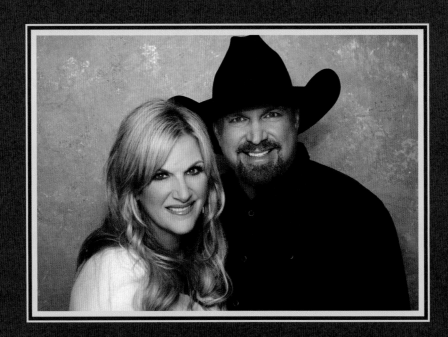

FAMILY

... that's what the Grand Ole Opry is. Whether you are Patsy Cline, Hank Williams, or the newest artist to just make your debut on the Opry stage, you are part of the family . . . a page in its beloved history. Known as "the show that made country music famous," the Opry is now enjoying newfound fame because of all who grace her stage. Celebrating her hundredth birthday, the Grand Ole Opry is younger than ever. She is timeless and continues to be the "Ellis Island of Country Music": a place where *all* are welcome, and country music is king . . . and queen.☺

From the early days of the War Memorial performances and the traveling Opry shows to, eventually, the Ryman Auditorium, the greatest names in country music made their home there. Led by the vision of Roy Acuff and Minnie Pearl, the Grand Ole Opry found its way to her new home, the Opry House. A house that, like country music, has seen its highs and lows. Nearly destroyed by the floods of 2010, the Opry House not only survived the devastating floods but came back even better.

As the grand ole lady makes the turn at one hundred, her future looks brighter than ever. Known as the longest-running broadcast in America's history, the Grand Ole Opry is not slowing down and now has become *the* "place to play" for other artists of all genres of music. Her architecture not only defines her look outside, but her look and sound inside. With a world-class staff and crew who believe in what she stands for, the Opry has established herself as one of the premiere places to play in the world.

But like all houses, it's the people inside who make it a home. It's those who fill the seats, night after night, who come with the respect country music deserves, who make the Grand Ole Opry performances ones to remember for a lifetime. As individual artists, as a duet, and as a married couple, being part of the Grand Ole Opry's story is the greatest honor in our careers. We feel lucky to be a part of this house and the family who always lives inside.

GARTH BROOKS & TRISHA YEARWOOD

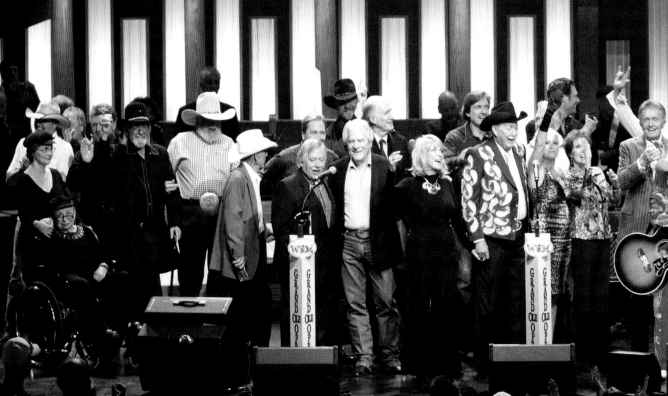

JUST SO PROUD TO BE HERE

1925-

–1940

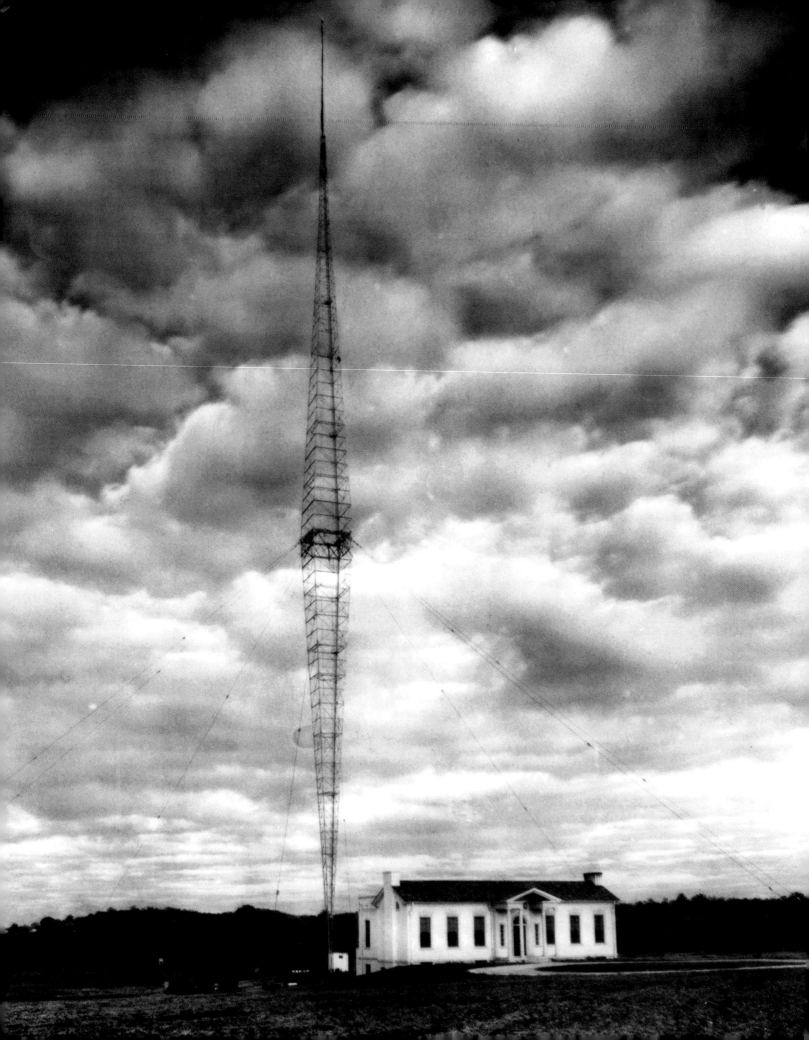

OPPOSITE: WSM's distinctive
diamond-shaped Blaw-
Knox tower and 50,000-watt
transmission station. ABOVE:
WSM's first broadcast studio,
located on the fifth floor of
the National Life and Accident
building, downtown Nashville

ANNOUNCING OPENING OF WSM

MONDAY NIGHT
(October 5th)
Continuous Program
From 7 P.M. to 2 A.M.

WSM Completed Dream of National Life Insurance Company

WSM, super-power 1,000-watt radio broadcasting station, now being dedicated to Nashville, the home city of The National Life & Accident Insurance Co., is the completed dream of the big insurance company's executives who when planning the erection of The National's beautiful home building, included in their plans the erection of one of the finest broadcasting stations the country affords.

Following the completion of The National Building, first steps were taken toward the building of the powerful station. Vice-President E. W. Craig (himself an ardent radio fan) was commissioned to begin the task of gathering together the best ideas of the radio world. The National Company earnestly devoted time and study to radio's advantages as exemplified by leading broadcasting stations in the United States, and many trips were made during the past year by Mr. Craig. Consultations were held with radio experts over the country and the best ideas of them all were collected for the purpose of incorporating them in the station that Nashville can proudly boast of as one of the very finest, equaled by only one other Southern station, and stronger than eighty-five per cent of all broadcasting stations in the United States.

Many obstacles had to be overcome before a class B wave length could be secured. As there are no exclusive Class B wave lengths obtainable, through the courtesy and co-operation of Dr. James D. Vaughan, owner and operator of station WOAN, a class B station operating on 282.8 meters, at Lawrenceburg, Tenn., arrangement was made by which station WSM could divide time on the air. This proved to be a very fortunate arrangement, as a class B wave length is considered to be the highest class functioning under a standard set by the Department of Commerce at Washington.

Among the many difficult tasks encountered by The National's scouts was the working out of details in connection with the remote control system. This system was adapted for use by WSM, after investigation upon investigation had been made as to its practibility. The remote control system was chosen for increased efficiency and it is said to be the practice of the most recent radio installations.

Next to be considered was the selection of a suitable site for the giant towers and radio machinery. This had to be found in a section where water pressure is good and a three-phase electric current could be had, also the location had to be available for four private telephone circuits, thus the selection on Fifteenth avenue, south, near Ward-Belmont.

After much thought and toil all of the apparently insurmountable difficulties were mastered and as a result the very latest and most perfect transmitting equipment, one which will carry to the world the worthy presentation of all that Nashville stands for, is now being placed at the disposal of the capital city's as well as the state's best talent by an Insurance Company that has already made her home city famous.

The National Life & Accident Insurance Co.'s Field Force of more than 2,500 working in as many cities and towns in twenty-one states who have never faltered in their efforts to aid in building what is now known as one of America's strongest Life Insurance Companies, are elated over the great station and they are telling thousands daily of the station that is destined to put Nashville on the International Radio Map.

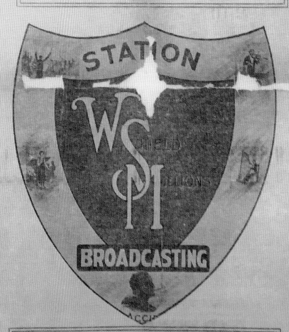

Western Electric Company to Install Loud Speakers for Public

Due to the limited number of persons able to be accommodated in WSM's auditorium, the station regrets that it cannot invite the general public to be present at the studio on opening night, October 5, but in order that those who have no receiving sets who desire to hear the program can do so, the Western Electric Company will install large loud speakers in windows of the National building and as many as care to can assemble in front of the building and enjoy the broadcast.

These horns or speakers forming the Western Electric public address system reproduces the music perfectly and can be heard for more than a block away. Mr. C. S. Powell, sales manager of the W. E. Company in Nashville, is installing the system, and those who would like to hear WSM's inaugural program or part of it may do so through these loud speakers.

After opening night WSM extends a cordial invitation to everybody to visit the new studio during broadcasting hours or between. A comfortable auditorium has been prepared to take adequate care of a normal audience, and visitors will be heartily welcomed after October 5 at any time to listen to the concerts being given by Nashville artists through WSM.

WSM Mammoth Dedication Program
7 P.M. to 2 A.M.

7:00 to 8:00 P. M.

1. Prayer — Rev. ___
2. Prayer — Rev. ___ of the ___ Church.
3. Shrine Band—Playing the National Anthem.
4. Dedicatory Message—President C. A. Craig of the National.
5. Music—The Shrine Band.
6. Brief Message—Gov. Austin Peay.
7. Song—Joseph Test McKeehan, Concert Baritone, with Miss Babita Paschal, Piano Accompanist.
8. Brief Message—Maj. D. R. Carmo, Commissioner of Navigation, Washington, D. C.
9. Song—Joseph Test McKeehan, Baritone; Miss Paschal Accompanist.
10. Brief Message—Major Hilary E. Howse of Nashville.
11. Song—Joseph Test McKeehan, Baritone; Miss Paschal Accompanist.
12. Brief Message—Mayor Walter Van ___ of the ___ District.
13. Instrumental Trio—Including Mrs. Horace Olson, Cello; Miss Alline Paschal, Violin; Miss Babita Paschal, Piano.

8:00 to 8:30 P. M.

Famous Fisk Jubilee Quintet of Fisk University. Brief Message by Dr. A. E. Black, Dean.

8:30 to 9:00 P. M.

Beasley Smith's Andrew Jackson Orchestra.

9:00 to 10 P. M.

Knights of Columbus Vocal Quartet—Including Eugene Cunningham, First Tenor; John A. Dowd, Second Tenor; Eugene Murphy, Baritone; Vernon S. Arrington, Bass, and Bill Copeland, Piano Accompanist.

Instrumental Trio—Including Mrs. Horace Olson, Cello; Miss Aline Fentress, Violinist, and Miss Babita Paschal, Pianist.

Miss Aleda Wagonner, Soprano Soloist.

Vincent Kuhn, Vocalist.

10:00 to 11:00 P. M.

Mrs. Daisy Hoffman, Concert Pianist and Duo Art Artist.

Mrs. Thomas J. Malone, Jr., Concert Soprano.

Mr. Kenneth Rose, Violin Soloist and Director of the Violin Department at Ward-Belmont.

Mrs. Kenneth Rose, Concert Pianist and Member of the Ward-Belmont Faculty.

Mrs. Robert Caldwell, Contralto Soloist of the East End Methodist Church Choir.

Mr. Milton Cook, Baritone Soloist of the First Presbyterian Church Choir.

11:00 P. M. to 12:00 M.

Francis Craig's Columbia Record Orchestra, with Vocal and Instrumental Soloists.

12:00 M. to 2 A. M.—Jamboree

Miss Brenda Barnhardt, "The Lady of the Studio," Singer of Southern Melodies.

Jack Keefe, Popular Entertainer.

Jos. Cannia, Tenor Soloist.

Ted Stover, Recognizing Pianist.

W. J. Kuehner, Saxophone Soloist.

Francis Craig's Columbia Recording Orchestra.

Other Features.

The National Life & Accident Insurance Company
(INCORPORATED)
NASHVILLE, TENNESSEE

eorge D. Hay made himself comfortable in a fifth-floor office at the corner of Seventh and Union in downtown Nashville. Seated among the other elite guests, Hay enjoyed the impressive talent of the Fisk Jubilee Singers and baritone Joseph McPherson; he listened as a parade of politicians and executives tried to capture the historic moment in words. Nashville residents had been tuning in to a couple of low-powered radio stations over the last few years, but on the evening of October 5, 1925, WSM's strong signal spread across the eastern side of the country. Congratulatory telegrams arrived from across Tennessee and as far away as Michigan, New York, and Texas.

When it came time for Hay's turn on the microphone, he naturally blew his trademark wooden steamboat whistle. Listeners at home would have smiled to hear it. Just a year earlier, Hay topped a readers' poll in *Radio Digest Illustrated* and received the Gold Cup Award as the favorite radio announcer in the country. At the time, Hay emceed *National Barn Dance* on the Chicago station WLS, though he'd begun his career in Memphis, where he picked up the nickname of "the Solemn Old Judge." In reality, Hay was in his twenties, and his only connection to the legal profession was documenting the exchanges he heard in the courtroom, which he then reprinted in his "Howdy Judge" column in the Memphis *Commercial Appeal*. When that newspaper established a radio station in January 1923, Hay signed on as a staff announcer, then headed to Chicago in the spring of 1924.

Front page of the *Nashville Banner* on the day before WSM's first broadcast, October 5, 1925

Hay attended the grand opening at the invitation of Edwin Craig, who'd spent the last three years striving to get WSM on the air. Craig was enthralled with the very idea of a radio station and wanted to use his family connections to deliver a powerhouse. His father, Cornelius A. Craig, was a cofounder of the highly profitable National Life and Accident Insurance Company; however, the elder Craig didn't want to give the appearance of nepotism. A few years earlier, when Edwin Craig dropped out of Vanderbilt University and took an entry-level job selling National Life insurance door-to-door in Dallas, Cornelius insisted that his son receive the same treatment as everyone in the sales force.

National Life's salesmen were known as "Shield Men," an allusion to the eye-catching blue symbol used in the company's marketing campaigns. Edwin Craig believed that advertising National Life over the radio would at least familiarize the public with the product they were trying to sell, rather than the Shield Men having to explain it one knock at a time. Cornelius may not have shared his son's passion for radio, but when National Life made plans to expand its office in 1923, a company announcement indicated the possibility of placing a radio tower on the roof.

But first, Edwin Craig needed to acquire a place on the radio dial at a time when wavelengths were being snapped up by amateurs and small businesses. It took an entire year of bureaucratic negotiations, but he finally struck a deal in April 1925 with WOAN, a small station in Lawrenceburg, Tennessee. In the agreement, National Life would take over the wavelength, but WOAN's former owner could still air his own programming for one hour on weeknights and one hour on Sundays.

Edwin Craig rose through the National Life ranks from a Shield Man to the title of vice president and manager of the industrial department. He knew he wanted to compete with the most powerful stations in the country, so a 1,000-watt transmitter was installed on a hill about two miles away from downtown, near Ward-Belmont College. A wire antenna suspended between two 165-foot towers would send out the signal. In July, Craig received word that National Life could rename the station WSM. The call letters were being used by the US Navy, but Craig had a new company slogan in mind: "We Shield Millions." National Life received its formal approval to broadcast just one day before going on the air; after all the speeches and presentations, two local orchestras took over the airwaves and WSM employees celebrated their achievement well past midnight.

About two weeks later, Edwin Craig and George D. Hay crossed paths again in Texas at a broadcasting convention. Exchanging more than just pleasantries, Craig offered Hay the job of WSM's "radio director." After giving it some thought, Hay stepped into the role on November 9, 1925, his thirtieth birthday.

WSM didn't air commercials in its formative years, and Hay preferred not to play phonograph records, so he quickly had to figure out how to fill all those hours with live entertainment. Eva Thompson Jones, a staff pianist at WSM, suggested that Hay might like to meet her uncle, a fiddler named Uncle Jimmy Thompson. A seasoned instrumentalist in his seventies, Thompson commanded attention and respect. He won a national fiddling championship in Texas in 1907 before moving back to Smith County, Tennessee, where he built up a regional

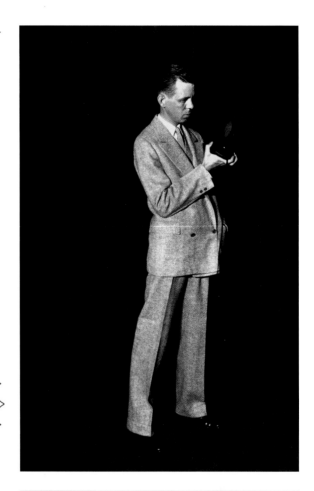

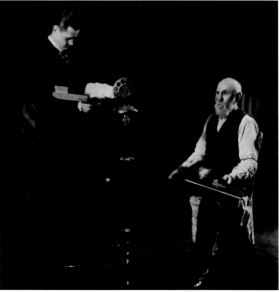

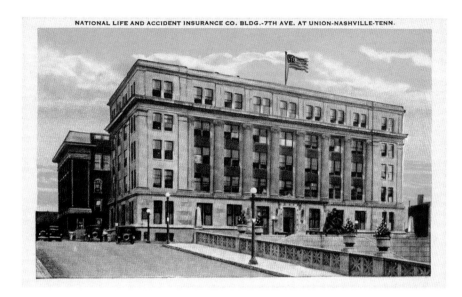

NATIONAL LIFE AND ACCIDENT INSURANCE CO. BLDG.-7TH AVE. AT UNION-NASHVILLE-TENN.

OPPOSITE, TOP: Edwin Craig poses with early WSM microphone, 1925. OPPOSITE, BOTTOM: Fiddler Uncle Jimmy Thompson during a broadcast with George D. Hay, c. 1926. Thompson was the first performer on WSM's barn dance program, which would become known as the Grand Ole Opry. LEFT: Offices of the National Life and Accident Insurance Company, which housed the WSM radio studio, 1930s

following. Starting his set with "Tennessee Waggoner," Thompson played an hour's worth of fiddle tunes over WSM on November 28, 1925, which prompted plenty of calls and telegrams. Nobody knew it, but the cornerstone of what would become the Grand Ole Opry had just been placed.

Following this overwhelming response from the listening audience, Hay's mind almost certainly drifted toward creating a new program spotlighting the old-time music he favored on WLS's *National Barn Dance*. Newspaper listings from late 1925 didn't specify any Saturday night barn dance programs or old-time music on WSM over the next three weeks, so it is unclear whether old-time music continued on Saturday nights. At any rate, preparations were being made at WSM for Hay's show to return on a regular basis. An article printed in numerous national newspapers, probably pulled from a press release, indicated that WSM would

air "an hour or two" of familiar tunes starting on Saturday, December 26, with Uncle Jimmy Thompson taking part in the 8 P.M. broadcast. To round out the show, Hay had a wealth of talent at his fingertips, notably Uncle Dave Macon, Sid Harkreader, and Dr. Humphrey Bate, all of whom had performed over the WSM airwaves before Hay joined the station.

Macon and Harkreader performed and recorded together often; sometimes fifty-five-year-old Macon even referred to twenty-seven-year-old Harkreader as his son. Macon appreciated Harkreader's skill on the fiddle and guitar, which complemented Macon's dexterity on the banjo. WSM listeners responded enthusiastically to their comic showmanship and lively, original songs such as "Keep My Skillet Good and Greasy." Even as Macon maintained his own busy schedule of personal dates, and didn't appear every Saturday night, he was viewed as the show's biggest attraction.

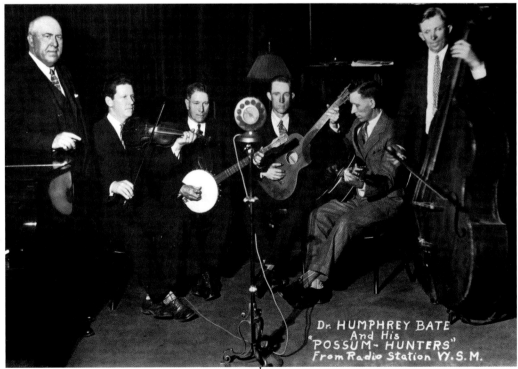

Dr. HUMPHREY BATE
And His
"POSSUM-HUNTERS"
From Radio Station W.S.M.

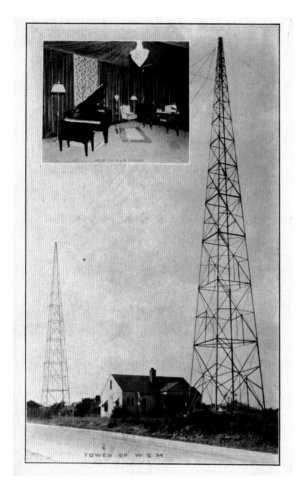

TOWER OF WSM

A physician with a degree from Vanderbilt, Dr. Bate had previously performed on WDAD, a 150-watt local radio station operated by Dad's Auto Accessory and Radio Store. WDAD sent out its signal a month before WSM, so Dr. Bate's appearance may have been the first country music to be played live on a Nashville radio station. Weeks after WSM's arrival on the dial, Dr. Bate brought his band to the fifth floor of the

OPPOSITE, TOP TO BOTTOM: Uncle Dave Macon and his son Dorris, with other Opry performers behind, c. 1933. Uncle Dave was billed as "The Dixie Dewdrop"; Dr. Humphrey Bate and His Possum Hunters pose in suits and ties, before the Opry adopted its "hillbilly" image, c. late 1920s. ABOVE: Postcard featuring WSM radio's 1,000-watt transmitter and studio, c. 1926

National Life building to perform; his teenage daughter, Alcyone, played piano and sang with the group. Hay especially admired Dr. Bate's skillful harmonica playing; the two men quickly bonded over their affection for old-time music. The Solemn Old Judge would later refer to his friend as "the Dean of the Grand Ole Opry."

Most performers on WSM's barn dance, as it came to be known, were locals with day jobs. There was no audience, no cast, and no attendance requirement (as would be true of the Opry in later years). In the spring of 1926, the self-described "one man orchestra" Obed Pickard and fiddlers Henry Bandy and Mazy Todd made regular appearances on the barn dance. By summer, Dr. Bate brought a local harmonica player he admired named DeFord Bailey and a string band called the Crook Brothers (including brothers Herman, Matthew, and later, the unrelated Lewis Crook) to the show. Sid Harkreader made his first documented solo appearance in July.

Old-time music filled most of the barn dance program, but listeners would have also heard Black gospel quartet singing, light jazz, and a hint of pop music. WSM continued to air a variety of programming, too, from classical music to football games. The station staged its barn dance at the Tennessee State Fair in September 1926, airing the show live from the Home and Education building at the fairgrounds. To cap a week of remote broadcasts, WSM delivered an all-star lineup of DeFord Bailey, Dr. Humphrey Bate, Obed Pickard, and Uncle Jimmy Thompson in the show's first-ever broadcast outside the WSM studio. By October, new barn dance performers included sewing machine salesman Theron Hale (on fiddle) and his teenage daughters Mamie

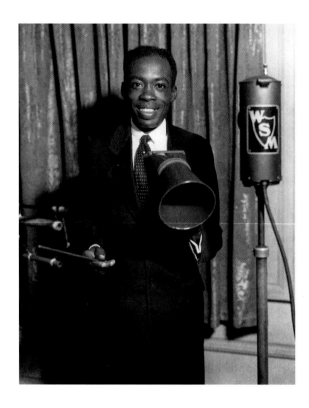

Ruth (fiddle and mandolin) and Elizabeth (piano). Their slow, evocative twin-fiddle repertoire set them apart from the barn-burning style of other string bands on the show.

About fourteen months after its official launch, WSM upgraded from a 1,000-watt station to a 5,000-watt station; during installation of the new transmitter, the signal went silent starting on Sunday, December 5, 1926. As a result, the barn dance missed four shows over the holiday season but resumed after WSM returned to the air on January 7, 1927. As the show caught on, more old-time instrumentalists found their way to the National Life building: George Wilkerson, a fiddler whose nickname was "Grandpappy";

ABOVE: Harmonica wizard DeFord Bailey holds the megaphone he designed to amplify his harmonica, early 1930s. OPPOSITE: DeFord Bailey's handwritten Opry cast questionnaire, c. 1937

Paul Warmack, a guitarist and mandolin player who worked as an auto mechanic; and Arthur and Homer Smith, cousins who played fiddle and guitar, respectively.

Franklin, Tennessee, musicians Sam and Kirk McGee often accompanied Uncle Dave Macon, but the brothers were starting to find their own style, with Sam playing flat-top guitar in tunings and techniques learned from Black railroad workers he heard as a boy, and Kirk playing fiddle and banjo in a musical style shaped by the blues. In a similar manner, growing up in Smith County, Tennessee, DeFord Bailey absorbed the fiddle tunes played by his grandfather Lewis Bailey, who lived with DeFord's family. In addition, two of his uncles played harmonica, and an aunt played guitar. Bailey described the music he heard back then as "Black hillbilly music," a style that leaned closer to string band music than spirituals or the blues.

Though Bailey could play a few other instruments, the harmonica was always within reach. As a three-year-old, he contracted polio and lay in bed for a full year, unable to move anything but his arms and head. His father would let him play harmonica or would lay a banjo or a guitar around his neck, as a way for the boy to pass the time. When he recovered, he carried on his musical path and met Dr. Humprey Bate during their appearances on WDAD. Time after time, Bailey politely declined Dr. Bate's invitation to join him at the Opry.

"Dr. Bate wouldn't take no for an answer," Bailey later told his biographer. "They had a hard time getting me to go down there. I was ashamed with my little cheap harp and them with all them fine, expensive guitars, fiddles, and banjos up there.

GRAND OLE OPRY ARTISTS

* * *

NAME _De Ford Bailey_ BAND OR GROUP _Single_

AGE _12_ YEARS ON GRAND OLE OPRY _____

HOW DID YOU GET STARTED IN RADIO _Mr Bate carried me_
up to WSM.

DESCRIPTION:

AGE _38_ WEIGHT _93_ HEIGHT _4 something_ EYES _Brown_ HAIR _Black_

BIRTHPLACE _Smith County_ MARRIED _yes_ CHILDREN _3_

WHERE LIVE _130 La Fayette St._ FAVORITE SPORTS _Bicycle_

WHAT SONGS HAVE YOU COMPOSED OR FEATURED _Pan American_
Fox chase – Ice Water Blues and many others

ANY COMMENTS ABOUT YOURSELF _The Girls Shure Worry my_
mind.

But Dr. Bate told me that 'we're going to take you with us, if we have to tote you.' So I went."

The barn dance was already underway on that Saturday night in May 1926 when Dr. Bate brought Bailey to WSM. Bailey remembered that as he played a couple of harmonica tunes, Hay fidgeted with his wooden steamboat whistle. At the end of the impromptu audition, though, Hay threw that whistle into the air, gave two dollars to the young musician, and exclaimed, "We're going to use you!" For the next fifteen years, barely a barn dance would go by without DeFord Bailey. His harmonica skills drew loads of mail and made him into a star attraction on the road. Some listeners told him that whenever he imitated the yelps of hunting dogs in a song

called "Fox Chase," their own dogs would erupt in fits of barking.

Working together in close quarters, Hay and Bailey quickly became familiar with each other's rhythm and repertoire. On November 12, 1927, they were killing time in the studio, waiting for a couple of NBC broadcasts to conclude. (Edwin Craig made a deal in early 1927 to air NBC programming on WSM, becoming the national network's first Southern affiliate.) On this particular

BELOW: The Fruit Jar Drinkers pose in their hillbilly costumes, complete with a moonshine bottle, early 1930s. Left to right: George Wilkerson, Claude Lampley, Tom Leffew, and Howard Ragsdale. OPPOSITE, TOP: Opry cast members in the WSM studios pose in their regular clothing, c. 1928. OPPOSITE, BOTTOM: Opry cast members in the mid-1930s, after hillbilly costumes had become part of the stage show

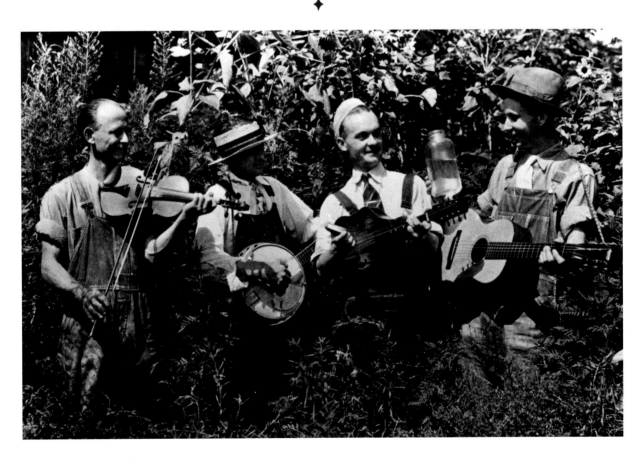

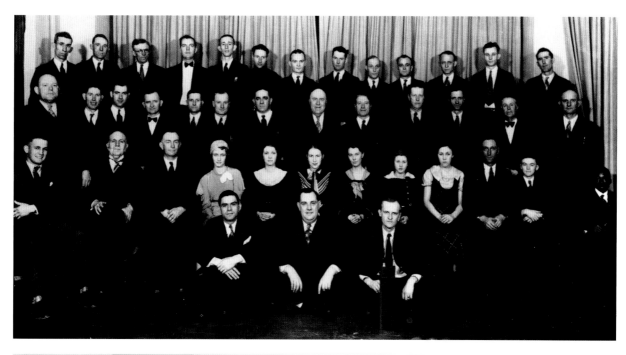

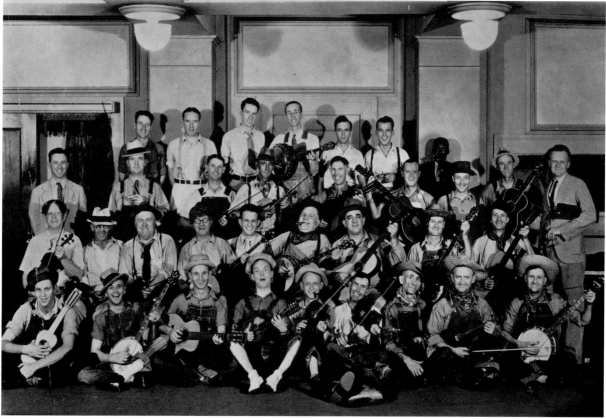

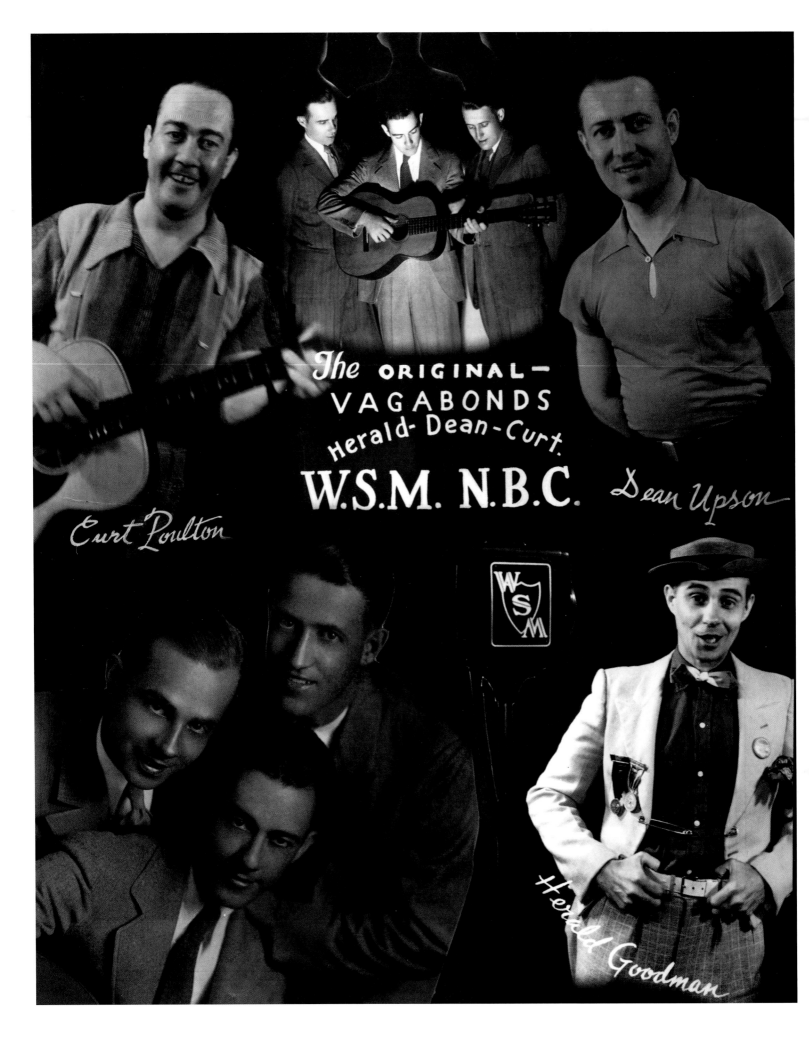

night, WSM was carrying NBC's broadcast of the *RCA Hour* at 7 P.M., which featured the New York Symphony Orchestra's performance of composer Arthur Honegger's *Pacific 231*. The *Philco Hour*, listed in local papers at 8 P.M., offered the comic opera *Robin Hood*. When the NBC programming concluded at 9 P.M., WSM's barn dance program would commence.

In his 1945 memoir, Hay may have mistakenly merged the two NBC broadcasts in his mind. He mentioned the "many 'shooshes' depicting an engine trying to come to a full stop" in Honegger's piece, which was introduced that night by the conductor Dr. Walter Damrosch. But he also made a reference to "Grand Opera," perhaps a nod to *Robin Hood*. The details are hard to pin down in this passage from his memoir, but his delight is on full display in recounting his words from that night:

> *"Friends, the programme [sic] which just came to a close was devoted to the classics. Dr. Damrosh [sic] told us that it was generally agreed that there is no place in the classics for realism. However, from here on out for the next three hours, we will present nothing but realism. It will be down to earth for the 'earthy.' In respectful contrast to Dr. Damrosh's presentation of the number which depicts the onrush of a locomotive we will call on one of our performers, Deford [sic] Bailey, with his harmonica, to give us the country version of his 'Pan American Blues.'" Whereupon, Deford Bailey, a wizard with the harmonica, played the number. At the close*

OPPOSITE: 1930s publicity photo advertising vocal trio the Vagabonds, who presented a more cosmopolitan image than previous Opry stars. Left to right: Curt Poulton, Dean Upson, Herald Goodman

> *of it, your reporter said: "For the past hour, we have been listening to music taken largely from Grand Opera, but from now on we will present 'The Grand Ole Opry.'"* The name has stuck for almost twenty years. It seems to fit our shindig, hoedown, barn dance or rookus, which has become known throughout America and in some foreign lands.

As Bailey honored Hay's request for "Pan American Blues," the spontaneous moment ushered in a memorable new name for the popular show. Printed radio listings on December 10, 1927, still referred to a "barn dance program," but the phrase "Grand Old Op'ry" showed up for the first time in local newspapers the next day.

The renaming didn't stop there. The Solemn Old Judge surveyed the string bands and conjured up something rustic. By December 1927, Wilkerson's band was reimagined as the Fruit Jar Drinkers, while Warmack's group would be known as the Gully Jumpers. Dr. Bate's ensemble, formerly the Augmented String Orchestra, became the Possum Hunters. Hay felt that listeners would respond to the down-home imagery, though a new WSM staffer named Harry Stone would gradually steer the show in a different direction.

Hired as an announcer on February 1, 1928, a few weeks shy of his thirtieth birthday, Stone had already worked for local radio stations operated by First Baptist Church and the Waldrum Drug Company. In his first few months on the job at WSM, Stone would have likely interacted with the show's first female solo performer, hammered dulcimer player Kitty Cora Cline, as well as blind fiddler Uncle Joe Mangrum and accordion player Fred Shriver. Some performers who

had only occasionally performed on WSM were now frequent visitors to the studio. For example, local jewelry repairmen and watchmakers Amos and Gale Binkley first appeared in 1926 but became Opry regulars in 1928, now billed as the Binkley Brothers' Dixie Clodhoppers. Stone wouldn't have often crossed paths with Uncle Jimmy Thompson, who found personal appearances to be more lucrative and significantly scaled back his time at the Opry.

Ralph Peer, a reputable talent scout and producer from New York, made his way to downtown Nashville in the fall of 1928 to cut some sides for the Victor Talking Machine Company. His sessions the previous year with the Carter Family, Jimmie Rodgers, and others in Bristol, Virginia, had sold surprisingly well. The Bristol Sessions, as they came to be known, proved the commercial viability of so-called hillbilly music and are considered by some historians as "the Big Bang of Country Music." However, the Nashville sessions wouldn't have that same impact. Because there wasn't yet a professional recording studio in the city, Peer set up at the YMCA and recorded several Opry regulars. One of those groups, Poplin-Woods Tennessee String Band, was relatively new to the Opry, likely first appearing in late 1927. Composed of rural mail carrier W. Ed Poplin and his son Ed Jr., as well as barber Jack Woods and his daughters Frances and Louise, the ensemble offered more singing than most Opry bands of the day and a predisposition for pop material.

WSM dedicated a second studio inside the National Life headquarters on October 6, 1928, coinciding with the station's third anniversary. The Opry moved into the acoustic-friendly Studio B, which could entertain a studio

audience of about two hundred. A month later, WSM upped its game again when it received its designation as a clear-channel station at a frequency of 650 kHz, where it would remain on the radio dial. WSM had sole claim to the frequency in the United States, eliminating most interference.

During this period of growth, Harry Stone was carving out his own career path at WSM. By January 1930, he'd been promoted to associate director. In June 1931, he hired a vocal group called the Vagabonds, whose polished singing style contrasted with the show's abundant string bands. Stone used the Vagabonds for the station's pop and country programming; in turn, the group capitalized on the opportunity by publishing and selling their own songbooks. Yet with folk-leaning songs, the Vagabonds didn't alienate the Opry's rural audience. Their biggest hit was titled "When It's Lamp-Lighting Time in the Valley," while their best-selling songbook

ABOVE: WSM associate director Harry Stone, 1932

was *Old Cabin Songs of the Fiddle and Bow.*

Stone continued to take chances with Opry performers, including cowboy singer and yodeler Zeke Clements and fiddler Curly Fox, who went by "Zeke and Curley," in September 1932 (though they departed the show by the end of the year). Around the same time, five-year-old Little Jimmie Sizemore appeared on the Opry with his father, Asher. The duo quickly attracted a fan base who loved their sentimental songs, as evidenced by the thousands of songbooks that the Sizemores sold over the air.

By November 1932 the WSM tower in the Nashville suburb of Brentwood was broadcasting the Opry over a brand-new 50,000-watt transmitter. The diamond-shaped cantilevered tower would have caught anyone's eye at 878 feet tall, making it the world's largest radio tower at the time. WSM's signal could reach forty states at night when it was allowed to transmit at full power. The tower soon inspired WSM's new nickname, "the Air Castle of the South." Within a month of the tower's completion, Harry Stone was promoted to WSM station manager.

For a time, duos became the order of the day. In addition to Little Jimmie and Asher Sizemore, the show added the Delmore Brothers (Alton and Rabon Delmore), who made their first Opry appearance on April 29, 1933. Their close-singing style would greatly influence many sibling duos yet to come. Robert Lunn, known as "the Talking Blues Boy," and a duo called Nap & Dee (Nap Bastien and Dee Simmons), likely debuted on the show on March 31, 1934. Blackface minstrel act Lasses & Honey made their first documented Opry appearance in April 1934, two years after George D. Hay hired them at WSM. *Amos 'n'*

Andy, a network show heard on WSM, also used white actors to portray a pair of Black friends, employing many of the same racist stereotypes and dialect.

Performing for an audience inside the WSM studio, Opry entertainers adjusted their wardrobe accordingly. A *Tennessean* story from November 1934 observed that some regulars started dressing like hillbillies, and that fiddlers and banjo pickers were now outfitted in overalls, hickory shirts, and battered hats. Sisters Edna Wilson and Margaret Waters, who arrived at the Opry in January 1935, comically depicted a pair of mountain women named Sarie and Sally, decked out in long skirts, old-fashioned bonnets, and high-topped lace-up shoes. Around the same time, WSM staff musician Jack Shook appeared on the Opry stage with his new band, the Missouri Mountaineers. A publicity photo shows their pants rolled up to mid-calf, with one member holding a hunting rifle. George D. Hay stuck with the classics: "a ten-gallon hat, a cutaway coat, flowing tie and shoe string watch chain," according to the story. Uncle Dave Macon also stayed the course with his gold teeth, chin whiskers, and gates-ajar collar. DeFord Bailey, however, didn't care for the hillbilly look. He wore overalls for two weeks but went back to his preferred coat and tie.

For Bailey, Macon, the Delmore Brothers, and other Opry entertainers, being on the road became a way of life during the week. Recognizing that promoting concerts with the Opry name was as good as money in the bank, WSM came up with the idea for the Artists Service Bureau. Launched in December 1934, and soon helmed by David P. Stone, Harry Stone's younger brother, the bureau booked an

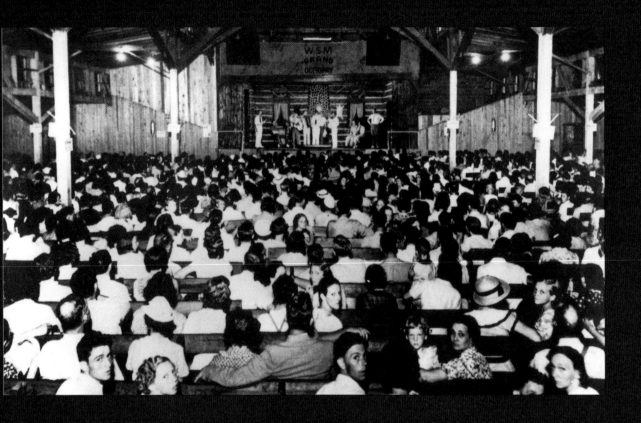

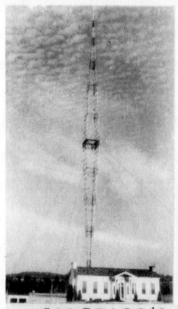

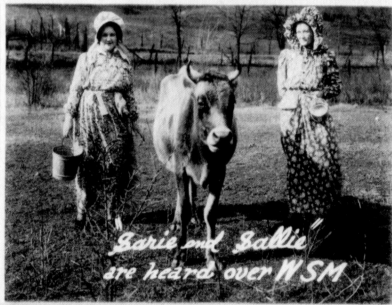

Sarie and Sallie
are heard over WSM

AMERICA'S TALLEST TOWER ~ 878 FEET
WSM The National Life & Accident Insurance Co., Nashville, Tenn.

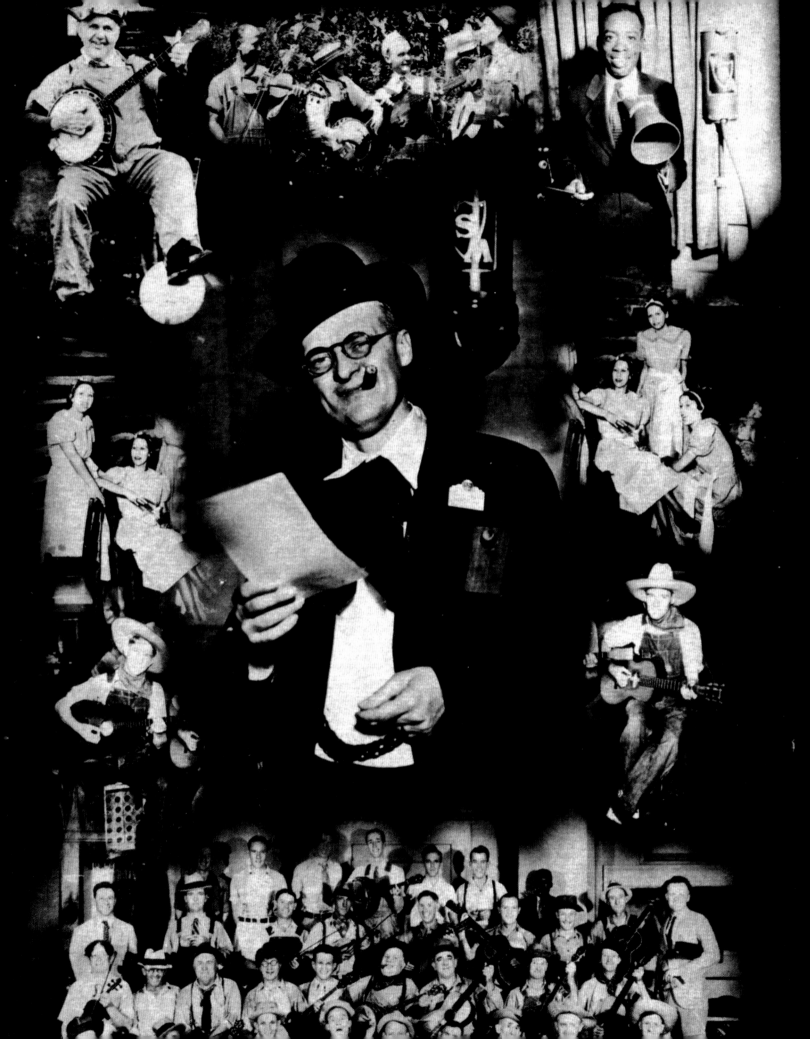

array of Opry stars and kept a percentage of the proceeds. David had managed movie theaters and operated the radio station located inside the Andrew Jackson Hotel in Nashville, so working for WSM was a natural fit. He had joined the WSM staff five years earlier, in 1928, to assist George D. Hay with Opry announcing, as Hay's health started to prematurely deteriorate. The younger Stone soon became one of the show's most familiar voices.

With business booming on all fronts, National Life expanded its downtown building. The Opry relocated to the new, much larger Studio C, but the move didn't last. Hay recounted that National Life executives couldn't access their offices on a Saturday night due to the crowds angling for admission. According to a report in a publication called *Radio Wave*, tickets were issued in three separate colors; each cluster of five hundred people could watch an hour of the Opry inside Studio C before the audience was turned. This strategy was dismantled by summer, when the show aired without a live audience, which would have been a challenge for the entertainers. After going back to an in-studio audience with the same frantic results as before, the Opry headed over to the Hillsboro Theater in the fall of 1935, and reinstituted the three-color ticketing tiers, with tickets distributed by the National Life insurance sales force. The new venue near Vanderbilt University did little to quell the "good natured riot," as George D. Hay once called the show.

Harry Stone assigned the station's music librarian, Vito Pellettieri, to help George D. Hay. It didn't take long for Pellettieri, also a classical violinist and orchestra leader, to realize he had his work cut out for him. Tasked with filing sheet

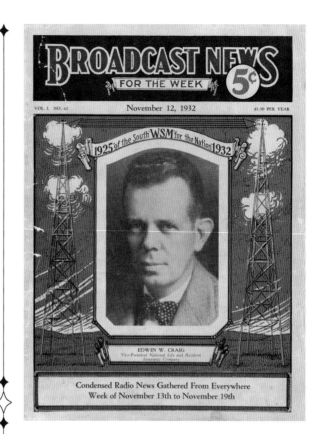

PREVIOUS SPREAD, TOP LEFT: The Grand Ole Opry at Dixie Tabernacle, late 1930s; BOTTOM LEFT: Promotional postcard touting WSM's iconic transmission tower and comedians Sarie and Sally; RIGHT: Advertising postcard depicting Grand Ole Opry creator George D. Hay, surrounded by images of early performers, mid-1930s. THIS PAGE, FROM TOP: Edition of *Broadcast News* with WSM founder Edwin Craig featured on the cover, November 12, 1932; ticket for the Grand Ole Opry at the Dixie Tabernacle, 1936

music, updating WSM logbooks, and monitoring the copyrights of the songs played on the Opry, Pellettieri depended on structure and order. The scene backstage at the Opry was precisely the opposite. Pellettieri was exhausted from chasing down musicians in the moments before Hay brought them to the stage, so he instituted show segments. As a result, artists had a clearer sense of their call time. But more importantly, Harry Stone sensed an opportunity. He took the concept to WSM advertisers, who latched on to the idea. More than ninety years later, sponsored segments are as familiar at the Opry as fiddles and applause.

Some locals bristled at WSM's weekend programming. A letter from *Nashville Banner* reader Frances M. Stephenson began, "So WSM has the tallest radio tower in the world? I represent a cross-section of the audience, getting crosser all the time. The station is so powerful we have little choice but to tune in on it. It drowns out everything else. All the week-end, we must listen to the jug-knockers and the gully-jumpers Saturdays, and, Sunday, be exhorted from every pulpit in town and half the theaters. The East may be putting on a program so wonderful that radio magazines rave about it for weeks. But on Saturdays and Sundays, WSM reverts to type and becomes fanatically mountaineerish and incredibly evangelistic . . ."

Love it or hate it, there was no doubt that people were paying attention to the Grand Ole Opry. When an opportunity arose in June 1936 for the Opry to move from the eight-hundred-seat Hillsboro Theater to a sprawling tabernacle in East Nashville, Harry Stone seized it. Situated at the corner of Fourth and Fatherland Streets, the 14,000-square-foot Dixie Tabernacle was built

in 1928 as a venue for itinerant fundamentalist preachers and revivals. Exposed timber framing gave it a rustic, barn-like quality, as did the wooden plank benches and sawdust floor. The one-level property advertised a capacity of five thousand people, though that was likely exaggerated. An Ohio preacher named Sam Swain used it for his ministry but leased it to WSM on Saturday nights for the next three years.

A few months after the Opry settled into the Dixie Tabernacle, George D. Hay suffered a nervous breakdown and took a long leave of absence. With Stone at the helm, the Opry tried out some new talent in 1937. The Lakeland Sisters arrived in January, followed by Curly Fox & Texas Ruby in August, but both duos left the cast in 1938. So did the Delmore Brothers, who departed after a disagreement over the Opry's booking policies. However, an accordion-playing bandleader from Wisconsin named Julius Frank Anthony Kuczynski–better known as Pee Wee King– showed staying power when he joined the Opry in 1937 with his band, the Golden West Cowboys.

King made his professional debut at the age of fifteen playing accordion in his father's polka band. While still a teenager, he formed his own group, landed a radio show in Racine, Wisconsin, and adopted the surname King in honor of his polka hero, Wayne King. Just five feet and six inches tall, King earned his "Pee Wee" nickname from cowboy singer Gene Autry when they worked together at a radio show in Louisville, Kentucky. Though King himself wasn't necessarily a singer, he did embrace the sounds of Western harmony. Vocalists Jack Skaggs and "Texas Daisy" Rhodes dazzled listeners; Rhodes's brother, Oral "Curley" Rhodes, also sang, played guitar and bass, told jokes, and even yodeled.

Guitarist and master of ceremonies Milton Estes made audiences feel welcome with his warm Southern accent. Clearly, King and the Golden West Cowboys set the bar high for any new band at the Opry. When Roy Acuff and the Crazy Tennesseans made their debut in October 1937, they fell flat in comparison.

King and Acuff knew each other from working on radio shows in Knoxville, where Acuff was living at the time. After trying and failing to get the band noticed in Nashville, Acuff asked King's manager for help. Soon, Acuff heard back that the Opry needed a guest fiddler to cover for Arthur Smith, who was performing out of town with Sam and Kirk McGee in their new band, the Dixieliners. Acuff agreed to open the show with fifteen minutes of fiddling.

What he really wanted, however, was to sing on the Opry. He'd learned to project as a teenager working on a traveling medicine show, yet he scaled back the volume of his voice whenever he performed on Knoxville radio stations, trying to be sensitive to what studio microphones could handle. After performing two fiddle instrumentals on the Opry, he attempted to sing "Great Speckle Bird," which always brought down the house in live performances. The microphones used by WSM probably could have handled his full-throated delivery, but Acuff hedged his bets and approached the song like a crooner. The audience inside the Dixie Tabernacle lost interest as Acuff muddled his way through. He knew he'd failed the audition.

That might have been Acuff's last time at the Opry if not for David P. Stone, who sent Acuff a letter and a lifeline. Stone asked the band to return on February 5, 1938, and this time Acuff

delivered "Great Speckle Bird" with gusto. Some folks in Opry management were still ambivalent about this relative unknown. That is, until bundles of fan letters arrived at the office. At Stone's request, Acuff became an Opry regular starting on February 19, 1938. And this time it wasn't George D. Hay who suggested a name change for the group. Harry Stone felt that the word "crazy" could be considered derogatory. Besides that, the show could be heard far beyond the Volunteer State. Because the band was from East Tennessee, Stone suggested Roy Acuff and His Smoky Mountain Boys.

When those band members opted to stay in Knoxville, Acuff had to hire a different batch of musicians. "It was important for me to stay on the Opry and with the new band it looked like I could do it," Acuff wrote in a 1983 memoir. "I mean, once you got on, you stayed. It was that simple. And you played every Saturday night, no matter where you went during the week; you got back to Nashville on Saturday night, and only a death in the family–say, your own–would excuse an absence."

George D. Hay returned to WSM in March 1938, mostly recuperated from his health woes. By this time, his beloved string bands were overshadowed by Acuff, whose mighty voice became a Saturday night staple in living rooms across the eastern half of the United States. Drifting back to the good old days, Hay waxed nostalgic in homespun articles for a magazine titled *Rural Radio* in 1938 and 1939 but held little sway in how the Opry itself would

Pee Wee King studio portrait, c. 1938

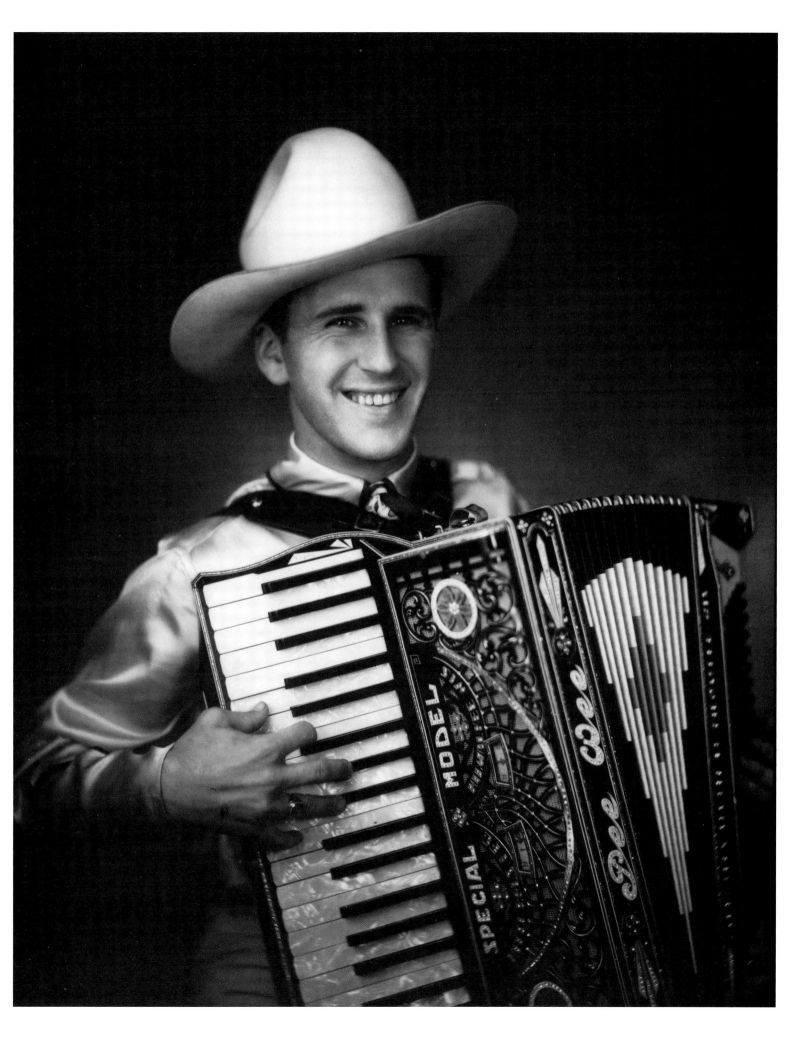

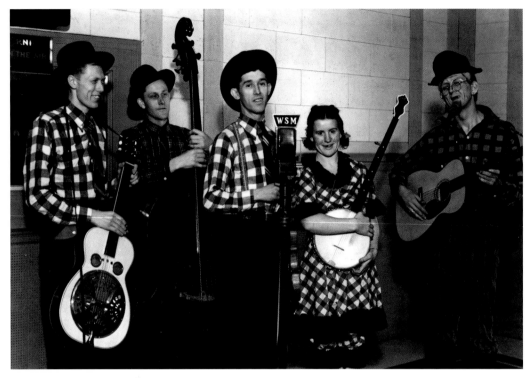

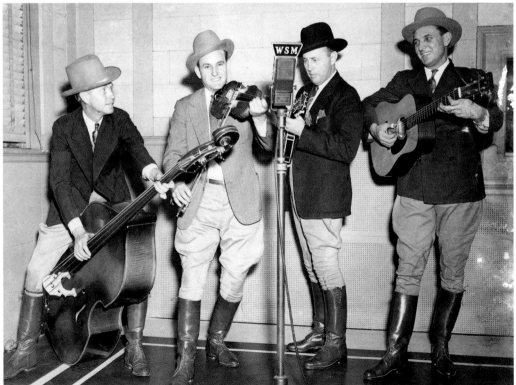

progress in the years to come. He did, however, stand out as a key cast member when the Opry jumped to yet another venue, expanded its relationship with NBC, and even got the attention of Hollywood.

When the Opry parted ways with the Dixie Tabernacle in 1939, the show headed back across the Cumberland River and settled once again in downtown Nashville. The opulence of its new home, War Memorial Auditorium, would have stunned anyone who still thought of the Opry as a barn dance. The imposing neo-classical building received a gold medal from the Architectural Institute of America when it opened to the public in 1925. Spacious with modern amenities, the auditorium shared its sprawling parcel with government offices, memorials to World War I veterans, and a large plaza in front. National Life executives and WSM staffers could easily walk there from the insurance company's headquarters.

War Memorial Auditorium was designed to seat 2,200 people, a fraction of the folks who wanted to see the show up close. WSM imposed an admission fee of twenty-five cents, which didn't seem to deter the crowd. Even when the admission price doubled, the venue stayed packed. Interest in the show grew exponentially when a half-hour segment of the Opry aired on NBC's national network for the first time on October 14, 1939. The deal was negotiated by Harry Stone and Jack Stapp, a new hire at WSM.

OPPOSITE, TOP: Roy Acuff and His Smoky Mountain Boys pose in WSM Studio B, c. 1939. Left to right: Pete Kirby (Bashful Brother Oswald), Jess Easterday, Roy Acuff, Rachel Veach, Lon "Pap" Wilson. OPPOSITE, BOTTOM: Bill Monroe poses with his band, the Blue Grass Boys, in the WSM studio, early 1940s. Left to right:"Cousin Wilbur" Wesbrooks on upright bass, fiddler Tommy Magness, Monroe, and Clyde Moody on guitar

Originally from Nashville, Stapp spent his teen and collegiate years in Atlanta, then served as evening network manager for CBS in New York. When Stapp landed the prestigious job of WSM program director, the hometown kid was all of twenty-six years old.

Stapp took the NBC partnership seriously, and rehearsals were instated for the Saturday night segments. He and Stone wanted to put their best foot forward and satisfy their prominent advertising client, the R.J. Reynolds Tobacco Company, which used the show to promote Prince Albert Smoking Tobacco. With the reach of the NBC network, familiar stars such as George D. Hay, DeFord Bailey, Roy Acuff, and Uncle Dave Macon all reached a new level of notoriety, and no other barn dance in America could compete. So it should have come as no surprise when a road-worn string band showed up in the lobby of National Life on a Monday morning, looking for an audition.

Bill Monroe and his group, the Blue Grass Boys, weren't exactly green. With his penetrating tenor voice and vigorous mandolin playing, Monroe had already built up a mighty audience on WBT, a 50,000-watt radio station out of Charlotte, North Carolina. He formed the Blue Grass Boys, named for his home state of Kentucky, after dissolving a popular duo with his brother Charlie in 1938. Monroe was twenty-eight years old when he appeared unannounced in the National Life lobby; by this time, he'd been performing for at least half his life. His mother taught him folk songs and dance steps as a boy, but it was his uncle, an old-time fiddler named Pendleton Vandiver, who may have been the most pivotal figure in his family. Monroe played local dances with him as a teenager and later immortalized

him in one of his best-known songs, "Uncle Pen."

In a 1975 interview with writer Charles Wolfe, Monroe recalled his impromptu Opry audition:

> *I went into Nashville on a Monday morning. I'd come from Greenville, South Carolina. I was going to move to some other radio station. I come in on Monday and I believe they told me that Wednesday was their day to listen, but they would be back. Judge Hay and Harry Stone and David Stone was all going out to get coffee–as I got off the elevator on the fifth floor, they was going out. And they come back and I played the "Mule Skinner Blues" for them, and "Bile Them Cabbage Down," "John Henry," and another one, and they said they had the music that National Life needed–that the Grand Ole Opry needed. Said I had more perfect music for the station than any music they'd ever heard. One thing they told me that made me feel good: they said, "If you ever leave the station, you'll have to fire yourself." And that stuck with me all the way.*

Monroe joined the cast on October 28, 1939, and his national profile rose enormously after appearing on the NBC network segment. About three months later, in January 1940, Pee Wee King added Eddy Arnold as a featured singer for the Golden West Cowboys. The Henderson, Tennessee, native had been singing for local radio stations and in bars by the time he was a teenager, developing a refined baritone and relaxed demeanor. By joining the sharply dressed Golden West Cowboys at the age of twenty-one, Arnold had taken the first step toward an illustrious career in country music and on television.

Meanwhile, a little bit of Hollywood came to Nashville that summer with the premiere of the 1940 Republic Pictures movie *Grand Ole Opry*. Though the script did not really pertain to the radio show, the film did offer a glimpse into the overall Opry experience. George D. Hay accepted a starring role, Roy Acuff and his Smoky Mountain Boys sang "Wabash Cannonball," and Uncle Dave Macon documented his inimitable entertainment skills. A landmark achievement for the Opry, the film also holds historical value, as it preserved the only moving images of Macon's singing and banjo antics. Tennessee governor Prentice Cooper gave his remarks before the Friday night premiere at Nashville's Paramount Theatre. Thirty-four years later, Acuff would reprise his film performance to celebrate another important Opry milestone.

Sarah Ophelia Colley was twenty-eight years old, disillusioned with her career, and living with her mother when she arrived as "Minnie Pearl" at the Opry. The youngest of five daughters, Colley grew up in Centerville, Tennessee, in a family of means until the Great Depression destroyed her father's lumber business. The family eked out enough money for Ophelia, as she was called, to attend Ward-Belmont College, a two-year finishing school in Nashville. She harbored dreams of being an actress on Broadway and threw herself into "expression," the term for her drama curriculum.

After graduation she accepted a position with a traveling theatrical company, where she directed plays owned by the company and later coached other young women as directors.

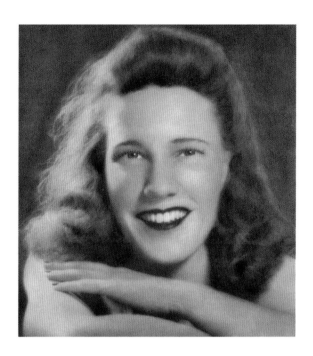

Leading up to the productions, Colley would arrive early in a small Southern town, rustle up some advertising, and teach the scripts to prominent locals (whose appearance onstage would almost certainly generate ticket sales). When a production wrapped up in one community, she'd start the process over a couple of hundred miles away.

On one life-changing trip, she arrived by train in northern Alabama in the middle of a snowstorm. The school principal didn't expect that she'd actually make it, considering the weather, and accommodations were hastily arranged in the log cabin of a family that lived nearby. The mother wasn't used to taking in boarders, but she watched over Ophelia with great care; Ophelia, meanwhile, picked up on her witticisms, mannerisms, and kindness. When they parted ways, the mother confessed, "Lord a'mercy, child, I hate to see you go. You're just like one of us." Touched by the sentiment, Ophelia carried

those memories, and, with some other anecdotes she picked up along the way, she created the character of Minnie Pearl, combining two Southern names she always loved.

She noted in her 1980 autobiography, "Little by little, I began doing Minnie more and more in my work on the road, and also back at the coaches' school. But at that point it was still me talking like a character named Minnie Pearl. But it was not me becoming that person."

When Colley prepared to stage a play in Aiken, South Carolina, in 1939, she slipped into the character of Minnie Pearl as she met the townspeople. The woman who'd hired the production company insisted that Minnie Pearl needed a costume, so they stopped into a thrift store and purchased a yellow organdy dress, cotton stockings, Mary Jane shoes, and a straw hat, all for less than ten dollars. The small investment in wardrobe would pay dividends for years to come.

As she traveled across the South, Colley couldn't help but notice that the public had grown more interested in radio programs than in her amateur theater productions. Burned out by producing the same set of shows year after year, she moved home to Centerville in 1940 and took the only job option presented to her: working at an after-school recreation center, funded by the Works Progress Administration.

Even at Colley's lowest point, Minnie Pearl rose to the occasion. The hometown Lions Club asked

ABOVE: Colorized portrait of Sarah Ophelia Colley during her years as a traveling theatrical director with the Wayne P. Sewell Company, late 1930s

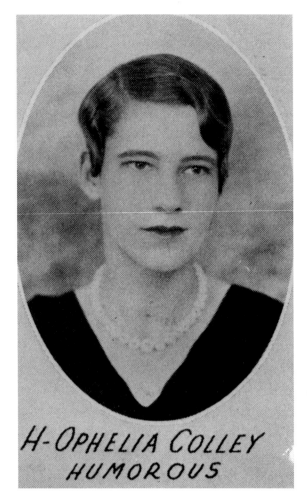

Ophelia to give a performance as Minnie Pearl that fall; a local banker and family friend in the audience then hired her to put on a show at a banking convention a few weeks later. Another banker who attended that convention liked Minnie Pearl's comedy so much that he called Harry Stone at WSM. Ophelia didn't listen to the Opry or care much for country music, but she immediately accepted Stone's invitation to audition.

Listening to her comedy routine in their offices, WSM management felt that Colley was putting on an act that its rural listeners might see

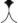

through; but to give her a chance, they slotted her for a low-risk 11:05 P.M. appearance in November 1940. The network portion would have signed off by then, and many listeners would have already gone to bed. But to everyone's surprise, cards and letters flooded the station. An invitation to join the cast soon followed.

George D. Hay relished the chance to bring some good-natured comedy to the show and offered to help Colley flesh out the character of Minnie Pearl. A few years later, during one of her appearances, the price tag attached to the new silk flowers on her straw hat tumbled over the brim. When cast members watching from backstage burst into laughter, she opted to leave the price tag as part of her costume.

Minnie Pearl would be a prominent and beloved part of the Opry story for more than fifty years. Her autobiography tenderly recounted a cherished moment from that first performance:

> *. . . I remember very little about my debut on that November night in 1940 except that I was scared to death.*
>
> *Judge Hay came up to me beforehand and saw the fright in my eyes. "You're scared, aren't you, honey?" he said in that gentle voice I grew to love so dearly.*
>
> *"Yessir, I am," I quavered.*
>
> *Then he gave me the very best advice any performer can get: "Just love them, honey, and they'll love you right back."*
>
> *Those words have remained a refrain in my mind ever since.*

LEFT: Sarah Ophelia Colley in the Ward-Belmont yearbook years before creating her Minnie Pearl character, 1931. OPPOSITE: Early Minnie Pearl publicity photo taken before she added the famous price tag to her hat

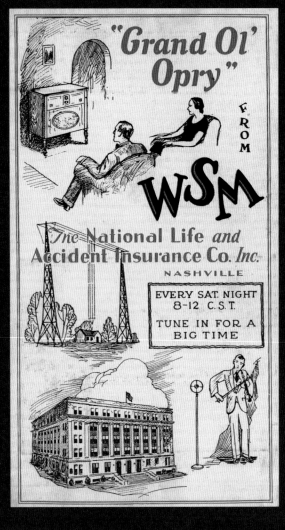

"Grand Ol' Opry"

FROM

WSM

The National Life and Accident Insurance Co. Inc.

NASHVILLE

EVERY SAT. NIGHT
8-12 C.S.T.

TUNE IN FOR A
BIG TIME

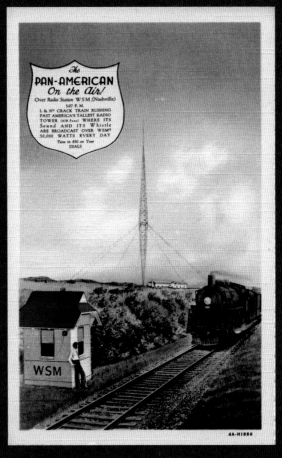

The PAN-AMERICAN On the Air!
Over Radio Station WSM (Nashville)
5:07 P.M.

L & N'S CRACK TRAIN RUSHING
PAST AMERICA'S TALLEST RADIO
TOWER (878 Feet) WHERE ITS
Sound AND ITS Whistle
ARE BROADCAST OVER WSM
50,000 WATTS EVERY DAY
Tune in 650 on Your
DIALS

WSM

DECEMBER 17, 1932

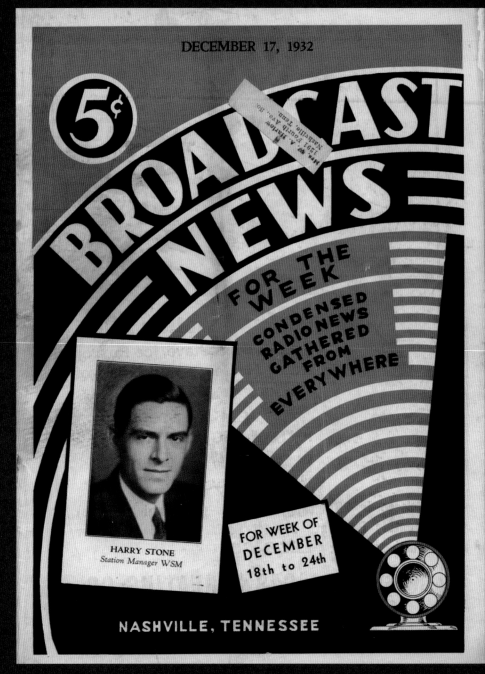

5¢

BROADCAST NEWS

FOR THE WEEK

CONDENSED RADIO NEWS GATHERED FROM EVERYWHERE

HARRY STONE
Station Manager WSM

FOR WEEK OF DECEMBER 18th to 24th

NASHVILLE, TENNESSEE

THE NATIONAL LIFE AND ACCIDENT INSURANCE COMPANY INCORPORATED
SHIELDS YOU
TRADE MARK REG. U.S. PAT. OFF.

GEORGE D. HAY
"THE SOLEMN OLD JUDGE"

REPRESENTING
RADIO STATION W S M

NASHVILLE, TENN.

THE BROADCASTING SERVICE OF
THE NATIONAL LIFE AND ACCIDENT INSURANCE CO. INC.

NASHVILLE, TENNESSEE

STUDIO

WSM
WE SHIELD MILLIONS

GEORGE D. HAY
The Solemn Old Judge
DIRECTOR

JACK KEEFE
ASSOCIATE DIRECTOR

SCHEDULE

MONDAY	6:00 TO 7:30
TUESDAY	6:15 TO 11:00
WEDNESDAY	6:15 TO 11:00
THURSDAY	6:15 TO 11:00
FRIDAY	8:00 TO 11:00
SATURDAY	6:15 TO 11:00

WSM, its Staff and Artists appreciate sincerely your interest.

It is only through your cooperation, your helpful suggestions and even your constructive criticism, that we may hope to render the greatest possible service. Since this is our constant aim, your comments will always be most welcome.

SCHEDULE

SUNDAY, 11:00 A.M., ALTERNATING

AND 6:20 TO 9:15 P.M.

EXCEPTING EVERY OTHER SUNDAY

SILENT FROM 7:15 TO 8:15

WSM
GRAND OLE OPRY
NASHVILLE, TENN.
.25 EST. PRICE .25
.05 FED. TAX .05
30¢ TOTAL 30¢
198600 198601

WSM
WE SHIELD MILLIONS
282·8
THE
NATIONAL
LIFE AND
ACCIDENT
INSURANCE
COMPANY
INCORPORATED
SHIELDS
YOU
NASHVILLE. TENNESSEE

E K
THE
NATIONAL LIFE
WSM
AND ACCIDENT
INSURANCE CO.

GRAND
OLE OPRY
SOUVENIR PROGRAM
WSM

COUNTRY CLUB

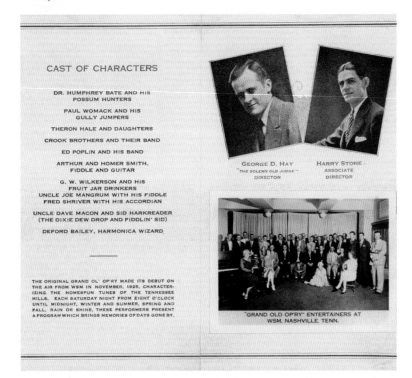

CAST OF CHARACTERS

DR. HUMPHREY BATE AND HIS
POSSUM HUNTERS

PAUL WOMACK AND HIS
GULLY JUMPERS

THERON HALE AND DAUGHTERS

CROOK BROTHERS AND THEIR BAND

ED POPLIN AND HIS BAND

ARTHUR AND HOMER SMITH,
FIDDLE AND GUITAR

G. W. WILKERSON AND HIS
FRUIT JAR DRINKERS
UNCLE JOE MANGRUM WITH HIS FIDDLE
FRED SHRIVER WITH HIS ACCORDIAN

UNCLE DAVE MACON AND SID HARKREADER
(THE DIXIE DEW DROP AND FIDDLIN' SID)

DEFORD BAILEY, HARMONICA WIZARD

THE ORIGINAL GRAND OL' OP'RY MADE ITS DEBUT ON THE AIR FROM WSM IN NOVEMBER, 1925, CHARACTERIZING THE HOMESPUN TUNES OF THE TENNESSEE HILLS. EACH SATURDAY NIGHT FROM EIGHT O'CLOCK UNTIL MIDNIGHT, WINTER AND SUMMER, SPRING AND FALL, RAIN OR SHINE, THESE PERFORMERS PRESENT A PROGRAM WHICH BRINGS MEMORIES OF DAYS GONE BY.

GEORGE D. HAY
"THE SOLEMN OLD JUDGE"
DIRECTOR

HARRY STONE
ASSOCIATE
DIRECTOR

"GRAND OLD OPRY" ENTERTAINERS AT
WSM, NASHVILLE, TENN.

RECEIVING AN INVITATION TO JOIN THE GRAND OLE OPRY IS ALMOST LIKE A MARRIAGE PROPOSAL. First, there are the courtship rituals: Getting together on Saturday nights, meeting the family, talking about the future. If all goes well, the Opry might pop the question at any moment.

There isn't a checklist or a formula to qualify for Opry membership. Instead, when trying to assess who makes a good member, a small number of people in Opry management consider an artist's overall talent and potential, their commitment to the show, rapport with other members, and the response from the Opry audience.

ABOVE: 1928 souvenir pamphlet with the earliest reference to an Opry "cast" OPPOSITE, TOP: An Opry Member Award has been presented to each new Opry member beginning with Brad Paisley's induction in 2001; Brad Paisley with the first Opry Member Award given to a new inductee, February 17, 2001. Left to right: Joe Galante, Steve Wariner, Brad Paisley, Opry Member Award sculptor Bill Rains, Pete Fisher, and Steve Buchanan; Reba McEntire and Grant Turner during her introduction as a member of the Grand Ole Opry, January 14, 1986.

Like most ensemble programs in early radio, the Opry sought out a cast of regulars, rather than operating under concept of "members," with Uncle Dave Macon being the most famous regular. A 1928 souvenir folio with a group photograph and list of names captioned "Cast of Characters" is the earliest known official acknowledgment of a core group of recurring performers.

As the Opry grew and the cast included more full-time professionals, the shift toward membership gave the show a certain durability. Cast members were expected to appear every Saturday night, even if it meant driving hundreds of miles overnight to get there. Although an Opry appearance fee was low, there were other benefits: performers could advertise upcoming appearances and identify themselves as Grand Ole Opry members in promotional material, thus driving interest and ticket sales for their own tour dates. Hopeful musicians would audition for George D. Hay, the Opry's founder, and other WSM executives such as Harry Stone and Opry announcer David Stone. Approved performers were simply added to the cast without any formal invitation or induction.

As these entertainers gained a huge audience through WSM-AM, a clear-channel 50,000-watt station, lucrative offers rolled in. High turnover among the Opry cast wasn't concerning; nor was membership considered permanent. By the late 1940s, most new members had radio experience and recording contracts. The show spotlighted individual stars, such as Bill Monroe, Minnie Pearl, or Ernest Tubb, rather than solo instrumentalists or string bands. Some top artists abandoned the Opry, as they felt restricted by the high volume of broadcasts they were expected to play each year.

When the Opry arrived on television in 1985, fans at home could finally share in what had become known as Opry inductions. Johnny Russell joined the cast on an episode of TNN's *Opry Live* that year, and Reba McEntire was introduced as a new member during a sixtieth-anniversary network anniversary special. By this time, most new members were established performers who revered the Opry, rather than depending on it for exposure. Most of the inductees in the 1990s, including Clint Black, Garth Brooks, Vince Gill, and Alan Jackson, were already well on their way to superstardom when they accepted their invitation.

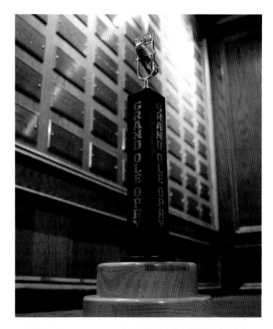

While the responsibilities and rituals of Opry membership evolved over decades, the idea of surprising an artist with an Opry invitation is still relatively new. In 1997, Johnny Paycheck became the first member to be asked to join onstage without any advance notice. Now, a surprise invitation is one of the Opry's hallmarks—and it is impossible to predict when it will arrive, who will deliver it, or even where it will take place. More than a dozen members have accepted their invitation away from the Opry stage, with locales ranging from a North Carolina military base (Craig Morgan) to a California concert stage (Dierks Bentley and Jon Pardi).

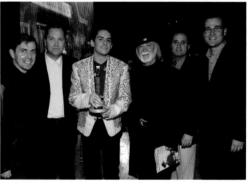

At his 2001 induction ceremony, Brad Paisley received the first Opry Member Award, a replica of a vintage Opry microphone stand that incorporates a small portion of wood from original Ryman Auditorium pews. Since then, every living Opry member has been given the award, and it is presented to each new member during their induction ceremony. Though it stands only fourteen inches tall, it looms large in the imagination of anyone who longs to become an Opry member.

CLOCKWISE FROM TOP LEFT: Craig Morgan recieves a surprise Opry invite from John Conlee during Morgan's concert for US troops at Fort Bragg in Fayetteville, North Carolina, September 18, 2008; Chris Young bear-hugs Vince Gill after receiving Gill's invitation to become the newest Opry member, August 29, 2017; Johnny Russell accepts a gift of a country ham during his first appearance as an Opry member, July 6, 1985; during a concert at House of Blues in Los Angeles, Marty Stuart surprises Dierks Bentley with an Opry invitation, July 27, 2005; Carrie Underwood embraces Randy Travis after being invited to become an Opry member, March 15, 2008; Trisha Yearwood shocks Lauren Alaina with an invitation to become a member of the Grand Ole Opry, December 18, 2021; Johnny Paycheck receives an invitation from Opry manager Bob Whittaker, September 20, 1997, becoming the first member to receive an onstage surprise invitation.

MOVING TO THE MOTHER CHURCH

19

1941

52

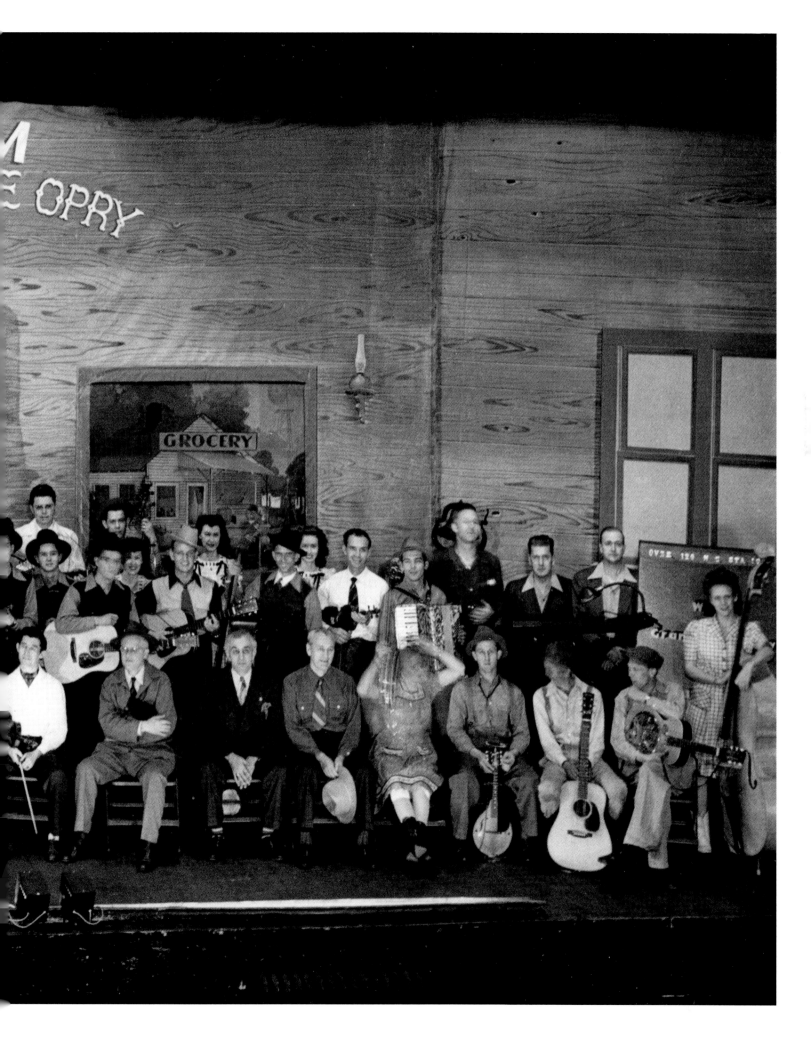

Americans were transfixed by the war raging in Europe in 1941, and maintaining the position of neutrality pledged by President Franklin Roosevelt seemed impossible. Even before America entered the war, WSM and the Opry went to great lengths to support the military. Because the hilly landscape of rural Tennessee reminded General George S. Patton of European terrain, the US Army started staging military training exercises there in 1941. WSM created a remote studio in a train car in Manchester, Tennessee, and reported on the maneuvers, including everything from tank training and parachute jumping to bridge building and blackout simulations.

To lift troop morale, R.J. Reynolds Tobacco created a series of package tours called the Camel Caravan. A troupe of entertainers from WSM's roster, including Minnie Pearl and Pee Wee King and His Golden West Cowboys, was dispatched to US military bases starting in the summer of 1941. These Opry stars were joined on the junket by pop singer Kay Carlisle, dancer Dolly Dearman, and a singing trio of women that included early Opry performer Alcyone Bate Beasley. A cluster of "Camelette" cigarette girls handed out thousands of free cigarettes to two million American soldiers over the next eighteen months.

Country music reminded some Southern service members of home; living in close quarters, they shared their musical tastes with their fellow troops, who may have been hearing country music for the first time. NBC's Prince Albert-sponsored portion of the Opry was even broadcast overseas, via the Armed Forces Radio Service, which probably gave the edge to Roy

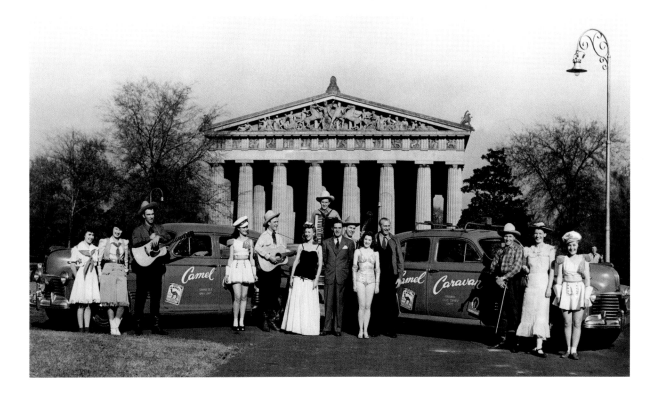

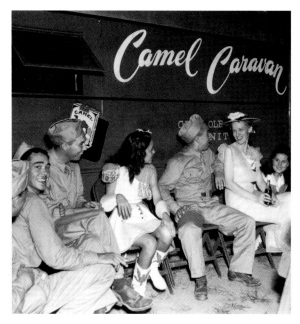

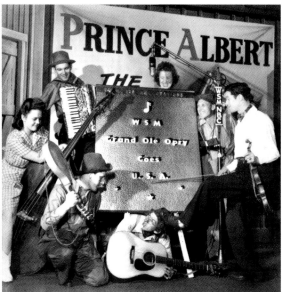

PREVIOUS SPREAD: Opry cast photo taken at Ryman Auditorium, 1943. OPPOSITE: Members of the Camel Caravan touring troupe, including Eddy Arnold, Pee Wee King, and Minnie Pearl, pose in front of the Parthenon in Centennial Park, Nashville, 1941. TOP: Minnie Pearl, sitting with US soldiers as part of the Camel Caravan tour, c. 1941. BOTTOM: Roy Acuff and band pose in front of a sign to announce the Grand Ole Opry's expanded presence on the NBC network, 1943. Clockwise from top of sign: Rachel Veach, Pete Kirby, Acuff, Lonnie "Pap" Wilson, Jess Easterday, Velma Williams , and Jimmie Riddle.

Acuff as he beat out Frank Sinatra in a 1945 popularity poll of the Seventh Army stationed in Germany. The name of the radio show's most popular star had already made its way to Okinawa, Japan. During one of the most arduous battles of World War II, Japanese soldiers were said to come into battle shouting, "To hell with Roosevelt! To hell with Babe Ruth! To hell with Roy Acuff!"

Fittingly, War Memorial Auditorium was still hosting the Opry on Saturday nights, though the show was making a more personal connection with WSM listeners through Opry-sponsored traveling tent shows. In 1942, after seeing comedy duo Jamup & Honey's success the previous year with the concept, Roy Acuff bought his own tent and headlined with his Smoky Mountain Boys. George D. Hay and Bill Monroe soon followed suit. From the spring to the fall, tent shows put down stakes in small Southern towns and charged a modest admission; some tickets were thirty-five cents for adults and fifteen cents for children. As popularity increased, admission prices hovered around a dollar, making it affordable entertainment in rural markets. Some tents could accommodate an audience of up to three thousand fans. Bill Monroe and his unit might even take it a step further by setting up a baseball game against the local team.

Among his Opry castmates, Monroe was especially fond of DeFord Bailey. Monroe, Roy Acuff, and Uncle Dave Macon had toured with Bailey and not only saw how popular he was with the fans, but also witnessed firsthand the indignities a Black musician was forced to endure on tour in the segregated South. In 1975, Monroe observed that "there wasn't a better man in the world than DeFord to get along with. He was

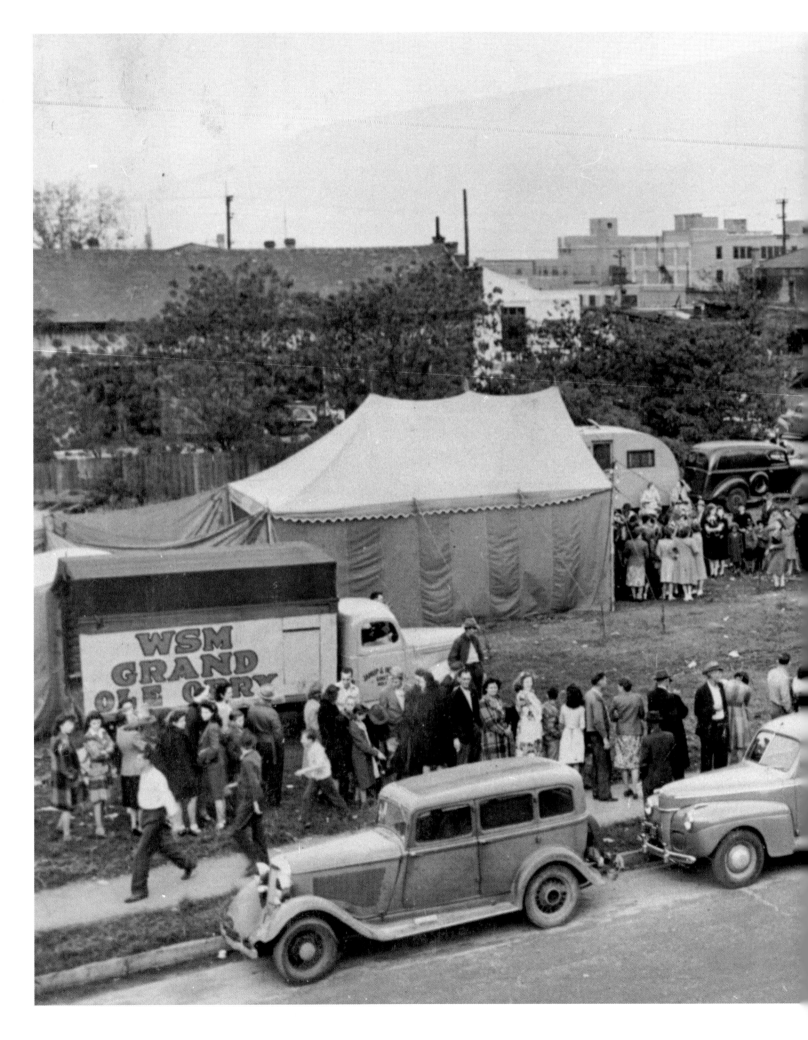

just a fine man, and with the harmonica, it was great. That's a kind of music that I love, too, you know, the way that DeFord played."

In one of the Opry's most controversial decisions, Bailey was removed from the cast in May 1941, ostensibly over the issue of copyrights. Two performance rights organizations monitored the songs performed on the Opry and processed the royalty payments to songwriters and publishers. One of the organizations, ASCAP, announced that it would double its annual fee paid by broadcasters, effective January 1, 1941.

PREVIOUS SPREAD: Fans line up in Mobile, Alabama, to see one of the Grand Ole Opry's traveling tent shows. ABOVE: Early Opry stars and old friends DeFord Bailey and Bill Monroe pose together in the 1970s at an Opry reunion show. OPPOSITE: Portrait of Ernest Tubb, mid-1940s.

Responding to an NBC boycott, Opry management asked cast members to stop performing ASCAP compositions on the show, or in some cases, to write their own material and license it with BMI, the other performing rights organization. Bailey didn't want to limit his repertoire, especially because his signature songs, such as "Fox Chase," were affiliated with ASCAP. When the Opry and Bailey couldn't reach an agreement, WSM dropped him from the lineup.

Bailey told his biographer, "I couldn't grow. They'd play my songs if they wanted. That was all right. If they had let me play like I wanted, I could have stole the show. If I had been a white man, I could have done it. They held me down . . . I wasn't free."

ASCAP and NBC came to an agreement that July, and the dispute was resolved by October, yet Bailey was not reinstated as a cast member. It is unknown whether other Opry performers came to his defense with management; some artists, including Bill Monroe, paid out of their own pocket for DeFord to appear during their set in the 1940s and 1950s, though this happened infrequently. In his biography, Bailey stated that WSM staffers asked him to spend time backstage at War Memorial Auditorium, probably to counter the public criticism of his departure: "The people talked about it a whole lot, about not treating me right. They [WSM] called me back up there to be around and let people see me. They'd give me $3 a night. I went about three times. Finally, I decided to quit. I didn't want no more of that."

Being in the right place at the right time was a common way to earn an audition, and maybe even join the Opry cast, but it wasn't that easy for Ernest Tubb. A recording contract with RCA Victor was a failure, and he didn't stay long at the radio jobs he'd found in Texas. A 1939 tonsillectomy lowered his voice and forced him out of his creative comfort zone. When he was no longer able to yodel like his musical hero, Jimmie Rodgers, he realized he had to change his songwriting and develop his own style.

Tubb adopted the nickname "the Texas Troubadour" in 1940 and achieved national stardom with "Walking the Floor Over You" a year later. Admittedly nervous, Tubb was introduced at his Opry debut by Roy Acuff during the Prince Albert segment on January 16, 1943. Tubb often stated that he was too afraid to remember anything about the moment, though Opry management did take note of the audience response. A four-week tryout period culminated in Tubb's first appearance as a regular cast member on February 13, 1943.

Around the same time, the Opry added more members to its cast: Paul Howard, who brought Western swing to the Opry with his band, the Arkansas Cotton Pickers, before leaving in 1949; a Southern gospel group called the John Daniel Quartet, who'd already amassed a following through a fifteen-minute morning radio show; and fiddler Curley Williams and his band the Georgia Peach Pickers, who stayed until 1945, then relocated to the West Coast.

The final performer to join the Opry cast at War Memorial Auditorium was Benjamin Francis Ford, otherwise known as the Duke of Paducah.

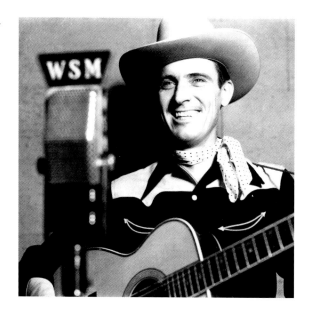

The Missouri native had a third-grade education, spent four years in the US Navy, and cultivated his comic chops on radio stations in Chicago and St. Louis. By the mid-1930s, he had adopted the Duke of Paducah persona. (His blond hair also earned him the nickname "Whitey.") After departing the *Plantation Party* radio show on NBC, Ford made guest appearances and toured with an Opry troupe before settling into a regular spot on the Prince Albert show cast in early 1943. Wrapping up his time on the Opry in the mid-1950s, it's easy to imagine him uttering his famous line for old times' sake: "I'm goin' back to the wagon, boys, these shoes are killin' me!"

Working on her own alter ego, Sarah Ophelia Colley perfected the comic timing and old-fashioned wardrobe that would turn Minnie Pearl into an iconic Opry performer. In her first few years at War Memorial Auditorium, she greeted audiences with a gentle and friendly "Howdy!" Around 1943, a representative from an ad agency working with sponsor Prince Albert

Tobacco approached her during a rehearsal. He asked her why she didn't shout "How-*dee*!" and let the audience holler it back. She replied that it would be out of character because country girls wouldn't say it that way. Yet she had to agree when he added, "I'll tell you, that's a great trademark."

In an interview for her biography, she stated, "I wish I knew who he was so I could thank him. He said, 'We'll have the announcer go out just before the network show and say, "When Minnie says howdy, you all say howdy back."' And it was just that quick that he ran out and said that. Well, the audience loved participation, so I would go out then and say, 'How-*dee*!' and they'd holler 'How-*dee*!' back at me. For the first couple of weeks and months that I did it, I didn't like it, but I realized eventually that it was to be one of the most important things that happened in my act—that and the price tag."

A victim of its own success, the Grand Ole Opry was asked to leave War Memorial Auditorium in 1943. The elegant venue's oversight committee was displeased with the rowdy crowds and the chewing gum they left under their seats. This time, the show relocated a half mile south to Ryman Auditorium, a redbrick tabernacle named for riverboat fleet captain and shipping magnate Thomas G. Ryman. Moved by the preaching of evangelist Sam Jones, Ryman led fundraising efforts to build a permanent structure for Jones and other visiting evangelists to use when preaching in Nashville. Initially called the Union Gospel Tabernacle and now revered as the Mother Church of Country Music, Ryman Auditorium opened in the heart of downtown

Nashville in 1892, with a balcony added in 1897. While Sam Jones was leading Thomas Ryman's memorial service inside the tabernacle in 1904, he called for the building to be renamed in the late captain's memory.

Venue manager Lula Naff was initially reluctant to bring the Opry into Ryman Auditorium every Saturday night. She'd booked a few country music shows in the past, though the venue usually hosted theatrical productions, orchestras, and accomplished vocalists such as Marian Anderson, Enrico Caruso, or the Fisk Jubilee Singers. But no matter how sophisticated the concert was, the wooden pews weren't very comfortable, there was just one dressing room backstage, and a lack of air-conditioning made the venue less than desirable for summer shows.

Nonetheless, WSM station manager Harry Stone needed to find a large venue as soon as possible. After negotiating with Naff, the Opry settled into the steaming Ryman Auditorium on June 5, 1943. The venue could hold about 3,800 people, though the show reached an even wider audience on October 9, 1943, when NBC expanded the Prince Albert show to its entire network of 130 stations, coast to coast.

By this time, Roy Acuff, Bill Monroe, and Minnie Pearl were household names. Eager to raise his profile as a solo performer, Eddy Arnold parted ways with Pee Wee King and His Golden West Cowboys in 1943 and launched his own fifteen-minute morning show on WSM. By summer, he'd made his way into the Opry cast, followed by the Smith Sisters, the Old Hickory Singers, the Poe Sisters, and the Cackle Sisters. The latter duo was noted for their close-harmony yodeling but

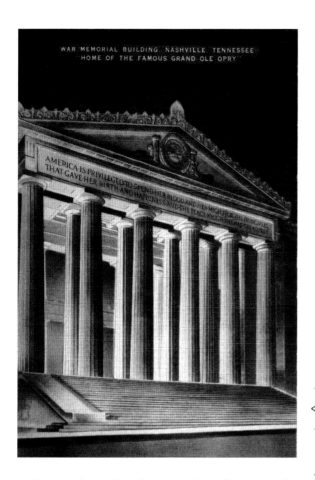

WAR MEMORIAL BUILDING NASHVILLE TENNESSEE
"HOME OF THE FAMOUS GRAND OLE OPRY"

AMERICA IS PRIVILEGED TO SPEND HER BLOOD AND HER MIGHT...
THAT GAVE HER BIRTH AND HAPPINESS AND THE PEACE...

truly stood out for their vocal tricks and trills that sounded like birdcalls.

Other new acts that received membership in the mid-1940s included the Bailes Brothers, Danny Bailey and the Happy Valley Boys, and the Tennessee Mountaineers. The latter group was fronted by Willie Egbert "Cousin Wilbur" Wesbrooks, who'd been a bassist and comic rube in Bill Monroe's Blue Grass Boys in the early 1940s. Three other former Blue Grass Boys were added to the cast around this time: Clyde Moody, whose smooth singing style resembled

ABOVE: Postcard depicting War Memorial Auditorium, the Opry's home from 1939 to 1943.

Eddy Arnold's, appeared regularly at the Opry from 1944 to 1948; Pete Pyle, who stayed for a few months in mid-1945 with his band, the Mississippi Valley Boys; and lanky old-time musician David "Stringbean" Akeman, who played banjo in Monroe's band before coming on as an individual cast member in 1945. Vaudeville-inspired entertainer Lew Childre and gospel singer Wally Fowler were also added to the roster in 1945.

And while Bob Wills and His Texas Playboys were never Opry cast members, the era's leading Western swing band made their first Opry appearance on December 30, 1944. Lead singer Tommy Duncan roused the audience with "New San Antonio Rose," a number three hit on *Billboard*'s first-ever country chart published earlier that year. Yet the night was historic for another reason. For the first time, a full drum kit appeared on the Opry stage. Reaching a compromise with Opry management, drummer Smoky Dacus played it behind the curtain.

Regardless of who was scheduled for the Opry, folks lined up at the Ryman doors every Saturday night. But after the announcement of President Roosevelt's death on April 12, 1945, the major radio networks suspended all regular programming through his internment on Sunday, April 15. For those who showed up on April 14, there was only a brief, ticketless performance.

Considered one of the Opry's headliners by 1945, Bill Monroe was chasing a certain sound, one that he came closer and closer to achieving as various Blue Grass Boys came and went. For a 1967 piece in *Bluegrass Unlimited*, Monroe spoke about his willingness to adapt the sound that he

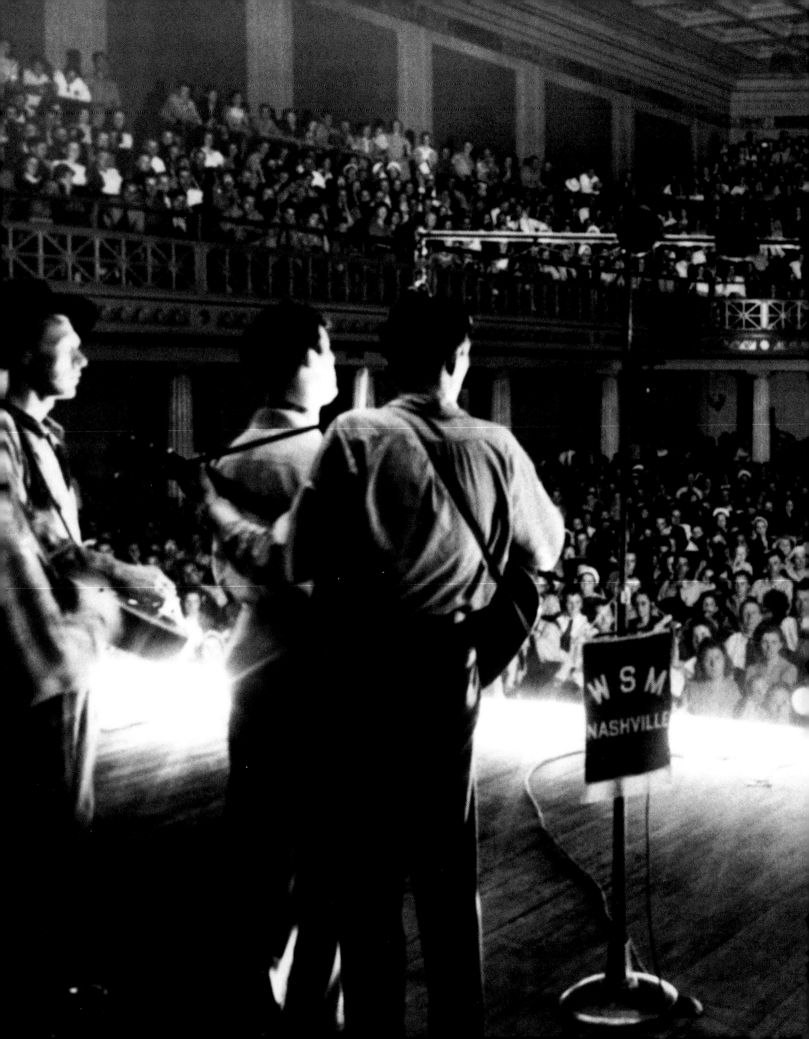

referred to as "blue grass." He noted, "I have had a lot of different people to work for me. I've been in it for twenty-seven years now . . . and I like the friendship of a man, but I don't think I would like to have kept the same musician for twenty-seven years, because his ideas would run out . . . and with bringing in new men to learn to play blue grass, with their ideas, why, it's helped blue grass along each year."

David "Stringbean" Akeman, who was Monroe's first banjo player, was certainly funny and well-liked, but his clawhammer banjo style didn't always suit Monroe's musical direction. When the opportunity arose in the fall of 1945 to form an act with Lew Childre, Stringbean gave his notice to Monroe.

Lester Flatt, the new guitarist in the Blue Grass Boys, felt that Stringbean couldn't keep up and wasn't sorry to see him go; Flatt wasn't even convinced that Monroe needed a banjo player. However, Monroe hired twenty-one-year-old Earl Scruggs, an unassuming yet dazzling picker from Flint Hill, North Carolina. When Flatt, Monroe, and Scruggs performed together for the first time on the Opry on December 8, 1945, the chemistry was immediate and undeniable. Scruggs played banjo in a stunning three-finger style, with a tempo that thrilled listeners. Monroe and Flatt were pleased with their new bandmate, though nobody in Ryman Auditorium realized at the time that they had witnessed the spark of what would become bluegrass music.

Still, on any night in late 1945 or early 1946, simply seeing the stars of the Grand Ole Opry would have been hillbilly heaven. Roy Acuff and His Smoky Mountain Boys, Bill Monroe and His Blue Grass Boys, Stringbean, and Ernest Tubb

were wildly embraced by listeners, as were the comic routines of Minnie Pearl, the Duke of Paducah, and Rod Brasfield. Inducted in the summer of 1944, Brasfield had been recruited as a cast member by George D. Hay after they performed together at a tent show. Brasfield dressed the part of a goofball—baggy pants, an oversize coat, and a too-small hat—but it was his comic timing and down-home humor that brought down the house.

Old-time music still served as a focal point of Saturday night programming, too. Becoming an Opry regular in January 1946, radio veteran Bradley Kincaid offered the traditional ballads, old-time music, and folk songs that had already made him a radio star on other stations. Kincaid soon arranged an Opry audition for a friend and former bandmate named Louis Marshall Jones, an old-time banjo player and singer better known as Grandpa Jones. Kincaid gave him the unlikely nickname during an early morning radio show in 1935, teasing him over the air about being tired and grouchy. "Get up to the microphone. You're just like an old grandpa," Kincaid quipped. Jones was a mere twenty-two years old then, but the name stuck.

In his memoir, Jones wrote, "Bradley gave me some leather boots that were all of fifty years old, and I started talking all the time on the radio in my whiney voice, and I've been Grandpa ever since." They took the joke even further when Kincaid bought him a wig and a fake mustache; Grandpa added a plaid shirt and suspenders to his stage costume and drew pencil lines on his face to look old. Jones made his Opry debut singing "I Like Molasses" as part of Pee Wee King and His Golden West Cowboys on March 16, 1946. After a period of working with King, Kincaid, and the Bailes Brothers, Grandpa became a member in his own right, often accompanied by his new bride, old-time fiddler and singer Ramona Riggins.

Another former member of Pee Wee King and His Golden West Cowboys, Milton Estes assembled a new band called the Musical Millers, inspired by longtime Opry sponsor Martha White, and returned to the Opry in 1946. On some WSM shows, Estes and the audience would shout that famous compliment for biscuits made with Martha White flour: "Goodness gracious, it's good!" Joining the cast in April that year, Lazy Jim Day made folks laugh with his "Singing News" gag, where he played guitar and sang rhyming versions of newspaper stories. That summer, the Opry also welcomed the Western style of the Oklahoma Wranglers, composed of three brothers who reunited after service in World War II: Guy Willis on guitar, Skeeter Willis on fiddle, and Vic Willis on accordion.

Over the next five years, these new inductees would move on from the Opry for various reasons, though Grandpa Jones and the Willis brothers eventually found their way back. Yet the most famous departure of the era was Roy

PREVIOUS SPREAD: Roy Acuff and His Smoky Mountain Boys perform to the Opry audience at War Memorial Auditorium, early 1940s. OPPOSITE: Bill Monroe performs on the Opry with Lester Flatt and Earl Scruggs, October 4, 1947. This iteration of Monroe's band set the stage for the bluegrass genre. Left to right: Robert "Chubby" Wise, Birch Monroe, Bill Monroe, Flatt (obscured), and Scruggs. TOP: Studio portrait of Louis Marshall Jones, better known as Grandpa Jones, August 18, 1961. BOTTOM: Chet Atkins, Grandpa Jones, and the Louvin Brothers pose together backstage at the Opry, May 7, 1955. Left to right: Ira Louvin, Chet Atkins, Grandpa Jones, and Charlie Louvin

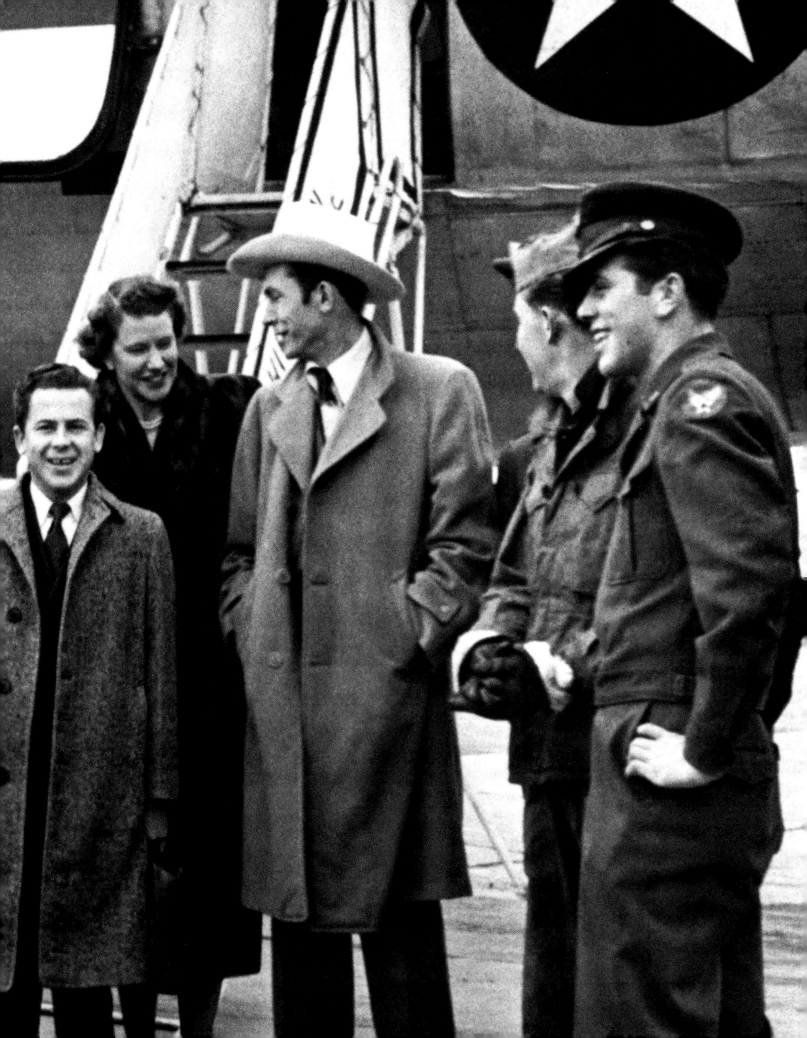

Acuff, who left the Opry in April 1946 over a salary dispute. Among devoted radio listeners, his replacement needed no introduction. Taking on hosting duties for the Prince Albert segment, the amiable Red Foley made a name for himself first on the *National Barn Dance* on WLS in Chicago, and through hits such as "Old Shep," "Smoke on the Water," and "Shame on You." Two months after joining the cast, he presided over an Opry show broadcast from a paddle-wheel showboat on the Cumberland River. WSM management invited press from around the country to ride along, with the expectation that the reporters would write stories about the Opry as a tourist destination. Foley jokingly referred to the Duke of Paducah as "the big gust of wind who sent the boat along."

Foley had racked up a sizable number of jukebox hits by the time he came aboard, but sometimes, it took just one song to get the Opry's attention. For Cowboy Copas, that song was "Filipino Baby." With its unconventional

storyline and a honky-tonk flair, the single charted nationally and led to an Opry membership in 1946. Copas briefly joined Pee Wee King and His Golden West Cowboys as a rhythm guitarist and singer that same year; he also stood out as a charming solo performer with an impressive array of love songs. Opry announcer Grant Turner admiringly referred to him as "Waltz King of the Grand Ole Opry." Copas remained with the show even after Pee Wee King's departure in 1947.

By this time, married couple Annie Lou and Danny Dill were also part of the Opry. They formed their act on a radio station in Jackson, Tennessee, before relocating to Nashville for an early morning show on WSM. Listeners responded to their singing talent and their comedic banter. Though they were nicknamed "the Sweethearts of the Grand Ole Opry," they eventually drifted away from the show and divorced. Danny Dill's spot in music history, however, is secure, as a cowriter of country

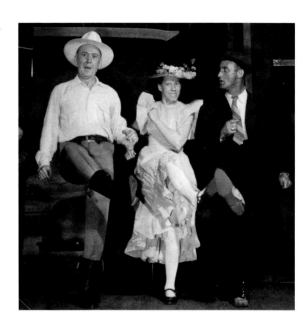

classics such as "Detroit City," "The Long Black Veil," and "So Wrong."

Brothers-in-law Johnnie Wright and Jack Anglin, billed as Johnnie & Jack, and their band, the Tennessee Mountain Boys, were added to the Opry cast in the spring of 1947. By the spring of 1948, they had moved on to the *Louisiana Hayride* radio show in Shreveport. Comedians Lonzo & Oscar (Lloyd George and Rollin Sullivan) branched off from Eddy Arnold's touring group to join the Opry in late 1947 and scored a 1948 novelty hit, "I'm My Own Grandpa." After George left for a solo career, Sullivan enlisted other Lonzos (including his older brother John Sullivan, the longest-tenured Lonzo) to keep the act going.

But when it came to comedy duos on the Opry, Rod Brasfield and Minnie Pearl's back-and-forth zingers remained the gold standard. Brasfield assumed an even bigger role in the show in 1947, when the Duke of Paducah

recruited him to take over as a comic foil for Red Foley. In a 1958 obituary, the *Nashville Banner* noted that Brasfield took his comedy seriously: "Rod was never fully satisfied by his performance. Striving for perfection, he would sit in his trailer and play back tapes of his radio show, analyzing his faults and attempting to improve himself. On and off the stage, he was full of spur-of-the-moment quips and left everyone laughing with his antics. People who never listened to the Opry, who scorned country music and entertainment, undoubtedly enjoyed Brasfield as a showman."

PREVIOUS SPREAD: The Opry performed overseas for the first time in 1949. Included in the tour to entertain US troops were Rod Brasfield, Red Foley, Little Jimmy Dickens, Minnie Pearl, and Hank Williams. They traveled to Austria, the Azores, England, Germany, and Newfoundland. OPPOSITE, LEFT TO RIGHT: Red Foley shakes hands with Roy Acuff, late 1940s; Cowboy Copas performs on the Grand Ole Opry backed by Pee Wee King and His Golden West Cowboys, 1947. ABOVE, LEFT TO RIGHT: Johnnie & Jack pose backstage at Ryman Auditorium, May 1954; Red Foley, Minnie Pearl and Rod Brasfield dance together onstage at Ryman Auditorium, late 1940s.

As a student at Ward-Belmont College, Minnie Pearl had dreamed of the stages of New York City, so it must have been especially satisfying when the Opry traveled to Carnegie Hall on September 18 and 19, 1947. *Billboard* published a recap of the two shows, which were introduced by George D. Hay and headlined by Ernest Tubb. After the critic amused himself with phrases like "corn-quered by hillbilly music" and "a corn-billy troupe called Grand Ole Opry," he got around to describing the audience: "These weren't just curious onlookers, out for a night of novelty. They were serious, devoted fans, almost rabid in their wild enthusiasm."

Minnie Pearl wired her own review back to a *Tennessean* reporter: "Scared to death at first, but patrons so nice, it was just like playing Red Bay, Ala." However, a Washington, DC, audience almost didn't get to see Minnie Pearl when an Opry troupe played Constitution Hall on October 31, 1947. Realizing that she had forgotten her costume and props in the car that dropped her off, she frantically started calling taxi companies in the city and was relieved when a driver returned to the venue with her belongings a few minutes before showtime.

Meanwhile, Roy Acuff had resolved his financial contention with the Opry and returned to the show in 1947. The Opry could still count on Acuff, Bill Monroe, Minnie Pearl, and Ernest Tubb on most Saturday nights, though as country music's popularity was booming nationally, it wasn't long before several stars abandoned the show for greener pastures. Lester Flatt and Earl Scruggs departed Bill Monroe's band in early 1948 to form their own group, Flatt & Scruggs and the Foggy Mountain Boys. That

summer, Grandpa Jones accepted a radio gig in Arlington, Virginia, and left the Opry for four years. Eddy Arnold played his final Opry show as a member on September 11, 1948, and launched a CBS radio show the following week.

Upon Arnold's departure, the Opry immediately brought in another crooner, George Morgan. Growing up in Akron, Ohio, Morgan had dreamed of singing on WSM since he was a boy. He signed with Columbia Records on September 14, 1948, and joined the cast the same month. By the spring of 1949, Morgan and his debut single, "Candy Kisses," were giving Arnold a run for his money.

Morgan joined the cast shortly after another crowd favorite, Little Jimmy Dickens. The oldest of thirteen children, Dickens grew up listening to the Opry with his grandparents on their battery-powered radio. He was raised in the coal-mining community of Bolt, West Virginia, but still managed to get into show business while in high school through an early morning radio show in Beckley, West Virginia. "My uncle and two of his buddies had a fifteen-minute program on WJLS and they'd take me with 'em," Dickens recalled. "One day the manager said, 'We need somebody to crow like a rooster.' I said, 'You got him right here!'"

After that cock-a-doodle-doo in 1938, Dickens kept at it, picking up radio shows in West Virginia, Indiana, Ohio, Kansas, and Michigan. Roy Acuff heard Dickens perform in Cincinnati in 1947 and arranged for an Opry debut on February 21, 1948. Standing just four feet, eleven inches, Dickens made a big impression in listeners' imaginations. He showed off his storytelling skills with a riveting version of "John Henry" and through

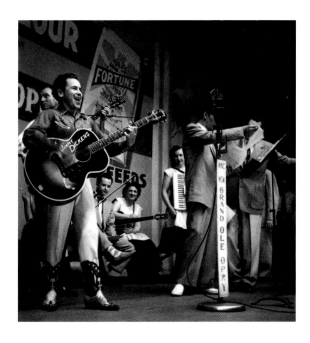

an emotional rendering of "I Dreamed of an Old Love Affair." In September 1948, he was officially made a member and acquired Paul Howard's hotshot band after Howard left the Opry.

Dickens signed a recording contract with Columbia just two days after George Morgan, though nobody would confuse the two new-comers. In contrast to the velvet voice behind "Candy Kisses," Dickens delivered a novelty number titled "Take an Old Cold 'Tater (And Wait)," which reached the Top 10 in the summer of 1949. In a matter of weeks, he repeated that feat with "Country Boy," a depiction of the sim-ple life that would make anyone chuckle.

Written by married couple Boudleaux and Felice Bryant, "Country Boy" caught the attention of Acuff-Rose Publications, a music publishing firm

Little Jimmy Dickens performing on the Grand Ole Opry stage at Ryman Auditorium, early 1950s

cofounded in 1942 by Roy Acuff and songwriter Fred Rose. By 1949, the company was turning a significant profit with titles such as Bob Wills's "New San Antonio Rose" and Pee Wee King's "Tennessee Waltz." Unlike those composers, the Bryants were not known as performers; when Acuff-Rose signed them to a publishing contract in 1949, they effectively became Nashville's first full-time professional songwriters. That same year, another groundbreaking composer on the Acuff-Rose roster would leave an indelible mark in Opry history.

While still employed by a radio station in his hometown of Montgomery, Alabama, aspiring country singer Hank Williams drove to Nashville to see about joining the Opry. He walked into the WSM office around 1945 or 1946 and asked for Opry announcer Jud Collins. Williams was told that he would have to audition for WSM program director Jack Stapp. Williams stammered and decided to just drive back home.

However, Williams soon earned a vote of con-fidence from Fred Rose, first as a songwriter, then as a recording artist. A lighthearted orig-inal called "Move It on Over" had performed well on the jukeboxes in 1947 and propelled Williams to the cast of the *Louisiana Hayride*. As quickly as the song's popularity had spread, so had stories about Hank's problems with alcohol. From two states away, the Opry's tastemakers could monitor his momentum without taking on a liability. That is, until the runaway success of "Lovesick Blues" in 1949.

Word of Williams's trouble with the bottle was no secret to the Opry cast and staff, but stars

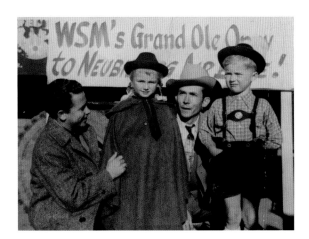

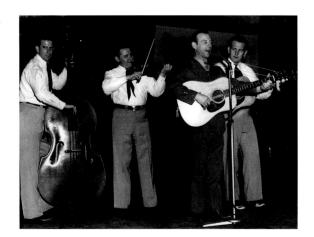

who toured with him reported that he appeared to be getting his act together. He and his wife, Audrey, had just welcomed their son, Hank Jr., at the end of May 1949, and Williams was thrilled to be considered by the Opry—and to be introduced at his June 11, 1949, debut by one of his heroes, Ernest Tubb. No recording has been found from that night, but Little Jimmy Dickens swore that Williams earned six encores for "Lovesick Blues." Dickens forged an easy friendship with Williams and didn't mind that Williams liked to call him "Tater."

Realizing that they had a star in their midst, though a reckless one, the Opry extended an offer. On the Prince Albert show one week after that first appearance, Red Foley told Williams, "Well, sir, we hope you'll be here for a good, long time, buddy." Indeed, Williams became such a key part of the cast that he joined Acuff, Dickens, Foley, and Minnie Pearl on a tour of international US Air Force bases that November. In a poll about which radio show American troops would most like to see in person, the Grand Ole Opry placed first. The patriotic jaunt marked the first time an Opry troupe had gone overseas, and over twenty days, they performed for soldiers in Austria, the Azores, England, Germany, and Newfoundland.

After the holidays, Opry management took Ernest Tubb's recommendation and introduced Canadian singer Hank Snow as a new cast member. Tubb heard potential in Snow's nasal delivery. Opry audiences, however, did not. His first appearance as a member on January 7, 1950, brought a mild reaction, as did pretty much every performance over the next four months. Snow feared that he'd be dropped from the show if the response didn't improve. Unbeknownst to him, those conversations were already underway.

An up-tempo song Snow had written two years earlier, "I'm Moving On," saved his career. His producer rejected it at Snow's first RCA session, but this time it made the cut. In his memoir, Snow wrote, "After 'I'm Movin' On' was released, many positive things happened to me. I continued on with the Opry, and the audiences changed overnight. It was like magic. They were completely indifferent one week, and the next they were wildly enthusiastic. I received one encore after another. It seemed like they just couldn't get enough of Hank Snow . . . In particular, I was

overjoyed because I wanted to prove my success to Ernest Tubb. He always believed in me, and he was just as happy about my success as I was."

If somebody dropped in a quarter in a jukebox to hear "I'm Movin' On," there was a good chance that Red Foley's "Chattanoogie Shoe Shine Boy" wasn't far behind. The snappy 1950 hit was likely written by Fred Rose but credited to Jack Stapp and Harry Stone as a thank-you for agreeing to put Hank Williams on the Opry. Released by Decca Records, "Chattanoogie Shoe Shine Boy" crossed over as a number one pop hit and kept Foley squarely in the spotlight. Decca also signed the Jordanaires in 1949, the same year they began performing on WSM. After some turnover in their lineup, the vocal quartet would go on to become studio legends in Nashville but were primarily known at the time for their gospel performances with Foley.

During one of Foley's radio shows in the spring of 1950, WSM announcer David Cobb ad-libbed that he was broadcasting live from "Music City, USA." The station's executives thought the phrase had a nice ring to it and swiftly adopted the off-the-cuff comment as a WSM slogan. By this time, Nashville had begun to earn the Music City moniker, largely thanks to WSM and the Grand Ole Opry.

Bigger cities, such as Atlanta, Chicago, and Dallas, rivaled Nashville through the 1930s and '40s with their own country music radio shows, professional recording studios, and entertainment business infrastructure to attract talent. However, bolstered by the reach of WSM's powerful 50,000-watt transmitter and perhaps by the culture of professionalism and the business acumen that surrounded them at the National

Life and Accident Insurance Company, staff and artists at WSM seized opportunities to build their own businesses to support—and to profit from—the growing star power gravitating to the Grand Ole Opry. In the end, they'd built the country music industry.

The station created Nashville's first booking agency in 1934 with the WSM Artists Service Bureau, helping the Opry cast members schedule personal appearances, which they advertised to the enormous radio audience each week from the Opry stage. Country music publishing,

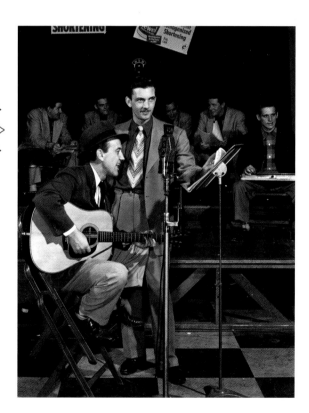

OPPOSITE, LEFT TO RIGHT: Little Jimmy Dickens and Hank Williams pose for a snapshot with local children at Neuburg Air Base, Germany, 1949; Hank Snow performs on the Ryman stage during National Life's fiftieth anniversary party, 1951. Left to right: Howard Watts, Tommy Vaden, Snow, and Hillous Butrum. ABOVE: Red Foley in WSM Studio C for a radio performance with WSM announcer David Cobb, late 1940s

inspired by Roy Acuff's success in selling his own songbooks, came to Nashville when the Opry star joined forces with WSM staff pianist and songwriter Fred Rose to form Acuff-Rose Publications. The firm grew into a multimillion-dollar company in less than a decade.

Into the mid-1940s, Nashville had no professional recording studio. Eddy Arnold made his first recordings for RCA Victor in 1944 in WSM's Studio B. Two years later, three of the station's audio engineers moved to fill the void

ABOVE: Postcard from Hotel Tulane, which housed Castle Recording Laboratory, where Kitty Wells, Hank Williams, Webb Pierce, and others recorded many of their hits. OPPOSITE: Opry star Hank Williams performing onstage at Ryman Auditorium, backed by electric guitarist Grady Martin and fiddler Jerry Rivers, early 1950s

with Castle Recording Laboratory, located two blocks from National Life at the Hotel Tulane. By 1955, when WSM forced Carl Jenkins, George Reynolds, and Aaron Shelton to choose between their recording studio and their jobs at the radio station, RCA had built its own studio. In addition, WSM pianist and bandleader Owen Bradley and his brother, guitarist Harold Bradley, were operating the first studio on what would later become known as Music Row.

On Saturday nights at the Grand Ole Opry, ambitious professionals gathered backstage to network and to catch up with artists and musicians before the bands packed up and headed back out on the road. The crowded wings at the Ryman served as Nashville's industry hub, where deals were struck, songs were pitched, and the country music business came into its own and found a permanent home in Nashville. Before long, Mother Maybelle & the Carter Sisters, guitarist Chet Atkins, and country singer Carl Smith all heeded the call of Music City, USA.

Maybelle Carter initially found an audience as a member of the Carter Family, considered the first family of country music. The trio's seminal 1927 recordings for RCA Victor introduced them to a broad audience fascinated by their harmonies and musicianship, as well as their repertoire of Appalachian folk and country music. When the group disbanded in 1943, Maybelle grabbed her guitar, her autoharp, and her three daughters—June, Anita, and Helen Carter—and went to work.

Although Maybelle was a pioneering guitarist in her own right, celebrated for a playing

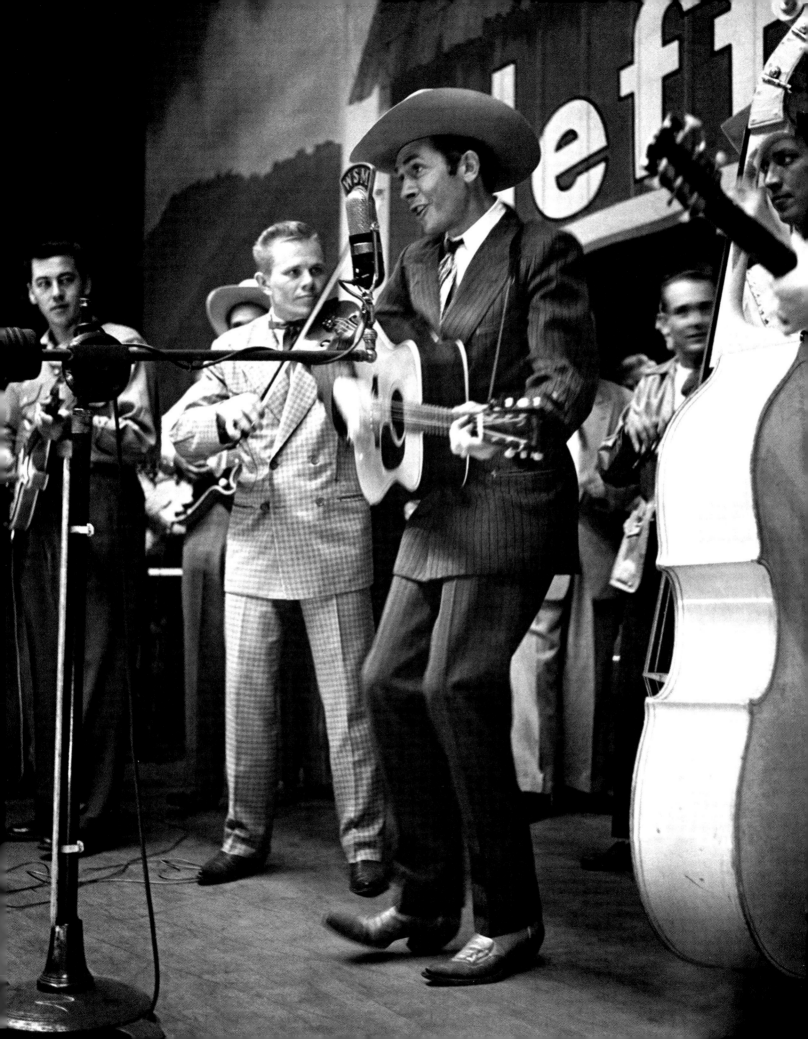

style that would come to be called "the Carter Scratch," the Carters hired a then-unknown Chet Atkins on lead guitar around 1947. June Carter was especially fond of Atkins, who was shy and rarely spoke, and she always tried to make him laugh onstage. June, having idolized Minnie Pearl as a child, would do most anything for a laugh. Sometimes she would swing out on a stage curtain; other times, she would slide her nose up and down the frets of Atkins's guitar, just to get a reaction. In 1950, the Opry tried to recruit Maybelle and her daughters away from a radio show in Knoxville. Maybelle's husband and manager, Ezra Carter, refused the offer unless Atkins could come along.

In her memoir, June Carter recalled, "They continued to call us daily from the Grand Ole Opry in Nashville, and finally decided we could bring Chet Atkins with us. It wasn't because they thought he couldn't play guitar. They knew he was probably the best in the business–and that was the trouble. The union musicians were afraid of the competition. Afraid he would soon take most of the recording sessions away from them. So they said we could bring him, but that he couldn't work with anyone except for us."

As predicted, after six months of exclusivity with the Carters, Atkins picked up countless studio sessions; he would become an Opry member as a solo artist in 1950. By the end of the decade, he was one of RCA's most valuable executives and in-house producers. It was a marked contrast to Atkins's first stint at the Opry, when he relocated from Chicago at Red Foley's request in 1946 but moved on for more lucrative work.

Carl Smith earned his Opry audition when a demo tape he made in Knoxville found its way to

WSM program director Jack Stapp's desk. Stapp offered a few guest spots on WSM in March 1950, allowed Smith to build an audience with a morning radio show, and then worked him into the Opry every few weeks as a guest performer. On July 1, 1950, Smith made his debut on the Prince Albert-sponsored segment of the Opry, and he developed a following for singing love songs with a honky-tonk feel. Within two years, the good-looking singer had charted three number one singles and married June Carter.

TOP: Chet Atkins standing with the Carter Family backstage, c. 1950s. Left to right: Maybelle Carter, Anita Carter, Atkins, Bea Puffenbarger, and June Carter. Left to right: Little Jimmy Dickens, Minnie Pearl, Don Helms, Hank Williams, and Sammy Pruett, c. 1949. BOTTOM: WSM president Jack DeWitt pins a service award on Opry general manager Jim Denny, December 6, 1955.

At twenty-five years old, the Grand Ole Opry appeared sturdy to the average listener, but there was turmoil behind the curtain. Harry Stone, who had been promoted to WSM general manager and vice president, submitted his resignation in 1950. Perhaps true to his surname, Stone was seen by some as stern, yet effective, in the way he ran the Opry. He didn't always get his way, however. He knew that Jim Denny, house manager at the Ryman, was reaping quite a profit from a side business of selling concessions during Opry shows. Stone tried to put a stop to it, but because Denny already had an agreement in place, the confrontation was seen as little more than an unwelcome suggestion.

To make matters more complicated, WSM founder and board president Edwin Craig tracked down former WSM engineer Jack DeWitt and asked him to the become president of WSM—and, thus, Stone's boss. DeWitt had been a childhood friend and WSM colleague of Stone's before moving out of Nashville and establishing an award-winning scientific career. Upset by the corporate jockeying but officially citing health concerns, Stone quit and moved to Arizona. The ever-enterprising Denny composed a letter to DeWitt pitching himself to take charge. Denny emphasized his achievements at WSM and insisted that he could streamline the booking and management processes through WSM's Artists Service Bureau.

DeWitt created the new role of general manager for Denny in January 1951, but, once again, there was the issue of concessions. As WSM president, DeWitt decided to ignore Denny's past agreement and shifted souvenir sales to the Opry's purview, which left Denny

seething—and losing about half of his take-home pay.

Even with the power plays going on, WSM executives were looking at a healthy bottom line that year. A 1951 article in *Collier's* magazine reported, "On the Opry itself, sponsors are lined up five deep waiting for the first spot to open up on the show—or even on the pre-Opry period. If the rest of the industry is in the doldrums, WSM has more business than it can handle, a situation attributed by Jack Stapp to two things. 'In the first place,' he said, 'it's the current folk and Opry trend; but even more important is the vital fact that television will not reach most rural areas for many years to come.'"

Stapp may not have felt that television was the best way to reach Opry fans, but the show's parent company, National Life and Accident Insurance Company, believed in the new medium's potential to reach large audiences. Nashville's first television station, WSM-TV, was launched on September 30, 1950, but country music programming was scarce on the channel.

Boogie-woogie piano player Moon Mullican joined the Opry cast in April 1951, followed in July by honky-tonk sensation Lefty Frizzell. Both were relishing the limelight with "I'll Sail My Ship Alone" and "If You've Got the Money, I've Got the Time," respectively. However, Frizzell was arrested backstage at the Opry that summer after an inappropriate encounter with a teenage girl in an Arkansas hotel room. Though he wasn't fired from the Opry cast, he opted to leave in 1952 in order to make more money

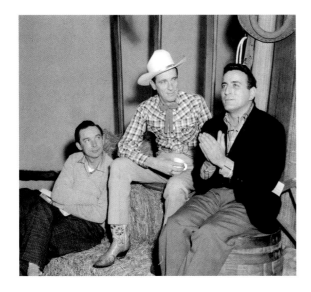

on tour. When Mullican's commercial career languished, he moved back to Texas.

Hank Williams was dealing with his own setbacks in 1951, a year that should have felt like a career high. Pop singer Tony Bennett put his own stamp on "Cold, Cold Heart" and introduced Williams's catalog to a whole new audience. The good fortune continued with mainstream covers of "I Can't Help It (If I'm Still in Love with You)" by Guy Mitchell, and "Hey, Good Lookin'" by Frankie Laine and Jo Stafford. All three titles were major country hits for Williams, too. Offstage, though, his personal life was bleak. He developed an addiction to painkillers after a 1951 spinal surgery related to his spina bifida, which had plagued him since childhood. By January 1952, he was separated from Audrey and living with a fellow Opry member, Ray Price.

The two friends met in 1951 during very different phases of their careers. Williams was setting the woods on fire, to borrow a song title, but

Price was still in the honky-tonk trenches. After serving in the US Marines during World War II, he'd gone to college in Abilene, Texas, with the intention of becoming a veterinarian. Those plans shifted as Price started a singing career in earnest, first at a local café, then on a local radio station, and finally on the *Big D Jamboree* radio show in Dallas. But he couldn't seem to catch a break with his first few singles.

After Williams met Price in the fall of 1951, the established star took a shine to the newcomer, invited him on the road, and started to write with him. Price recorded one of their songs, "Weary Blues From Waiting," which garnered just enough attention for the Opry to add Price to the cast in January 1952. He turned to Williams's former band, the Drifting Cowboys, to back him.

By this time, black-and-white televisions were making their way into more and more homes, potentially rendering a radio show obsolete. Although NBC made overtures about airing the Opry on television, the promotion director for WSM and WSM-TV told the *Tennessean* that WSM didn't have the facilities to feed the show to NBC, and that the show could not be filmed at Ryman Auditorium in its present format.

Yet the Opry did reach a national television audience in 1952, when Roy Acuff, Hank Williams, and several other members of the cast traveled to New York City for a guest spot on *The Kate Smith Evening Hour* on NBC. The March 26 episode presented a group of Opry stars representing the radio show for the first time on national television. Williams returned with other Opry cast members to *The Kate Smith Evening Hour* on April 23, 1952. These two episodes yielded

rare performance footage of Williams, whose magnetic presence and strong vocals belied the slow and steady decline that was well underway. His recording output was still incredible: "Half as Much," "Honky Tonk Blues," and so on. But his unpredictability and his drunkenness had derailed his professional reputation.

Jim Denny considered Williams a friend and wanted to keep him in the cast, but most of the other WSM executives felt it was time for Williams to go. Denny went so far as hiring a security guard to monitor Williams at the Opry and on tour to keep him sober, but Williams would sometimes get the guard drunk, too. When Williams missed an Opry appearance in August, Denny drove to the singer's apartment to deliver one last warning. When Williams missed the next date, too, Denny picked up the phone and placed the call.

"It was the toughest thing I ever had to do in my life," Denny said years later. "But I had to do it. I figured, too, that maybe it would shock him into changing his way of living."

The *Louisiana Hayride* rehired Williams that fall, just as "Jambalaya (On the Bayou)" was roaring up the chart. In December, the twenty-nine-year-old singer took a break from the Shreveport show and retreated to his home in Montgomery, Alabama, hoping to rest before a couple of concerts around New Year's Eve. Although he could build a sturdy set list from his dozens of hits, he also had a new single out: "I'll Never Get Out of This World Alive."

This time, Williams was true to his word. His chauffeur found him dead in the back seat of a sky-blue Cadillac on the morning of January 1, 1953.

OPPOSITE: Ray Price, Ernest Tubb, and Tony Bennett rehearsing for a Purina-sponsored Grand Ole Opry television program, January 7, 1955. TOP: Hank Williams, Minnie Pearl, and Little Jimmy Dickens at the Tulsa Municipal Airport, early 1950s. BOTTOM: Hank Williams, early 1950s

HIGH LONESOME SOUND

TOP: Bill Monroe and His Blue Grass Boys before Stringbean was replaced with Earl Scruggs, mid-1940s. Left to right: Bill Monroe, Howard "Howdy" Forrester, Clyde Moody, Willie Egbert "Wilbur" Wesbrooks, and David "Stringbean" Akeman. BOTTOM: Bill Monroe and His Blue Grass Boys perform on the Opry at Ryman Auditorium, October 4, 1947. Left to right: Lloyd "Lonzo" George, Robert "Chubby" Wise, Monroe, Lester Flatt, and Earl Scruggs. OPPOSITE: Original wood block used for printing Bill Monroe and His Blue Grass Boys Hatch Show Print posters

BLUEGRASS DIDN'T YET HAVE ITS NAME WHEN THAT HIGH, LONESOME SOUND WAS TAKING SHAPE ON THE GRAND OLE OPRY STAGE. Bill Monroe and His Blue Grass Boys had been playing string band music at the Opry since 1939, with the first lineup built around four instruments: fiddle, mandolin, guitar, and bass. After adding banjo player David "Stringbean" Akeman, Monroe liked the new configuration and subsequently hired banjo player Earl Scruggs when Stringbean left the lineup. Instantly, the new band's sound shifted into something more progressive—Scruggs played fast, in the three-finger style, and his syncopation and speed immediately set apart the Blue Grass Boys from other bands of the era. During an Opry appearance on December 8, 1945, when Scruggs debuted with Monroe, guitarist Lester Flatt, and the other Blue Grass Boys, the group captivated listeners with a new twist on an old sound, laying the groundwork for what would come to be known as bluegrass music.

In 1948, Flatt and Scruggs parted ways with the Blue Grass Boys to form their own unit. Some fans still wanted to hear them perform the songs they recorded with Monroe but knew there was lingering tension after the split. In those instances, some believe that fans would ask for "the Blue Grass songs." Other theories suggest that disc jockeys recognized that this new style differed from the usual country music they played and started calling it "bluegrass" after Monroe's band.

As with every other style of music, the parameters of bluegrass expanded over time, which bothered the purists but intrigued new listeners. The Osborne Brothers and Jim & Jesse brought incredible harmonies, riveting musicianship, and quality material to their audiences, but these brother duos weren't strictly traditional. The Osborne Brothers found broader appeal when they added drums to their band; Jim & Jesse and the Virginia Boys put their own spin on Chuck Berry songs with a 1965 album appropriately titled *Berry Pickin' in the Country.*

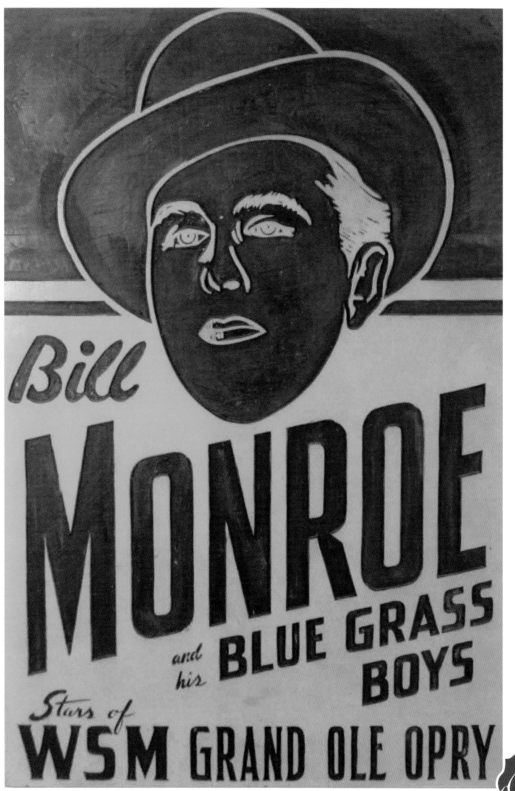

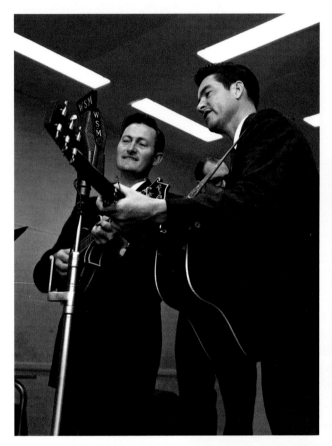

CLOCKWISE FROM TOP: Jim & Jesse—Jesse McReynolds on mandolin and Jim McReynolds on guitar—perform in a WSM studio; the Osborne Brothers perform on the Opry with Sonny on banjo and Bobby on mandolin, August 24, 1968; Flatt & Scruggs and the Foggy Mountain Boys perform on the Martha White portion of the Grand Ole Opry, August 1956. Left to right: Jake Tullock, Paul Warren, Josh Graves (obscured), Earl Scruggs, and Lester Flatt. OPPOSITE, FROM TOP: Del McCoury Band, February 8, 2022; Rhonda Vincent, January 26, 2024; Ricky Skaggs and Ralph Stanley, October 13, 2001

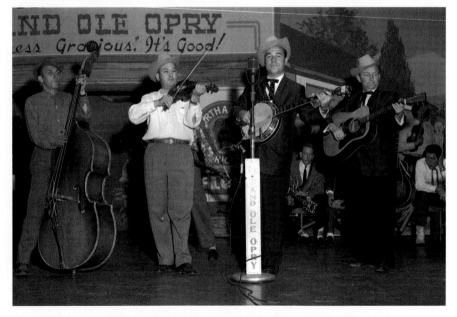

Now remembered as the Father of Bluegrass, Monroe remained a fixture at the Opry for decades to come. Perhaps because he felt protective of his style, only a handful of bluegrass artists were invited to become members during his lifetime. Nonetheless the music expanded. Bluegrass festivals cropped up in rural areas such as Fincastle, Virginia, and Bean Blossom, Indiana, where fans could watch, meet, or even jam alongside their favorite artists. Children who showed promise on their instruments were treated with respect as the elders made it a point to give a quick lesson or offer encouragement.

Modern Opry stars, including Dailey & Vincent, the Del McCoury Band, the Isaacs, Ricky Skaggs, Marty Stuart, Rhonda Vincent, and the Whites all came up in the bluegrass festival scene, though they, too, interpreted the bluegrass sound in their own way.

With pure mountain soul, the Stanley Brothers drew inspiration from listening to the Grand Ole Opry and the musical styles of Bill Monroe and his Blue Grass Boys. After Carter Stanley's death in 1966, Ralph Stanley carried on. He served as a role model and bandleader to future country stars Keith Whitley and Ricky Skaggs. Skaggs officially entered the Opry ranks first, in 1982, but Stanley was welcomed on January 15, 2000—the first induction at Ryman Auditorium since 1973. He shared the moment with one of his admirers, Patty Loveless, who joined him in a performance of "Pretty Polly."

For many Opry members, it's that collaborative spirit that makes bluegrass special. Award-winning banjo picker Mike Snider has proudly provided up-and-coming bluegrass musicians such as Sierra Hull, Cody Kilby, and Josh Williams a chance to play during his Opry segment. Vince Gill, Joe Diffie, Alison Krauss, and Diamond Rio's Gene Johnson and Dana Williams were among the 1990s inductees who played in bluegrass bands before finding mainstream country success. In contrast, Opry members Dierks Bentley, Patty Loveless, and Alan Jackson would all go on to record well-received bluegrass albums during their thriving careers in country music.

Sixty years after that pivotal night at the Ryman, bluegrass music continues to be an essential part of the Opry story. Nearly every time the curtain rises at the Grand Ole Opry House, devout traditionalists and adventurous listeners alike are rewarded with an opportunity to hear bluegrass music performed on the very same radio show where it all began.

THE GOLDEN ERA

1967

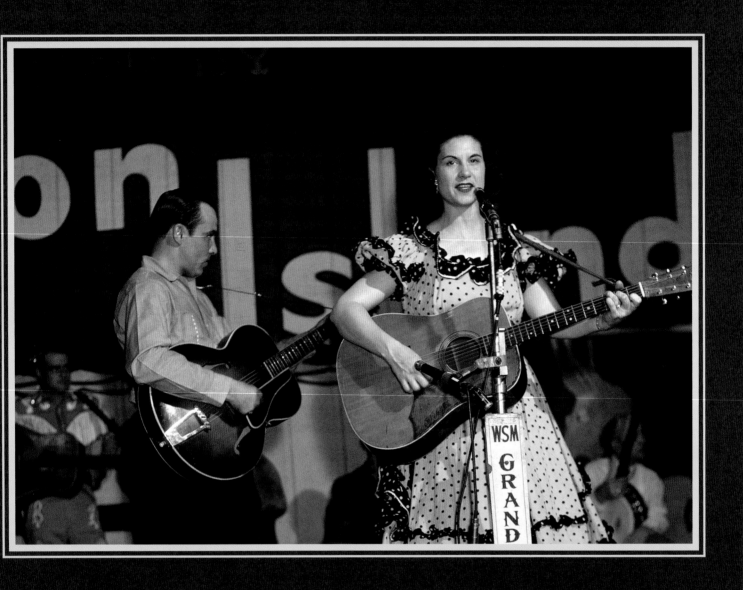

he Grand Ole Opry and WSM forged ahead after the dismissal of Hank Williams, their star attraction. Martha Carson, a boisterous performer known for singing and writing "I'm Satisfied," arrived in April 1952. Shreveport, Louisiana, native Faron Young, one of country music's most outsize personalities, became a regular with his first guest spot on June 14, 1952. He was drafted into the US Army five months later, then resumed his membership after his term of service. Webb Pierce, another honky-tonk stylist from Louisiana, followed Young into the Opry on September 13, 1952, after earning back-to-back hits with "Wondering" and "That Heart Belongs to Me."

Although she was polite and professional, Kitty Wells may have been the most controversial new member of 1952. She'd already made a name for herself with "It Wasn't God Who Made Honky Tonk Angels," which was composed using the melody of Hank Thompson's "The Wild Side of Life," but sung from the woman's point of view with new lyrics by J. D. Miller. The "answer song" turned the unknown singer into a country music sensation. In the chorus, Wells insisted that God wasn't to blame for a woman's ruin; instead, it was the married men whose infidelity "caused many a good girl to go wrong." The groundbreaking message resonated with female listeners and sent Wells to the top of the country chart, the first woman to reach the summit.

The Opry, however, took a wait-and-see attitude. In a 1987 biography, Wells recounted the Opry's opinion that she didn't have enough personality. She added that Roy Acuff told Opry management, "She don't need to go out there and jump around. She's a singer that's sincere in her presentation. She don't have to jump around to sell her song—and neither do I! Singing from the heart sells 'em." By year's end, Wells was an Opry member.

Charismatic singer-songwriter Marty Robbins made his first appearance as a cast member on January 24, 1953, not long after releasing his first chart-topping single, "I'll Go On Alone." Three more additions to the cast followed that year: Goldie Hill, who'd achieved a number one hit with "I Let the Stars Get in My Eyes," an answer song to Slim Willet's "Don't Let the Stars (Get in

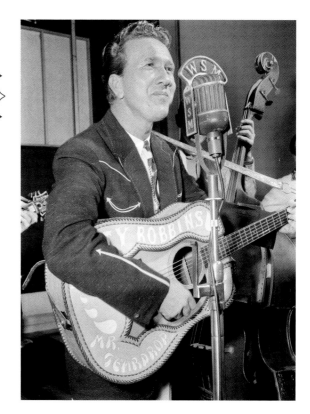

OPPOSITE: Kitty Wells performing on the Grand Ole Opry with Leslie Wilburn accompanying her on guitar, late 1950s.
ABOVE: Marty Robbins performs on the *Friday Night Frolic* show, live from WSM Studio C, July 13, 1956.

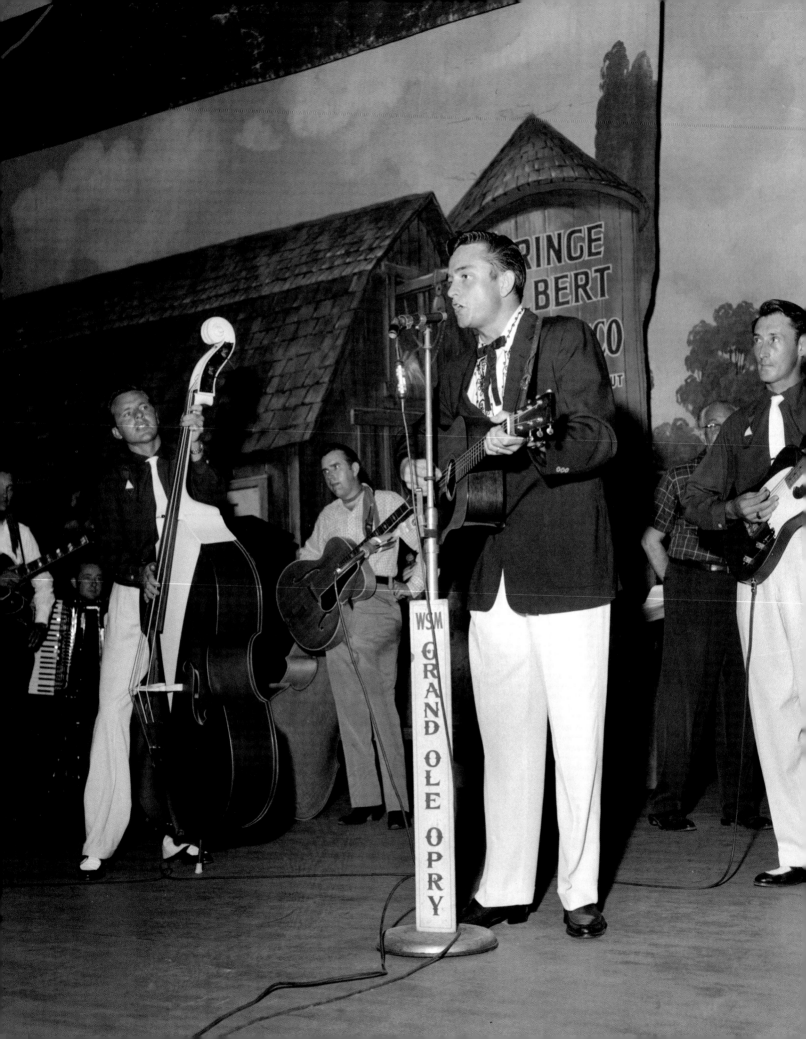

Your Eyes)"; Del Wood, a Nashville native known for her 1951 hit "Down Yonder," a ragtime piano instrumental; and Bill Carlisle, a comedian and songwriter whose antics onstage earned him the nickname "Jumpin' Bill." Ferlin Husky came on board in 1954, a year after he and Jean Shepard, another newcomer on Capitol Records, topped the chart with "A Dear John Letter."

However, with the one-two punch of television and rock 'n' roll threatening the relevance of a time-tested radio show, the Grand Ole Opry nearly buckled under the pressure, and it was evident that neither management

OPPOSITE: Johnny Cash and his band the Tennessee Two, featuring Marshall Grant on bass and Luther Perkins on guitar, perform on the Prince Albert portion of the Grand Ole Opry, August 1956. ABOVE: Jumpin' Bill Carlisle earns his nickname while performing in WSM Studio C for the *Friday Night Frolic*, June 1956.

nor members would embrace those they saw as the competition. On October 2, 1954, Elvis Presley performed Bill Monroe's "Blue Moon of Kentucky" on the show; his electrifying presence apparently wasn't a good fit because he never returned. Wanda Jackson, a teenage recording artist from Oklahoma, arrived for her Opry guest spot in the spring of 1955 wearing a formfitting fringed dress with rhinestone straps made by her mother. Minutes before going on, Ernest Tubb informed her that she wasn't permitted to show her shoulders onstage. Almost in tears, Jackson performed her ballad cloistered in a Western jacket, while Minnie Pearl and Stringbean distracted the audience by clowning behind her.

With reluctance to showcase rock 'n' roll, the Opry played it safe while recruiting talent. Red Sovine, a former cast member of the *Louisiana Hayride* who became famous for his recitations, was announced as a new cast member in January 1955. The Louvin Brothers, known for their stunning sibling harmonies, followed on February 26, 1955, and charted their first national hit later that year with "When I Stop Dreaming." Flatt & Scruggs were rewarded with an Opry membership in the summer of 1955, seven years after Lester Flatt and Earl Scruggs departed Bill Monroe's Blue Grass Boys to launch their own successful group.

By September, the Opry had also added Hawkshaw Hawkins, a honky-tonk singer from West Virginia, and Justin Tubb, the twenty-year-old son of Ernest Tubb, who later wrote hits for Hawkins, George Jones, and Patsy Cline. Two of country music's most evocative singers, Jim Reeves and Slim Whitman, joined on October 22 and October 29, respectively. An outspoken

TOP: Hawkshaw Hawkins with Opry manager D. Kilpatrick, mid-1950s. BOTTOM: The Louvin Brothers, Ira and Charlie, perform during the Martha White–sponsored Opry segment, late 1950s. OPPOSITE: Jim Reeves performs on the *Pet Milk Show* in WSM Studio C, September 7, 1956.

honky-tonk singer who paid her dues in the West Coast country scene, Jean Shepard came on board in November. Shepard met Hawkshaw Hawkins a year earlier at another radio show, the *Ozark Jubilee* in Springfield, Missouri, and the couple married onstage during a concert in Wichita, Kansas, in 1960.

Johnny Cash joined the cast on July 7, 1956, with undeniable momentum from hits such as "Folsom Prison Blues," "I Walk the Line," and "Get Rhythm." Cash had a tenuous relationship with the Opry in the decades that followed, particularly when he was fired in 1965 for smashing the footlights with a microphone stand and spraying glass into the audience. The Opry was also where he first met June Carter in 1956, though they wouldn't marry until 1968.

While the recording industry had its eye on crossover potential for country stars, the Opry stayed the course with new members whose appreciation for traditional country would not waiver. Perhaps best known for a plaintive single titled "Cry, Cry, Darling," Louisiana singer-songwriter Jimmy C. Newman became part of the Opry cast on August 4, 1956. (Opry announcer T. Tommy Cutrer added the "C" to Newman's stage name, short for "Cajun.") Newman would perform on the Opry stage for the rest of his life, always charming the audience with his Cajun drawl, a suit jacket decorated with alligators, and the down-home catchphrase "Aaaay-*eeee*!"

A rising star from East Texas, George Jones, joined the cast that same month. Although Jones would come and go from the Opry over the years, and eventually earned the nickname "No Show Jones," he never strayed from singing

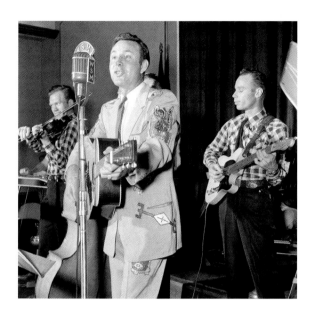

traditional country music. Listeners clamored to hear his early hits, including 1955's "Why Baby Why" and 1956's "You Gotta Be My Baby."

Behind the curtain, Opry manager Jim Denny had attracted considerable attention, too. In September 1956, six months after *Billboard* named Denny their Country & Western Man of the Year, the Opry fired him. As Opry manager, Denny handled the in-house booking agency, WSM Artists Service Bureau. He saw no reason that he shouldn't also act as a show promoter if he was booking Opry artists for personal appearances. With this arrangement he stood to profit personally as promoter, and WSM profited from the booking fee. Roy Acuff was among those who felt like Denny was double-dipping. Other acts believed Denny showed favoritism toward some stars while neglecting others. WSM president Jack DeWitt was more concerned that Denny was not dedicating himself full-time to the Opry and that his other businesses represented a conflict of interest.

Finally, DeWitt issued an ultimatum to WSM staff in August 1955: Divest and dedicate attention to WSM full-time or leave. Denny refused to divest. After his departure, he formed his own agency and added several Opry artists to his roster. Webb Pierce, who formed the profitable Cedarwood Publishing Company with Denny in 1953, quit the Opry in solidarity.

Almost immediately, Denny aligned himself with the tobacco company Philip Morris to promote a free tour of big-name country stars throughout the Southeast. Red Sovine, Carl Smith, and Goldie Hill quit the Opry and joined the entourage. Jimmy Dickens followed suit six months later and didn't come back to the Opry cast until 1975. At a time when country tours were being overshadowed by television and rock 'n' roll, the tour was massively successful, playing for four million people over its run.

Walter David "D" Kilpatrick had his work cut out for him when he replaced Jim Denny as the Opry's general manager in late September 1956. A respected producer and talent scout, Kilpatrick had a good ear for new music and a willingness to venture beyond the country music sounds that traditionalists were clinging to. While the Opry cast still had its holdouts when it came to embracing rock 'n' roll, Kilpatrick kept his sonic options open.

About a month into the job, Kilpatrick signed the vivacious singer Rose Maddox to the cast. A child of the Depression who was born in Alabama and raised in California, Maddox had performed since 1937 with her siblings in the

Maddox Brothers & Rose, reputed to be "the most colorful hillbilly band in America." By the time the family band guested on the Opry in 1949, Maddox was one of very few female honky-tonk singers to reach a national audience.

During her solo debut at the Opry, she surprised the audience and management by taking the stage in a revealing cowgirl outfit to sing "Tall Men." The uproar from some Opry stalwarts gave an inkling that the show might be too conservative for Maddox's taste. What worked on the California country music circuit wouldn't necessarily be a fit on the Opry stage. Jean Shepard, a friend from California, welcomed

Maddox, once even giving up her slot to the Opry newcomer, but others groused when the dynamic performer was routinely booked on local WSM television programs. Maddox stated in her biography that Roy Acuff gave the Opry program director an ultimatum: She goes, or I go. Maddox exited the cast in early 1957.

ABOVE: Cedarwood Publishing office, founded by Jim Denny and Webb Pierce, on the first day of operation with a plethora of Opry stars, c. 1953. Left to right: Frankie Moore, Teddy Wilburn, Doyle Wilburn, Johnnie Wright, Hank Snow, Ernest Tubb, Minnie Pearl, Carl Smith, Webb Pierce, June Carter, Kitty Wells, Ray Price, Bill Carlisle, Jack Anglin, Jim Denny. OPPOSITE: Hawkshaw Hawkins (right) performs onstage at the Grand Ole Opry with guitarist Earl White, late 1950s.

TOP: Wilma Lee and Stoney Cooper perform on the Grand Ole Opry with their daughter Carol Lee Cooper, c. 1957. BOTTOM: Porter Wagoner performs onstage at Ryman Auditorium, accompanied by band members Don Warden on steel and Red Gale on guitar, late 1950s. OPPOSITE: Stonewall Jackson performs onstage at the Grand Ole Opry, late 1950s.

Doyle and Teddy Wilburn, billed as the Wilburn Brothers, had been performing since they were kids and first came to the Opry in 1940, though they only stayed a few months because of child labor laws. Signed to Decca Records, the Wilburns had been professional entertainers for nearly twenty years when they joined the Opry on November 10, 1956. Country traditionalist Stonewall Jackson first appeared on the Opry as a guest on that same night. Jackson had driven from Georgia to Nashville just a few days earlier and walked, without an appointment, into the offices of Acuff-Rose, trying to get his songs recorded by established artists. Wesley Rose arranged for Jackson to audition with George D. Hay the next day; even with limited performing experience, Jackson was nonetheless added to the Opry's next show. Three weeks later, on December 1, 1956, he became a member.

It was unusual for the Opry to bring in a novice like Jackson. After he was added to the cast, the Opry turned to entertainers with more experience. Gregarious entertainer Porter Wagoner enjoyed a few years of television exposure on the *Ozark Jubilee* and a number one hit with "A Satisfied Mind" before he joined the Opry on February 23, 1957. Influenced by old-time music, Wilma Lee & Stoney Cooper were veterans of the *WWVA Jamboree* in Wheeling, West Virginia, and first charted nationally in 1956 with "Cheated Too," a song written by Wilma Lee. With their daughter, Carol Lee, as part of the group, the Coopers joined the cast on March 2, 1957.

Courting a younger audience, the Opry added two sibling duos in 1957: the Everly Brothers and Rusty & Doug Kershaw. Upon hearing "Bye

Bye Love" at the Everlys' debut, the *Nashville Banner* observed, "This tuneful duo swept the Opry crowd off its feet within 10 minutes after the show opened–an almost unprecedented event because it usually takes the crowd about 30 minutes to warm up." As fate would have it, the Everlys were bound for bigger things and the Kershaws were drafted into the army. A little-known pop vocal trio called the La Dell Sisters were also part of the cast during this era, inducted in late 1956. The two sisters in the group (no member was named La Dell) were married to Opry musicians.

Family acts were not uncommon on the Opry stage. When a teenage Dolly Parton made her Opry debut a few years later, she had her beloved uncle Bill Owens at her side. Even as a child in East Tennessee, Parton envisioned herself on the Opry stage. Her family grew up without electricity, but her father tuned in WSM on a battery-powered radio, though only after somebody went outside and poured water on the ground wire, which mysteriously improved

reception. At ten years old, the already ambitious Parton talked her way into singing on a television series in Knoxville called the *Cas Walker Farm and Home Hour*. She told Walker she wanted to *work* for him, so he gave her a shot. With the money she earned from the show, Parton bought her family their first television set.

Parton soon became a regular on Cas Walker's show, as did the Everly Brothers before her. She took note of two more Knoxville musicians who made their way into the Opry cast: Don Gibson and Carl Butler. Although Gibson was a star on the Knoxville radio show *Mid-Day Merry-Go-Round*, he was barely known in Nashville until Chet Atkins, who befriended him when they both lived in Knoxville, offered to produce a few sides for RCA. Hot on the success of writing and recording "Oh Lonesome Me," Gibson was announced as a new Opry member on his very first performance on April 12, 1958.

A strong singer and prolific songwriter, Carl Butler appeared often as an Opry guest and made his membership official on July 19, 1958. He and his wife, Pearl, took a shine to a young Parton, who was then traveling to Nashville with her uncle as often as possible, hoping that somebody would listen to their songs.

Accompanied by her uncle on guitar, the thirteen-year-old singer finally stepped onto the Opry stage in 1959 when Jimmy C. Newman generously offered Parton his late spot. Reminiscing about the realization of her childhood dream, Parton said the applause felt wonderful, since she knew everybody back home was listening. Her lively rendition of George Jones's "You've Gotta Be My Baby" led to three encores.

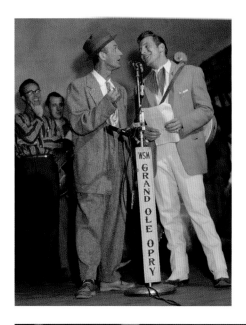
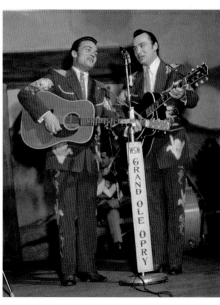

CLOCKWISE FROM TOP LEFT: Comedian Rod Brasfield banters with Ferlin Husky as musicians Don Helms and Randy Hughes watch amusedly, late 1950s; the Wilburn Brothers, Doyle and Teddy, perform wearing matching "Nudie" suits, late 1950s; Faron Young performs in the late 1950s, accompanied by bassist Tom Prichard; Marty Robbins dons a jacket that nods to his 1957 crossover hit "A White Sport Coat (And a Pink Carnation)," late 1950s.

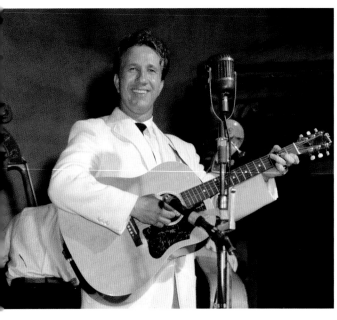
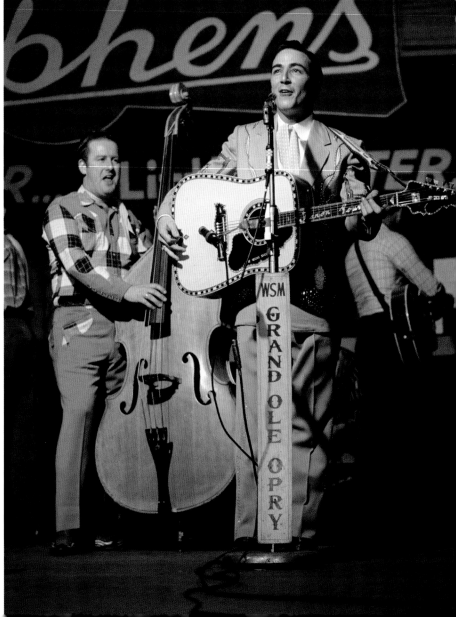

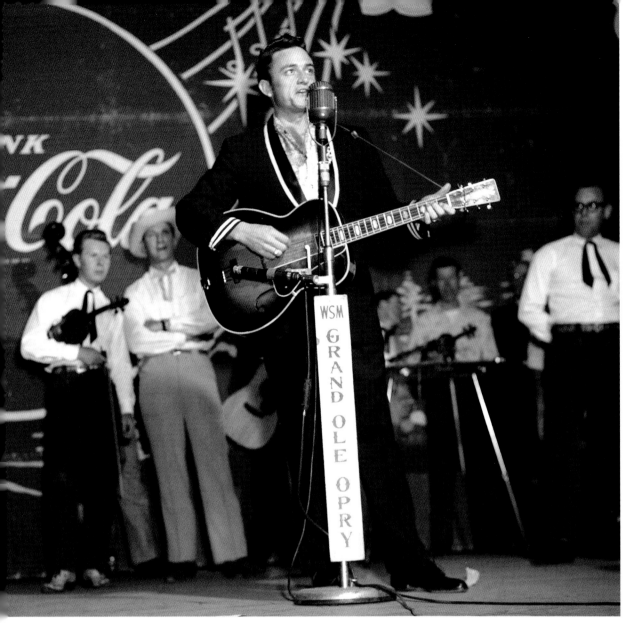

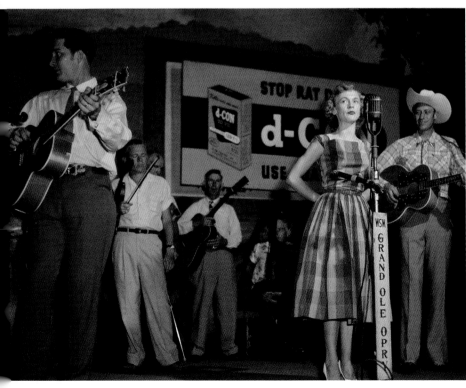

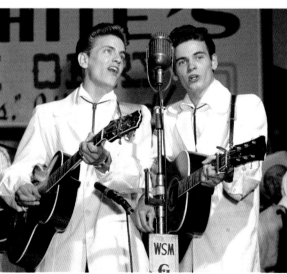

CLOCKWISE FROM TOP: Johnny Cash takes the stage, late 1950s; the Everly Brothers (Phil and Don) treat the Opry audience to their otherworldly harmonies, c. 1957; Jean Shepard, known for performing with her hands behind her back to signal timing to the band, sings while her husband, Hawkshaw Hawkins, looks on, late 1950s. Left to right: Earl White, Jerry Rivers, Sam McGee, Shepard, and Hawkins

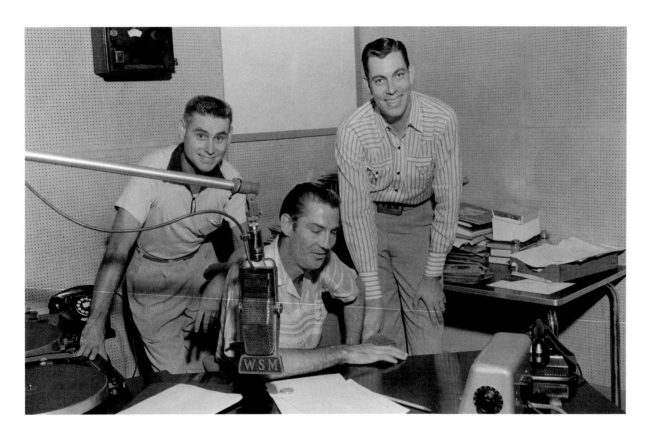

The revolving door of the Grand Ole Opry continued to turn. North Carolina dance troupe Ben Smathers and the Stoney Mountain Cloggers were made cast members on the spot at their first Opry appearance in 1958. New artists Margie Bowes and Billy Grammer joined the cast in 1959, as did Archie Campbell, a comedian from Knoxville. Around the same time, D Kilpatrick stepped down from Opry leadership. Like Jim Denny before him, he planned to launch a touring agency; Kilpatrick's partners were none other than Roy Acuff and Wesley Rose.

———

WSM program director Ott Devine moved into the general manager role and wasted no time enhancing the cast. Roy Drusky had written a few hits for Faron Young and signed to Decca Records when he joined in mid-1959. Though Jimmy Driftwood, a schoolteacher and folk musician from Arkansas, didn't stay long, he was added to the cast around the same time, coinciding with the immense popularity of two songs he wrote: Eddy Arnold's "Tennessee Stud" and Johnny Horton's "The Battle of New Orleans."

The Opry could still draw talent without having a national television presence. Billy Walker, a rising star who'd appeared on the *Big D Jamboree* in Dallas, moved to Nashville in 1959 to be an Opry regular. Similarly, Bobby Lord came to the Opry the following year after frequent appearances on the *Ozark Jubilee*. He would host his own show on WSM-TV starting in 1963. Tompall

& the Glaser Brothers, a vocal group from Nebraska that supported Marty Robbins, were also added to the cast in 1960, six years before they achieved hits of their own.

Skeeter Davis had barely started her solo career when she was welcomed into the Opry in August 1959. Nicknamed "Skeeter" by her grandfather, the Kentucky native practiced harmonizing by singing along with the performers she heard on the Grand Ole Opry. In 1953, Davis and her best friend from high school, Betty Jack Davis, reached the top of the country chart with "I Forgot More Than You'll Never Know," a heartbreak ballad credited to the Davis Sisters, even though the young women weren't actually related.

Just as radio stations were discovering the Davis Sisters, Skeeter sustained serious injury in a car accident that killed Betty Jack. After a slow recovery, Skeeter briefly reformed the duo with Betty Jack's sister before deciding to go solo. Davis and producer Chet Atkins would double-track her vocals in the studio, as if she were singing harmony with herself. The unusual strategy worked, and her confessional recitations in dramatic singles such as "Set Him Free" and "The End of the World" made her one of the Opry's most identifiable cast members.

Patsy Cline and George Hamilton IV were not as well-known when they followed Davis into the cast in 1960, even though they'd both been at it awhile. Cline grew up in Winchester, Virginia, and made frequent appearances on a weekly television show in Washington, DC, called *Town and Country Time*. Killing time backstage in the summer of 1956, she spotted George Hamilton IV, a college student at the University

of North Carolina who'd just had a pop hit with "A Rose and a Baby Ruth."

"She had a white Stetson on and white cowgirl boots, and she came over and she said, 'Hey, hoss, I'm Patsy Cline. Who are you?'" Hamilton recalled. "I said, 'I'm George Hamilton IV.' She thought that was kind of funny. She laughed and said, 'The fourth?' She looked me up and down and said, 'What kind of country singer are you?' I had on my penny loafers and my college blazer and my button-down collar shirt. I looked very much like a freshman; I had just finished my freshman year in college. She said, 'Who do you think you are? The Pat Boone of country music?' That was Patsy. She loved to tease you."

Just a year later, Cline attracted a national audience by singing "Walkin' After Midnight" on *Arthur Godfrey's Talent Scouts*. A manipulative recording contract and a divorce derailed her career momentum, and she moved to Nashville

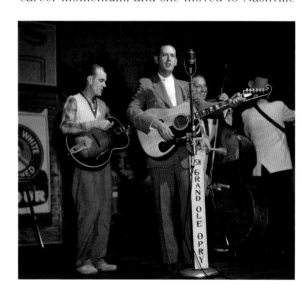

OPPOSITE: George Jones, disc jockey Dan Ayers, and Van Howard pose in a WSM studio, 1957. TOP: Jimmy C. Newman performs onstage at Ryman Auditorium with Ray Edenton on acoustic guitar and Lightnin' Chance on upright bass, late 1950s.

in 1959 to try to get it back. Road dates were sparse and paid poorly, but Randy Hughes felt he could turn things around as her manager. Hughes had worked at the Opry as a sideman since he was a teenager and occasionally toured as a rhythm guitarist with Opry artists. On January 9, 1960, after several guest appearances on the Opry, Cline worked up the courage to ask Ott Devine if she could ever become a member.

"Of course, I knew of her talent," Devine recalled. "I had heard her sing. She had a beautiful voice. And so I replied, 'Patsy, if that's all you want, you are on the Opry.'" The following spring, finally freed from her prior recording contract, she raced to number one with the tender ballad "I Fall to Pieces," produced by Owen Bradley for Decca Records.

Meanwhile, Hamilton decided to leave pop music behind in favor of breaking into country music. He hosted a program on ABC-TV in 1959 but hadn't yet released a country hit when he signed on as a cast member on February 2, 1960. His definitive hit, "Abilene," appeared three years later. In contrast, the singer Hank Locklin had just reached the peak of his career when he was added to the cast in November 1960. His clear tenor proved to be a perfect match for "Please Help Me, I'm Falling," a vocally expansive cheating song that spent fourteen weeks atop the country chart. Locklin returned to the Top 10 in 1961 with "Happy Birthday to Me," written by new Opry member Bill Anderson.

Anderson's parents brought him to the Opry when he was fourteen years old. He'd been listening to the Opry on WSM, which was

TOP: Patsy Cline studio portrait, May 12, 1961. BOTTOM: Patsy Cline performs on the Opry stage with Randy Hughes on guitar and Lightnin' Chance on bass, early 1960s.

advertised as "the Air Castle of the South," so he expected the Ryman to look like a castle. He was disappointed to come inside and notice a big tear in the curtain. Still, watching the show from the pews, it never dawned on him that he would soon be on the stage.

"I sat out there along with everybody else and just marveled at the people and the music and the whole atmosphere," Anderson recalled. "I was just so enamored by it. I don't think at that point that I really had it in my mind that in a matter of just a few years, I would be up on that stage. At that point in time, I wanted to be the world's greatest baseball pitcher or sportswriter, and the tables kind of turned a little bit and I went in a different direction. But it wasn't one of those things where I said, 'Someday I'm going to grow up and be on the Grand Ole Opry.' It really didn't happen that way, although I was tickled to death when the opportunity came around."

Anderson studied journalism at the University of Georgia and worked as a disc jockey on the side; however, it was a honky-tonk song he wrote titled "City Lights" that set him on his path. Ray Price's version of "City Lights" reached number one in 1958 and Anderson quickly found acceptance as a songwriter and performer when he moved to Nashville. He almost didn't answer the phone when Opry manager Ott Devine called during the all-star baseball game. Luckily, he picked up and immediately accepted Devine's invitation to join the Opry. Anderson was added to the cast on July 15, 1961.

Another of country music's great songwriters, Loretta Lynn, followed Anderson into the Opry family. Her Opry debut obviously thrilled and overwhelmed the singer, causing her to burst

out of the Ryman doors afterward and shout, "I've sung on the Grand Ole Opry!" She'd spent weeks visiting with disc jockeys at radio stations across the country, promoting her 1960 single, "I'm a Honky Tonk Girl," when she and her husband Doolittle Lynn pulled into downtown Nashville. Truth be told, the Opry audience probably had little idea who she was at that first appearance in 1960, since "I'm a Honky Tonk Girl" spent only nine weeks on the chart and peaked at number fourteen. Shortly after signing a contract with Decca Records, she was invited to join the cast on September 25, 1962, and gave her first performance as a member four days later. But she wouldn't be the newest Opry member for long.

Leroy Van Dyke dominated the airwaves from late 1961 through early 1962 with the jaunty single, "Walk on By." He joined the Opry on October 20, 1962, followed a week later by Sonny James, primarily known at the time for the irresistible 1957 number one hit "Young Love." Marion Worth was added as an Opry regular on February 2, 1963; she achieved her biggest hit in 1960 with a smooth, sentimental ballad she wrote titled "That's My Kind of Love."

By this time, the twang of traditional country music had faded significantly, *Billboard* dropped the "W" (for "Western") from its C&W Hot Sides chart in late 1962. Renamed "Hot Country Singles," the tally offered number one hits such as Hank Snow's "I've Been Everywhere," Carl & Pearl Butler's "Don't Let Me Cross Over," and Flatt & Scruggs's "The Ballad of Jed Clampett." Hawkshaw Hawkins, an Opry star since 1955, would soon join their ranks at the top of the chart, though the circumstances would be devastating.

Jean Shepard stood at the kitchen sink, giving her son a bath, when a paralyzing sensation gripped her. Eight months pregnant and home alone with a year-old son, Shepard feared she had just gone into labor. When the feeling finally passed, she gathered her thoughts, put the child in his crib, and crawled into bed. When the phone rang at 10 P.M., a woman who handled Hawkins's fan club was on the line. Shepard told the *Tennessean* that she knew, instinctively, that there had been an accident.

On the evening of March 5, 1963, a Piper Comanche aircraft crashed near Camden, Tennessee, killing Patsy Cline, Cowboy Copas, and Hawkshaw Hawkins, Shepard's husband of less than three years. Cline's manager, Randy Hughes, was piloting the plane. He'd been looking for dry weather since leaving Kansas City, where the performers had taken part in a benefit concert for the family of a disc jockey.

For months after these tragedies, Shepard felt lost. Radio stations were playing music from the stars who had been killed. Hawkins's "Lonesome 7-7209" reached the summit in May. A posthumously released song by Copas titled "Goodbye Kisses" rose to number fourteen on the chart and Cline's rendition of "Sweet Dreams (of You)" climbed into the Top 5. Shepard, now a single mother, went back to work just a month later.

"I looked down my driveway one day and here come two big black limousines, full of the so-called 'higher-ups' from the Grand Ole Opry. They said, 'We want you to come back to the Grand Ole Opry.' And it really meant a lot because these were the guys that were the cream of the crop from WSM and the Grand Ole

Opry," she said. "I didn't go back right away. I waited a few weeks and went back, just to test the water one night. And it was a little rough. But we made it through. And I knew that I could handle it from then on."

Three days after the plane crash, Opry member Jack Anglin of Johnnie & Jack was killed on the way to Cline's funeral after crashing into a ditch. Before month's end, former Opry member Texas Ruby perished in a house fire, likely having fallen asleep while smoking a cigarette. Ruby had been a popular Opry star in the 1930s and 1940s, first with Zeke Clements and his Bronco Busters, and then with her husband, Curly Fox; they'd just moved back to Nashville and finished recording a new album. Because Ruby was in deteriorating health, Curly was performing at the Opry alone at the time of her death.

Through the grief, the Opry persisted and managed to grow. The Browns, a sibling trio from Arkansas who sent away for Opry stars' songbooks as children, had built up a small catalog of hits such as "The Three Bells" and "Looking Back to See" when they became part of the cast on August 10, 1963. Jim Ed launched a solo career when the group disbanded and remained a steadfast Opry member for the rest of his life. Asked to join the cast by Ott Devine on March 2, 1964, brother duo Jim and Jesse McReynolds used bluegrass as their foundation for musical innovation, eventually adding electric guitars and steel guitars into their production. Just five days later, "Talk Back Trembling Lips" singer Ernest Ashworth was added as a member. In later years, going by Ernie instead of Ernest, the

OPPOSITE: Front page of the *Nashville Banner*, March 6, 1963, announcing the death of Patsy Cline, Hawkshaw Hawkins, Cowboy Copas, and Randy Hughes

4 OPRY STARS DIE IN CRASH

Plane Debris Yields Bodies At Camden

By LARRY BRINTON and CLAY HARGIS

Camden—The remains of four country music personalities, including three nationally-known Grand Old Opry stars, were found this morning in the scattered bits of a private plane which crashed in rugged woodlands near here.

The victims were assumed to be Patsy Cline, Cowboy Copas, Hawkshaw Hawkins and Randy Hughes, believed pilot of the ill-fated aircraft.

The wreckage was discovered about 6 a.m. after a night-long search by highway patrol, Civil Defense and local officers.

Parts of the yellow plane and bits of human flesh were scattered over a 60-yard area a mile off Highway 70 about three miles west of Camden. The wreckage was between the highway and a ranger tower, which had served as a base of operations for searchers.

Civil Defense official Dean Brewer, asked whether all four bodies had been located, replied: "There's not enough to count . . . They're all in small pieces."

The plane left Dyersburg about 6 p.m. Tuesday for a flight to Nashville. The entertainers had been in Kansas City, Kan., for a benefit performance for the late Cactus Jack Call, a disc jockey.

Sam Webb, whose farm is near the dense woodland, said he saw a plane circling his home about 7 p.m. and that it was "revving up its motor . . . going fast and then slow, like it was attempting to climb."

Webb said the plane left his sight and then he heard something "like it struck the tops of some trees.

The weather in this area at the time of the accident was termed "extremely turbulent."

The wreckage was located by searchers using field glasses in the ranger tower and almost simultaneously by ground searchers Lewis and Cloyd Bradford brothers, who farm near the scene, and W. J. Hollingsworth of Randy River Road.

The plane apparently struck a large tree before hitting the ground. Pieces of the aircraft were hanging in the tree and a thumbtack later marked the spot where the main part of the fuselage struck the ground.

The terrain in the area is so rugged that some searchers confirming during the night were covered with bruises, scratches and blood and, according to one observer, "looked like they had been in a bear fight."

The wreck scene is about five miles west of the Tennessee River.

After the wreckage was located, about 200 cars lined Old Stage Road, about 100 yards from the scene.

Benton County Sheriff Lowe Parr described the area as "full of woods, hills, hollows and swamps."

Refueling Stop

The single-engine plane stopped at Dyersburg to refuel and the Dyersburg Airport manager, Bill Braese, said the occupants "had a cup of coffee or something" while refueling was accomplished.

Engine gave his name as pilot of the craft but no flight plan was filed, the airport manager said. Braese attended the plane had a fuel load on himself which could have kept it in flight three and one-half hours.

Hughes telephoned his wife in Nashville from the Dyersburg Airport to say he would be home soon.

Opry singer Jean Shepphard, wife of Hawkshaw Hawkins, said her husband called her from Kansas City that he was leaving for Nashville aboard Hughes' plane and that he called again from Dyersburg.

Hughes was Miss Cline's manager and a son-in-law of Cowboy Copas.

The remains were brought to

POLICE OFFICERS and funeral home attendants comb wreckage of a plane which crashed near Camden for parts of the bodies of four Grand Old Opry personalities. The wreckage was strewn over an area of about 60 yards. Pieces of the single-engine plane hung in trees, along with some clothing.

(Turn to Page 2, Column 5)

★ ★ ★

Three Were Headliners

Opry Hit Hardest By Fatal Air Crash

By RED O'DONNELL
Television and Radio Editor

THE four victims of the plane crash Tuesday night near Camden represented a multi-million dollars worth of three business talent.

Patsy Cline, 30, has been described as one of the finest girl singers in the world.

Cowboy Copas, 49, was a long established country and western star, one of the most popular performers in his field.

Hawkshaw Hawkins, 42, an all-long, hard persevering struggle, was coming into his own as a headliner both in personal appearances and on records.

Randy Hughes, 35, was known for his versatility. He functioned as a manager of talent (one of the clients was Patsy Cline). He was an able guitarist, and as a sideline, paid stocks and bonds for Jack M. Hunt and firm, Nashville brokerage firm.

All 'Opry Stars

All were regular members of WSM's Grand Ole Opry, the longest sustaining weekly show in radio.

Patsy Cline was best known perhaps for her coll-recording records such as "I Fall to Pieces," "Walking After Midnight," and her current "Leaving On Your Mind."

She got her professional start after winning an Arthur Godfrey Talent Scouts contest on television in the mid-50s. She joined the Opry in 1960 and has been voted numerous

awards for her recording achievements.

"There is no better female (Turn to Page 2, Column 2)

No Space On Plane

'God On My Side,' Says Billy Walker

Billy Walker

"God was on my side," Billy Walker said today.

"Else how can you explain my being here . . . and Patsy, Copas and Hawk and Randy gone."

Walker, a Columbia recording artist and member of the Grand Ole Opry, was one of the entertainers who appeared on the benefit show the past weekend in Kansas City.

"No," said the tall, lanky Texan, "I was not scheduled to ride in the plane.

"Actually there wasn't enough room for me in the five-seater. So I went out and took on a commercial flight.

"There was some kidding about my size and how I weighed too much to get in the small ship.

"Ironic isn't it that the final appearance of Patsy, Hawk, Copas and Randy would be at a benefit for the widow of a disc jockey (the late Jack Call)," commented Walker, who lives at 1602 Inverness Dr., Madison.

Walker's recent record hits have been "Charlie's Shoes," "Willie the Weeper" and "Funny How Time Slips Away."

"Facts prophetic title, isn't they?" he asked. "Willie Shoes' title about a sad fellow who would rather be somebody else. Today I'm fortunate to be just Billy Walker.

"This terrible tragedy — and my nearness to it—will haunt me a long, long time."

Rivers Over Banks, Pose Small Threat

Four Middle Tennessee rivers, which absorbed four inches of rain since Monday night, poured over their banks in several areas today but posed little flood threat to residents.

The rivers, including the Duck, Stone, Elk and Barren Fork, were expected to begin receding late today. Weather Bureau officials at Nashville did not report the Cumberland River to go over its banks.

At McMinnville, rescue squads today were to remove a season for Madam Eugene Varner, 20, missing and presumed dead after his boat was swept over a dam on the rain-swollen Barren Fork River Tuesday.

Would Wait

Officials said they would wait for the river to calm down before searching for Varner who had been fishing on the river Tuesday.

Late Tuesday, a bill was introduced in both houses to carry out Gov. Frank Clement's campaign pledge to set up a loan fund for deserving college students.

Bedford County officials said the Duck River there appeared to have crested this morning at flood stage—710 feet above sea level. The results is completely a flood control project and release largely neutralized dikes and large water stumps place keep the river from channeling Caney Mill Bend, usually the first section to be swamped, officials said.

28.5 Feet

The Duck River at Columbia reached 28.5 feet this morning. City police said the river would have to reach at least 30 feet before they began evacuating residents along East Seventh St. Flood stage there is 32 feet and officials had expected the river to reach 34.5 feet during the night.

The Elk River at Fayetteville appeared to have crested this morning at 663 feet above sea level.

Senate Considering Truck Weights Bill

By NEIL CUNNINGHAM

The State Senate today will consider raising the maximum weight for trucks from 42,380 to 73,280 pounds.

Final debate in the Senate is also scheduled on a proposal to require seat belts on all automobiles beginning with 1964 models and another bill to authorize consolidation of city and county school systems.

Passage Urged

The truck weight bill has been recommended for passage by two legislative committees and public hearings have been held on the proposal.

Action Deferred

The House calendar con-

mittee Tuesday deferred action on a bill which would repeal (the) fair trade liquor law.

Earlier in the day, the Senate voted 20 to 9 to repeal the law which was passed by the 1961 Legislature.

Rep. Gene McIlwain, who is sponsoring the liquor bill in the House, said he will attempt to bring the proposal out of the committee this week.

Sen. Barton Dement, who sponsored the whisky bill in the Senate, introduced a proposal Tuesday which would legalize horse racing and pari-mutuel betting in Tennessee.

The Senate passed and sent to the Governor a bill to raise the pay of State judges by $3,000 a year, effective in 1966.

Gets Other Proposals

Also sent to the governor's desk were proposals to provide clerks for Supreme Court justices and creating an executive secretary for the Supreme Court.

A joint committee created to work out differences between the House and Senate versions of a bill to institute the size of automobile license plates voted to support the proposal approved by the Senate.

This bill establishes $12 fee for licenses for smaller cars, and $15.50 for heavier ones. The House had approved a bill establishing a fee of $13 for all cars, regardless of weight.

The reapportion plan now will be presented to both houses.

This afternoon, public hearings will be held on two other Senate bills which have been introduced.

One of the bills would authorize the sale of liquor-by-the-drink in wet counties and the proposal would permit cities with a population of 3,000 or more to hold local option liquor elections. The law now requires that such referendums be held county-wide.

'Round The Clock
WITH RED O'DONNELL

TALES OF ONE CITY

Mrs. Fred Walker, 224 Russell on Pike, was downtown with her daughter, 2½-year-old Jo Ann.

On Sixth Ave. the child saw a parking meter and s-p-e-e-d and s-p-e-e-d. "Mama, does that make chewing gum?"

Following a misunderstanding element somewhere forecast the other night, Mr. Mrs. James E. Farkis, 1808 Ranchwood Drive, commented "Why there weren't be any more snow this year."

Immediately their 5-year-old son David, inquired: "Why Daddy, did God stop all of snow?"

(Thanks to WLAC's Ted Con-

(Turn to Page 11, Column 5)

City Special

TENNESSEE — Clearing and cooler over much of the state today with a few light showers east this morning. Clear to partly cloudy tonight and Thursday. Cooler east tonight. Thursday, a little warmer east Thursday afternoon. High today 45-55, low tonight 25-35.

Temperatures

12 midnight	40	1 a.m. ... 37
1 a.m. ... 40		2 a.m. ... 37
2 a.m. ... 38		3 a.m. ... 37
3 a.m. ... 36		4 a.m. ... 35

STATE NEWS ROUNDUP Pages 12-14

FEATURE INDEX

Amusements	21	Farm Talk	
Bridge	32	Homes	25
Churches		Horoscope	35
City Hall		Jumble	35
Comics	24, 35	Markets	
Crossle Mail		Radio, TV	22, 25
Crossword		Sports	16-19
Deaths	27	Society	30-32
Editorials	6	Want Ads	27-35

• BESSEMER, ALA.—Tornado rips 100 homes.
• BIRMINGHAM—Boswell, Connor face runoff race.
• MONTGOMERY, ALA.—Legislature faces two sessions.
• ROCHESTER, KY.—Bank burglary nets $3,000.

• NATIONAL and INTERNATIONAL roundups, Pages 3, 4.

PATSY CLINE HAWKSHAW HAWKINS COWBOY COPAS RANDY HUGHES

RADIO STATION

WSM INCORPORATED

50000 WATTS

650 KILOCYCLES NASHVILLE 3, TENNESSEE ★ ★ ★ CLEAR CHANNEL ★ ★ ★

Dear Friends:

By this time all of you have heard of the tragic deaths of Patsy Cline,
Cowboy Copas, Hawkshaw Hawkins, Jack Anglin and Randy Hughes.
Thousands of words have been written and spoken. Many of you have
presented memorial programs ... some have broadcast all-day tributes ..
many have called .. sent cards, letters and telegrams. For all of these
we are most grateful.

But somehow .. today .. at the beginning of a new week .. we find our-
selves remembering not the tragedy of last week but the many times when
Patsy .. Cope .. Hawk .. Jack and Randy came by the office .. or called
to tell us about a birthday party .. a new record .. a new dress .. a
special PA .. or to say: "Just called to see how everythings going".

This is the way we'll remember them.

Instead of our usual letter .. we're sending you some unprinted pictures
that we had in our file ... and one we made at the Opry last Saturday
night during our Grand Ole Opry tribute. We thought you might like them.

March 11, 1963

smiling Alabama native tickled Opry audiences by wearing a matching blazer and trousers festooned with oversize red lips.

The sense of normalcy didn't last. The country music community faced another stunning loss when Jim Reeves and his manager were killed in a plane crash in a wooded area of a Nashville suburb on July 31, 1964. Marty Robbins, who lived nearby, helped in the search for the wreckage. So did Roy Acuff, Minnie Pearl, and Ernest Tubb. Eddy Arnold identified the body when it was found two days later. A debonair crooner with international appeal, Reeves had racked up number one hits such as "Four Walls," "Billy Bayou," and "He'll Have to Go" since joining the Opry in 1955, though he had resigned his membership in 1963.

On August 8, 1964, eight days after Reeves's death, Dottie West sang on the Opry as a new member for the first time. West grew up in McMinnville, Tennessee, and moved to Nashville in 1961 determined to make it as a songwriter. Reeves scored a hit with one of her compositions and introduced her music to Chet Atkins, who signed her to RCA Victor. "Here Comes My Baby," a memorable single written with her husband, Bill West, started to pick up steam at radio stations just weeks after she joined the Opry. The lushly produced ballad would earn a Grammy Award in 1965, making her the first woman in country music to win one. On the same night that West joined the cast, so did the Osborne Brothers, a bluegrass duo from Kentucky. Bobby Osborne's exceptional tenor voice and Sonny Osborne's inventive banjo

OPPOSITE: WSM press release written by public relations director Trudy Stamper

playing remained consistent throughout their career, even as they explored (and achieved) mainstream country appeal.

Willie Nelson made his first appearance as an Opry member on November 28, 1964, but only stayed in the cast for a short time. Tired of making the Saturday drive from his concerts in Texas, where he was drawing good crowds, to Nashville, where he was struggling to connect as a mainstream country artist, Nelson ultimately chose Texas. Yet the songs he wrote in the early 1960s remain enshrined in Opry history–Patsy Cline's "Crazy," Ray Price's "Night Life," Billy Walker's "Funny How Time Slips Away," and Faron Young's "Hello Walls," to name a few.

At the time, Opry management expected members to commit annually to twenty-six Saturday night shows. As if to prove a point publicly, in December 1964, Opry management dropped eleven members from the cast because they didn't reach the required number of shows. When a front-page story stated that twelve members were dismissed, Chet Atkins clarified that he shouldn't have been included, because he had parted ways with the Opry years before. Minnie Pearl was granted a leave of absence but could still use the Opry name in promotions. Kitty Wells, the only other female performer on the list, got the boot along with her husband, Johnnie Wright. Five artists eventually came back, including Stonewall Jackson and George Morgan, but others moved on.

In light of the exodus, the Opry bolstered its cast. Norma Jean, a traditional country singer from Oklahoma who was referred to as "Pretty Miss Norma Jean" in Porter Wagoner's touring

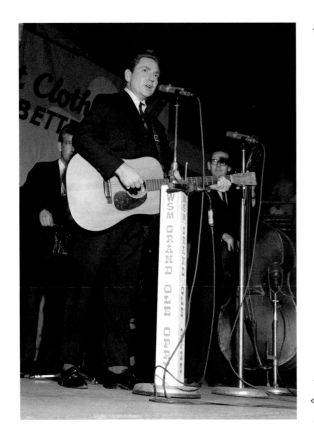

group, joined in 1965. She'd just found success in her own right with the 1964 single "Let's Go All the Way" and remained with the Opry until 1969. The accomplished businessman, Broadway performer, Western actor, and cowboy singer Tex Ritter came on board upon moving from Hollywood to Nashville in 1965. Ritter, the father of actor John Ritter, also hosted *Opry Star Spotlight*, a late-night WSM radio show with Grant Turner and, later, Ralph Emery.

Bobby Bare, another West Coast transplant via Ironton, Ohio, arrived in Nashville in 1964, two years after signing with RCA. With more of a folk influence than most other country artists of the time, Bare had reached the pop chart with "Shame on Me," the first song he recorded for the

label. "It didn't even get in the Top 10 in country," he said. "A lot of that was my fault because I wanted the younger audience. And I also wanted the country audience. That's why I moved to Nashville, because I was living out there in LA and all my friends were having short careers. They were becoming a 'whatever happened to . . .' type artist, and I didn't want that. I wanted to be a country singer, which is what I was. I moved back to Nashville, got married, and joined the Grand Ole Opry and laid all that aside. I wanted people to think of me as a country singer."

Introduced as an official cast member on August 7, 1965, Bare had already achieved Top 10 country hits with thoughtful, well-crafted songs such as "Detroit City," "500 Miles Away from Home," "Miller's Cave," and "Four Strong Winds" by the time he joined. A decade after the emergence of rock 'n' roll, the Opry didn't feel the same hesitation about the folk music revival of the 1960s. Bare, the Browns, the Glaser Brothers, George Hamilton IV, Jim & Jesse, and the Osborne Brothers would have appealed to young folk fans and a typical Opry listener. But like others before him, Bare would leave the Opry when the attendance requirements became too cumbersome.

Bob Luman was added to the cast on August 21, 1965, just as he started to resume his recording career after being drafted into the army. His career really picked up in the mid-1970s with soul-influenced singles like "Lonely Women Make Good Lovers" and a cover of Gladys Knight & the Pips' "Neither One of Us." His showmanship took center stage whenever he performed a souped-up version of "A Satisfied Mind," the 1955 hit most associated with Porter Wagoner. On the same night that Luman became a member,

so did a young singer from Ohio named Connie Smith, who'd been a complete unknown just two years earlier.

Born in Indiana and raised in West Virginia, Smith declared at five years old that someday she would be singing on the Grand Ole Opry. When her family could pick up the WSM signal on the battery radio, she always listened for the Louvin Brothers, drawn at a young age to the emotion in their lyrics and harmony. Despite her stage fright, she loved to sing. Nobody would have guessed she was shy after hearing her strong, soaring vocal delivery.

In August 1963, Smith had intended to see a George Jones concert at Frontier Ranch, just outside of Columbus, Ohio, but upon arrival, she learned she'd had the date wrong. Rather than head back home, her friends and then-husband talked her into entering the afternoon's talent show, where the grand prize was five silver dollars and a chance to perform onstage that night with the evening's headliner, Bill Anderson. Smith sang Jean Shepard's "I Thought of You" and won.

Things happened quickly after that. Impressed with her talent, Anderson spent a year laying the groundwork for a career. He invited her to Nashville to sing at the Ernest Tubb Record Shop *Midnite Jamboree*, arranged for meetings with Chet Atkins at RCA, and even wrote her debut single, "Once a Day." At twenty-two years old, Smith debuted at the Opry on June 13, 1964.

"The very first time singing on the Opry was a dream that I really didn't think would come true," she said. "And the very first time I was

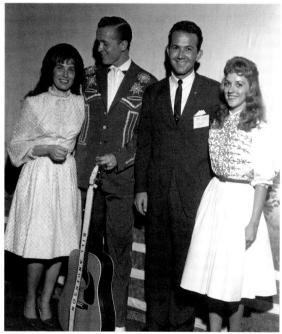

OPPOSITE: Willie Nelson performs on the Grand Ole Opry for the first time since becoming a member, November 28, 1964. TOP: Portrait of Connie Smith, June 23, 1965. BOTTOM: Loretta Lynn, Bill Anderson, and visiting disc jockey Clay Daniels pose with new member Connie Smith backstage at the Grand Ole Opry, August 29, 1964.

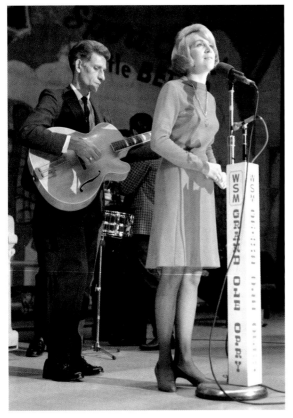

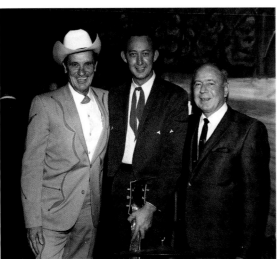

TOP: Jeannie Seely performs for the first time as a member of the Grand Ole Opry, backed by Ralph Davis on guitar, September 16, 1967. BOTTOM: Ernest Tubb and Ott Devine stand backstage at the Opry with Jack Greene (center), who was making his first appearance as an Opry member, December 23, 1967.

on the Grand Ole Opry, I went out and I was shaking. I'd heard about your 'knees knocking.' I thought that was a saying, but my knees were actually hitting together, and my voice was just coming out in spurts. And when I finished, I ran off the stage and busted out crying."

Although she occasionally toured with Anderson and he continued to write hit songs for her, Smith saw herself as too independent to be anyone's "girl singer," a term commonly ascribed to the sole female performer in a male artist's touring ensemble. Still, she said it felt good to hear Roy Acuff himself call her "the Sweetheart of the Grand Ole Opry." By the time Smith joined the cast in August 1965, Acuff had doubled down on his Opry commitment. Seriously injured in a car crash just a month earlier on the way to a tour date, Acuff decided to scale back on touring, preferring instead to hold court on the Opry stage.

After Smith's induction, it would take two years before another woman joined the cast, following the addition of Stu Phillips, Ray Pillow, Del Reeves, Charlie Walker, and a vocal group from Ohio called the Four Guys. Of these new members, Reeves had the most commercial success, thanks to the 1965 number one hit "Girl on the Billboard." Meanwhile, Phillips became the second Canadian artist after Hank Snow to join the cast, and Pillow charted a Top 10 duet with Jean Shepard. Walker released his signature hit "Pick Me Up on Your Way Down" in 1958, but his belated Opry invitation coincided with a novelty tune titled "Don't Squeeze My Sharmon." And even though the Four Guys

hadn't released a hit, they stayed active with the cast from 1967 until 2000, when no original members remained in the lineup.

Meanwhile, Jeannie Seely kept wondering when she'd get the call. The Opry had been a way of life for her since she was a young girl in Pennsylvania. On Saturday nights, if the radio in the house couldn't pick up the signal, her family would listen in the car. And if it still didn't come in, they'd drive to a hill. From then on, Seely never lost sight of wanting to join the Opry.

A budding songwriter, Seely moved to Los Angeles in 1961, then to Nashville in 1965. She had songs recorded by Ray Price, Connie Smith, and Dottie West, and gained some early touring experience with Porter Wagoner when his usual "girl singer," Norma Jean, took time off for a family matter. By March 1967, Seely had won a Grammy for "Don't Touch Me," a torch song written by her then-husband Hank Cochran. Still, the Opry didn't reach out. Asked how she was invited to join the cast, Seely succinctly responded, "After much badgering on my part."

On Cochran's recommendation, Seely contacted booking agent Hal Smith. However, Smith was reluctant to help because other artists had asked for that same favor, then drifted away from the Opry. Seely insisted that she shouldn't be punished for other artists' behavior, and Smith agreed to place the call. Ott Devine invited Seely to come to his office and then warmly welcomed her into the cast on September 16, 1967.

"I knew when I was eight years old, in third grade, what I wanted to do," Seely said. "But besides singing on the show, I heard something else that was just as important to me back then, and still is. And that's hearing these people, like Mr. Acuff and Minnie and Dickens and all of them, coming together every week. They always sounded like they were so glad to be together. They picked on each other and joked, and I thought, 'That's just like a family.' And I wanted to be a part of that. As much as I wanted to be on the show, I wanted to be a part of that."

Expressive and versatile singer Jack Greene collected three wooden trophies at the first-ever CMA Awards on October 20, 1967, due in large part to his huge hit, "There Goes My Everything." As the former drummer for Ernest Tubb's Texas Troubadours, Greene was already a familiar face at the Opry when he joined the cast on December 23, 1967.

Though Porter Wagoner wasn't nominated for a CMA Award that year, he was thriving on television with his signature style–rhinestones, rhinestones, and more rhinestones. Employing a small cast and periodic guest stars, he launched *The Porter Wagoner Show* into syndication in 1961; the loose and lively episodes were usually taped in just one or two takes. Recorded first in black and white, then color in 1966, the show ultimately reached more than one hundred markets and three million homes.

After Norma Jean's departure from the show in 1967, Wagoner hired Dolly Parton as her replacement, forging an alliance that yielded several successful duets and led to Parton's recording contract with RCA. That fall, the *Tennessean* theater critic Clara

Hieronymus recapped an RCA label show-case at Municipal Auditorium that was part of the Opry's forty-second anniversary celebration. Hieronymus lavished praise upon Parton and Connie Smith in particular. The headline summed it up: "Blondes in the Spotlight at RCA's Opry Breakfast."

"We all got our bleach at the same store, I think," Parton remembered with a laugh. "But we all love country music. And I have to say Connie Smith, in my book, is one of the greatest singers that ever sang a song in country music. I used to love when I was on the Opry at the same time when she was working. I think she was [performing] with Bill Anderson at the time, and I was with *The Porter Wagoner Show*, and we were blondes in the spotlight. I used to stand backstage and watch her and think, 'Wow, that girl can sing!'"

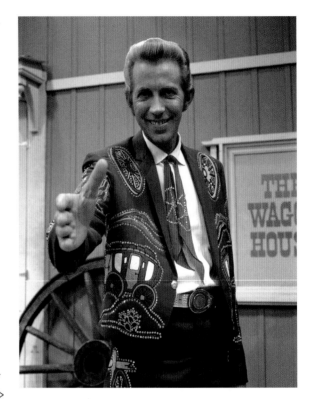

TOP: Porter Wagoner on the set of *The Porter Wagoner Show*, September 10, 1968. BOTTOM: Dolly Parton studio portrait, dated December 4, 1967. OPPOSITE TOP AND BOTTOM: Dolly Parton, Porter Wagoner, and the Wagonmasters perform on the Grand Ole Opry, October 11, 1969. FOLLOWING SPREAD, CLOCKWISE FROM TOP LEFT: Marty Robbins, Johnny Cash, Tammy Wynette and George Jones, Loretta Lynn, Johnny Cash, Johnny Cash with June Carter and Tex Ritter, Johnny Cash, Minnie Pearl with Johnny Cash, Billy Walker and Patsy Cline at Tootsie's Orchid Lounge, Tammy Wynette and George Jones

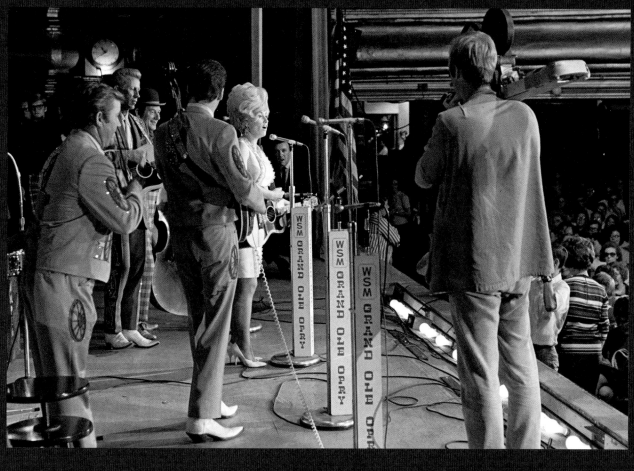

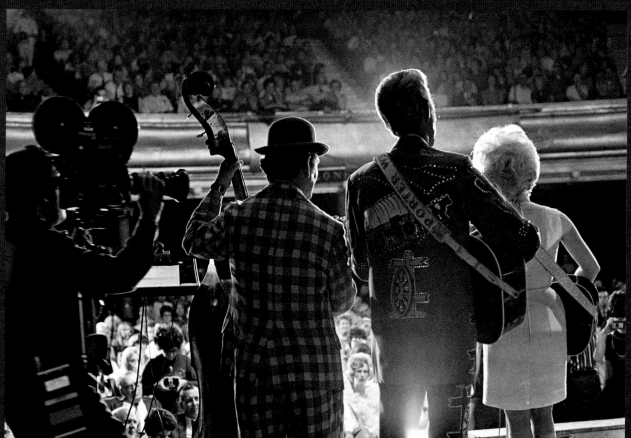

OCT • 60 •

YOU'RE LOOKIN' AT COUNTRY

ABOVE: Uncle Dave Macon, known as the "Dixie Dewdrop," flashes his gold-toothed grin, 1930s. OPPOSITE, FROM TOP: Detail of Nudie's Rodeo Tailors label. While there have been many designers of the flashy, rhinestoned Western wear throughout the years, "Nudie suit" has become a collective term for the style; Gene Autry (back row, fourth from left) visiting the WSM radio studio and posing with manager Joe Frank, Sarie & Sally, Pee Wee King and His Golden West Cowboys, and Asher, Buddy, and Jimmie Sizemore, c. 1938. The popularity of Hollywood cowboys like Autry influenced Opry attire, inspiring some performers to transition from the Appalachian "hillbilly" look to the more glamorous style of Western movie cowboys.

"On December 1, the Grand Ole Opry, WSM's four-hour Saturday night barn dance, will celebrate its ninth anniversary as one of the most popular programs of its kind ever put on the air. For the first time since the program was started, the performers are dressing their parts. Overalls, hickory shirts and battered hats predominate among the old time fiddlers and banjo pickers while Uncle Dave Macon, long since the star performer, continues to wear his ten-gallon hat, gates-ajar collar and flashes his gold teeth at the spotlight, which plays on him in WSM's brand new auditorium studio."

The November 18, 1934, *Tennessean* documented the Opry's evolution from a barn dance of the airwaves and imagination—where a few lucky fans could crowd into a radio studio each week—to a stage show where musicians' costumes reflected the hillbilly image the show cultivated from the beginning. In WSM's Studio C, five hundred fans per two-hour segment could witness the performances. Even if the hillbilly look was out of character for musicians such as Dr. Humphrey Bate, a harmonica player with a medical degree from Vanderbilt, it was powerful in distinguishing the Opry and underscoring the show's down-home identity. From then on, each show would be a feast for the eyes as well as the ears.

As the Opry attracted more full-time professionals, some musicians felt that the hillbilly image was denigrating, so they took a cue from the cowboy movies dominating the cinematic landscape of the day. Zeke Clements, Texas Ruby Owens, and Pee Wee King donned cowboy hats and colorful Western wear and adopted band names such as the Bronco Busters and Golden West Cowboys. The cowboy style became more fanciful through the 1940s in the hands of Jewish immigrant tailors such as Rodeo Ben in Philadelphia, Pennsylvania, and Nathan Turk and Nudie Cohn in Hollywood, California.

Though small in stature, Little Jimmy Dickens made a sizable impression in 1949 when he took the Opry stage wearing one of Cohn's creations, which would become known as "Nudie suits"—the first Opry member to do so. In the 1950s, the style was embraced by many top young country stars. As Nudie's designs became more elaborate and eye-catching, the Opry sparkled with flashing rhinestones and colorful embroidered designs that reflected performers' individuality. From Hank Snow's "I'm Moving On" suit with embroidered train motifs to Porter Wagoner's heavily rhinestoned stage suits decorated with Conestoga wagons and wagon wheels, audiences knew, without a doubt, they were seeing a star.

Stage wear for Opry women proved more conservative in the 1950s. Minnie Pearl's frilly dress and a $1.98 price tag hanging from her hat became her signature look. Similarly, Kitty Wells and Wilma Lee Cooper dressed modestly, cradling

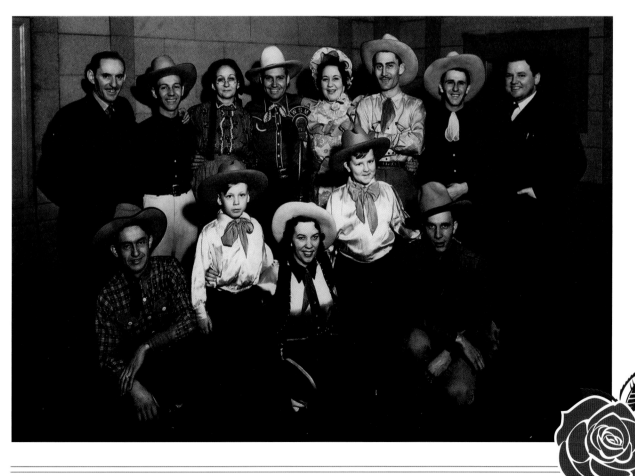

120

acoustic guitars against their square-dance-style dresses. By the 1960s, women were making more fashionable style choices. Patsy Cline helped usher in elegant cocktail dresses, many made by her mother. Sonny James, Jim Reeves, and other smooth-singing men in the Nashville Sound era opted for trim, modern suits.

The 1970s saw a new era of self-expression for women. Loretta Lynn donned floor-length gowns; Dolly Parton's embellished bell-bottom jumpsuits created an unforgettable silhouette; and Dottie West raised the glam factor with stage wear by Bob Mackie, designer of choice for Cher and Carol Burnett. Success allowed these stars to leave behind the old-fashioned notions of how a woman in country music should look and dress.

The Outlaw and Urban Cowboy eras introduced a much more casual country style, with jeans, cowboy boots, and Western shirts worn by entertainers and their audiences alike. As the nineties rolled around, the look got crisper. Jeans showed an ironed-in crease. Cowboy hats, which were back in style for Clint Black, Terri Clark, and Alan Jackson, were pristine and clean. In the 2000s, the Del McCoury Band, Ricky Skaggs, and Rhonda Vincent carried on the dress-to-impress bluegrass tradition, always looking sharp for their audience.

OPPOSITE: Porter Wagoner's Nudie-made jacket with the singer's signature covered wagon design embroidered on the back. CLOCKWISE FROM TOP LEFT: "Gentleman" Jim Reeves showcases a style of attire reflective of the adult-pop-oriented era of country music known as the Nashville Sound, early 1960s; while her fashion has evolved through the years, Dolly Parton's blonde wigs have remained a constant; Loretta Lynn favored floor-length gowns throughout most of her career.

BELOW LEFT: Minnie Pearl, Wilma Lee Cooper, Jan Howard, Skeeter Davis, June Carter, and Kitty Wells pose together backstage at the Grand Ole Opry, October 1, 1961. BELOW RIGHT: Jeannie Seely pushed boundaries through her daring fashion sense, from introducing miniskirts to the Opry stage in the 1960s to donning this pantsuit with plunging neckline and bare midriff for the Opry House grand opening show, March 16, 1974. OPPOSITE: Johnny Cash, known as "the Man in Black," in his signature all-black stage wear, July 24, 1971

These days, the Opry stage might showcase fashion inspiration from throughout the show's history. Banjo player and comedian Mike Snider has been known to sport overalls, Riders in the Sky adhere to the Western look, and Marty Stuart and His Fabulous Superlatives wouldn't dare come to the Opry without gorgeous custom-tailored Western suits. For his induction, Mark Wills borrowed an embellished jacket that George Jones wore for his final promotional photo. Terri Clark, Jamie Dailey of Dailey & Vincent, and Jamey Johnson are among the Opry artists who turned to esteemed Nashville designer Manuel Cuevas (a protégé of Nudie Cohn simply known as Manuel) for their induction wardrobe.

Meanwhile, the glamour of a bygone era continues to inspire fashion-forward entertainers such as Sara Evans, Carly Pearce, and Carrie Underwood. Said Underwood, "I always try to dress a certain way for the Opry because of the rich tradition established by women at the Opry. You look at the pictures on the walls, they're just stunning. And they really respected the Opry and wanted to dress a certain way. I try my best to keep that going."

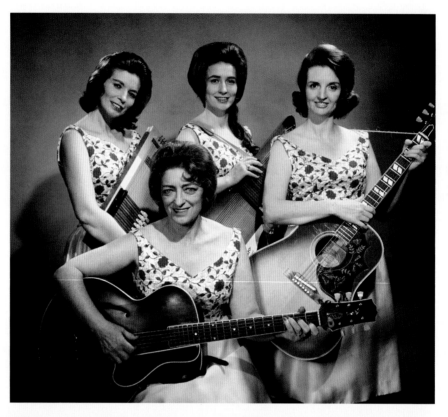

CLOCKWISE FROM TOP LEFT:
The Carter Family in matching dresses with floral embroidery, January 26, 1965; Dottie West showcases her extravagant Bob Mackie–designed stage wear, c. 1974; Minnie Pearl in her iconic hat with the $1.98 price tag, February 1974; No one has preserved the golden era of country couture more passionately than Marty Stuart, who frequently wears suits by modern tailors Manuel Cuervas and Jaime Castaneda; Carly Pearce incorporates traditional country flourishes into her glamorous contemporary style, June 19, 2024; Riders in the Sky carry on the cowboy way with Western wear reflective of the golden era of the Hollywood cowboy, April 20, 2024.

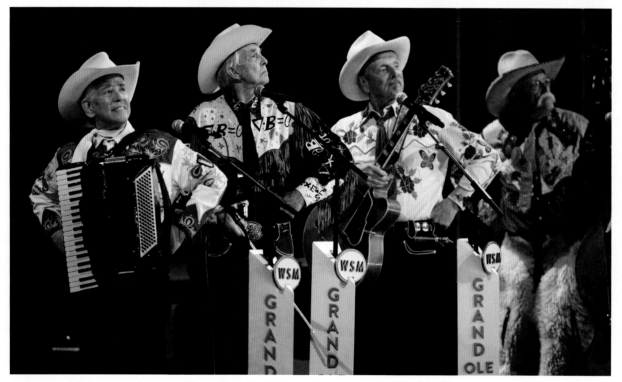

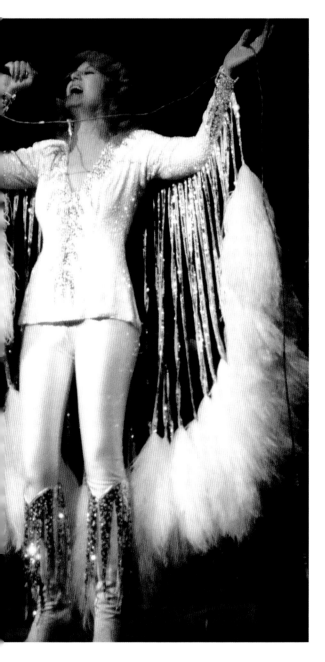

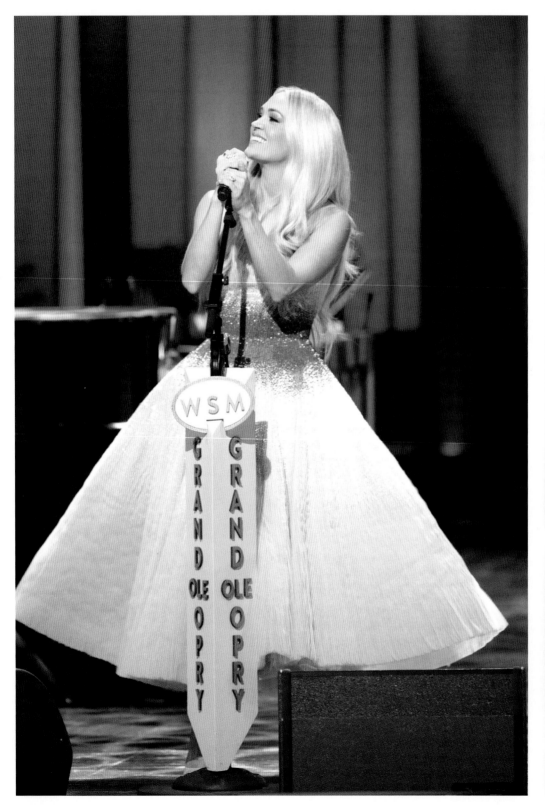

OPPOSITE: Carrie Underwood shines on the Opry stage, October 23, 2021. THIS PAGE, TOP AND CENTER: Clint Black, Terri Clark, and Alan Jackson are known for their signature cowboy hats while Luke Combs and Darius Rucker opt for baseball caps.

THIS PAGE, BOTTOM: Members of Little Big Town are known for wearing modern high-fashion brands such as Gucci, Valentino, and Isabel Marant. Here, they perform for the Opry's ninety-fifth anniversary special, January 19, 2021.

PREVIOUS SPREAD: Jon Pardi at Stagecoach Festival after receiving his Opry invitation on April 28, 2023. THIS SPREAD, CLOCKWISE FROM TOP LEFT: Rodney Crowell joins the Grand Ole Opry Square Dancers, August 13, 2016; Ralph Sloan calls a dance for his Tennessee Travelers troupe, March 1958; Grand Ole Opry Square Dancers coax Wendy Moten into the act, May 11, 2019; Charley Pride shows off his fancy footwork with the Melvin Sloan Dancers, October 27, 2001; square dancers take the stage at the Opry House grand opening, March 16, 1974; Ben Smathers leads his Stoney Mountain Cloggers, late 1950s.

THE CIRCLE

1968–
1977

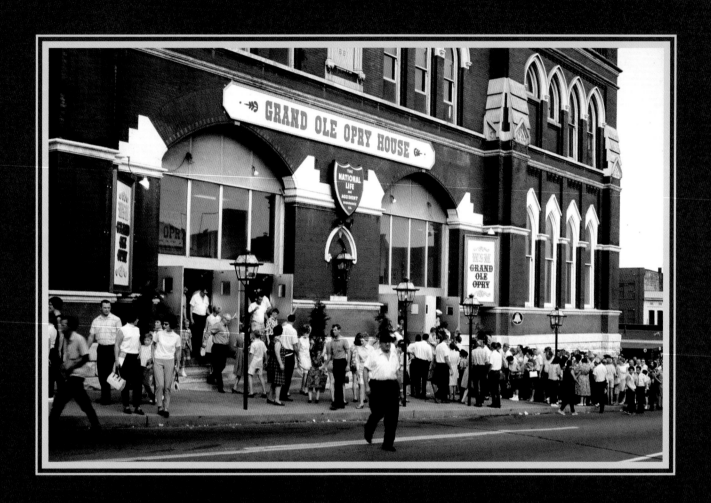

 Nine Cadillacs were lined fin-to-bumper in the stage-door alley when I visited Nashville recently," wrote Larry L. King in a 1968 piece about the Opry in *Harper's Magazine*. "Backstage, only five minutes before airtime, there was a fleeting impression of firemen, policemen, stagehands, loose children, and of all the pickers-and-singers on earth. Some performers wore suits of psychedelic hues, tricked up with rhinestone patterns in the shape of horseshoes, alligators, or ruby-red lips; most wore outfits only mildly Western, or plain business suits. Then the curtain rose, and a cowboy in a yellow shirt and lavender tie began to saw a fiddle, and the string of almost ninety musical laments and hoedowns had begun."

On most Saturday nights, that vivid description would have rung true. On April 6, 1968, though, Ryman Auditorium was quiet. Martin Luther King Jr. had been murdered two days earlier in Memphis; the mayor of Nashville imposed a curfew starting on Saturday at 7:00 P.M. after reports of looting and gunfire in parts of the city. E. W. "Bud" Wendell, who'd started a new job that week as Opry manager, pressed the mayor about making an exception, but the conversation went nowhere. Instead, WSM aired a rerun, adding an asterisk to the Opry's status as the world's longest-running live radio show. That afternoon, Roy Acuff, Sam and Kirk McGee, and others improvised a show inside Mr. Ed's, a country music nightclub across the alley from the Ryman's stage entrance, for a group of fans who'd shown up for the Opry.

Fresh out of college with a degree in economics, Wendell started his career in 1950 as a door-to-door insurance salesman for National Life and

Accident Insurance Company. Like other salesmen employed by the company, he would introduce himself as being from the Grand Ole Opry's parent company to gain trust and entrance. The Ohio native admittedly didn't know much about country music when he moved to Nashville in 1962 to work in the home office; instead, he was a businessman who easily climbed the corporate ladder. He was named assistant to Jack DeWitt, the president of WSM, before taking on the role as the Opry's GM. Going into it, Wendell knew he wanted to create a family atmosphere, give performers a raise, and add more bluegrass and a variety of comedy to the show.

Wendell's colleague Irving Waugh had his own vision of the Opry he wanted to implement. Waugh joined WSM as a radio announcer in 1941 and gained experience ranging from early morning broadcasts about country music to covering World War II in the Pacific Theater as an NBC correspondent. By 1960, he had risen through the ranks to become vice president of

PREVIOUS SPREAD: Minnie Pearl and Roy Acuff perform on the stage of the new Opry House for the first time on March 16, 1974. OPPOSITE: Ryman Auditorium, c. 1967. BELOW: Opry manager Bud Wendell poses with Tammy Wynette and George Jones backstage at the Grand Ole Opry on the evening of Wynette's first performance as a member, May 17, 1969.

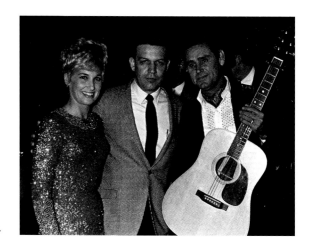

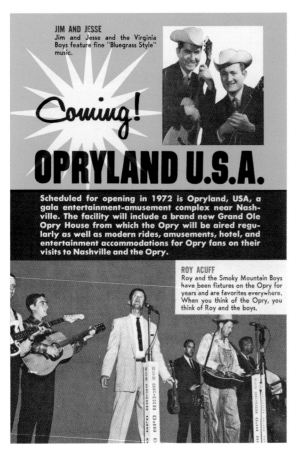

JIM AND JESSE
Jim and Jesse and the Virginia Boys feature fine "Bluegrass Style" music.

Coming!

OPRYLAND U.S.A.

Scheduled for opening in 1972 is Opryland, USA, a gala entertainment-amusement complex near Nashville. The facility will include a brand new Grand Ole Opry House from which the Opry will be aired regularly as well as modern rides, amusements, hotel, and entertainment accommodations for Opry fans on their visits to Nashville and the Opry.

ROY ACUFF
Roy and the Smoky Mountain Boys have been fixtures on the Opry for years and are favorites everywhere. When you think of the Opry, you think of Roy and the boys.

OPRYTOWN

OPRY PLAZA

OPRYLAND U.S.A.

TOP: National Life and Accident Insurance flyer from 1969, announcing the coming of Opryland USA. BOTTOM: Aerial view of land allocated for the new Opry House and Opryland USA amusement park. OPPOSITE, TOP: Dolly Parton performs onstage at the Grand Ole Opry for the first time as a member, January 11, 1969. OPPOSITE, BOTTOM: Dolly Parton and Porter Wagoner perform one of their classic duets, March 2, 1974.

WSM-TV. Named president of WSM, Inc., upon DeWitt's retirement in 1968, Waugh made a new home for the Opry a major priority.

Costs to modernize Ryman Auditorium with air-conditioning, nicer backstage facilities, and additional restrooms would be exorbitant. Finding a parking place was never easy for artists or the audience. Plus, the people waiting in line outside were being approached by vagrants and other seedy characters; when the shows let out after dark, attendees spilled out onto the edge of Lower Broadway, where dingy bars and adult businesses were not uncommon. Yet the Opry remained popular enough that people were still being turned away, which meant revenue was being left on the table.

Waugh and his fellow executives considered how the Astrodome anchored the Astroworld theme park in Houston, and that Sleeping Beauty Castle sat in the center of Disneyland in Anaheim, California. What if a brand-new Grand Ole Opry House, with more seating, the newest technology, and lots of parking, could be the cornerstone of its own theme park? It was ambitious, but in October 1969, WSM executives announced that Opryland USA would spring up on 369 acres in a bend of the Cumberland River northeast of downtown Nashville; a five-thousand-seat Grand Ole Opry House would be its showpiece. Only five miles from the airport, the property would be easy to access on Briley Parkway, which was under construction.

G. Daniel Brooks, the board president of WSM, Inc., and of National Life and Accident, told the *Tennessean*, "It is our plan to create a park of great beauty. We expect to give it the strictest maintenance, and the surrounding land will

enable us to keep out the garish, honky-tonk commercialism that has sprung up around some of the other amusement areas around the nation." The estimated cost would be $16 million.

Dolly Parton and Tammy Wynette were announced as future Opry members in the *Tennessean* on New Year's Eve, 1968, alongside George Jones, returning from hiatus, and Mel Tillis. Wynette had just scored a massive hit with "Stand by Your Man," which she cowrote with producer Billy Sherrill. One month after their Opry invitation, she and Jones married; their six-year marriage yielded classic duets such as "We're Gonna Hold On" and "Golden Ring." Parton and Porter Wagoner, who were not romantically linked, had charted three Top 10 hits together; a few of Parton's solo singles on RCA were performing modestly. It wasn't long before she learned that Opry management hoped to bring her into the fold.

"Porter said, 'They want to put you in as a member,' and I said, 'Hallelujah!'" Parton remembered. "I mean, that was like a dream come true. I don't remember their hoopla as much as I remember my own, of how I was feeling so excited and how that was such a big deal, not only to me but to my family. Country people loved the Grand Ole Opry, especially my country people. And so, for me to get to be a member of that sacred group of people, I was just so honored. I remember I was in a glorious spot that whole night."

As the 1960s turned to the 1970s, women in country music were breaking ground with some of the most interesting and enduring songs of the era. Jeannie C. Riley caused a stir

OPPOSITE: Studio portrait of Barbara Mandrell posing with her Sho-Bud pedal steel guitar, mid-1970s. THIS PAGE, CLOCKWISE FROM TOP LEFT: Linda Martell becomes the first Black woman to perform on the Grand Ole Opry, August 1969; Linda Martell poses backstage at the Ryman with Bill Monroe, August 1969; Lorrie Morgan makes her Opry debut at Ryman Auditorium, December 14, 1973.

in 1968 by calling out the hypocrites in "Harper Valley P.T.A." Linda Martell, her labelmate on Plantation Records, charted two Top 40 singles in 1969, becoming the first Black woman to achieve mainstream success in country music. The Opry welcomed each of them to perform as guests on the Ryman stage.

Women in the Opry cast were proving that long-held notions of limited potential for female solo artists were patently false. In 1970, Tammy Wynette released two more number one singles, Loretta Lynn returned to the top with "Coal Miner's Daughter," and Skeeter Davis, Dolly Parton, Jeannie Seely, Jean Shepard, Connie Smith, and Dottie West all charted Top 10 singles.

Jan Howard, best known for the 1966 singles "Evil on Your Mind" and "Bad Seed," joined the cast on March 27, 1971. She grew up as Lula Grace Johnson in West Plains, Missouri, and listened to the Opry with her father; he would tune in only long enough to hear Texas Ruby, his favorite singer. Howard always enjoyed music as a girl but wouldn't sing in front of anyone.

That all changed when her second husband, the then-struggling songwriter Harlan Howard, overheard her singing around their home in Gardena, California. He finally convinced her to record the work tape for a song he wrote, "Mommy for a Day." After Kitty Wells recorded it, Jan slowly started getting comfortable with her own budding music career. The couple moved to Nashville in 1960, and Jan debuted at the Grand Ole Opry that same year, singing "The One You Slip Around With" on the Prince Albert segment emceed by Ray Price. She was petrified; it was only the third time she ever sang in public.

Howard would weather numerous personal setbacks, including a divorce and the tragic deaths of two sons. Meanwhile she earned two Grammy nominations, wrote singles for Connie Smith and Kitty Wells, and lent her vocals to the Johnny Cash hits "Ring of Fire" and "Daddy Sang Bass." She also spent so many Saturday evenings at the Ryman that Opry manager Bud Wendell assumed she was already a cast member. She later recalled, "One night I told him I wasn't going to come, because I didn't have to. They made me a member the next night."

Like Howard, Tom T. Hall made a number of guest appearances before being formally added to the Opry cast. In a 2013 interview, Hall recalled his first performance as a member, on January 8, 1971, when Roy Acuff brought him to the stage as "Tom P. Hay." With a laugh, Hall recounted, "That's all Roy could get in his head! And I was still new in the business and new at the Opry. I got a tremendous round of applause and I don't know who they thought they were seeing."

Hall left the Opry cast after a few years, reportedly because he wanted his full show band with horns, drum kits, and multiple fiddles. (He was welcomed back as a member in 1980.) Asked about his memories of the Ryman, Hall observed, "It was the mother church of country music and we were kind of a congregation. We had our own religion, which was country music. So, we kept the thing going, you know? Roy Acuff was the 'pastor' of the church . . . We were all his children and God's children, and we'd sing and then we'd fan out in all directions and go play shows, and then come back on Saturday night. It was a family, a very spiritual thing."

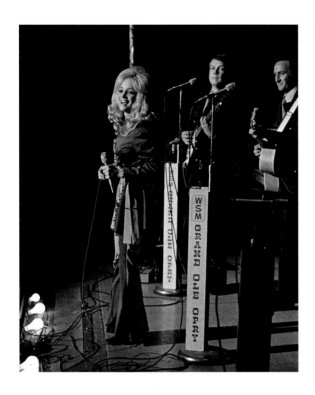

David Houston, a well-regarded singer remembered for his 1966 cheating ballad, "Almost Persuaded," came aboard on August 12, 1972, just as he landed his twentieth Top 10 single. Houston was backed that night by Japanese fiddler Shoji Tabuchi, who won over the crowd and eventually became a regular Opry guest in his own right. Rising star Barbara Mandrell, who'd recorded several hit duets with David Houston, was twenty-four years old when she joined the Opry on July 8, 1972, though she already had a lifetime of experience onstage.

Born in Texas and raised in California, Mandrell spent hours upon hours practicing the steel guitar as a young girl. She was eleven when she

Barbara Mandrell performing onstage at Ryman Auditorium for the first time as a Grand Ole Opry member, July 8, 1972

was spotted by country star Joe Maphis at a music trade show. Sliding the tone bar across the strings, working the levers with her knees, and shifting her feet on the pedals, Mandrell made the complicated instrument look easy. At Maphis's invitation, she appeared in his Las Vegas act, and later, on the West Coast television series *Town Hall Party*. Nicknamed "Princess of the Steel," the instrumental prodigy joined a package tour where she opened shows for Johnny Cash, shared a hotel room with Patsy Cline, and subbed as George Jones's steel guitarist. A year later, she toured military bases in the United States and Asia with her family's band but decided to retire from music as an eighteen-year-old newlywed, with no hint of the superstar she would become.

After one last overseas tour with her family's band, Mandrell's parents and two younger sisters moved from California to a farm in West Tennessee. Without much to do after the deployment of her husband, navy pilot Ken Dudney, Mandrell arranged for a visit. In the summer of 1968, her father drove the whole family to Nashville in a travel trailer and picked up tickets to the Friday Night Opry.

"I had never been to Tennessee, so therefore I had never been to the Opry," Mandrell said. "I had heard it on some recordings, but growing up in California, you know, I just was in awe of the reputation of the Opry."

Before the WSM broadcast that night, the Mandrells watched a taping of the *National Life Grand Ole Opry* television show unfold on the Ryman stage. Porter Wagoner, by this time, was one of the Opry's brightest stars, though it was Dolly Parton who dazzled Mandrell. The

impromptu vacation to Nashville proved to be a life-changing moment.

"There's a balcony there, and dead center in that balcony we were sitting, the five of us, watching the Opry. And as I watched it, my mind was going a hundred miles an hour. At this one point, I made up my mind. I turned to my father and I said, 'Dad, I should be up there. If you'll manage me, I would like to get back into country music.' And he said, 'OK, I'd bet my last penny on you.' That was the deciding factor, right there."

Mandrell is far from the only young performer who was transfixed by the Opry. Patty Loveless, Marty Stuart, Steve Wariner, and Lorrie Morgan all have enduring Opry memories from the early 1970s, years before their own inductions.

As a toddler, Loveless (then Patty Ramey) would be hoisted onto the kitchen table while her mother mopped and listened to the Opry. A few years later, Patty's father took her to the Pollyanna Drive-in in Pikeville, Kentucky, to watch Flatt & Scruggs perform on top of the concession stand. At six years old, the thought crossed her mind: "That's what I want to do." Her older brother, Roger, noticed her musical interests and nurtured them. They soon formed a duo and warmed up the crowd with a few songs at a 1971 country package show in Louisville. Watching from the side of the stage, the Wilburn Brothers liked what they heard and invited them to Nashville. But when the Rameys showed up a few weeks later, the Wilburns were out of town. So they knocked on Porter Wagoner's office door instead.

Wagoner was impressed with the fourteen-year-old girl's singing and writing; he invited the siblings to a taping of *The Porter Wagoner Show* and welcomed them backstage at the Opry. Loveless was spellbound when she met Dolly Parton that night. Loveless watched and learned as Parton applied her makeup; not long after, Loveless bought a short, blonde wig for herself, too.

"When I was around Dolly, she was always jolly and always treated me like a little sister," Loveless said. "She was the sweetest creature on earth, as far as I'm concerned. She always gave you love, honestly, with everything. And being around her, she was a hoot. There's been times a few words came out of her mouth, and I think Porter's daughter was in shock. I was like, doesn't shock me because I'm around musicians all the time."

Marty Stuart had been similarly enraptured by country music as a boy. Listening to the radio on his grandmother's lap at four years old, Stuart could hear people sobbing in the audience during a moment of silence at the beginning of a 1963 Opry show; Patsy Cline, Hawkshaw Hawkins, Cowboy Copas, and Randy Hughes had perished in a plane crash just days before. At twelve years old, he talked his dad into driving two hundred miles to Jackson, Alabama, to see Bill Monroe in concert. After the show, Stuart confessed to Monroe that he wanted to play mandolin just like him; Monroe kindly gave Stuart his mandolin pick and told him to go home and learn how to use it. There was no turning back.

At thirteen years old, Stuart was invited by a new friend, Roland White, the guitarist in

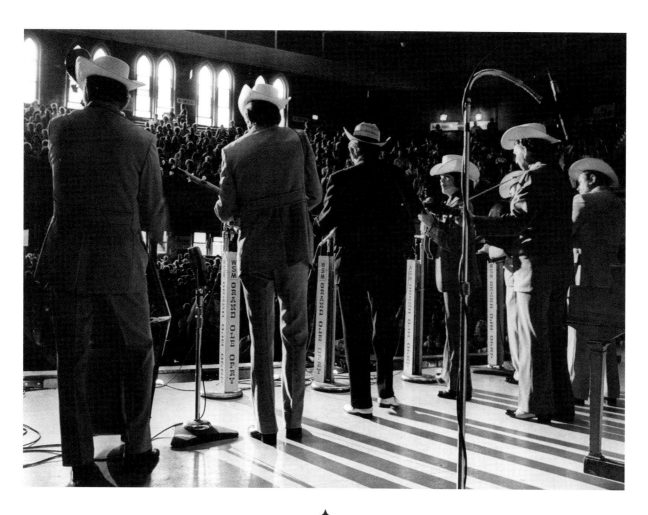

Lester Flatt's band, to come to Nashville and ride along on some tour dates. With his parents' permission, Stuart eagerly boarded a Greyhound bus in Mississippi and was deposited at the bus station in downtown Nashville at 2:30 A.M. Looking for his ride, Stuart walked around the corner and came face-to-face with the imposing Ryman Auditorium, and, eventually, Roland White. After getting to know the young picker and hearing him play with White at the back of the tour bus, Flatt decided to feature the two musicians during an encore at a Grand Ole Opry appearance. More than fifty years later, Stuart's first-ever Nashville performance on that night in September 1972 remains vivid in his memory.

"If something happens and it blows the house up, if an event or a moment happens onstage, people get out of the dressing rooms and they find their way to the wings," Stuart explained. "I've always called it an Opry moment, and there's this feeling that comes over this building [the Opry House] or the Ryman when that happens. And so, an Opry moment happened around me

Future Opry star Marty Stuart plays mandolin as a member of Lester Flatt's band the Nashville Grass, June 6, 1973.

that first night. We encored the song, and when I turned around to walk offstage, there was Tex Ritter, and Roy Acuff and his whole band, and there were journalists, there were people taking pictures, and the musicians had gathered around. The stage was packed to crowd around and see what was going on. And I could see Lester beaming, like, 'I got one here!' Roy Acuff shook my hand, Tex Ritter shook my hand, and they all made me feel welcome. And I think coming in with Lester, it gave me instant acceptance into the family of the Opry."

Steve Wariner was a senior in high school when Dottie West heard him in the band that was opening her show at a club outside of Indianapolis. Wariner grew up listening to the Opry with his father and uncle; he knew West's hits and figured it would be fun to be a part of the night, even though he would be playing bass instead of his usual guitar. During the set, he noticed West in the back of the room, watching intently. When he heard a woman's voice come in on a Merle Haggard cover, he looked over and saw that she had hopped onstage. Suddenly, everyone was paying attention to the opening act. "Do something else," she told him. Wariner suggested "Together Again," which brought down the house.

West needed to hire a new bass player and offered him a job after the concert. Wariner figured out how to graduate early from high school and joined the band. His parents trusted West to keep an eye on their son; Wariner remembers being treated like one of her own kids. It didn't take too long for Wariner to discover that West was always running late. Shortly before an Opry appearance in 1973, Wariner grabbed his gear and jumped into

West's white Cadillac and raced toward downtown, tuned in to WSM 650.

"As we're turning off of Broadway, I can hear Roy Acuff saying, 'Now, this here's a young lady from McMinnville, Tennessee,' and I went, 'Oh no, he's introducing her!'" Wariner recounted. "She slides into the parking lot and I jump out, and there's two or three people grabbing her to take her in. She opens the trunk and I grab my bass and I go, 'Where do I go?' And somebody goes, 'Follow me!' I was just like, 'My God, all these Opry stars,' and I'm running past them, bumping into them, and the guy goes, 'Here, give me your cord.' I'm trying to get my cord and the applause has died down already. Dottie walked out and just took over. She goes, 'How's everybody doing?' She saw me back there and she started talking to the crowd. It didn't even rattle her. She just acted like she was ready. And then she goes, 'Are you ready?' And I go, 'Yeah,' and we broke into whatever it was. That was my first Opry, and I remember being petrified and then it was just surreal. I looked around, like, 'Oh my God, this is it.'"

Lorrie Morgan spent as many Saturday nights as she could attending the Grand Ole Opry with her father, "Candy Kisses" singer George Morgan. As a fourteen-year-old who was obsessed with the show, she could hardly believe it when he offered to let her sing during his segment the following weekend. For her song, they picked "Paper Roses," a recent number one country hit for Marie Osmond. A bridesmaid dress belonging to Morgan's sister was altered for the occasion. On the night of December 14, 1973, the young singer stood at the side of the stage, shaking in high heels and unable to control her throat. Her father told her to give him a signal

if she couldn't go on. As she waited, other Opry members came up to talk to her, which only caused more stress as she tried to listen for her introduction.

"Finally, my dad looked over at me and I shrugged my shoulders. So, he took it upon himself to introduce me," Morgan said. "I don't know how I did it. My dad was standing there bawling. I remember looking at one pole in the Ryman Auditorium. I thought, 'Don't take your eyes off that pole. Stay focused, remember the words.' I actually think I forgot the words. I think I did the first verse twice. It was pretty shaky, but I was happy. My dad was happy."

Morgan received a standing ovation. Suddenly, she could see her future before her. "I was like, this is my life," she added. "This is who I'm about. These are my people. It was a change of life."

In the summer of 1972, families from Nashville and all over the South could meander through New Orleans, the American West, and Appalachia with just one visit to Opryland USA. The Timber Topper and the Flume Zoom appealed to thrill seekers, but Opryland was marketed as a show park rather than a theme park, with a focus on American music of all kinds. The Grand Ole Opry House was still two years away from completion when the insurance conglomerate's new chairman of the board revealed plans for another building envisioned for the park.

"It has been our thought that the most dignified and appropriate way to perpetuate the institution that the Ryman Auditorium has become, will be to enshrine some of its materials in a

'Little Church of Opryland,'" wrote William C. Weaver Jr. in the first paragraph of a long article in the *Tennessean*. In grandiloquent language, he suggested that the Ryman ought to be demolished and the bricks repurposed for the chapel. The tone-deaf comments caught the attention of *New York Times* architecture critic Ada Louise Huxtable, who wrote a searing response in May 1973. "That probably takes first prize for the pious misuse of a landmark and the total misunderstanding of the principles of preservation," she wrote. Such harsh public scrutiny from the *Times* amplified local preservationists' efforts to save the Ryman and ultimately forced the insurance corporation to put the wrecking ball on hold.

With less than a year to go before the show moved to the suburbs, the Opry brought in two more members: "Satin Sheets" singer Jeanne Pruett on July 21, 1973, and comedian Jerry Clower on October 27, 1973. Relatable and reliable, they were both comfortable choices for

Artist's rendering of a scrapped idea to disassemble and rebuild Ryman Auditorium at Opryland

the Opry cast. But within a few weeks' time, that sense of security would be shattered.

As a regular on *Hee Haw*, the gangly banjo player Stringbean found renewed popularity on the Opry. He was also known to keep a lot of money stashed in his overalls. On the night of his final Opry appearance on November 10, 1973, there was $3,182 in cash sewn into a hidden pocket in his overalls. His wife, Estelle, had $2,150 tucked in her bra. As their Cadillac pulled up to their tiny cabin in rural Goodlettsville, Tennessee, about a half hour's drive from the Ryman, Stringbean must have sensed something was off, perhaps noticing that the things on his porch weren't just as he'd left them. He pulled a .22 from his stage bag. Estelle stayed behind.

Opening the front door and looking around, Stringbean hesitated. The cabin was a wreck. A man wearing a stocking over his head and another in a Halloween mask quietly waited for him. Doug Brown and John Brown were twenty-three-year-old cousins who had been listening to the Opry on the couple's radio and drinking their beer from the fridge. Moments after stepping inside, Stringbean took a bullet to the heart. Hearing the gunfire from the front yard, Estelle ran toward the road until she was shot twice in the shoulders and fell to the ground. One of the cousins put a bullet in the back of her head. Robbery may have been the motive, but the cousins missed the money in Estelle's bra and found only $250 in Stringbean's back pocket. His body was left in front of the fireplace, face down.

This was the scene that Grandpa Jones encountered when he came by early the next morning to pick up his best friend for a weeklong hunting

trip. Jerry Thompson, who covered the case for the *Tennessean*, wrote, "Grand Ole Opry performers are accustomed to living under the constant threat of travel accidents and burglaries because their work demands an enormous amount of roadwork. However, until yesterday they weren't under the pressure of murder." The police investigation stretched through the holidays before the cousins were arrested and ultimately imprisoned.

In between two Opry slots that December, Skeeter Davis drove to a nearby mall to pick up some last-minute Christmas gifts. To her surprise, she recognized some members of a street ministry she met in Indiana earlier in the year. They chatted for a while, but with the late Opry show on her mind, she didn't linger. But something caught her eye on the way out of the mall. Police officers had detained, to her count, eighteen members of the ministry. Upset, she confronted

the mall's manager, who said he didn't want the members of the ministry scaring away shoppers. The incident bothered her all the way back to the Opry stage. During her performance, she opted to sing "Amazing Grace" instead of a hit. Telling the audience what she'd seen, she added, "I can't believe that some of my brothers and sisters were arrested for telling everybody that Jesus loves them and to keep Christ in Christmas."

The comments elicited applause but the policeman on staff at the Opry was none too pleased. Days later, Davis learned from Bud Wendell that she'd been suspended from the show. Management wouldn't specify an end date; sixteen months would pass before she returned to the Opry stage.

In February 1974, Porter Wagoner and Dolly Parton announced their impending professional split. Future lawsuits indicated otherwise, but the decision seemed amicable. "Dolly is now a superstar in every way," Wagoner observed. "She's well prepared to go on her own. I am very happy that I have helped Dolly in preparing for this day." Parton replied, "I have mixed emotions about leaving *The Porter Wagoner Show*, because it is sad to leave a man and a show that have meant so much to me. But I'm glad that I have reached the point where I can have a show of my own."

In contrast, a surprising reunion took place a few days later when DeFord Bailey appeared as an Opry guest star on February 23, 1974, his first official appearance in thirty-three years. Still hurt from being fired in 1941, Bailey limited his interactions with the Opry and instead developed a successful shoe-shine business. Occasionally, he would participate in special events, including a

1955 performance recorded in WSM Studio C, as well as two *National Life Grand Ole Opry* television shows taped at the Ryman in the 1960s. But more often than not, he would decline invitations to appear on WSM.

OPPOSITE: Stringbean (David Akeman) and his wife, Estelle, eating breakfast during the WSM disc jockey convention, November 4, 1960. TOP: DeFord Bailey, Minnie Pearl, and Roy Acuff at Ryman Auditorium during the first Old Timers' Night on the Grand Ole Opry, February 25, 1974. BOTTOM: Alcyone Bate Beasley, daughter of Dr. Humphrey Bate and longtime Opry member, joins Roy Acuff during the first Old Timers' Night.

In an interview with Bailey's friend and future biographer David C. Morton, WSM executive Jud Collins wondered aloud what it would take to bring Bailey back to the Opry stage. That simple question sparked the idea to create the first Old Timers' Night. The nostalgic lineup filled out with past Opry legends such as Sid Harkreader, Zeke Clements, Clyde Moody, Pee Wee King, and many others. Introduced to the stage by Roy Acuff, with Minnie Pearl happily clapping nearby, Bailey thrilled the crowd with renditions of "Pan American Blues" and "Fox Chase." When he spent his seventy-fifth birthday at the Grand Ole Opry House that December, he became one of just a few performers to have set foot in all six of the Opry's homes.

A few months later, the writer Garrison Keillor filed a protracted piece with the *New Yorker* about the Opry's final night at Ryman Auditorium and his impressions of Nashville at the time. The talkative Keillor wandered around the premises, chatting people up and sometimes hearing their grievances. At one point, he was invited to watch the action in the control room, where WSM engineer Gordon Evans was adjusting dials to get the levels right for Jim & Jesse's performance of John Prine's "Paradise."

"The best place to see the Opry that night, I decided, was in the booth with my eyes shut, leaning against the back wall, the music coming out of the speaker just like radio, that good old AM mono sound," Keillor wrote. "The room smelled of hot radio tubes, and closing my eyes, I could see the stage as clearly as when I was a kid lying in front of our Zenith console. I'd seen a photograph of the Opry stage in a magazine back then, and, believe me, one is all you need. So it was good to let the Opry

go out the same way it had first come to me, through the air in the dark. After the show, it was raining hard, and the last Opry crowd to leave Ryman ran."

Keillor, who would later create his own long-running radio show, *A Prairie Home Companion*, opted to skip opening night at the Grand Ole Opry House. So did Grandpa Jones, who couldn't find a parking spot at the bustling venue and turned around for home. In the midst of the Watergate scandal, President Richard Nixon flew to Nashville to commemorate the grand opening on March 16, 1974. The first American president to visit the Opry, he took a seat at the piano and led the audience in singing "Happy Birthday" to First Lady Pat Nixon, and also performed "God Bless America" and "My Wild Irish Rose." Roy Acuff attempted to give him a yo-yo lesson onstage, but Nixon couldn't get the

ABOVE: Richard Nixon appears onstage with Roy Acuff during the opening of the new Grand Ole Opry House, March 16, 1974. OPPOSITE: Executives Bud Wendell and Irving Waugh look on as Roy Acuff directs carpenters installing the famous circle of Ryman flooring in the new Opry House, January 17, 1974.

hang of it. "I will stay here and try to learn how to use the yo-yo," the president told him. "You go up and be president, Roy."

With cast members scheduled to perform in alphabetical order, Roy Acuff was on first. As the curtain lifted, Bill Anderson watched from the audience as performance footage from the 1940 film *Grand Ole Opry* was projected on a scrim. When the lighting shifted, Acuff and the Smoky Mountain Boys materialized onstage, playing the same song, "Wabash Cannonball."

"The audience just leaped to their feet," Anderson remembered. "I teared up, I really did. It was a very

special moment and then I remembered, 'Hey, you ain't got time to stand here and cry! You're on in a minute! You better get backstage, turkey!'"

Acuff stood in a six-foot wooden circle at center stage, but these were no ordinary boards. The weathered stage of Ryman Auditorium had been replaced in 1951; over the next twenty-three years, the footsteps of Patsy Cline, Hank Williams, and innumerable Opry legends crossed over its maple planks. Two months before the new venue's grand opening, Roy Acuff, Bud Wendell, and Irving Waugh looked on as a construction crew fitted a circular portion of wood cut from the Ryman stage into the

CLOCKWISE FROM TOP RIGHT: The Pointer Sisters backstage with Jeanne Pruett at the Grand Ole Opry House, October 25, 1974. Left to right: Ruth Pointer, Anita Pointer, Pruett, Bonnie Pointer; the Pointer Sisters perform onstage at the Grand Ole Opry House, October 25, 1974; Roy Acuff and Ronnie Milsap, mid 1970s; Paul and Linda McCartney, with daughters Mary and Heather, visit with Dolly Parton and Porter Wagoner at Opryland USA, June 16, 1974; ticket for the Opry's special performance for United Nations delegates

SPECTATOR

A VERY SPECIAL

Grand Ole Opry

PERFORMANCE

7:00 p.m. June 7, 1976
Grand Ole Opryhouse

U.N. Visits Tennessee Nº 4048

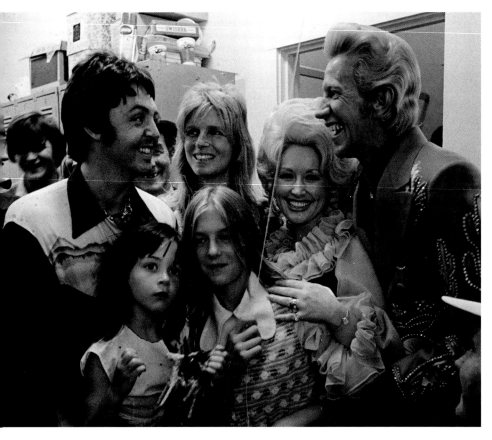

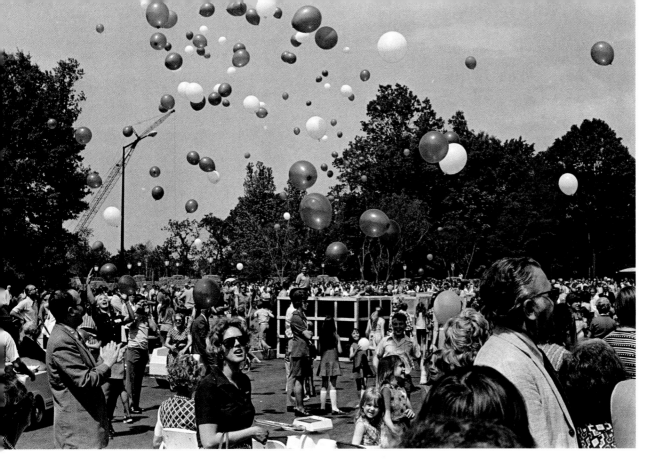

CLOCKWISE FROM TOP: Crowds attend the dedication of Opryland amusement park, May 21, 1972; Opry manager Hal Durham introduces the US astronauts and Soviet cosmonaut of the Apollo-Soyuz space mission, October 24, 1975 (left to right): Alexey Leonov, Vance Brand, Donald "Deke" Slayton, and Thomas Stafford; Ivory Joe Hunter performing on the Ryman stage with Opry announcer Hairl Hensley, October 19, 1972; artists Andy Warhol and Jamie Wyeth join the Opry audience on a Saturday night, January 29, 1977. Visiting backstage, Warhol recalled listening to the Opry as a child in Pennsylvania.

floor of the Grand Ole Opry House. More than fifty years later, the well-trodden pieces of wood are still considered the venue's defining feature. When contemporary artists talk about playing the Opry for the first time, they inevitably speak about "stepping into the circle."

After three years of controversy surrounding the future of Ryman Auditorium, concerns were quietly addressed in an obscure *Tennessean* clipping roughly the size of a deck of cards. Readers learned that the venue would be open seven days a week for tours led by Opry hostesses, with one-dollar admission for adults and fifty cents for children. "There have been rumors that the Ryman Auditorium was going to be demolished the day we moved to Opryland," Bud Wendell stated. "That is simply not true."

A year later, plans for the Opry House's first anniversary celebration went awry when the Cumberland River flooded the venue's parking lot and the theme park. On the bright side, when the show relocated downtown to Municipal Auditorium on March 15, 1975, more than seven thousand fans showed up, making it the largest live Opry audience to date. Billed as the second annual Old-Timers' Night, the lineup leaned heavily into nostalgia: DeFord Bailey played "Pan American Blues"; Alcyone Bate Beasley, the daughter of 1920s Opry star Dr. Humphrey Bate, sang a solo; and Mother Maybelle Carter beautifully strummed her autoharp. Edna Wilson, also known as Sarie from comedy duo Sarie & Sally, wore an outrageously large bonnet as she cracked up the crowd with her stories; the Duke of Paducah interspersed his jokes with a few tunes on a four-string banjo. Now legends in their own right, Roy Acuff, Minnie Pearl, and Hank Snow participated in the historic show, too.

That fall, *Billboard* covered the fiftieth anniversary of the Grand Ole Opry with a detailed spread written by former WSM writer and reporter Bill Williams. Wendell told the industry publication, "The Opry is really a weekend show, so—despite our optimism—it's unlikely we'd expand into other days or nights of the week. Instead, we would consider additional weekend performances. Since its inception, the Opry has shown growth. There's absolutely no indication that pattern will change now. That's one reason why we keep investing profits back into the park and into the house."

The housewarming party for the Grand Ole Opry House carried on for the next few years. Roy Acuff introduced Paul McCartney to the Opry crowd in the summer of 1974; the former Beatle and his wife, Linda, were recording in Nashville with their band Wings. That fall, the Pointer Sisters came to the Opry, becoming the first Black female group to perform on the show. They would go on to collect a Grammy in the category of Best Country Vocal Performance by a Duo or Group for their self-penned "Fairytale." Don Gibson, who'd been dismissed in 1964, resumed his membership in 1975.

Four astronauts in the Apollo and Soyuz crews (three Americans and a Russian cosmonaut) visited the Opry in 1975 after completing their mission, which came to be known as the "handshake in space." A year later, the entire United Nations delegation assembled in Nashville and caught an Opry show specially staged on a Monday night. Andy Warhol and Jamie Wyeth attended the Opry in 1977 as guests of Tex Ritter's widow, Dorothy. The accomplished artists were in town for a local exhibition of the portraits they painted of each other.

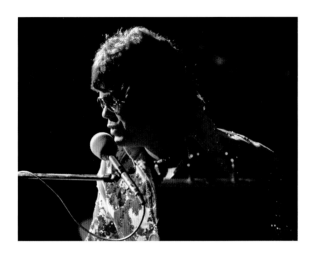

By this time, Wendell had assumed the roles of general manager for the Opry and the new theme park; adding to his clout, he was also named vice president of WSM. Wendell promoted WSM-AM program director Hal Durham to Opry manager in 1974. And when it came time to induct new members, Opry management didn't have to look any further than the *Billboard* charts. Ronnie Milsap, Don Williams, and Larry Gatlin and the Gatlin Brothers arrived with radio hits and industry awards already under their belts.

Milsap grew up in Western North Carolina listening to the Opry with his grandparents who raised him. As a boy, he took apart their Philco radio to better understand how it worked. Though he was born blind, Milsap was able to put it back together. When his grandparents enrolled him in the North Carolina State School for the Blind and Deaf in Raleigh, Milsap kept his radio close by.

Reminiscing about those formative years, Milsap said, "I remember calling up WSM: 'Why don't I

ABOVE: Ronnie Milsap performs on the Opry, mid-1970s.

ever hear Lester Flatt and Earl Scruggs? Why do they not play the Opry?' And the guy told me, 'Well, they're out on the road playing shows. I said, 'Oh, OK, I understand.' But I always loved listening to the Opry. WSM, that signal gets everywhere.'"

Milsap considered law school but couldn't resist trying to make it in music. After stints in Atlanta and Memphis, he moved with his wife, Joyce, to Nashville in late 1972. His buoyant personality and strong baritone grabbed the country music industry's attention almost immediately. Within two years, he'd signed to RCA and notched two number one singles. A powerhouse rendition of Don Gibson's "A Legend in My Time" returned him to the top in 1975. As a singer and piano player influenced by R&B music, Milsap noted that there was no resistance from anyone at the Opry to his musical style. He joined the cast on February 6, 1976, after a conversation with Roy Acuff.

"He said, 'Ronnie, do you drink?' I said, 'Water,'" Milsap remembered. "He said, 'I don't mean . . . do you drink whiskey?' I said, 'No, I don't.' He said, 'All right. Then you could become a member of the Opry.' What if I'd said yes? I think he would have said, 'Well, come on back here. Let's have some good ol' Tennessee whiskey.'" Milsap laughed at the memory, adding, "I loved him. I'd listened to his music for a long time."

Don Williams followed Milsap into the Opry family, though his time on the show was short-lived. Williams had just landed his fourth number one hit with "'Till the Rivers All Run Dry" in early 1976. Although he soon accepted an invitation to join the Opry, his broad appeal translated internationally and he toured the world, which made regular appearances difficult. After only a

handful of performances in the circle, Williams faded from the cast by 1981.

The Opry tapped Larry Gatlin and his younger brothers, Steve and Rudy, to join the Opry on Christmas Day 1976. Two months later, Gatlin won a Grammy in the category of Best Country Song for writing the trio's first significant hit, "Broken Lady." This wasn't a case of overnight success, though. As young boys in Texas, the Gatlins sang gospel music and accrued decades of stage experience before country stardom arrived. After hearing his songs in Las Vegas, Dottie West signed Gatlin to a song publishing contract and recorded two of his originals. Between 1972 and 1974, his composition "Help Me" was picked up by Kris Kristofferson, Ray Price, Connie Smith, and Johnny Cash. Gatlin would go on to write seventeen Top 10 hits for the Gatlin Brothers.

Larry Gatlin had been in Nashville for five years when Durham extended the invitation, which Gatlin said he immediately accepted. "Dottie introduced us, and he was a gentle spirit and he knew entertainment, he knew artists, he knew songs. He knew how to run a business," Gatlin said. "I really believe that he believed his job was to nurture young talent. He realized that to keep it vibrant and to keep it alive, we needed young talent. And I'm not bragging. We give God the glory, but we can sing. We've always been able to sing. And so they allowed us that great honor.

"And look, here's what we have to understand. We were not the same," Gatlin continued. "When we came here, we weren't the same as the Statler Brothers or Tompall and the Glaser Brothers or the Carters. We were different.

The Gatlin Brothers performing onstage during the CMA awards, October 13, 1980

Roy Clark was different than Roy Acuff. Marty Stuart is different than Marty Robbins. To keep fresh blood and to take care of us old codgers is what the Opry is about."

Steve Gatlin agreed. "The Opry is just like anything else. It's a work in progress," he said. "It's different today. It's the same, but it's different, very much, from where it was forty years ago. And forty years from now, when we're all dead and gone, it will be still carrying on and be different. It'll have a different tweak, a different something to it. You have to grow and you just have to go with it."

Asked about what Opry membership means to him now, Rudy Gatlin added, "Maybe you get a little satisfaction in knowing that maybe you helped keep the tradition alive and we brought a little fresh blood like these new artists are doing today."

The music of Milsap, Williams, or the Gatlins could never be mistaken for a forgotten honky-tonk number of the 1950s. As the twang of traditional country music softened, a number of Opry stars felt slighted. Some backed an organization called the Association of Country Entertainers (ACE), which stated its intention to emphasize traditional country artists, but mostly sought to keep crossover stars such as Olivia Newton-John and John Denver from making further inroads into the format. In addition, several women in the cast were frustrated by management decisions that felt unfair.

Because every musician who sets foot on the Opry stage is paid, budgets were steep when stars brought their own band. Meanwhile, the staff band would have to sit out most of the show. After one of the house musicians complained, Opry GM Hal Durham asked who the staff band would most like to back. The staff musician suggested Connie Smith and Jeannie Seely. The backhanded compliment meant that both women would have to drop their band for Opry performances. In protest, Smith quit the Opry for a year, but Seely stuck it out. Rehearsals weren't guaranteed, so her performances with the house band were hit and miss. At other times, Durham wasn't scheduling her at all.

"I had friends and family members saying during the rough time, 'Why didn't you just not go?' I said, 'Because they win.' Number one, I always considered it my Opry, and I had as much right, or more, than some people to be here," she said. "And if I gave in, I wasn't going to be any happier sitting at home than I would being here and seeing what happened."

Seely added, "The truth is, I loved Hal Durham. To me, Hal Durham was probably one of the greatest on-air voices, and he could read copy without ever a flaw. But when you think about it, he had no experience or training to manage the Opry. I always thought then, this is the Peter Principle at its very best. You're taking him off the air, where he excelled. So, that was part of what hurt so bad. I always liked Hal and we shared so many good, fun things when he was an announcer. And so to be treated like that was really rough."

Wilma Lee Cooper had no choice but to adapt. When her husband, Stoney, died in 1977 after years of declining health, she assumed the role of bandleader, hired a fiddle player, and stayed with the Opry despite her misgivings. In an interview for the journal *Southern Exposure* in

1977, she spoke about how Kitty Wells proved that women could sell records, but that the industry was "still holding on to some of their old ways. Like the Grand Ole Opry, they won't let a woman emcee a fifteen- or thirty-minute show. Well, you see, that is taking part of the opportunity away from her and makes it harder for her to do what the man does."

Reba McEntire, then a young singer from Oklahoma, was also facing an uphill battle. She managed to get a contract with Mercury Records after being discovered singing the national anthem at a rodeo. However, her first three singles tanked. When she enlisted a new booking agent, he got her a guest spot on the Opry on September 17, 1977. Her parents and older sister drove 750 miles from Chockie, Oklahoma, for the occasion. But when McEntire's name wasn't on the security list, she asked her dad to find a pay phone at a nearby gas station. McEntire's agent cleared things up and the McEntires were welcomed backstage on their second attempt.

McEntire grew up hearing the Opry on Saturday nights. Her parents would drop the kids off at a picture show, then go play dominoes with their friends. At the end of the night, Reba and her siblings would crawl back into the family car. Her mom would be reading a book with the dome light, her dad would be relaxing in the back seat, and the Opry would be playing on the radio. Whenever they went to see the Opry on family vacations, they usually ended up with seats under the balcony but always tried to move closer to the stage, not only for a better view but to avoid a spilled Coca-Cola dripping onto their head through the leaky balcony floor.

Shortly after the McEntires walked into the Opry House for Reba's debut, they were greeted with a surprise: Dolly Parton had just pulled up, so the show producers needed to take away one of McEntire's two songs.

"I said, 'Well, shoot. She could take all of them, and can I meet her?'" McEntire remembered. "I didn't get to meet her, but when she walked in, it just kind of parted the sea. Everybody got out of the way, and she walked back with this beautiful cotton candy platinum hair, and this black chiffon outfit with these rhinestone butterflies on them. I thought, 'That's the prettiest woman I ever saw in my life.' I don't think I could have spoken to her if she'd have walked up to me. But I was so nervous I forgot all about Dolly when they said it was my time to perform. I was scared to death."

Escorted to the stage by the Four Guys, the vocal group who became Opry members a decade earlier, McEntire performed "Invitation to the Blues," a song by Roger Miller she recorded on her first album. Because she still lived in Oklahoma, McEntire would usually try to pencil in an Opry date whenever she passed through Nashville. She charted a Top 20 single in 1979 with a rendition of "Sweet Dreams," an homage to Patsy Cline, and finally hit number one in 1983 with "Can't Even Get the Blues." During her slow but steady build, she expanded her musical palate without forsaking traditional country music or her childhood dream of becoming an Opry member.

"I always wanted to be a part of the Grand Ole Opry," McEntire said. "Anybody who didn't, I was like, 'Where are you from? Why wouldn't you want to be?'"

Reba McEntire sings onstage during a Grand Ole Opry birthday week showcase, October 11, 1984.

OPRY ON-SCREEN

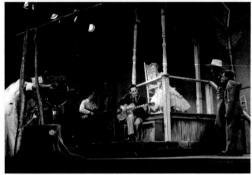

EVER SINCE HOLLYWOOD'S REPUBLIC PICTURES PRE-MIERED *GRAND OLE OPRY* AT NASHVILLE'S PARAMOUNT THEATER ON JUNE 28, 1940, THE WORLD'S LONGEST-RUNNING RADIO SHOW HAS FASCINATED FILMMAKERS. That movie's A-list cast included Roy Acuff and his Smoky Mountain Boys, Uncle Dave Macon and his son Dorris, and the Solemn Old Judge himself, George D. Hay. The Weaver Brothers & Elviry, a hillbilly musical comedy act, also appeared in the film, which capitalized on the popularity of the radio show and its stars, rather than depicting a Grand Ole Opry show.

A series of syndicated television films, titled *Stars of the Grand Ole Opry*, also showcased the Opry's star power. In 1954, a New York–based production company signed a deal with WSM to produce 35mm color films at Ryman Auditorium and other locations. With hay bales and a barn decorating the set, country singers and musicians gathered at the center of the stage to entertain viewers, as various folks in the background clapped along.

The first Grand Ole Opry television show (usually referred to as the "Purina Opry," due to its livestock feed sponsor) aired in 1955 and 1956 on ABC-TV. Staged at Ryman Auditorium just before the Saturday night Opry show, each episode of the Purina Opry had a theme (such as "Old West" or "general store"), a special set, and a blended cast of Opry stars and special guests from other entertainment fields. In the 1960s, syndicated shows produced by WSM-TV, such as *Pet Milk Grand Ole Opry* (1961–1964) and *National Life Grand Ole Opry* (1965–1968), presented the Opry brand, if not the actual Grand Ole Opry show, to a broad viewing audience.

Newly signed to RCA Records, Waylon Jennings stepped onto the Opry stage as the character Arlin Grove in the 1966 inde-pendent film *Nashville Rebel*. The colorful and endearing 1972 film *The Nashville Sound* packaged several Opry appearances

TOP: Lobby card advertising the 1940 movie *Grand Ole Opry*, which featured Opry cast members Uncle Dave Macon and Roy Acuff, as well as Opry founder George D. Hay. BOTTOM: Chet Atkins performs on the Purina Grand Ole Opry, filmed at Ryman Auditorium, January 7, 1955. OPPOSITE, FROM TOP: Waylon Jennings performing onstage with the Ryman's Grand Ole Opry set in *Nashville Rebel*, which premiered in 1966; Barbara Mandrell performs onstage during the second annual PBS telecast of the Grand Ole Opry, March 3, 1979; promotional material for *Coal Miner's Daughter*, a 1980 film about Loretta Lynn starring Sissy Spacek

from the 1969 WSM birthday celebration and offered a capti-vating glimpse of downtown Nashville. The Opry remained a focal point of Hollywood storytelling in 1975, playing a role in the Burt Reynolds heist comedy *W.W. and the Dixie Dancekings* and the Robert Altman masterpiece *Nashville*.

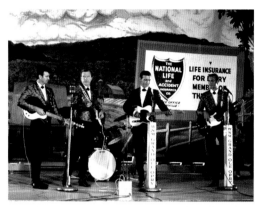

For an up-close (but pretaped) look at the Opry in 1975, Hal Holbrook hosted *The Grand Ole Opry at 50: A Nashville Celebration* on ABC; subsequent anniversary shows aired on CBS and NBC. Even PBS got in on the action during its 1978 annual fundraising drive, when the Grand Ole Opry was telecast in its entirety for the first time ever. After three more successful years, PBS hoped to continue the annual fund-raising broadcast, but WSM officials turned down the offer. However, the experience proved that the Opry could success-fully translate to television. Meanwhile, on daytime television, Bill Anderson and Jeanne Pruett appeared in two 1980 epi-sodes of the ABC soap opera *One Life to Live*, interacting with the characters Becky Lee Abbott and Johnny Drummond on an Opry stage re-created in a New York studio.

The Opry continued to make cameos on the big screen, too. Some of the most memorable scenes in *Coal Miner's Daughter*, the 1980 film about Loretta Lynn, were filmed at the Ryman. Sissy Spacek received an Academy Award for her portrayal of Lynn; Minnie Pearl, Roy Acuff, Ernest Tubb, and Opry announcer Grant Turner eagerly portrayed themselves. The Ryman also factored into Opry-related scenes in the 1982 film *Honkytonk Man*, starring Clint Eastwood as a hope-ful country singer during the Depression, and 1985's *Sweet Dreams*, starring Jessica Lange as Patsy Cline.

On the small screen, Kurt Russell reenacted Elvis Presley's Opry debut at the Ryman in the 1979 TV film *Elvis*. In 1985, TNN launched the long-running series *Opry Live*. An Opry scene filmed at the Ryman is also part of the 1995 made-for-TV movie *Big Dreams and Broken Hearts: The Dottie West Story*, which starred Michele Lee in the title role. However, Opry-related moments in 2005's *Walk the Line* and 2015's *I Saw the Light* were not filmed at the historic venue.

During a brief respite from biopics, the Grand Ole Opry played a recurring role in the nighttime drama *Nashville*. Several characters performed regularly on the Opry and occasionally mingled with real-life members like Del McCoury or Pam Tillis. The soapy show premiered on ABC in 2012 and concluded its

ABOVE: Brad Paisley and Blake Shelton host the Grand Ole Opry's ninety-fifth anniversary special, January 15, 2021. OPPOSITE, FROM TOP: Film still from *Sweet Dreams*, starring Jessica Lange as Patsy Cline; still from the 1982 film *Honkytonk Man*, starring Clint Eastwood

run on CMT in 2018. *Patsy & Loretta*, the 2019 Lifetime movie about the friendship shared by Patsy Cline and Loretta Lynn, featured Opry scenes filmed at Ryman Auditorium, as did *George & Tammy*, the 2022 Showtime miniseries.

Seventy-five years after the Nashville film premiere of *Grand Ole Opry*, a new generation of entertainers lit up the screen in *American Saturday Night: Live from the Grand Ole Opry*. The 2015 limited theatrical release filmed at the Grand Ole Opry House starred Opry members Brad Paisley, Darius Rucker, and Blake Shelton, and special guests the Band Perry and Brett Eldredge. After interviewing more than one hundred participants, from Dierks Bentley to Little Jimmy Dickens, documentary filmmakers Ken Burns and Dayton Duncan wove the story of the Grand Ole Opry throughout the sixteen-hour 2019 PBS series, simply titled *Country Music*.

Lainey Wilson, a breakout star who had debuted at the Opry only four years earlier, accepted her surprise invitation from Reba McEntire on the season finale of *The Voice* on May 21, 2024. Wilson had just finished singing "Hang Tight Honey" when McEntire rose from her coach chair and approached the stage. Noticing that McEntire was carrying a small black box, Wilson thought she was about to receive a birthday cupcake. Instead, she was presented with a custom-made belt buckle with the words "Opry" and "Lainey" gleaming on the front. Wilson fought back tears as McEntire formally invited her to join.

Just under three weeks later, at her induction on June 7, Wilson told reporters, "I've been in Nashville for thirteen years, and I started working on this long before then. I was nine years old when I wrote my first song, and when I came to the Grand Ole Opry for the very first time. I mean, I remember exactly where I was sitting . . . and I remember looking at that circle, thinking, 'I'm gonna do that, I'm gonna stand up there.' Out of all the accolades and everything that has happened this past year, and the year before that, too, tonight is the biggest honor of my life, being able to be a member of the Grand Ole Opry."

SWEET DREAMS

SD - 4
Charlie Dick (ED HARRIS) congratulates Patsy Cline (JESSICA
LANGE) after a performance at the Grand Ole Opry, while Patsy's
manager, Randy Hughes (DAVID CLENNON) looks on.

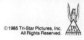

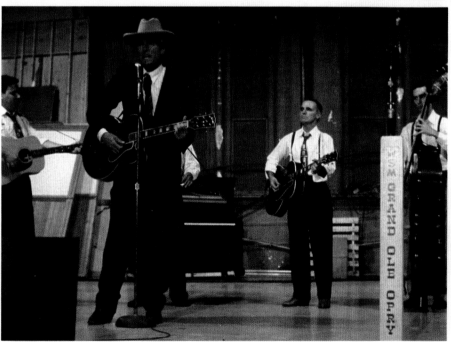

4

Honkytonk Man

FROM **WARNER BROS**
A WARNER COMMUNICATIONS COMPANY

LITHO. IN U.S.A. 820151

WHO'S GONNA FILL THEIR SHOES

1978-

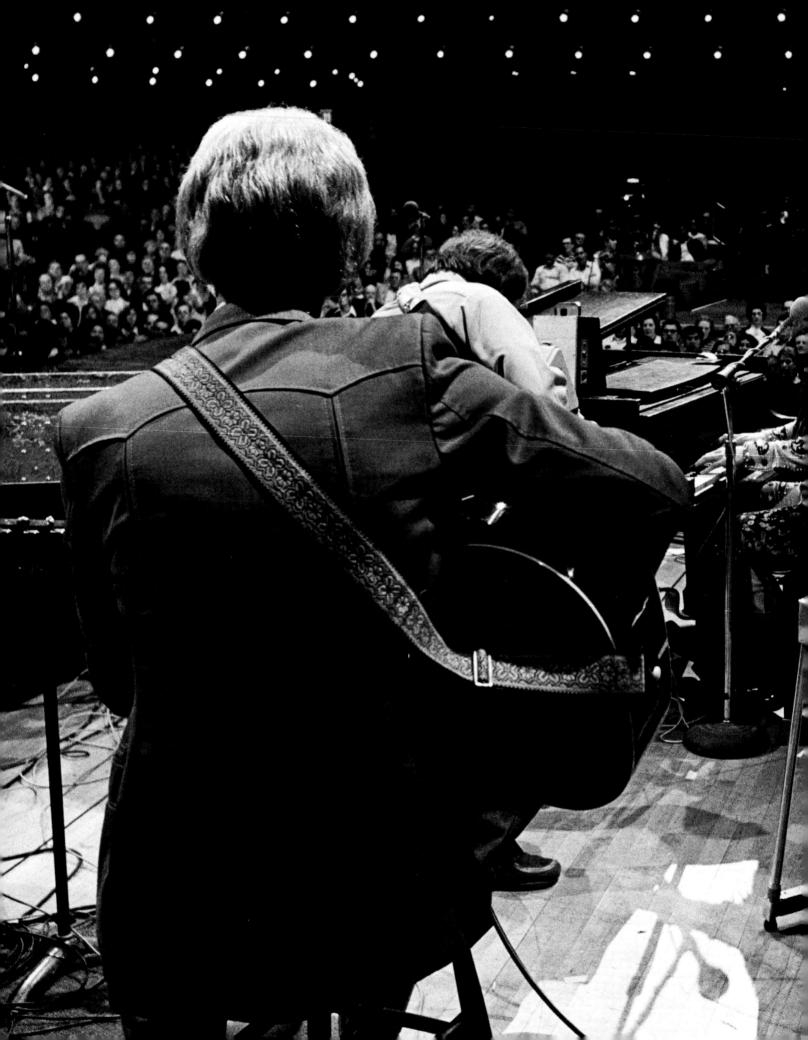

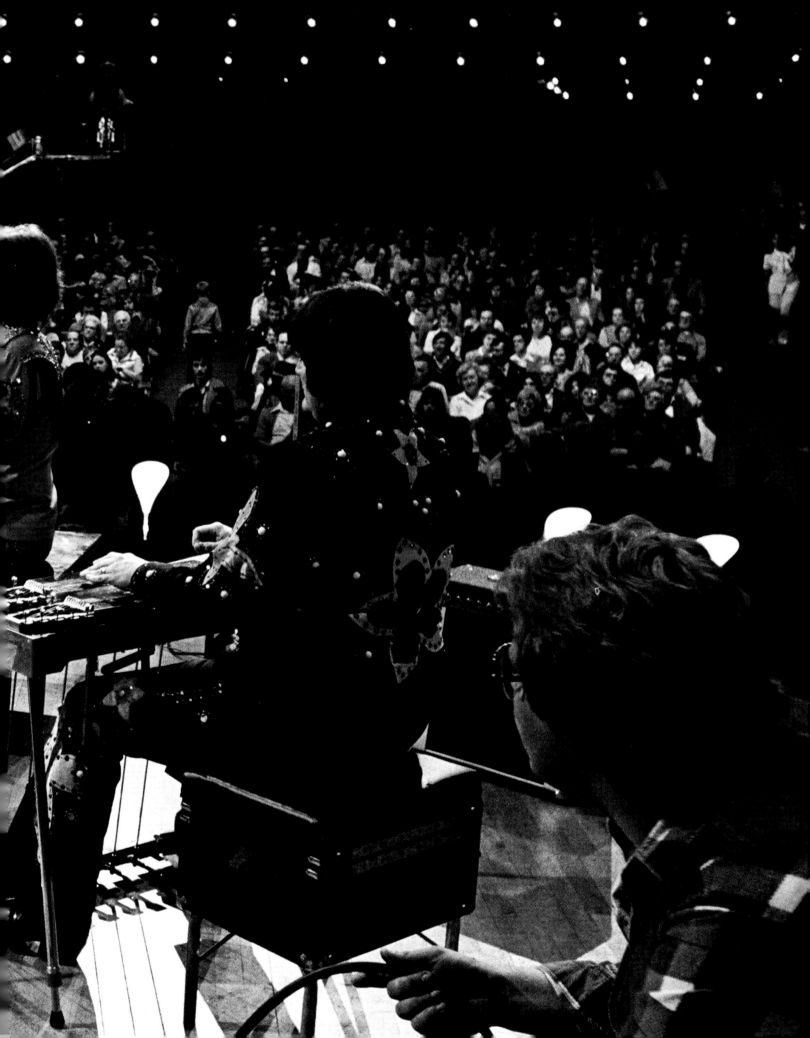

rior to 1978, a variety of television shows aired with "Opry" in the title. These productions included Opry talent, and most were staged at the Ryman, but they were not the Grand Ole Opry as it was performed and broadcast over WSM radio. It proved difficult to imagine how a radio show as loose and informal as the Opry would translate to television. However, when PBS staffers gathered at their annual convention at Opryland Hotel, they wondered among themselves if the Opry could possibly work as a one-time-only fundraising telethon. In doing so, the Opry could reach an audience that WSM-AM couldn't; PBS, in turn, could attract new donors who weren't interested in educational programming.

PBS and WSM reached an agreement, and Opry artists lined up to take part. The printed program from the broadcast on March 4, 1978, lists thirty-two names, from Del Reeves and Stonewall Jackson to Bill Carlisle and the Fruit Jar Drinkers. Connie Smith wowed the audience with "How Great Thou Art," Porter Wagoner sang a medley of hits in a purple rhinestone-studded suit, and new members Ronnie Milsap and Don Williams received rapturous responses. Roy Acuff, of course, balanced his fiddle on his chin and cheerfully bantered with Minnie Pearl, who wore a lime-green gingham dress for the occasion. Setting up a familiar joke for a new audience, Acuff said he'd heard from the band that something unusual happened to Miss Minnie as she arrived backstage that night.

"Well, it was awful!" she replied. "I started in back there and there was a fella come up to me and he had a gun in his hand and said, 'Give me

your money!' I said I haven't got any money. He frisked me up and down and he said, 'You haven't got any money, have you?' I said, 'No, but if you do that again, I'll write you a check!'"

As the crowd roared, Minnie scampered backstage and promptly situated herself on a stool between comedian Archie Campbell and announcer Grant Turner. "When television first came in, Roy Acuff and I begged WSM to just go ahead and to do it this way," she told Turner. "They told us that they couldn't at that time, on account of they said they couldn't get the voice levels and the instrument levels. But I watched the [beginning] of the show tonight and they were getting levels that were great! And all you fine folks that are listening and looking in at your home are getting the same kick that those fine folks are back there and didn't have to drive all that distance."

Extremely satisfied with ratings and fundraising totals, PBS aired three more annual Opry specials. For the 1979 edition, fiddle-playing US senator Robert Byrd of West Virginia performed "Turkey in the Straw" and "Will the Circle Be Unbroken," cheered on by Acuff and Minnie Pearl. At other Opry shows that year, Skeeter Davis introduced special guest Stevie Wonder to sing "Behind Closed Doors" on the Opry stage, and Loretta Lynn introduced Sissy Spacek, who would go on to win an Oscar for the film *Coal Miner's Daughter*.

On March 10, 1979, Porter Wagoner brought out his own special guest, the Godfather of Soul himself, James Brown, who was in town for a recording session. Brown held nothing back in his opening number, "Get Up Offa That Thing," which elicited screams from the crowd and

Public TV's festival '78
Join the celebration!

0:00 TONIGHT

LIVE FROM THE GRAND OLE OPRY

Minnie Pearl and Roy Acuff lead an all-star cast in the first live TV broadcast from Opryland! Two and one-half hours!

ALSO TONIGHT

7:30 THE MACNEIL/LEHRER REPORT
Public TV's in-depth news program focuses on the women's-rights amendment.

11:00 THE DICK CAVETT SHOW
A lively half-hour with Dean Martin and Jerry Lewis.

11:30 ABC EVENING NEWS
Captioned for the hearing-impaired.

COME TO PUBLIC TV'S SILVER ANNIVERSARY PARTY ON

CHANNEL 99 PBS

TO: CHANNEL 99, 78 Festival Street, Festival City, California

I would like to become a paying member of the Channel 99 viewing audience. Enclosed is my check for:

_____ $15 Regular Membership, includes a full year's subscription to the Channel 99 monthly magazine/program guide.

_____ $25 Special Membership, includes the 2 long-playing record set of THE VIENNA PHIL-HARMONIC, plus 1-year subscription to Channel 99 monthly magazine/program guide.

NAME

STREET & NO.

CITY/TOWN

STATE & ZIP

PREVIOUS SPREAD: Ronnie Milsap performs on the PBS televised Opry, March 4, 1978. THIS PAGE, CLOCKWISE FROM TOP LEFT: Advertisement for the Grand Ole Opry on PBS, 1978; Stevie Wonder and Skeeter Davis share smiles onstage, September 8, 1979; Senator Robert C. Byrd on the second PBS broadcast of the Opry, March 3, 1979; Loretta Lynn and Sissy Spacek pose together backstage, January 27, 1979.

168 WHO'S GONNA FILL THEIR SHOES

TOP: Porter Wagoner welcomes James Brown to the Opry stage, March 10, 1979. BOTTOM: James Brown at the Opry House. OPPOSITE: John Conlee performs wearing his signature rose-colored glasses, February 7, 1981.

almost certainly scandalized a few Opry stars. His fervent interpretations of "Your Cheatin' Heart," "Georgia on My Mind," and "Tennessee Waltz" were well-received, but the hardest-working man in show business didn't stop there. Backed by Wagoner's band, augmented with an organ, he delivered a medley of "Cold Sweat," "Can't Stand It," and "Papa's Got a Brand New Bag," riffs from "I Got You (I Feel Good)," and a finale of "Please, Please, Please." Wagoner praised him as "one of the greatest guests we've ever had" and asked him to encore with a little more of, as he called it, "Get Up and Get Off of It." The whole thing lasted just under twenty minutes, which was lengthy for an Opry debut.

"I went and talked with the people at the Grand Ole Opry and we were aware that there probably would be some people that would get their feathers ruffled. But I felt like it was a great thing for the Grand Ole Opry when you can get worldwide attention by something happening," Wagoner said in 1983. "That's what happened that night. There were people there from all over the world. Stories were carried in all the foreign countries, and every place worldwide: 'James Brown Appeared on the Grand Ole Opry.'"

A white supremacist group known as the Greater Memphis White Citizens Council did not share Wagoner's enthusiasm and fired off a letter to the Opry:

> *We consider it almost sacrilegious that the Grand Ole Opry stage (the last bastion of Southern white culture) should be open to soul singer James Brown as well as other blacks who are not a legitimate part of country music . . . We protest this infiltration of country music, which represents white*

roots–white culture. For, if blacks are allowed to move into country music, it will lead to its demise. What has made it special to white people will no longer exist.

In a firm response dated March 20, 1979, Opry general manager Hal Durham wrote:

Your letter concerning the recent appearance of James Brown on the Grand Ole Opry has been brought to my attention.

Since Mr. Brown's appearance represented neither an endorsement of his music by us, nor indicated any change in the direction of the Opry, one wonders why some were so affronted by it. The list of non-country acts that have appeared on the Opry is quite lengthy, and includes Perry Como, Dinah Shore, the Pointer Sisters, and Ivory Joe Hunter. We don't anticipate any change in this policy of occasionally introducing the non-country performers who are internationally acclaimed in their field.

Obviously, the Grand Ole Opry does not determine who enters the field of country music, nor did it ever. The Opry reflects, to some extent, the broad spectrum of country music, from the traditional sounds of the Crook Brothers to the modern music of Larry Gatlin and Barbara Mandrell. We have never considered the Opry the "last bastion of white culture." The Opry is a 53-year-old radio show that features country music (with occasional non-country guests). Nothing has happened recently to alter that fact, despite efforts by some who would create controversy where there is none.

When the Opry got around to inviting a new batch of members after five years, they chose five artists who offered five divergent styles of country music. John Conlee, a confident singer who gravitated to songs that, in his words, "tell a story and make a point," joined on February 7, 1981, followed by Boxcar Willie, B. J. Thomas, Ricky Skaggs, and Riders in the Sky.

Conlee had become so identifiable through his signature hit, 1978's "Rose Colored Glasses," that he often slipped on his own pair of rose-colored glasses when he sang it. Building upon that initial success with the hits "Lady Lay Down" and "Backside of Thirty," Conlee had accrued enough royalties to buy a farm outside of Nashville. One of his neighbors, who was a booking agent, recommended Conlee to Hal Durham as a potential Opry member. On the night of his debut, he was accidentally introduced by Jim Ed Brown

as John Thomas Conley (conflating the name with fellow hitmaker Earl Thomas Conley), but he enjoyed the experience all the same. Conlee played the Opry only two or three times before being asked to join. Four decades later, he's still a regular.

"When you were on Mr. Acuff's segment of the Opry, if you hadn't done your signature song—which evidently, I didn't do on one occasion—if there was time, he would a lot of times bring you back out to do it. He was a firm believer in doing the one that brought you to the dance," Conlee recalled. "So, he did that with me one night, and I happened to have my glasses with me. I said, 'Well, I'll do it if you'll stand here and wear them for me.' And he did. He stood beside me as I sang 'Rose Colored Glasses' with the glasses on his face, and that was a special moment."

Boxcar Willie, born as Lecil Martin, tapped into his audience through television and touring abroad. The former US Air Force pilot hosted a television program in Lincoln, Nebraska,

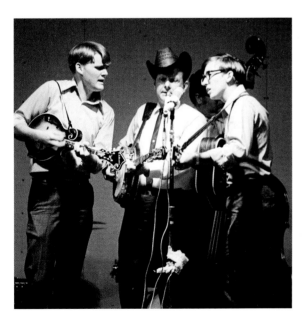

and took his stage name after spotting a hobo on a passing train who looked like a coworker named Willie. On a tour of the United Kingdom, audiences responded overwhelmingly to the persona. Encouraged by the response, he domestically marketed a 1980 album titled *King of the Road* through TV ads and reaped a sizable profit (though still dressed as a hobo). He joined the Opry on February 21, 1981, eight months after his debut.

B. J. Thomas came on board on August 7, 1981, after making it known publicly that he wanted to join. As a kid, Thomas attended the Opry with his father on a night when Hank Williams performed; he soon latched on to Williams's story and his songwriting. After watching a 1963 biopic based on the late singer's life, Thomas fell back in love with "I'm So Lonesome I Could Cry" and worked it into the sets when his band, the Triumphs, played the clubs around Houston.

When the Triumphs went into the studio to record their first single, Thomas was persuaded to sing "I'm So Lonesome I Could Cry" as the B-side. The original single didn't go anywhere, but Thomas's rendition of the country classic became a surprise pop hit in 1966. After keeping the momentum going with "Hooked on a Feeling" and "Raindrops Keep Falling on My Head," he earned a country crossover number one single in 1975 with "(Hey Won't You Play) Another Somebody Done Somebody Wrong Song" but struggled to hold on to the country audience. He then found his footing in gospel music, yet reconnecting with a mainstream audience wasn't far from his mind.

An April 1981 feature in *Record World* noted that Thomas had played the Opry for four

consecutive weekends the year before. "When I was a kid in Houston, my dad was a big Ernest Tubb and Hank Williams fan, and he tuned in to the Opry all the time. Being on the Opry would be like a dream come true to me for that reason," Thomas stated. "And it would also help me to establish without saying outright what I'm trying to do. I'm ready to get back to work." Four months after the piece ran, Thomas was inducted on his thirty-ninth birthday.

Thomas's career rebounded as hoped with back-to-back number one country hits in 1983. With a demanding tour schedule, his Opry appearances dwindled. In a letter to Durham, he wrote, in part, "Throughout this entire year I've been troubled about letting you and the Opry down. I feel that I have let myself down also. To have been associated with the legendary performers of the Opry was something special to me. And because it is something special to everyone in our business, I feel that I should advise you of my resignation. I never wanted to be a no-show member so I think this is best for both parties."

Roy Acuff, for one, noticed that some new Opry members were choosing lucrative road work instead of staying in town on Saturday night. After Ricky Skaggs's induction, Acuff pointedly remarked, "Guess you probably won't be coming around much anymore."

"He sure did," Skaggs remembered. "I said, 'Mr. Acuff, I'm going to make you eat those words.' With a smile I said it. Every time I would come to the Opry, I'd always go by his dressing room. He usually had the door open all the time, and I'd say, 'Hey, Mr. Acuff, I'm here.' 'Yeah, I see you.' Finally, it got to be, I'd walk by, and I'd look at

OPPOSITE: Future Opry star Ricky Skaggs and Keith Whitley when they were members of Ralph Stanley's Clinch Mountain Boys, c. 1972. Left to right: Ricky Skaggs, Ralph Stanley, Keith Whitley. ABOVE, BOTH: Ricky Skaggs visits Roy Acuff before Skaggs's first performance as a member of the Grand Ole Opry, May 15, 1982.

him and he'd say, 'Oh, go on. I know you're here.' So, yeah, I mean, he ate those words very well."

Skaggs's childhood unfolded almost like a map to the Opry stage. As a small boy, his family lived in a hollow called Brushy Creek, near Blaine, Kentucky. There was no electricity where his grandfather lived, so whenever Skaggs would come to visit, they would listen to the Opry together in a Ford pickup truck parked by the barn. Skaggs would drift off to sleep during the broadcast; when he was roused just before bedtime, the show was still going as the old truck headed back to the house.

When Bill Monroe came through nearby Martha, Kentucky, for a show, the unassuming six-year-old could hear some people in the audience shouting, "Let little Ricky Skaggs up and sing a song!" Finally, Monroe relented. Skaggs stepped onstage and Monroe offered his mandolin to the bony little kid, who impressively belted out "Ruby, Are You Mad at Your Man."

From there, Skaggs's dad got him up with the Stanley Brothers at a few Kentucky shows. Before long, the family moved to a suburb of Nashville in hopes of getting Ricky heard by the right people. His dad even talked his way backstage at the Opry, where Earl Scruggs noticed the little boy quietly playing a mandolin in the hallway. Scruggs asked Skaggs and his father to come audition for Flatt & Scruggs's television show. Both elder bluegrass musicians were clearly amused and pleased by this mandolin prodigy (even though Flatt flubbed his name as Ricky Scraggs during the taping).

As he matured, Skaggs rooted himself in bluegrass; in time, he would make a name for himself through touring and recording with Ralph Stanley, J. D. Crowe, and Emmylou Harris. His 1981 album yielded back-to-back number one country hits with interpretations of Flatt & Scruggs's "Crying My Heart Out Over You" and Webb Pierce's "I Don't Care." Ernest Tubb presided over Skaggs's induction on May 15, 1982.

"I never take it for granted that I'm a member here," Skaggs said. "I don't always like certain things, but I'm a member and I'm going to keep my foot planted firmly out here as a leader and as someone that holds a standard to the music, especially traditional country and bluegrass and gospel. It's all been a part of the Grand Ole Opry all these years. And as long as I live, I'll do my part."

Riders in the Sky have kept Western music alive on the Opry since their induction on June 19, 1982. Doug Green, known onstage as Ranger Doug, and Fred LaBour, better known as Too Slim, first met as neighbors in Nashville, though both had moved from Michigan. Green grew up with uncles who loved playing traditional country music; LaBour listened to the Opry as a kid in Grand Rapids, where he could get the WSM signal during the winter.

"I heard the Everly Brothers on the Opry, so I was probably nine years old. And then I heard, 'And here she is, Minnie Pearl!' and she said, 'Howdy! I'm just so proud to be here!' Oh my God, it was so electric to me. I said, 'I've got to go see that room where that happened.' It was the sound of the audience that just killed me. It was so vibrant and exciting to me. That was the beginning of my thinking of Nashville as Oz. It was like this enchanted city."

Green and LaBour decided to audition independently for musical productions at Opryland USA theme park. Neither one made the cut, but LaBour struck up a conversation with a fiddler, Paul Chrisman, who adapted his stage name to Woody Paul. Chrisman grew up near Nashville and had tagged along with Sam and Kirk McGee to Opry shows when he was around twelve years old. By August 1978, Chrisman, Green, and LaBour were turning heads in Nashville as Riders in the Sky. Roy Acuff was skeptical of their wily stage antics during their Opry debut in December 1978, but the group was asked back about twenty-five times before joining.

Green had been part of Bill Monroe's Blue Grass Boys, first as a guitarist in the summer of 1967,

then as a bass player in 1969. He'd also worked as a writer, editor, and historian at the Country Music Foundation, so he felt comfortable writing a personal letter to Hal Durham, asking to be considered as members. "He was not any great buddy, but he was a nice man, and I figured it was worth a shot," Green said. "I mean, we are different and we're funny. So, you're getting a comedy act and you're getting a completely different sound that is part of the country music tradition, the grand tree of country music."

Durham agreed. Riders in the Sky have since played more than two thousand Opry shows.

Riders in the Sky— Too Slim, Ranger Doug, and Woody Paul— congregate backstage with Opry manager Hal Durham and Ernest Tubb on the night of their induction, June 19, 1982.

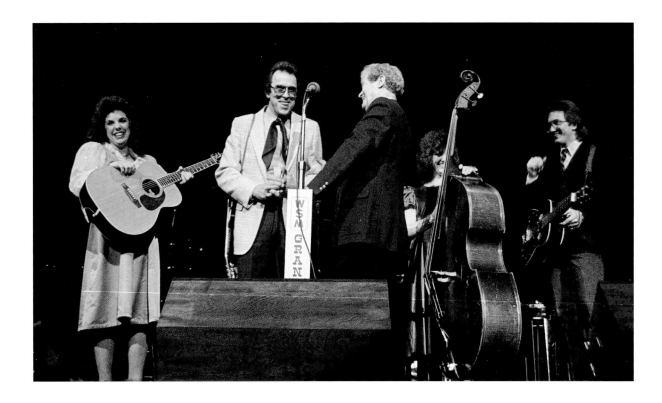

With more than four decades of exemplifying "the cowboy way," they still love to hear themselves introduced to the stage as members of the Grand Ole Opry.

"I always like to get here early, so I have plenty of time to get settled in and feel like I can pull a straight bow," Chrisman said. "But it's different from any other gig. When I'm going to the Opry, this is it. This is a big deal, and I know I'm going to mess it up. And I do mess it up quite often."

———————

For the first time in a decade, the Opry added women to the cast, bringing in the Whites and Lorrie Morgan in 1984. Both artists had strong family ties and a reverence for the Grand Ole Opry.

Burned out as a local musician, Buck White and his wife, Pat, moved their family from Texas to the outskirts of a small town in Arkansas in 1962. He worked as a plumber, then returned quickly to performing when he made some musically inclined friends in the area. Cheryl and Sharon White, the two oldest daughters, soon started singing with the adults onstage. When the family traveled to their first bluegrass festival, they made a stop in Nashville to see the Opry.

Heading back to Arkansas from another bluegrass festival in 1971, Sharon and Cheryl told Buck, "Dad, if you're ready to move, we are." He put a FOR SALE sign in the front yard that same night before the car was unpacked. While Pat

looked for a place to live on their first night in Nashville, Buck, Cheryl, and Sharon headed to the Opry, where Bill Monroe helped them get in. The show played a major role in the family's life from that point forward.

"That's why we came. I don't think I had dreamed deep enough about the Opry at that time," Cheryl said. "Daddy, I think, did. When he saw that we were really learning and that we were passionate about it, I think he had a dream, but I didn't at the time. We just loved to go, and the place we'd listened to on the radio so many times, we're finally seeing it! We went a lot, too."

Touring and recording as Buck White & the Down Home Folks, with Buck on mandolin, Sharon on guitar, and Cheryl on bass, they even auditioned for a spot at Opryland USA at one point. Roy Acuff, who was among the judges that day, told them their music didn't belong at a theme park. He intended it as a compliment to their musical versatility, but they went home disappointed.

Still, they hustled. At a tour date in Washington, DC, they met Emmylou Harris, who admired the White sisters' singing and hired them for recording sessions and tour dates. Ricky Skaggs and Sharon White, who had become friends on the bluegrass circuit, married in 1981, just as both of their careers were about to break. Buck and his daughters then rebranded their group as the Whites and landed their first Top 10 hit, "You Put the Blue in Me," in 1982. The Whites earned a Grammy nomination for the single, and started getting more and more calls from the Opry.

Sharon recalled the night backstage that announcer Hairl Hensley had been feeling out whether Buck might like to be a member: "Daddy said, 'Well, how do you do that?' Hairl said, 'Wait right here.' He ran and got Hal Durham. Then Hal was questioning him, and Daddy said, 'Wait, let me go get my girls!' He wanted us all to be standing there to hear it, and we were just floored." Roy Acuff happily presided over their induction on March 2, 1984, telling them this time, "Y'all are the kind of people we need out here."

Lorrie Morgan was also no stranger to the Grand Ole Opry House hallways after her father, Opry member George Morgan, died in 1975. In fact, she nearly wore out her welcome with the Opry management.

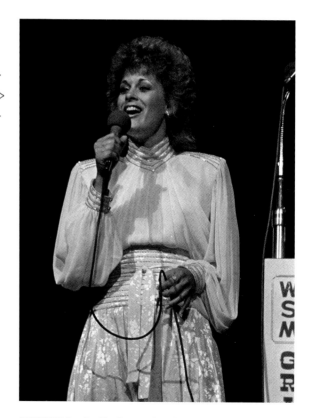

OPPOSITE: Roy Acuff welcomes the Whites—Sharon, Buck, and Cheryl—as Opry members while dobro player Jerry Douglas watches, March 2, 1984. ABOVE: Lorrie Morgan performs for the first time as a new member of the Grand Ole Opry, June 9, 1984.

"After my dad passed away, I was at this back door in Hal's office, knocking every couple days of the week. It seemed like every day. My mom said it was every day. Hal said it was every day, but I think I had a better life than just here every day. I don't know," Morgan remembered. "But I would come in and I would cry. I would say, 'Hal, y'all call me every time somebody cancels out here. I'm here on the Opry stage. I'm here when I'm not needed. I'm here when I'm needed. The Opry is about loyalty and it's about believing in the Grand Ole Opry. Why won't you . . . ?' I mean, I would *cry*, and he would say, 'Just give it a little time, Lorrie, give it a little time.'"

Morgan's sultry alto and poised stage presence complemented the classic country songs she sang as a guest at the Opry, yet she'd been making her own way in the Nashville music industry, too. Prior to her induction, she appeared on a local morning show hosted by Ralph Emery, toured with George Jones as a backup singer, and wrote songs for Acuff-Rose Music, where she worked as the receptionist. A few independent singles had faltered, but a new label deal with MCA held potential.

Right after she received an award nomination for Best New Female Vocalist from the Academy of Country Music, it was Hal Durham's turn to reach out. Morgan remembered that she dropped the phone when he finally said he was ready. At twenty-five years old, she was inducted by Bill Anderson on June 9, 1984. When her MCA deal fizzled out, she was also the rare Opry member without a hit song. Five years would pass before a new contract with RCA would make her one of country music's most popular stars.

Another longtime figure at the Opry came on board that summer. As a Ryman Auditorium employee beginning in the early 1970s, Tim Thompson's duties included managing Opry attendees lining up on Fifth Avenue, locking up the ticket office after shows, and shooing away the drunkards on Lower Broadway who would rattle the doors late at night. After the 1975 flood at the Grand Ole Opry House, he pitched in to help preserve photographs and soaked newspaper clippings. During those efforts, he got acquainted with some Opry House employees and soon took a job as an Opry staff supervisor.

Thompson became a familiar face around the Opry after that. His 1980 wedding was the first to take place on the Opry House stage. From the audience, he watched George Strait's one and only Opry appearance on October 9, 1982, just a few years into the singer's extraordinary career. Because he'd struck up a professional rapport with Hal Durham, Thompson asked him why Strait wasn't a member. Durham replied that he'd floated the idea to Strait's manager, but was told that because Strait lived in Texas, he couldn't commit to the number of required appearances.

When an Opry stage manager position came open in June 1984, Durham and Jerry Strobel, the Opry's public relations director and Opry House manager, wondered if Thompson was interested. He didn't have any stage experience, but Durham and Strobel knew that the Opry cast members liked him. Thompson thought about it and agreed to give it a shot. On his first night on the job, the stage manager who was supposed to train him called to say he couldn't make it. He casually told Thompson, "You'll be fine. You can do it."

"So that was my training. It was to get out there and do it. And I knew nothing about the microphones. I didn't know which one was which, but it didn't take me long to learn what was what," Thompson said. "The Opry setup was a little simpler in those days than it is now, and what it became through the years, but pretty much it was, 'It's out there, go plug in and play.'"

The Opry cast certainly kept Thompson on his toes. Roy Acuff might need an introduction to the stage at a matinee as Grant Turner was scaling back his time at the Opry. Loretta Lynn often walked up to him and asked, "What song am I singing?" Grandpa Jones complained when Thompson told him he'd have to stretch for time (and that was only if his faulty hearing aids would allow him to hear the request in the first place). Always running late, Dottie West would leave her car idling at the canopy and scurry behind Thompson to get to the stage. They both knew if she was scheduled for Hank Snow's segment, he would not stall.

Fortunately, Thompson easily interacted with artists who were decades older. He'd gone to school with some of the Opry members' kids, so he didn't have stars in his eyes. A steady presence backstage, he stayed on as a stage manager through his retirement in 2015, weathering the changes in management, set designs, and musical styles, as well as the deaths of Opry greats, including Lester Flatt in 1979, Marty Robbins in 1982, and Ernest Tubb in 1984. Because these three members' styles had ranged from bluegrass to Western to honky-tonk, their very presence on the Opry stage practically guaranteed a well-rounded show, even as the show and its audience continued evolving.

A merger between two insurance companies, valued at $1.5 billion, cast a shadow on the future of the Grand Ole Opry, along with Opryland Hotel, Opryland USA theme park, WSM-FM, WSM-AM, and a country music-themed cable network that had yet to launch. Nashville Life and Accident Insurance Company, the parent company of the properties, had reorganized into a holding company, NLT Corporation. Houston-based insurance holding company American General Corporation ended a hostile takeover bid and merged with NLT in November 1982. However, the American General Corporation only wanted the insurance-related assets. They had no interest in hospitality or entertainment.

Into this uncertain environment, TNN: The Nashville Network went on the air on March 7, 1983. Public and private investors circled the hospitality and entertainment entities for months, though the bid ultimately went to Gaylord Broadcasting Company for a reported $250 million. Edward Gaylord, head of the Dallas-based media company, enjoyed country music entertainment; his company also syndicated *Hee Haw*. The name of the portfolio changed from WSM, Inc., to Opryland USA, Inc., when the deal was completed in September 1983.

Even though TNN and the Opry were now both owned by Gaylord, it took roughly eighteen months of conversations to bring a live version of the show to the network. Some executives felt that if the Opry aired live, fans would be less likely to buy a ticket. Finally, on April 13, 1985, a one-hour Opry segment aired live on TNN. A thirty-minute portion was broadcast live in subsequent weeks.

Later that summer, Opry management hired Steve Buchanan as the first marketing manager in the show's sixty-year history. Moving to Nashville in 1975 to study environmental engineering at Vanderbilt University, Buchanan signed up for the Vanderbilt Concert Committee, which brought live music to campus. As he interacted more and more with the music industry while marketing the shows, he reconsidered his career trajectory. Upon graduation, he was hired by Buddy Lee Attractions, the talent agency that booked Bill Monroe, Porter Wagoner, and other veteran performers. A few years later, he re-enrolled in Vanderbilt, and he earned an MBA in 1985. The marketing manager role had been open for a year when he applied; after multiple interviews with Hal Durham, Buchanan accepted the position.

Going to an Opry show in 1985, the audience would almost certainly have a chance to see the stalwarts, such as Grandpa Jones, Minnie Pearl, Bill Monroe, and Hank Snow. Roy Acuff even moved into a house built for him on the Opry property in 1983, the year he turned eighty. A recent widower, he became a daily presence in the corporate office. Every morning and afternoon, he would come by for coffee and conversation. Occasionally, someone from the office would drive to a nearby Sam's Club to buy his favorite foods, such as orange slices candy or deviled eggs.

Buchanan could sense that some of these aging performers still wanted to deliver an experience not unlike the heyday of vaudeville. "Roy used to talk about it in the sense that one minute you have them belly-laughing, and then the next minute you have them weeping," Buchanan recalled. "And they regarded the fact that it was

their responsibility to portray this full range of what was a show."

There was no marketing budget to speak of, so Buchanan worked proactively. Almost immediately, he instituted an internal awareness campaign for the Opry's anniversary month, trying to inject some enthusiasm among corporate staff. He also recognized that Opry attendance relied on theme park attendance and convention business from Opryland Hotel. Hoping to attract families to the Opry throughout the year, he made it his mission to "create demand and appeal."

From the start, Buchanan worked closely with Durham and considered him a career mentor. He noticed that Durham tried to appease the elder members who felt that the affiliation with TNN was overshadowing the Opry's history with WSM-AM. These members had essentially dedicated their careers to the Opry during a time when management diligently kept track of Saturday night appearances, with threat of dismissal for missing too many shows. But those consequences were no longer enforced, so members who could make more money on the road were doing so. As a result, Opry lineups of the 1980s depended heavily on the country stars popular in the 1950s and 1960s who were used to the old way of things around the Opry House.

George Jones touched a nerve with a 1985 single titled "Who's Gonna Fill Their Shoes?" In hindsight, there was no cause for alarm when he wondered in the chorus, "Who's gonna play the Opry?" Nearly all the new members from the early 1980s have maintained close ties with the show, namely John Conlee, Ricky Skaggs, Riders in the Sky, the Whites, and Lorrie Morgan.

Johnny Russell, the 1985 inductee best known for writing "Act Naturally," and Mel McDaniel, the 1986 inductee famous for "Baby's Got Her Blue Jeans On," also remained active for the rest of their lives.

Another small but mighty cadre of singers from the mid-1980s should have calmed anyone's concerns that the proverbial shoes would not be filled. Reba McEntire was revealed as the Opry's newest inductee during a sixtieth-anniversary CBS taping on November 21, 1985; the special aired on January 14, 1986. Rather than selecting a flashy, upbeat number, she sang "Somebody Should Leave," a ballad about an impending divorce complicated by child custody. Country radio stations still played the mainstays who didn't adhere to traditional country, such as Crystal Gayle, Ronnie Milsap, and Kenny Rogers. However, industry awards now went to the Judds, McEntire, Skaggs, Strait, and newcomer Randy Travis, who all kept it country.

Less than a year before joining the Opry, Travis worked as a cook and dishwasher at the Nashville Palace, a medium-size music venue and bar across the street from Opryland Hotel and the Grand Ole Opry House. His manager, Lib Hatcher, had discovered Travis, then a troubled teenager, singing in a North Carolina nightclub she was managing. She moved to Nashville with him in 1981 and took a job managing the Nashville Palace. When her protégé wasn't stirring or scrubbing in the back, he was singing onstage as Randy Ray, a riff on his given name, Randy Traywick. He'd landed a couple of guest slots on TNN shows, including singing "I Told You So" on Ralph Emery's *Nashville Now*, but wider recognition eluded him.

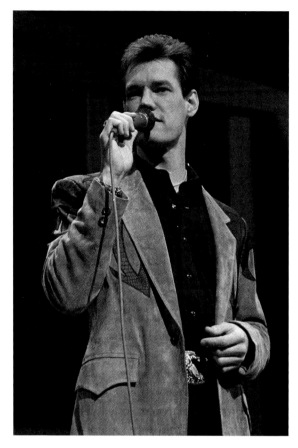

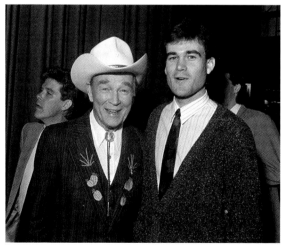

TOP: Randy Travis onstage during his induction night at the Opry, December 20, 1986. BOTTOM: Roy Rogers poses backstage with Steve Buchanan on January 27, 1989.

Martha Sharp, an A&R executive for Warner Bros., eventually agreed to see one of his performances at the Nashville Palace in late 1984. Although the label (and many others) had previously turned him down, Sharp could see something in him. She signed him to Warner Bros., changed his surname to Travis, and started looking around for material. His album *Storms of Life* resonated with an audience hungry for traditional country music, especially with strong singles such as "Digging Up Bones," "On the Other Hand," and "1982." Released in June 1986, the project sold one million copies in less than a year, making him the first country artist to reach platinum with a debut album. His breakout year concluded with an Opry induction on December 20, 1986, just nine months after his first appearance on the show.

"You know, this is probably one of the biggest, happiest nights of my life, to tell you the truth," a beaming Travis told the audience. "It's been an honor just to be able to come backstage and be around some of the great people here at the Grand Ole Opry. People that I've admired for a lot of years, and admired their music and loved their music. And it's hard to explain how good it made me feel to be asked to be a member of the Opry."

A versatile instrumentalist and song stylist, Roy Clark accepted his Opry membership on August 22, 1987. The good-natured country star found radio success with sentimental songs such as "Come Live with Me" and "Yesterday, When I Was Young," but could still make audiences chuckle with "Thank God and Greyhound." Clark maintained his home base in Oklahoma and had declined past overtures about becoming a

member. After his recording career cooled, he set his Opry appearances around filming schedules for *Hee Haw*, which was then taped inside the Opry House complex.

The Opry's oldest and longest-tenured member at that time, Herman Crook, died on June 10, 1988. At eighty-nine years old, he was one of the Opry's last links to the 1920s; the Crook Brothers joined the cast in 1926. Joking with audiences over the decades, he would remark, "I've never taken a drink of beer or whiskey in my life. I never smoked a cigarette, never used curse words in my life, but I'm a Crook."

In an interview for the Opry's sixtieth anniversary special, Crook said he had no regrets about his time on the Opry, but made it clear he didn't like having drums onstage: "The Opry has changed quite a bit. It's not supposed to change. Country music doesn't change. George Hay would never have allowed drums. I wouldn't have a drum because of all that racket and noise."

Crook's resistance to change was understandable; however, the key to the Opry's longevity had always been balancing traditional and contemporary country music.

For example, Ricky Van Shelton joined the cast on June 10, 1988, just a year after his debut, when he earned a standing ovation and an encore with "Somebody Lied," a ballad that showed off his vocal range and traditional country bent. Over the next five years, he notched seventeen Top 10 singles, including a reverential remake of Jack Greene's 1969 hit "Statue of a Fool." Greene assisted Roy Acuff with Shelton's induction. At the microphone,

the young singer took off his signature white hat in deference. Shelton made his final Opry appearance in 2004, two years before retiring to his hometown in Virginia.

Patty Loveless also earned an encore at her 1986 debut with "I Did," a breakup song she wrote when she was just fifteen. Some in the Opry cast remembered her as Patty Ramey, the young woman who came backstage as a guest of Porter Wagoner in 1971, or later as the "girl singer" for the Wilburn Brothers. After marrying that duo's drummer, Terry Lovelace, and settling in North Carolina, she fronted cover bands, singing anything from Linda Ronstadt and Bonnie Raitt to Journey and Donna Summer. When she started getting requests for songs by the Judds or Randy Travis, she called her brother in Nashville because she didn't recognize the names. He informed her that traditional country music was coming back around. Record labels were even looking for it. Ditching rock 'n' roll for good, she adjusted her former married name of Lovelace to Loveless and decided to chase her dream once again.

The Opry audience's response to "I Did" was undeniable; Loveless sang it again for her encore. However, MCA Records had signed Loveless to a singles deal. Looking at the bottom line, the label yanked "I Did" from radio promotion because there was no accompanying album ready to sell yet. Loveless understood the decision but floundered for a couple of years until a 1988 remake of George Jones's "If My Heart Had Windows" sent her into the Top 10 for the first time. The Opry seized the opportunity to induct her. She joined on June 11, 1988, a day after Shelton's induction.

"I do remember that when they called me in to ask me if I wanted to be a member, I said, 'Honestly? Really? Are you kidding me? Yes! Yes!' I just couldn't believe it was happening, because after all those years of coming to the Opry, and seeing the excitement out here, and the love that was given from the audience and from the artists . . . Just to be accepted into this family—I've been so blessed to be a member of the Opry because they always got your back. No matter what, they always got your back," Loveless said.

ABOVE: Porter Wagoner inducting Patty Loveless as an Opry member, June 11, 1988.

In the summer of 1990, Roy Acuff, Bill Monroe, and other Opry stars boarded a chartered jet bound for Houston, where President Bush was hosting the sixteenth G7 world economic summit. Along with a rodeo and barbecue dinner, the summit offered international leaders a Sunday night staging of the Grand Ole Opry in the Astroarena. TNN documented the show for a one-hour special, which also featured Loretta Lynn, Charley Pride, and Larry Gatlin and the Gatlin Brothers singing their signature songs. Minnie Pearl delivered a hearty "How-DEEEE!" (followed by a "Bonjour," "Ciao," "Konnichiwa,"

and "Guten tag"), and Acuff got the crowd clapping along to "Wabash Cannonball." After a cast performance of "I Saw the Light," President Bush emerged from the barn backdrop to personally express his appreciation.

Meanwhile, back on the Opry stage, Acuff had taken a special interest in two new members: Holly Dunn and Mike Snider. Acuff welcomed Dunn as an Opry member with a backstage kiss on the cheek; her parents and brothers smiled

Hal Durham discussing the Opry's participation in the Economic Summit of Industrialized Nations in Houston, Texas, c. 1990. Left to right: Loretta Lynn, Bill Monroe, Durham, Charley Pride, and Minnie Pearl

and shared in the photo op. As a small child, Dunn was mesmerized by a concert of Opry stars in her hometown of San Antonio. Two weeks after college graduation, she moved to Nashville to pursue a career in country music. She reached the Top 10 in 1986 with the self-penned "Daddy's Hands" and joined the cast on October 14, 1989, two months after she notched her first number one hit, "Are You Ever Gonna Love Me."

Similarly, Acuff had befriended banjo picker Mike Snider, the pride of Gleason, Tennessee. Inspired by Earl Scruggs, Snider received a banjo from his parents for his sixteenth birthday; he barely put the instrument down for the next seven years. In 1983, he sneaked away to Winfield, Kansas, with his new wife, Sabrina, and won the prestigious National Bluegrass Banjo Championship. At a church potluck celebrating the surprise victory, everybody signed a letter to Roy Acuff, asking him to give their hometown boy a chance to perform on the Opry.

Acuff responded through a newspaper article about Snider's win, stating, "If Hal Durham puts Mike on the Opry, I'll be more than happy to introduce him. I'd love to work with him onstage and hear him play. He must be highly thought of to have that many people behind him."

The Bank of Gleason president also wrote to a *Tennessean* columnist looking for a way to get Snider's story in front of the Opry folks. Soon enough, that letter ended up on Bud Wendell's desk. In addition, over the Thanksgiving holiday, Snider met and picked a few tunes for Gordon Stoker, a Jordanaires member whose brother lived in Gleason. Stoker said he'd put in a good word. Taking it all in, Wendell had an unusual

idea: What if the Opry gave away tickets to the entire town of Gleason during a slow Saturday night in January? In a memo to Durham and Jerry Strobel, he scribbled, "The press would eat it up I expect."

Wendell was right. An NBC affiliate in Memphis picked up the story, which got the attention of an Atlanta station and producers of *NBC Nightly News*. Within two days, Snider's friends and family snapped up fifteen hundred free Opry tickets from the county courthouse. With money from community fundraising, they piled into chartered buses to catch Snider's debut on January 21, 1984. From the Opry stage, Acuff gushed over the blushing banjo champion. Naturally and disarmingly funny, Snider continued to make numerous TNN appearances over the next six years, eventually hosting his own show for the network about fairs and festivals. He became the first new member to join in the 1990s, inducted by Minnie Pearl on June 2, 1990.

With a grin, Snider said he considers himself the most obscure member of the Opry, yet he's probably played the Opry at least four thousand times since his debut in 1984. His mix of down-home humor and instrumental skill wins over the audience nearly every time. "Somebody asked me one time, 'Are you a banjo player or a comedian?' I said, 'It depends on whether they're laughing or not.' And that's pretty much it," Snider said. "I'll go out there and hit them with a couple. If they're just non-revivable, I'll cover up with the banjo. But I like to do both. I like to play good music and hear them laugh, too."

By the time of his induction, Snider had proven himself to be a favorite with live audiences,

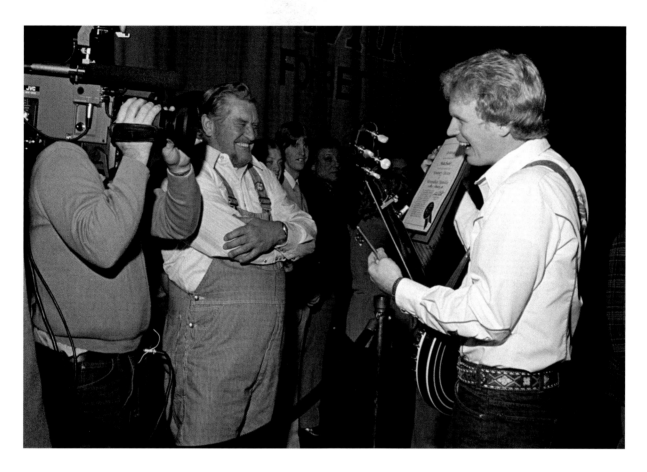

TNN viewers, and the Opry legends backstage. However, unlike most of his fellow members, Snider didn't have a hit record. As radio programmers turned their attention to a fresh generation of country stars who were selling millions of albums, Opry lineups rarely reflected what was happening on the weekly country countdowns. As Opry management considered their next move, and perhaps even the next inductee, there were suddenly dozens of young new artists to choose from, with a few on the cusp of superstardom.

GRAND OLE OPRY.

Saturday January 21
6:30 p.m.

SPECIAL GUEST
MIKE SNIDER

No 2485

General Admission - Balcony

ABOVE: Mike Snider smiles for the news cameras on the night of his debut while Boxcar Willie looks on, January 27, 1989; one of 1,500 free Opry tickets provided to the town of Gleason, Tennessee, for Mike Snider's debut performance. OPPOSITE: Roy Acuff looks on after fulfilling his promise to introduce Mike Snider on the Opry, January 21, 1984.

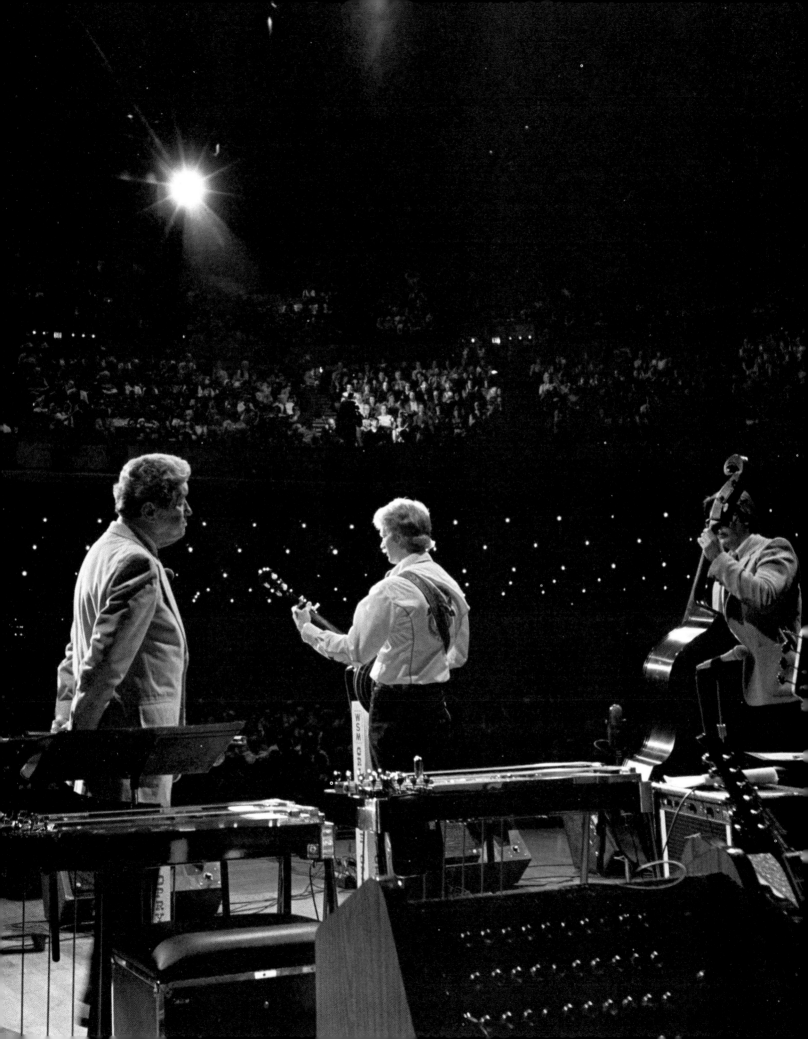

COMEDY IN THE SPOTLIGHT

TOP: Studio portrait of Stringbean wearing his costume, January 14, 1965. BOTTOM: Cousin Jody (the stage name of James Clell Summey) performs a comedy routine with Hank Snow on the set of a Purina-sponsored Grand Ole Opry Christmas special, December 9, 1955.

THE OPRY IS A FUNNY THING. And it has been from the start. With a mix of banjo picking, comic routines, and undeniable showmanship, Uncle Dave Macon brought a boisterous vaudeville flair to WSM's barn dance since its inception, way back in 1925. Sarie & Sally, a sister duo, charmed audiences with skits performed in the characters of two old mountain women on a daytime show on WSM-AM in 1934; their piles of fan mail helped them parlay their popularity into Opry membership. Blackface comedy, now recognized as a harmful racist tradition in American entertainment, was part of the Opry through performances by the duo Jamup & Honey (and their predecessor Lasses & Honey) into the early 1950s.

When string bands prevailed on the Opry, one of the musicians might play the part of comedian, too. In 1939, resonator guitar (dobro) player Bashful Brother Oswald (aka Beecher "Pete" Kirby) took on the role in Roy Acuff's group, the Smoky Mountain Boys. Oswald replaced dobro player Clell Summey, who later became known for his own comical character, Cousin Jody. David "Stringbean" Akeman, who was Bill Monroe's first banjo player, signed on as Opry member in 1945. Belting his pants just above the knees, and then tucking in his lengthy striped shirt, Stringbean used his wardrobe to make an audience chuckle before he ever strummed a note.

Characters like Stringbean were common on the Opry stage by this time. Sarah Ophelia Colley concocted a winning personality as Minnie Pearl, the stage persona that would become an integral part of the Opry cast in 1940. Over the next few years, the Duke of Paducah (aka Whitey Ford) and Rod Brasfield each played the part of a rube on the Opry's thirty-minute Prince Albert–sponsored segment carried by NBC. Lew Childre, a well-established comedian whose moniker was "That Boy from Alabam," joined the Opry in 1945 and often worked alongside Stringbean. The old-time banjo player known as Grandpa Jones adopted the elderly look for his character despite being just twenty-two years old. Born

CLOCKWISE FROM TOP LEFT: Bashful Brother Oswald, who often played a comedic role in Roy Acuff's Smoky Mountain Boys, poses with band members Rachel Veach, Acuff, Velma Williams, and Jess Easterday and Lon Wilson, who are tickling his feet in comically large shoes, early 1940s; Early Opry stars Sarie & Sally, portrayed by sisters Edna Wilson and Margaret Waters, perform one of their comedy acts in the WSM studios, mid-1930s; Minnie Pearl, the enduring character created by Sarah Ophelia Colley, performs on the Grand Ole Opry stage, c. 1950; Mississippi's Jerry Clower entertains the Opry audience and Roy Acuff with his tales of the antics back in his hometown; Archie Campbell, Tennessee Ernie Ford, and Minnie Pearl perform on a WSM-TV set, March 2, 1961.

CLOCKWISE FROM TOP: Musical comedic duo Lonzo & Oscar at the Opry microphone; Ferlin Husky in costume and demeanor of alter ego "Simon Crum" as part of WSM's Pet Milk Show, April 20, 1956; comedian Henry Cho on the Opry stage; June Carter, who grew up idolizing and emulating Minnie Pearl, cuts up onstage while guitarist Ray Edenton and bass player Lightnin' Chance back her up. FOLLOWING SPREAD: Minnie Pearl's handwritten notes for comedy routines

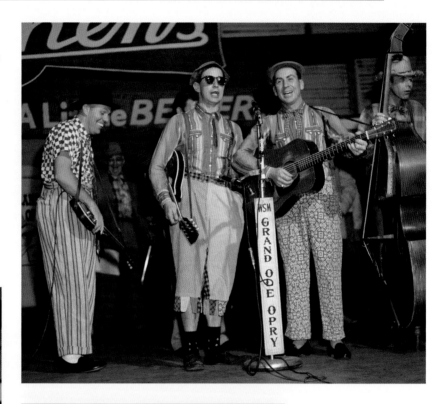

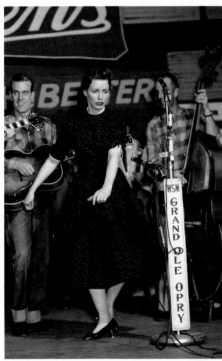

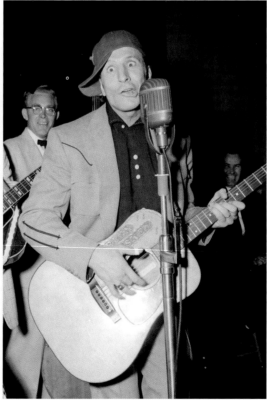

Louis Marshall Jones, he was inducted into the Opry in 1946. A year after that, the Opry added comedy duo Lonzo & Oscar, whose signature novelty hit was "I'm My Own Grandpa."

Additions to the cast in the 1950s brought even more comic relief: June Carter, the silly and often off-key member of the Carter Sisters; Jumpin' Bill Carlisle, who wrote and sang "Too Old to Cut the Mustard"; Simon Crum, the amusing alter ego of Capitol Records artist Ferlin Husky; and Archie Campbell, who brought his wise-guy, cigar-chomping character to the Opry.

Cracking up audiences with the tales of Amite County, Mississippi, former fertilizer salesman Jerry Clower was welcomed as an Opry member at Ryman Auditorium in 1973. After the show moved to the Grand Ole Opry House, new inductees Riders in the Sky, Roy Clark, and Mike Snider were primarily recognized for their musical talent, though comedy remained a centerpiece of their acts. In the 1990s and 2000s, legacy members such as Little Jimmy Dickens, Johnny Russell, and Jeannie Seely consistently delivered perfect one-liners and humorous anecdotes during their time in the circle.

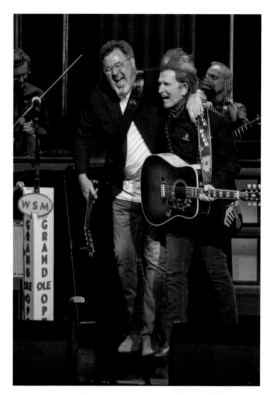

On January 6, 2023, Marty Stuart got the last laugh at the end of a Facebook Live chat with Henry Cho and Gary Mule Deer. After leading a conversation about comedy at the Opry, Stuart stunned them both with an invitation, making them the first comedians to join the Opry cast in fifty years. Rising and established comics alike have stepped into the Opry circle in recent years, ensuring that the Opry continues to offer a well-rounded show focused on entertainment more broadly, and that appeals across generations.

Speaking about his own Opry experience, Mule Deer says, "It's like a big family getting ready to go out for dinner. We can't wait. Everybody's just right on top of it. Out of my sixty-some years doing comedy, it's still the greatest feeling to walk out there to that audience. It doesn't get any better than this."

TOP: Vince Gill embraces veteran comedian Gary Mule Deer during his Opry induction, March 10, 2023.
BOTTOM: Comedian Henry Cho performs stand-up on the Opry stage, November 10, 2023.

AH'VE FINISHED READIN' THE CATALOG
SO WRITE SOON!

Note

Purtiest houn
Dog - Half pointer
+ half setter -

Bro made awful
mistake - Ata
whole box of
mothballs - was
thought they was
Candy - jva

Hippie can't hold
out forever -
he wont live
that long

I got a dog that
grows a parrot
that swears a g
fireplace that
smokes + a old
tomcat that stay
out all nite
should I get marrie

don't get around much anymore

Should have
hung his
over the door
I tried that
what hap,
They kissed
the door -

Any way were awfully
glad to have you here
with us - Have a
nice trip over?
come on bus - crowded
- way squeeze you on
- these busses - it's
wonderful!
Had unpleasant incident
xerless - family resemb-
wooden bey some one
isnt there you orter
browse here you know -
know - yes that handsom

sey shoes? what's
shoes? & the
feller sey these
here are shoes —
you put em
on your feet
& walk around
sez yeah? is that
right — then what
happens? Heart
Tuesday

unc & aunt —
she's a back seat
driver — had
laryngitis couldn't
drive above a
whisper —
& crossin — now
you git your
half across —
aint gonna
be much of a
party —

Bro a inventer
— unc come over
what's gadget —
put a nickel in
& you'll git a
new wife —
never be a
success sonny
what

unc co
with a
tell ab
mand
a hour
fifteed
to one
plaster
& he lif
the
nose til
— but he
fun — e
the sne
blows —
& she
Dove g
without

Mother's Day—
Whittaker Stabl
last year —
Miranda when
me & you got
married up
under that
grape arbor
Shore warn't
aimin to start
all this

P.A. may
all '59

[faded text]
Theres
real little
s you
t is bad
he —
Im play
ke duckin
in the
und
t you

h — season to love
feller men — I do
love fellers & love
em!
last year no good
shoppin for a
missletoe —
es foot
letoe
stood & stood
toe — Nobody
a tear
in my shut—
one look it
— run back

What do with it
if he caught it —

Carmen Miranda

Road block — Tom Parker

Bizness for myself

baseball job Delivering papers
player, kin hit bat
inventor whick

awkward income
too poor to paint bracket
proud Whitewash
grapefruit on garbage
journey proud

night
nickel

THE NEW TRADITION

1990
—
1999

As a brand-new artist with his first radio hit, Garth Brooks held it together pretty well at his Opry debut on June 24, 1989–that is, until Johnny Russell came over. After singing "Much Too Young (To Feel This Damn Old)," Brooks stood thunderstruck onstage. "So, this is the Grand Ole Opry?! Yeah, I can handle this," he said as he scanned the balcony. "It's very nice. Is anybody out there as scared as I am, by any chance? It would help a lot."

To conclude his two-song set, he previewed his next single, a philosophical ballad titled "If Tomorrow Never Comes." Tipping his hat to the audience and heading toward the wings, Brooks spotted Russell, the segment host, beckoning him back to center stage. Russell gently put his arm around Brooks's shoulders and told him, "Stand out here and enjoy this, son. You'll remember it for the rest of your life." As TNN went to commercial, Brooks dissolved into tears.

"I think a lot of times with fear, if you dig into the ingredients of what makes you scared, one of them might be the realization of what you're going through," Brooks said. "You're on the Grand Ole Opry. The last thing you want to do is embarrass the Grand Ole Opry. Johnny Russell's out there. He's talking to me. He's making me feel welcome."

Within a year, Brooks was pulling out all the stops on an arena tour, singing songs such as "Not Counting You," "The Dance," and "Friends in Low Places." Undoubtedly the most charismatic entertainer of his generation, Brooks absorbed his audience's manic energy and radiated it back tenfold. Brooks still made it a point

to return to the Opry stage and joined the cast on October 6, 1990, inducted by none other than Johnny Russell. "We all want to take the adventure but we'd all love a guide with us," Brooks said. "Johnny Russell was mine."

Brooks could be spotted among the stars singing the gospel song "Turn Your Radio On" during the opening number of the 1991 CBS special *The Grand Ole Opry 65th Anniversary Celebration: The New Tradition*. Viewers would have quickly noticed Kitty Wells, Earl Scruggs, and Loretta Lynn in the front row, not to mention Roy Acuff, Grandpa Jones, Bill Monroe, and Minnie Pearl. Later in the special, Opry legends including Chet Atkins, Little Jimmy Dickens, and Pee Wee King joined them in a circle to swap stories. Near the end of the two-hour show, Brooks introduced the Opry's newest member, Clint Black.

PREVIOUS SPREAD: Vince Gill performing on the night of his Opry induction while Roy Acuff looks on, August 10, 1991. OPPOSITE: The Opry cast and special guests take the stage for the show's sixty-fifth anniversary television special, January 10, 1991. ABOVE: Garth Brooks performs on the Opry stage for the first time as a member, October 6, 1990.

Hailing from Houston, Texas, and rooted in traditional country music, Black quickly sold a million copies of his 1989 debut album, *Killin' Time*. By the time the anniversary show was taped, the album had yielded four number one hits and sold two million copies. His follow-up album, 1990's *Put Yourself in My Shoes*, reached platinum sales in just two months. Because he joined the Opry at the height of his popularity, Black didn't have much spare time to get acquainted with the cast.

"I got invited to be a part of some small, personal gatherings, but I was gone. My manager and my agent had me on a bus most of the year," he said. "It wasn't until I could get my arms around it all and start carving out some time . . . but even then it wasn't much, unless we were all there for an anniversary taping, and then I was just hanging out with them. I clung to them and wanted their stories. But the problem with it back then, and for several years into my career, I was moving too fast to really soak that up as much as I should have."

Though he was onstage with Black and Brooks for the sixty-fifth anniversary show, Alan Jackson wasn't yet an Opry member, despite an already established relationship with the Opry staff. In 1985, stage manager Tim Thompson owned a house nearby with a downstairs apartment that had never been used. Jackson, a new employee in the TNN mailroom, had just moved to Nashville to try to make it as a country artist. He noticed an ad for the basement apartment posted in a well-traveled Opry House hallway, and asked if he and his wife, Denise, who was working as a flight attendant, could come by and take a look. Thompson was happy to lease them the space.

"I was proud for him, and I thought he would make it," Thompson recalled. "I remember trying to go to Mr. Durham in the office back there and saying, 'Hey, I got a guy you really need to put on.' And he'd say, 'What do you know about that guy?' I said, 'I'm telling you the guy's good. He's a *country* singer, too.'"

Jackson stayed on at TNN from September 1985 until July 1986, when he earned a song publishing contract; a few years later he signed a record deal. Though his first single failed to catch on, a second release, "Here in the Real World," fared better, and Durham booked him for an Opry debut on March 3, 1990. "Wanted," a heartbreak song structured around placing a classified ad, kept his career momentum going. By this time, all the furniture in the Jacksons' apartment was being moved out to the driveway to accommodate band rehearsals. After that, there was a van with a trailer, then a little motor home with a trailer. Even when their first daughter was born and a tour bus showed up in the driveway, the Jacksons stayed in the apartment until the fall of 1990.

Jackson generally shied away from interviews at the time, but he made his musical intentions clear with his sixth single, "Don't Rock the Jukebox," which was on its way to number one when he joined the Opry on June 7, 1991.

PREVIOUS SPREAD: A circle of past and present Opry stars perform and tell stories as part of the Opry's sixty-fifth birthday telecast on CBS, January 10, 1991. Clockwise from top center: Kitty Wells, Roy Clark, Roy Acuff, Minnie Pearl, Bill Monroe, Jimmy Dickens, Chet Atkins, Loretta Lynn, Earl Scruggs, Grandpa Jones, and Pee Wee King. OPPOSITE, TOP: Garth Brooks and Clint Black onstage during Black's induction as a member of the Grand Ole Opry. OPPOSITE BOTTOM: Alan Jackson performs on the Opry for the first time as a new member while Roy Acuff and Randy Travis look on, June 7, 1991.

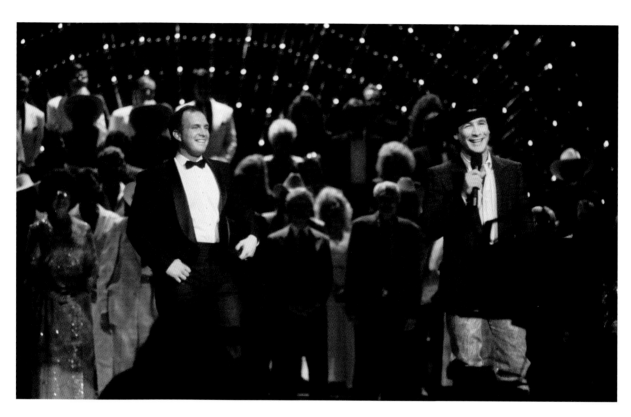

TOP: Alan Jackson's induction night with Roy Acuff's approval, June 7, 1991. BOTTOM: Minnie Pearl poses gleefully in front of roses sent by Dwight Yoakam in celebration of her fiftieth year on the Grand Ole Opry, November 3, 1990. OPPOSITE: *Opry Observer* newsletter with a headline announcing Vince Gill's induction, September 1991

"Randy Travis was the host that invited me out, which was very cool because Randy was a big inspiration that sang real country music and opened the door for a lot of artists like me in the mid-to-late eighties," Jackson said. "When I walked out there, I don't even remember it. I was so nervous . . . I'm standing there with Randy Travis, and Roy Acuff is standing beside me. I'm pretty tall and [Roy] wasn't that tall. He was just looking up at me, right beside me the whole time I was singing . . . I think I was just in shock. It was so crazy and everything was going wild at that time anyway with my career. It was just a big moment and a very cool part of my early days especially. And to have somebody like Roy Acuff there and have that memory forever, that's very cool."

Reminiscing on that era, Thompson also mentioned Minnie Pearl and her husband, Henry Cannon, who would often sit just behind the curtain and crack his own jokes while Minnie and Roy were onstage. On November 3, 1990, in a show celebrating the fiftieth anniversary of Minnie Pearl's induction, Thompson had to figure out what to do with a surprise delivery from country singer Dwight Yoakam: fifty bouquets of roses, with a dozen flowers in each one. Thompson retrieved the poinsettia tree used at Christmas and quickly stocked it with six hundred stems. The beautiful gift was wheeled out to the Opry stage for all to enjoy.

Minnie Pearl gave her final public performance the following summer in Joliet, Illinois, as part of a Grand Ole Opry tour. Two days after that June 15, 1991, show, she suffered a stroke and never returned to the Opry. A large photograph of Minnie Pearl, positively beaming in the Opry circle, now hangs in the artist entrance of the

Grand Ole Opry House, welcoming every performer and backstage guest.

Barbara Mandrell, an Opry member who'd reached superstar status in the 1980s, loved Sarah Cannon as much as she loved Minnie Pearl. "She was one of my best girlfriends in the world. We had fun together, even away from work," Mandrell remembered. "We would be at a dinner party or a gathering, and she was such a lady, such a grand lady, such a classy lady, a sophisticated lady. And then, when she was Minnie Pearl, she was the best. Her timing, her speed at which she would come up with anything and everything, or giving a speech or doing her act, I admired her totally. She was a hero to me."

Vince Gill's easygoing demeanor belies a determination that kept him in pursuit of an elusive goal. After graduating from high school in 1975, he bought a vintage Martin guitar and moved from Oklahoma City to Louisville, Kentucky. He rented a room in a friend's attic for fifteen dollars a month and toured with Bluegrass Alliance, a well-known band on the festival circuit. Bluegrass Alliance played at the Opry House as part of Fan Fair in 1975, marking Gill's first time on the Opry stage. However, fourteen years would pass before he made his Opry debut as a solo artist.

Gill moved to Nashville in 1983 after seven years based in Los Angeles. He'd take family members to the Opry when they came to visit, but because he wanted his first time to play an Opry show to be as an artist in his own right, he routinely turned friends down when they asked

THE OPRY OBSERVER

Vol. 5, No. 1 The Official Grand Ole Opry Fan Club Newsletter September 1991

Opry 'calls' Vince Gill's name

him to sing harmony or accompany them on guitar at the Opry. Meanwhile, his solo career recording for RCA was faltering. His wife, Janis Gill, was having country hits with her band Sweethearts of the Rodeo, while Gill picked up work as a studio musician to keep afloat.

In 1989, he was offered a lifeline to sign a record deal with MCA Nashville. Around the same time, Mark Knopfler asked Gill to join Dire Straits, which would have alleviated any financial setbacks, even if it dashed his aspirations to make it in country music. Gill weighed his options and decided to bet on himself.

Not long after Gill signed with MCA, the Opry called. They wanted him on the show, but it overlapped with his daughter's first-grade talent show. Gill respectfully declined and performed "You Are My Sunshine" that night at his daughter's school. But soon, on July 29, 1989, he'd make his debut, taking the stage with just his guitar, singing "Oklahoma Borderline" and a waltz titled "When I Call Your Name." Then his first two singles on MCA stalled outside of the Top 10. "When I Call Your Name," his third single,

turned things around fast. Six months after winning a Grammy for "When I Call Your Name," Gill was inducted into the Grand Ole Opry by Roy Acuff on August 10, 1991.

"Mr. Acuff loved 'When I Call Your Name,'" Gill added. "He said, 'That's my favorite song with harmony that I've ever heard.' I have memories of him making me sing it every time I was on his portion of the show. He couldn't see five feet in front of him, so he would come and stand literally next to my face. I was singing it one night and he had tears in his eyes. It was awesome."

Just a month after Gill's induction, the Opry lost one of its most beloved members when Dottie West succumbed to injuries sustained in a car crash on her way to perform on the Opry. When

her car stalled out, she accepted a ride from an elderly neighbor. Her neighbor sped toward the Opry House, taking the Opryland entrance ramp too fast. He lost control of the car, sending it airborne into an embankment. West sustained internal injuries and was reported to be in critical condition.

"I just remember being totally in shock about it, and [thinking] this can't happen," said Jeannie Seely, who was West's best friend. To keep her mind occupied in the days after the crash, Seely poked around an antique store in a small town just outside of Nashville. "As I walked in, the ladies just looked at me and started shaking their heads," Seely recalled. "I said, 'What?' And they said, 'You hadn't heard?' I said, 'She's gone, isn't she?'" West died in surgery five days after the accident. She was fifty-eight.

Although she'd reinvented her own image in the 1970s and early 1980s, Dottie West didn't have an opportunity to see the dramatic revitalization of Ryman Auditorium, where she became an Opry member in 1964. Purchased by Gaylord Entertainment in 1983, the tabernacle still attracted tourists and hosted occasional TV tapings with limited audiences. In 1989, plans were announced to spend a million dollars to fix the roof, repair the masonry, and restore a large decorative window, the first steps toward what would become a massive overhaul.

TNN used the atmospheric space to film a concert series called *Onstage* in early April 1991. Emmylou Harris followed suit, booking three shows that spring with her new band, the Nash Ramblers, to record the *At the Ryman* live album and a related TNN special. Because of the state of interior disrepair, only about 250 listeners

OPPOSITE: Dottie West performing on the Opry stage in the final year of her life, March 22, 1991. TOP: Emmylou Harris performs with her band the Nash Ramblers at Ryman Auditorium, 1991. Left to right: Roy Huskey Jr. and Harris. BOTTOM: Album cover art for the Grammy-winning live album *At the Ryman*

were allowed to sit on the main floor, but not the balcony, out of safety concerns. At one of the shows, after singing the Hank Williams song "Half as Much," she asked the audience, "Is it wonderful to sit out there? I mean, is this a great place to sort of feel the hillbilly dust? I played a lot of different places in the last sixteen years–from really megabuck, you know, multi-million-dollar places that really sound terrible, to one place in Lake Charles, Louisiana, where the only way to get to the stage was to climb through a window. This is the best."

After hiding in plain sight, the Ryman was cool again. Harris would go on to win a Grammy for *At the Ryman*. She returned to the venue for an architectural awards program in May 1992, as well as a one-act play named *The Ryman: The Tabernacle Becomes a Shrine*. Vince Gill, Bill Monroe, Ricky Skaggs, and Connie Smith also took part in the production commemorating the building's one hundredth birthday in 1992.

Entering its second century, the Ryman temporarily closed its doors in March 1993 to prepare for an $8 million upgrade. Steve Buchanan, who'd been handling marketing at the Opry, took the reins to get the Ryman reopened by June 1994. The tabernacle had been renamed the Grand Ole Opry House in 1963; it would now be known once again as Ryman Auditorium. Buchanan took a page from the venue's history prior to 1943 and started booking a variety of programming, including theatrical productions and symphony performances, along with concerts by Elvis Costello, Merle Haggard, and others.

Buchanan added, "Another piece that was important to me was the preservation of the stage, and working with a guy who did the

TOP: Ryman Auditorium interior with the oak pews removed for restoration, 1993. CENTER: Exterior view of Ryman Auditorium during renovation, 1993. BOTTOM: Portions of the balcony that had wrapped around the wings of the stage to the building's back wall were removed and a proscenium wall constructed. OPPOSITE: Travis Tritt performs following his Opry induction on February 29, 1992.

refinishing of the stage, to make sure that we didn't have to replace it anytime soon. And we didn't; it was years. I thought it was really important that those boards were the same boards that had been walked on by the generations before."

Five country artists who first charted in 1989 and arguably set the nineties country music boom in motion soon became linked in the media as the Class of '89. By the end of 1991, three of these musicians had been inducted into the Opry: Clint Black, Garth Brooks, and Alan Jackson. A fourth, Mary Chapin Carpenter, won numerous industry awards and charted country singles for the rest of the decade while keeping her home in Washington, DC. The fifth member of the Class of '89, Travis Tritt, joined the Opry on February 29, 1992.

Born and raised in Georgia, Tritt possessed a Southern sensibility that appealed to fans of Lynyrd Skynyrd and Charlie Daniels. Unlike others in the Class of '89, Tritt wasn't a "hat act." Neither was Marty Stuart, who'd been around the Opry for decades as a musician and aspiring artist himself. After climbing the chart together with a raucous duet titled "The Whiskey Ain't Workin'," Stuart followed Tritt into the Opry cast on November 28, 1992.

Stuart examined the Opry roster after Lester Flatt's death in 1979 and noted that none of the bluegrass bands had an open spot in their lineup. After a tour with Doc and Merle Watson, Stuart signed on with Johnny Cash's band, but whenever he was off tour, Stuart dropped in backstage at the Opry to see his buddies. After a slow start in his own career, Stuart charted his first Top 10

country single in 1990 with "Hillbilly Rock." Over the next two years, several more radio hits came his way, so he decided to call Hal Durham.

"I remember saying, 'I want to come home . . . I want to be a member of the Grand Ole Opry,'" Stuart noted. When he received word from Durham that Opry management was on board with the idea, Stuart responded that he needed to get the blessing from two specific Opry members first.

Roy Acuff gave his permission freely, Stuart recalled. "He said, 'Well, I think you'd be pretty good for the show. You don't come in here with cow shit on your boots and you know good country music, and I think you'll be true to it.'"

When Sarah Cannon received Stuart as a guest in her home, she overlooked his armful of white roses and exclaimed, in true Minnie Pearl fashion, "Look at them tight pants!" Drifting in and out of a fog, she chided Stuart for using the word "hillbilly" in his music. "We've worked so hard to get past it," she told him. "I wish you would reconsider." Because she offered it as a suggestion and not a demand, Stuart felt he had her blessing, too. He called Hal Durham on the way home and told him he would be honored to join.

Out on the road with Tritt, Stuart performed for young and lifelong country fans alike. Often he'd introduce his rendition of the country classic "Long Black Veil" by saying, "This is one that some of us old farts might remember." When he repeated that remark at his Opry induction, the audience laughed at the comment, but the joke didn't go over so well among viewers. The switchboard operator caught Stuart on his way offstage and told him, "I don't know what you did, but it ain't good."

"It killed me that I'd made such a big misstep," Stuart said. "I finally broke down and I called Little Jimmy Dickens. I said, 'Tater, I need to talk to you. Can we meet?' And he said, 'Let's meet at the Cracker Barrel on Harding Place.' I went in looking for him and I kept hearing, 'Psst, Psst!' It was around Christmas. I looked and he was standing in the Christmas tree with one of those flap caps on! And I laid it out to him when we finally got to the table. I said, 'It breaks my heart.' He said, 'It will pass.' And so, it was a misstep, but we got past it and went on. But if I had it to do over again, I wouldn't tell that joke."

Just five days prior to Stuart's induction, Roy Acuff died at the age of eighty-nine on

Roy Acuff watches the Opry
from the side of the stage,
August 11, 1976.

CLOCKWISE FROM TOP LEFT: Charley Pride performing on the Opry at Ryman Auditorium earlier in his career, July 10, 1971; Garth Brooks welcomes Alison Krauss as the newest Opry member, July 3, 1993; Porter Wagoner inducts Joe Diffie, November 27, 1993; Charley Pride and his wife, Rozene, pose with Opry manager Hal Durham during Pride's induction party, May 1, 1993.

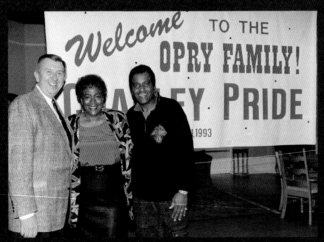

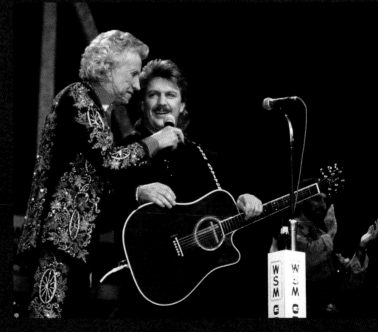

November 23, 1992. Per his request, he was buried just hours later at Spring Hill Cemetery, a couple of miles from the Opry House. A member since 1938, Acuff had been the preeminent presence of the Opry, if not country music, for more than fifty years.

At his final Opry appearance on October 23, 1992, Acuff performed a pensive ballad called "I Wonder if God Likes Country Music" alongside Bill Anderson. They'd recorded it as a duet in 1983 and performed it on the Opry stage together many, many times.

"Those were special nights when I got to sing with him, or he came out and sang with me," Anderson said. "People don't believe this sometimes when I tell them, but I would go to his dressing room and say, 'Do you want to do our song tonight?' 'Can we rehearse it?' He wanted to rehearse it *every single time*. He did not want to go on the stage unless we rehearsed it. Professional. He wanted the Opry to be everything it could and should be."

In a *Los Angeles Times* obituary, Porter Wagoner stated, "I think he'll be missed probably more than any entertainer or singer ever has in the history of our business, because Roy Acuff was certainly known worldwide . . . I don't think anyone will ever replace Roy Acuff."

Just as he'd supported Stuart's membership, Acuff would have been delighted to see Charley Pride and Alison Krauss inducted into the Opry in 1993. Born and raised in Mississippi, Pride grew up listening to Acuff and other country stars of the 1930s and 1940s because his father was a devoted Opry listener. Just weeks after Pride charted his first single on RCA, he made his Opry debut on January 7, 1967. He'd been asked privately to join the cast in the late 1960s, but committing to a number of Saturday night Opry shows while touring proved to be a tall order. Inducted on May 1, 1993, Pride became the second Black artist to join the cast, after DeFord Bailey in 1926.

Inducted by Jimmy C. Newman, Pride received a rousing welcome and sang his massive 1971 hit, "Kiss an Angel Good Morning." He also reminisced about singing bluegrass songs with Acuff backstage in the early period of his career. "This takes me right back to the first time I ever appeared on the Opry when Ernest Tubb introduced me at the old Ryman and I want to tell you, I'm not quite as scared and nervous as I was then, but I am close to that," he told the crowd. He attempted to read a telegram from Henry Cannon and Minnie Pearl, but emotions got the best of him. He concluded his segment with "Wings of a Dove" and "Kaw-Liga," both of which he'd recorded in the 1960s. "I don't want to overstay my period up here on the Opry," he said, "but I appreciate all of your response, and I appreciate that you appreciate me."

Like Acuff, Krauss played traditional fiddle, and the instrument became a key part of her musical identity. In her early teens, she and another friend who played fiddle traveled from their hometown of Champaign, Illinois, to Bloomington, Indiana, to try out for the shows at Opryland USA; the auditions went well, but Krauss was too young to meet the theme park's age requirement of sixteen years old. She attended her first Opry show in 1985 to see one

of her heroes, Randy Howard, who'd just won the Grand Master Fiddler Championship. That same year, she signed with Rounder Records and developed her gift for transcending the familiar topics of bluegrass songs while still appealing to the genre's core audience.

At seventeen years old, Krauss made her Opry debut and took lots of photos of Roy Acuff and Bill Monroe. Another time, Loretta Lynn invited Krauss to her dressing room for a visit. Although not one to seek the spotlight, Krauss had won a Grammy in 1991 and recorded with one of her heroes, Dolly Parton. When Krauss was inducted by Garth Brooks on July 3, 1993, she became the first bluegrass artist to join the Opry in twenty-seven years, since the 1964 inductions of Jim & Jesse and the Osborne Brothers.

"I know that Sonny Osborne was very support-ive," Krauss recalled, "and Hal Durham was here at the time. We came in to meet with him and talked about it. But you didn't think that that was going to happen. I don't even know how pres-ent I was with some of that stuff. It's surreal. It doesn't really register, you know what I mean? When you're in there and you're that age, you're so excited in the moment that I don't think you really know the weight of certain things that are happening."

Joe Diffie joined the cast next, on November 27, 1993, just as his irresistible hit "John Deere Green" was climbing the chart. Diffie had accrued eight Top 5 hits by this time, deliver-ing ballads and novelty songs alike with his expressive baritone. Another hitmaker of the era, Hal Ketchum, followed on January 22, 1994, on the strength of singles such as "Small Town Saturday Night" and "Past the Point of Rescue."

Diffie and Ketchum were tapped by the Opry's new GM, Bob Whittaker, who started his Opry career in the personnel office of Opryland USA, helping to staff up the park when it opened in 1972. A people person who loved live entertain-ment, Whittaker especially enjoyed bluegrass and occasionally sang onstage in cast ensem-bles. Early in his tenure, he assigned Jeannie Seely and other female cast members to regu-larly host segments; nobody seemed to mind (or perhaps notice) that women were finally sharing that responsibility with the men in the cast.

His decisions to induct Diffie and Ketchum were safe bets, but bringing on Bashful Brother Oswald, who'd played dobro in Roy Acuff's Smoky Mountain Boys since the late thirties, was a sentimental choice. Whittaker figured since Oswald (a stage name for Beecher "Pete" Kirby) was still playing guest slots at the Opry after Acuff's death, there was no harm in making him a member. At the age of eighty-three, Oswald joined the Opry cast on January 21, 1995.

That same year, country star Pam Tillis signed on as a host of a TNN music series to be filmed at the Ryman. For years, Tillis struggled to emerge from the shadow of her father, Mel Tillis, until her 1990 breakout hit, "Don't Tell Me What to Do," set the tone for a decade of radio success. As a teenager, she'd spent a hot sum-mer working at Opryland USA sticking straws into plastic fruits filled with juice. Now with some hit records, she was headlining the park's Chevrolet Geo Celebrity Theater.

"To tell you the truth, once my career did hit on the heels of 'Don't Tell Me What to Do,' I was tearing up the road, so I wasn't doing the

Opry as frequently as I would have liked," Tillis said. "And then later on, I did get it in my head that I could possibly become a member. I spoke with my manager about it, and he said, 'We just need to get you out there a lot more. You need to show that you're committed to it,' and so I started doing it more frequently."

To that end, Tillis signed on for the CBS television special commemorating the Opry's seventieth birthday, which aired on January 4, 1996. Tillis and Connie Smith sang a duet of "I'm a Honky Tonk Girl," Barbara Mandrell and Reba McEntire graced the Ryman stage for "I Was Country When Country Wasn't Cool," and Chet Atkins coaxed Don Gibson back into the spotlight to perform "Oh Lonesome Me" together. For two hours, legends such as Roy Clark, Ray Price, and Jean Shepard shared screen time with a host of contemporary Opry stars. In the opening moments of the show, Dolly Parton led an all-star sing-along of "Wabash Cannonball." When Emmylou Harris later presented a bronze bust of Bill Monroe commissioned by the Opry, Monroe quipped, "He looks like a wonderful man."

At the end of the special, Martina McBride paid tribute to Patsy Cline by singing "Crazy," just before being welcomed by Loretta Lynn as the Opry's newest member. Although the Kansas native hadn't yet charted a number one single, she created a buzz with the music video for "Independence Day," which addressed domestic violence head-on. She sang with astonishing power and had earned a reputation on Music Row as an excellent song-finder. Inducted during the CBS taping on November 30, 1995, McBride pledged to do her best to make the Grand Ole Opry proud.

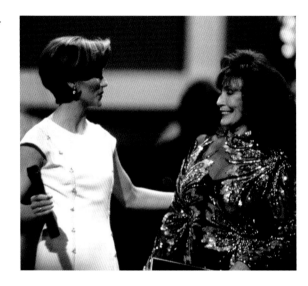

Unbeknownst to the audience, McBride had unintentionally ruffled some feathers a month before as she closed out the Saturday night show that served as the Opry's annual birthday celebration. Tasked with performing a medley of hits by female country legends, McBride accidentally sang more of "Making Believe" than she was supposed to. As a result, the segment ran over time and TNN had to go to commercial. Certain Opry members were fuming because they were ready to wheel out an oversize cake and sing "Happy Birthday" to the Opry, a ritual that McBride didn't know about.

Scathing letters, signed only "Members of the Grand Ole Opry," were promptly sent to McBride and Gaylord Entertainment CEO Bud Wendell. The unnamed members made accusations that she "carelessly overlooked" the veteran artists and "single-handedly reduced the 70th Birthday to a meaningless celebration." In a

ABOVE: Loretta Lynn welcomes Martina McBride as the newest member of the Grand Ole Opry during the Opry's seventieth anniversary special, November 30, 1995.

six-page handwritten letter sent to Opry members, McBride apologized for the mistake and asked for forgiveness, but also wrote, "I take my responsibility to country music very seriously. And, frankly, it upsets me greatly to be told via your letter that I have no respect for the members of the Opry as well as the Grand Ole Opry itself. No matter what you believe, it is important to me that you know that when I stood on that stage and sang that medley, it was from my heart and in the spirit of the deepest respect for the tradition of the Opry and the women whose music I love so much."

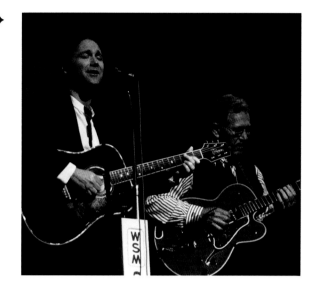

Steve Wariner, who'd first come to the Opry in 1973 as Dottie West's bass player, joined the cast on May 11, 1996. With his friend and mentor Chet Atkins already onstage, Wariner spoke fondly of Minnie Pearl, who'd passed away two months earlier. Across the program's one-hundred-year history, no woman has been more closely identified with the Grand Ole Opry. Initially envisioned by Sarah Ophelia Colley as a comical, crowd-pleasing character, Minnie Pearl arrived in the cast in 1940 with a huge smile, a straw hat, and no real career to speak of–just the recommendations of some bankers who'd seen her perform and the willingness of WSM management to give her a shot. She brought laughter to the Opry for more than fifty years; that night, perhaps for the first time, listeners wept when they heard her name.

In humble tribute, Wariner and Atkins performed her favorite song, the sentimental "Have I Told You Lately that I Love You," popularized in the 1940s by Lulu Belle and Scotty. As the former head of RCA's Nashville office, Atkins had played

a crucial role in Wariner's ascent to country stardom, first hiring him as a bass player on a package tour of RCA artists, then signing him to the label in 1976. Since that time, Wariner had picked up twenty-eight Top 10 hits, including "Lonely Women Make Good Lovers," a song he played countless times as Bob Luman's bassist in the mid-1970s.

In a *Nashville Banner* story coinciding with the induction, Wariner admitted that he always felt misplaced, like he should have been an artist from a different era. His viewpoint never changed, even fifty years after first setting foot on the Opry stage.

"I won't back up on that one because that's true. I would listen to the radio with my uncle and that's the era that I love so much," Wariner said. "And by the time I got here, by the time I was having hits, country music was changing.

TOP: Steve Wariner and Chet Atkins perform in honor of the late Minnie Pearl on Wariner's Opry induction night.

This is not me being a jerk or ego, but I was part of changing it. Some of my records were more pop, but that's where country was going."

Though the Opry continued to add contemporary stars such as McBride and Wariner, the cast lost yet another giant when Bill Monroe died on September 9, 1996, six months after his final Opry performance. Although he was considered the Father of Bluegrass, Monroe feared that he would be forgotten and that his music would not outlive him. As Monroe's health faltered, Ricky Skaggs spent time at his bedside between tour commitments.

"I told him one time, 'Mr. Monroe, you don't have to worry about what's going to happen to your music, I'm telling you. Me and Marty and Vince and Alison and people like that, we're going to keep playing this music. We're going to keep playing your music and telling people about you, that you started this music,'" Skaggs said. "There was a peace that would come over him when I would talk and encourage him to just relax and try to enjoy his last days on earth."

The Opry had plenty to keep people talking in the fall of 1996 and the spring of 1997. First off, Hal Durham announced his retirement from his position as president of Gaylord Entertainment's Grand Ole Opry Group. Bob Whittaker would stay in place as Opry general manager. In February 1997, Gaylord Entertainment sold TNN and CMT to Westinghouse Electric Corporation, the owner of CBS, for $1.55 billion in stock. Three months later, Bud Wendell retired from his role as president and CEO of the corporation.

There were changes happening among the Opry cast members as well. A new romance had blossomed between Marty Stuart and Connie Smith; after working together on Smith's first new album in twenty years, they wed on July 8, 1997. In addition, Barbara Mandrell gave her final concert on October 23, 1997, at the Grand Ole Opry House, capping an exceptional career in country music. True to her word, she never performed live again, but she did make an Opry appearance in 2022 for a special show celebrating her fiftieth anniversary as a member.

Bob Whittaker inadvertently ushered in a new tradition in the fall of 1997 by surprising Johnny Paycheck onstage with an invitation to join the Opry, rather than having a private conversation about it in advance. Two months after that unexpected offer, a formal induction followed on November 8, 1997. The change in protocol likely didn't upset some people as much as Paycheck's unsavory past, which involved jail time for aggravated assault after shooting someone in a bar fight.

But the biggest shocker of the year was the closure of Opryland USA theme park, which would be razed and replaced by a shopping mall. In the summer of 1996, the *Tennessean* reported that the Opry was considering cutting the number of Friday night shows due to sluggish attendance, with overall Nashville tourism flat or in decline. In addition, during the first six months of 1997, heavy rains translated into a dip in theme park ticket sales. A *Tennessean* article stated that the park reportedly generated only $4 million in profit in 1996, out of $53 million in revenue, not enough to keep Gaylord engaged. On December 31, 1997,

Opryland USA ceased operations after twenty-five years.

The Opry grappled with yet another loss when Grandpa Jones suffered a stroke on the first Saturday night of 1998. Coming offstage, he collapsed after signing an autograph and died the following month at the age of eighty-four. For the first time since 1946, seeing an Opry show without Roy Acuff, Grandpa Jones, Bill Monroe, or Minnie Pearl became the new reality. For those who viewed the Grand Ole Opry as living history, these deaths were especially devastating.

"It's like losing family, losing parents, losing aunts, uncles, cousins," Patty Loveless mused. "It's friends, but family. You're losing a family member, but you look back at all those years, and the music lives on. Their music will always live on through the Opry and through the next generation of Opry members."

With only one induction each in 1996 and 1997, it appeared to be the right time to enhance the roster. Then, as now, there was no shortage of opinions among Opry members and country fans about who should receive the next invitation. When the decision was finally announced on March 14, 1998, it was front-page news as the *Tennessean* headline trumpeted: "Diamond Rio first band since '84 to join Opry."

"It was an easy ask for Diamond Rio to be members because we were courting the Opry mighty hard. Just being down here as much as we possibly could," band member Dana Williams said. "At the time, we were doing really well on

radio, and we were playing out on the road a lot. But every chance we got, we'd be out here at the Opry, making the powers that be aware that we would love to be a part of this. And it worked!"

Diamond Rio's Opry pedigree was hard to beat. In 1982, lead singer Marty Roe cleared the extensive audition process to sing in a musical revue at Opryland USA called *Country Music USA*, a step up from his prior job operating the Sky Ride. In his early twenties, Roe appeared dozens of times alongside Minnie Pearl and Roy Acuff at Opryland Hotel. In turn, the Opry stars would occasionally surprise audiences by portraying themselves in the *Country Music USA* show.

Roe also befriended Porter Wagoner, who introduced him to the Opry stage for the first time in 1982. A few years later, Roe signed on with Tennessee River Boys, a country band that performed at Opryland USA. Williams, who played bass for Jimmy C. Newman at the time, used to check out the band's performances between the Opry matinees and evening shows. As the nephew of Bobby and Sonny Osborne, Williams spent a part of his childhood backstage at the Ryman, where he and his cousin would aggravate Opry stars by twisting tuning pegs on their guitars when nobody was looking.

Fast-forward to 1991. Roe and Williams are part of an entirely different six-piece band that evolved out of the Tennessee River Boys. That reinvention came with a new band name: Diamond Rio. Signed to Arista Nashville, they scored right out of the gate with the nostalgic "Meet in the Middle." When they accepted an offer to perform on the

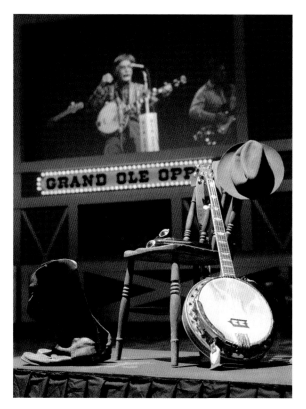

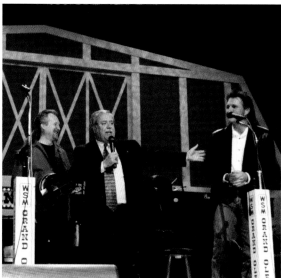

TOP: Grandpa Jones's signature boots, hat, glasses, and banjo on display during his funeral at the Opry House, February 21, 1998. BOTTOM: Opry GM Bob Whittaker invites Diamond Rio to become Opry members, March 14, 1998.

Opry, Roe and Williams savored the opportunity to reconnect with old friends.

"Grandpa Jones was hilarious," Roe said. "I think the first time we were on here as Diamond Rio, in '91, he was hosting his spot, and he's deaf. And he's like, 'Now what's the name of that band again?' I said, 'Diamond Rio. R-I-O. Diamond Rio.' 'OK,' he says, 'I know I'll mess it up.' And he goes out there and goes, 'Ladies and gentlemen, it's a great band, you're gonna love them, it's the Diamond Trio!' And I just cracked up. Then when he came right by me, he goes, 'I knew it!' Never even looked at me, man!"

Diamond Rio joined the Opry on April 18, 1998, and it proved to be Whittaker's final induction as GM. On a business trip to Orlando, he suddenly fell ill and was hospitalized in Florida for several days. While recuperating in Tennessee, he stated his intention to retire. In the fall of 1998, he moved onto his farm, formerly owned by Bill Monroe, and offered to be a consultant for the show.

"I never got a call," Whittaker said, "but I'm retired because of my health, and I also saw a change in the direction. I was too much of a traditionalist, and a fan of the legends, to continue with what I thought was going to happen. And it did. And that's OK. I made a comment to someone who questioned me about the changes, and I said, 'Look, they allowed me to row the boat while I was there, and they're going to allow someone else to row the boat when they take that place, and that's OK.'"

In September 1998, Steve Buchanan was named president of the Grand Ole Opry Group, responsible for the Opry, Opryland Productions, and

1st OPRY BROADCAST FROM THE RYMAN SINCE 1974

JAN 15 JAN 16

★ 7:30 ★ ★ 6:30 - 9:30 ★

GRAND OLE OPRY

AT THE
RYMAN AUDITORIUM

★ ★

NASH. TN. 19 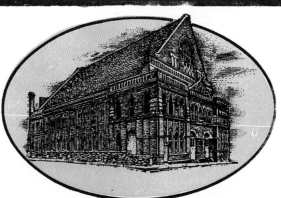 99

1st OPRY BROADCAST FROM THE RYMAN SINCE 1974

the Ryman. Another announcement soon followed: For the first time since 1974, and for one weekend only, fans could watch the Opry at the beautifully restored Ryman. The temporary move offered a new generation a chance to experience the show in its most storied historical home. Over the course of a show on Friday night and two on Saturday, at least thirty-three members performed. The ranks would swell, though, as Trisha Yearwood received an Opry invitation from Ricky Skaggs on Saturday, January 16, 1999. Notably, she became the first artist to be invited at Ryman Auditorium and inducted at the Grand Ole Opry House. Porter Wagoner served as emcee at her induction on March 13, 1999.

Yearwood already considered herself a singer at the age of five. "I was like, 'This is what I do,' and I'm sure people thought I was a crazy little kid, but I'd never felt like I chose it. I always felt like this is just who I am and I'm gonna have to figure out a way to do it," she recalled. At fifteen, she talked her parents into a family trip to Nashville, where they attended the Opry and toured the Country Music Hall of Fame and Museum.

She pleaded with her parents to let her stay behind, to no avail. Yet the trip made it clear to Yearwood: She needed to be in Nashville. That strong will and determination is echoed in her 1992 hit, "Wrong Side of Memphis," about feeling the irresistible pull of the Opry stage.

"I was born in Georgia, so I wasn't really on the wrong side of Memphis, but to me, any place that wasn't Nashville was the wrong place—it was the wrong side of Memphis. So, that song felt like my story, just getting in the car and getting to where the music was being played. And 'calling my name on the Opry stage,' that's the dream. That's the entire dream. So, to get to sing that on the Opry? That never gets old."

OPPOSITE: Hatch Show Print poster commemorating the Opry's return to the Ryman, January 15–16, 1999. ABOVE, FROM LEFT: Trisha Yearwood performs for the Opry audience during her induction night, March 13, 1999; Porter Wagoner hugs new Opry member Trisha Yearwood on the night of her induction, March 13, 1999.

WELCOME TO THE FUTURE

ABOVE, FROM TOP: Jeannie Seely signs the computer monitor after chatting with fans online on the Opry website, October 17, 1998; backstage at the Opry, Little Jimmy Dickens participates in an online chat forum with fans, October 17, 1998. OPPOSITE, FROM TOP: Brad Paisley and Alison Krauss perform their hit song "Whiskey Lullaby" at Carnegie Hall, November 14, 2005; Brad Paisley performs for President Barack Obama and First Lady Michelle Obama in the East Room as part of the White House Summer Music series, July 21, 2009.

AT ONE HUNDRED YEARS OLD, THE GRAND OLE OPRY REMAINS at the forefront of country music entertainment. In some ways, a visit to the Opry is like witnessing history, as country music icons and contemporary stars carry on the legacy of the world's longest-running radio show. At the same time, with the prevalence of social media, the Opry offers an up-to-the-minute look at country music, enticing fans from around the world to visit Nashville and see it for themselves.

Just twenty-five years ago, the Opry reached its audience solely by AM radio and a weekly spotlight on cable television. The Opry officially went online in 2000, signaling the start of a transformative time. Colin V. Reed joined Gaylord Entertainment as CEO in May 2001, shortly after the closure of Opryland USA theme park and as the Opry faced a dwindling presence on television. He now holds the title of executive chairman of the board of directors.

Reed noted, "I've stood up in front of my board, basically every year for the last twenty-three years, and said, 'My goal is to make the Opry ubiquitous right across the planet, not just in the United States of America.' We won't be satisfied until every single human being on this Earth has access."

Reed grew up in the United Kingdom and first attended the Opry in 1987 as a tourist when his mother visited from England. He'd moved to Memphis a few months earlier, accepting an executive role at the corporate offices of Holiday Inn. He still remembers buying the Opry tickets, walking through the theme park, and enjoying the show from the top left balcony as the likes of Porter Wagoner and Roy Acuff entertained the crowd.

"One of the attributes of people who grew up in England is that we tend to revere history," Reed added. "So, when I came here, I was deeply concerned about doing anything to an

institution that had so much history and that had shaped, to a large extent, music in this country. I had this sort of kid glove approach to the Grand Ole Opry. And it was only ten years later where we were really trying to adapt the Opry to this phenomenally changing environment around us."

Meanwhile, the Grand Ole Opry grew steadily in the first decade of the 2000s, particularly as social media sites such as MySpace and Facebook connected fans and artists with the click of a button. The Opry also nurtured relationships with new artists such as Montgomery Gentry, Josh Turner, and Carrie Underwood, all of whom made the show a priority in their fast-rising careers.

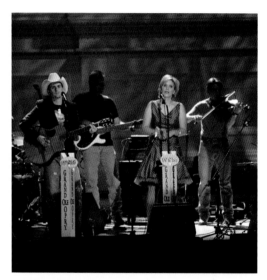

Brad Paisley, an Opry member since 2001, became one of the Opry's most prominent stars in the new millennium. Although he wrote most of his material, he delivered an instant country classic in 2004 with "Whiskey Lullaby," a devastating narrative written by Bill Anderson and Jon Randall and recorded as a duet with Alison Krauss. Paisley and Krauss performed the heartbreaking ballad together at Carnegie Hall in 2005 for a special event commemorating the Opry's eightieth birthday. The following year, Paisley and Opry legend Dolly Parton returned to the top of the charts with a beautiful and emotional collaboration, "When I Get Where I'm Going."

Drawing inspiration from the changing American landscape, Paisley wrote "Welcome to the Future" shortly after the 2008 presidential election. On July 21, 2009, he performed it in the White House for President Obama, First Lady Michelle Obama, and numerous members of the administration. Representing the Grand Ole Opry, Paisley was joined by Krauss, Charley Pride, and WSM announcer Eddie Stubbs; the event was part of a music series created by Michelle Obama to encourage arts and arts education, focusing on country, jazz, and classical music.

In addition, Paisley made a cameo in the first season of *Nashville*, the network series co-produced by Opry Entertainment, ABC Studios, and Lionsgate. Debuting in 2012, *Nashville* introduced fascinating (though fictional) characters that rang true with country fans, particularly as the actors performed new songs on the hallowed ground of the Opry stage.

Steve Buchanan, the president of Opry Entertainment Group at the time, served as an executive producer on the series. Asked why he wanted *Nashville* to draw attention to the Opry specifically, he noted, "I wanted something that could be a catalyst for people coming to the city, and if people come to the city, a certain percentage will come to the Opry. But if the show is also a showcase for the Opry, where people can become more familiar with the Opry and have a greater appreciation for it, then that adds to the level of overall interest."

At the time, Buchanan took note of the high ratings for the Country Music Association (CMA) Awards, the success of the FOX series *Glee*, and the fact that numerous contestants from *American Idol* were making inroads at country radio. Buchanan felt that a scripted television show about the inner workings of the country music industry would appeal to all of those viewing audiences. He added, "I was selling it on the fact that there is a story to be told here about this industry. I'm the guy from the Opry, and this is a perfect setting and location. And there are other obviously great locations, and you don't have to go too far to figure out the drama between the industry and the artists."

The popularity of *Nashville* unquestionably factored into a tourism boom in Music City. In 2018, more than 13.7 million tourists visited Nashville. A year later, that figure rose to 15.4 million tourists. Between July 2022 and July 2024, the Opry staged 491 performances and sold more than 1.5 million tickets. Today, Opry members such as Dierks Bentley, Garth Brooks and Trisha Yearwood, Luke Combs, Alan Jackson, Blake Shelton and Lainey Wilson have all welcomed guests to their lively establishments downtown. After recovering from a dip in visitors during the pandemic, a projected 17.5 million guests are expected to visit Nashville in 2025.

From the very beginning, fans have wanted to see the show in action. Jamey Johnson, who joined the Opry in 2022, observed, "The spirit, it's never changed. It's adopted from one generation by another generation, and it's passed down.

That's why the Opry is what it is. It's the same spirit today that it was back in the twenties and thirties. It's the same spirit today that it'll be a hundred years from now."

Opry NextStage, a talent development platform launched in 2019, has supported a generation of new artists, including Ashley Cooke, Riley Green, Chapel Hart, and Lainey Wilson. For a Saturday night stadium show in 2022, Garth Brooks opened his concert with an all-star Opry performance alongside cast members Lauren Alaina, Larry Gatlin, Jeannie Seely, Trisha Yearwood, and Chris Young and special guest Chase Rice. The entertainers all returned to the massive stage for a rendition of "Will the Circle Be Unbroken."

A fan favorite on NBC's *America's Got Talent*, Chapel Hart received their debut invitation in a surprise tweet from the Opry. Backstage before their first appearance in 2022, group member Danica Hart said, "It's been such an emotional moment because everything that we've done up to this point has led us right here. All the passion and drive that we've put into creating and becoming Chapel Hart, to give to the world, it all comes to this moment tonight, to stand in that circle and sing at our Grand Ole Opry debut."

As the Opry continues to evolve in its one hundredth year, many of its new members feel a responsibility to carry the show into its next century. "I made a commitment to this building that I would take it and hold it precious, and I really do take that seriously," said Carly Pearce, an Opry member since 2021. "I think of the last few generations, Carrie Underwood has been the one that has really held the Opry as part of her brand. I want to follow in her footsteps, and I think the Opry knows that. I'm a woman of her word and I'll never stop playing."

Moments after his Opry invitation in 2023, Scotty McCreery observed, "I've always felt the responsibility. I grew up loving country music and I want to make country music proud with my music and what I'm out there doing. And now, getting to be a part of the family here at the Opry, I think that's only exponentially more true. It's family here and there's been so much great music that's come through here. I want to hold up my end of the bargain and make people proud."

OPPOSITE, FROM TOP: Charles Esten, who played Deacon Claybourne on the series *Nashville*, makes his Opry debut, November 10, 2012; *Nashville* cast members Clare Bowen and Sam Palladio make their Opry debut, November 17, 2012; real-life sisters and performers Lennon and Maisy Stella pose with Little Jimmy Dickens during their Opry debut, December 15, 2012; the Opry NextStage class of 2023 with NextStage 2021 alum Lainey Wilson. Left to right: Chapel Hart (Devynn Hart, Danica Hart, Trea Swindle), ERNEST, Ashley Cooke, Kameron Marlow, Jackson Dean, Lainey Wilson, and Corey Kent. ABOVE, FROM TOP: Carly Pearce performs on the Opry, October 10, 2023; Scotty McCreery waits to go onstage at the Opry, July 28, 2024.

2000

COMPETING TO BE HEARD

-2009

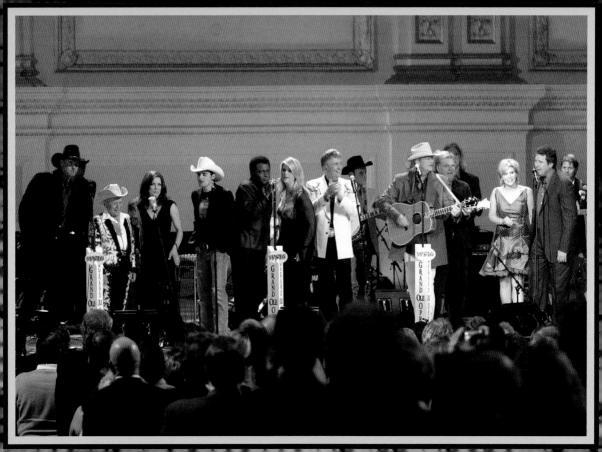

In the first year of a new century, the Grand Ole Opry had some catching up to do. Bluegrass hero Ralph Stanley accepted an invitation to join the cast on the Ryman stage, where the Opry had booked a residency for the month. The next night, on January 15, 2000, Stanley entered the ranks with enthusiastic remarks from Patty Loveless and Porter Wagoner. After Pam Tillis had appeared numerous times on the Opry stage and racked up thirteen Top 10 hits in the nineties, she received her invitation from Little Jimmy Dickens to join the Opry on June 24, 2000. She finally stepped into the circle as a member on August 26, 2000, inducted by her good friend Marty Stuart.

The Opry House also welcomed a new neighbor as the sprawling Opry Mills mall opened in May. A month later, Ricky Skaggs played "Tennessee Waggoner"–the fiddle tune performed by Uncle Jimmy Thompson on that seminal WSM broadcast back in 1925–to commemorate the Opry's first internet broadcast. A contemporary set replaced the wooden barn and received positive reviews from the cast. Although it maintained the barn motif, the modern set incorporated video screens to accommodate fans watching from the balcony, along with an array of colorful lighting that changed throughout the show. Wilma Lee Cooper told the *Tennessean*, "It's beautiful. It makes you feel proud that something is a little bit better than it was."

But as the Opry headed toward its seventy-fifth anniversary that October, controversies began

OPPOSITE: The Grand Ole Opry visits the famed stage of New York City's Carnegie Hall for the third time in the Opry's history, November 14, 2005. Left to right: Trace Adkins, Little Jimmy Dickens, Martina McBride, Brad Paisley, Charley Pride, Trisha Yearwood, Bill Anderson, Alan Jackson, Ricky Skaggs, Alison Krauss, and Vince Gill

swirling behind the scenes. In the summer of 1999, Steve Buchanan hired Pete Fisher as general manager of the Opry. Fisher had solid music industry experience in artist management and music publishing. A few years earlier, he tried to get his client Paul Brandt, a rising country artist from Canada, booked on the Opry stage without luck. Even though Brandt had a couple of Top 10 hits in 1996, Opry management waited a few years, making it clear that they would be the ones reaching out to artists when they felt the time was right for a debut.

"And then when I got out there, I was surprised," Fisher said, "and I'll be real candid here, I was sad. I mean, it was like, gosh, how disappointing that this audience isn't just filled with three generations of fans and the stage isn't filled with three generations of performers."

Just five months into the job, after surveying (or perhaps scrutinizing) the landscape, Fisher dismissed five members of the Opry's house band. These were more than just hired hands–Buddy Harman, a first-call drummer for studio sessions, and guitarist Leon Rhodes, who had played guitar for Ernest Tubb, were dropped from the show, along with fiddler and guitarist Joe Edwards, rhythm guitarist Ralph Davis, and drummer Jerry Ray Johnson. In the *Tennessean*, Fisher announced his plans to hire a new fiddler and guitarist, along with a utility musician who could play mandolin, fiddle, and guitar. Recognizing that country music had changed drastically in the nineties, Fisher said he sought to find musicians who "could play more contemporary styles and sounds, and also utilize contemporary production, as opposed to where country music had been, which was a beautiful but more simplistic

presentation. It didn't mean the musicianship was any less. It was just a different kind of musicianship."

The move rankled many of the legacy artists, but Jeannie Seely acknowledged the decision to replace staff band members wasn't entirely out of line. "All those people were my friends and I felt bad for them, devastated for them, because I already knew what it was like not to be scheduled because you're being told you're not important enough. So, I hurt that way, but I also had to admit that some of the guys had gotten complacent and weren't developing their craft," she said.

Vince Gill took another angle in a 1999 interview with the *Tennessean*. "The real crux of the problem for me is in Garth and in Reba and in Alan and in Clint and on and on and on–the so-called big stars of today that don't support the Grand

Opry Live host Katie Cook interviews Vince Gill onstage for Opry at the Ryman, January 26, 2002.

Ole Opry," he said. "That's just a cold, hard fact. That's what it needs."

Asked about his comment from years ago, Gill replied, "I don't think that was controversial. I don't say that with any animosity towards anybody who's a member of this place. I can't help the way I feel about it, and I can't expect other people to have those same feelings and those same reasons. That's fair. But so many marquee-named artists never play the Opry. And I don't know why. I'm not trying to cast any kind of finger-pointing, or shame, or any of that. But the marquee value of a night with so many of those nineties folks who are members but haven't turned up . . . it could be pretty astounding!

"Because the beauty of that generation," he continued, "is the marquee value of so many of those artists. And you had that with Roy. You had that with Little Jimmy. You had it with Porter. And on and on and on. Most of those folks are gone now. You don't have that echelon of firepower out here to count on a lot of weekends. It's easy for an artist to say, 'Hey, I could be playing a stadium full of sixty thousand people, or down there for a few hundred bucks.' You can't fault them, and I don't. There's not an ounce of judgment coming from me by saying any of that. I just would've loved for the place to have had their presence. All it would do was make the Opry even better."

Fisher made the most waves among the elder cast members by reducing their appearances and offering more slots for guest performers. To further complicate things, Opry members would lose their health insurance if they didn't make a certain number of appearances each year, even if earning a spot on the

weekend schedule was beyond their control. It was no longer a given that Charlie Louvin or Stonewall Jackson, who'd been around for decades, would appear on Saturday night. Instead, audiences might hear young talent like Mandy Barnett, BR549, Elizabeth Cook, Craig Morgan, or Brad Paisley. By October, the front page of the *Tennessean* summed up the tensions in a six-word headline: "Young artists squeezing out music legends." Jan Howard, who'd been playing at the Opry for more than forty years, told the paper, "I don't want this to sound like sour grapes, but why not honor the people who have made the Opry what it is for seventy-five years?"

Ricky Skaggs tried to be a mediator between the generations. "It was hard. People like Stonewall or Jeanne Pruett and some others didn't get as many spots. It was easy for me to be caught in the middle because the new artists, or the new members, looked up to me. I didn't want to burn bridges with them, but I also wanted to honor and do what I could to make the other older members feel welcome, instead of agreeing and pity-partying with them. And there were some side musicians who were feeling a little fluffed as well. I think the Opry was going through a real identity crisis and some real growing pains," he said.

Jim Ed Brown, an Opry member since 1963, made an effort to befriend the new faces. "I've always loved to see talent come along, because as we grow older, something has to come along to take its place," he said in 2013. "I told Pete Fisher and the people out there, 'Bring in new talent because if you don't, when all of us old folks die, then what's going to happen to the Opry? Don't let that Opry die.'"

Not unlike other families gathered around a turkey and trimmings earlier in the day, the Opry family set aside their differences for a good-natured seventy-fifth anniversary special that CBS aired on Thanksgiving night. Over the two-hour show, performers talked respectfully about the past and remembered those who had passed on. They joked around and included the newcomers in the family rituals. Older members and younger members found common ground, usually through music. Garth Brooks shared his segment with Johnny Russell, John Conlee, and Porter Wagoner, with each singing a few lines of "Friends in Low Places." With his confident, full-throttle vocals, Conlee nearly stole the show.

Yet the program was spent mostly on reflection, with tributes to Roy Acuff, Patsy Cline, Bill Monroe, Minnie Pearl, Marty Robbins, and Hank Williams. While the special boasted a who's who of contemporary talent, the real showstopper was a segment featuring five Opry stars who were also members of the Country Music Hall of Fame: George Jones, Loretta Lynn, Little Jimmy Dickens, Dolly Parton, and Charley Pride. After each delivered a sampling of a signature song, they stood together in solidarity. More than thirteen million people tuned in.

Throughout January and February 2001, the Opry wintered at the Ryman. A regular guest performer who made no secret about his Opry ambitions, Brad Paisley officially joined the cast on the Ryman stage in February. Two months earlier, just nine days before Christmas, he'd been invited by Bill Anderson, Little Jimmy Dickens (dressed as Tater Claus), and Jeannie Seely (as Ms. Claus). Known for his quick wit and

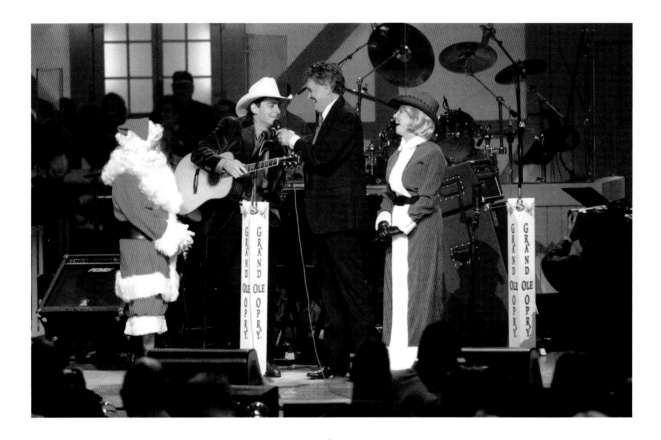

occasionally sentimental songs, Paisley found himself at a total loss for words when the long-awaited invitation arrived.

It would be eighteen months before the Opry celebrated another induction as America reeled from the terrorist attacks of September 11, 2001. On the CMA Awards show broadcast from the Opry House stage that November, Alan Jackson stunned country fans with a poignant original, "Where Were You (When the World Stopped Turning)." The Opry show carried on, even amid reports in December 2001 that WSM-AM would drop its classic country format, possibly in favor of a sports talk format, as Gaylord Entertainment was losing money on the station. After an overwhelming

public campaign to keep the station country, fans got their way.

Colin V. Reed, who had been named president and CEO of Gaylord Entertainment just seven months earlier, had mentioned in a private business meeting that he was open to the idea of adding a few hours of daily sports talk to WSM 650 in an effort to generate advertising revenue. Another employee in the meeting took the comment out of context and leaked the story to the *Tennessean*. Although Reed insisted there was never any intention

Little Jimmy Dickens, dressed as "Tater Claus," joins Bill Anderson and Jeannie Seely, who dressed as "Ms. Claus," to bestow an Opry invitaion on Brad Paisley, December 16, 2000.

of switching formats completely, he recalled that Bill Anderson, Jimmy C. Newman, Jeannie Seely, and other Opry members put appointments on his calendar at the height of the controversy.

"Most of the topic of discussion was the way the Opry was when it was on TNN to where it was when I joined," Reed said. "The Opry had sort of atrophied. We no longer had the theme park, and it wasn't being watched by as many people. In the theme park days, we were putting, annually, three-quarters of a million people through the Opry. When I turned up, that number was [in the] high four hundred thousands and not really on real TV. And so, the questions from the artists were, 'What are we going to do about that? How are we going to refresh the Opry to make it available to basically everyone in this country?'"

Meanwhile, the tug-of-war between Opry management and older members showed no sign of abating. Stonewall Jackson zeroed in on Pete Fisher, telling the *Tennessean*, "He said he would work as hard as possible until no gray hair was in the audience or on the stage." Then and now, Fisher denied the claim. Charlie Louvin kept a running tally of the shows he wasn't asked to play. Del Reeves complained that he was chastised for going over his allotted time onstage, which he claimed was due to sustained applause. Fisher declined to elaborate publicly on specific claims and instead emphasized his focus on broadening the Opry audience.

The Opry's reach was indeed growing. CMT began airing one-hour Opry segments on Saturday nights starting in August 2001, after

TNN rebranded as The National Network. Sirius Satellite Radio started its Opry broadcasts in November 2002. Additionally, artists who weren't typically a part of Opry activity were encouraged to be more involved. For example, in 2002, Kenny Chesney and Lee Ann Womack participated in an Opry tribute to George Jones. The Dixie Chicks broke the news from the Opry stage that Bill Carlisle and Porter Wagoner would be inducted into the Country Music Hall of Fame. With a decade of hits behind them, Tim McGraw and Toby Keith were belatedly slotted for Opry debuts as some longtime members waited for the Opry to call and schedule an appearance.

Darryl Worley, a promising new artist from Tennessee with a couple of country hits, had just returned from performing for American troops in Afghanistan and Kuwait when he appeared at a special Opry show on January 14, 2003, honoring military veterans. Just a day or two before, Worley finished cowriting a song called "Have You Forgotten?" and he taught it to his band in the dressing room that night.

From the Ryman stage, Worley could look into the eyes of his audience. He surmised that many of them were World War II veterans. As the song progressed, he'd see a cluster of them stand up, then another, until the whole room stood. Watching from the wings, Fisher caught Worley as he was coming offstage and invited him back on Saturday for the televised portion of the Opry.

This time, TV cameras captured the audience rising from the Ryman's pews just moments into the song. Fans retrieved the audio from the Opry archive over the weekend and sent it to

their local radio stations for airplay. Worley's single at the time fell off the chart as the Opry recording of "Have You Forgotten?" took hold. Worley quickly recorded a studio version of the song that spent seven weeks at number one and became the defining hit of his career.

"Have You Forgotten?" was considered by some as controversial, especially with the nation's divided opinion concerning the Iraq War, but the song's overall message aligned with the Opry's long-standing support of the US military. Worley noticed a couple of men in the Ryman pews that weekend who reminded him of the great-uncles he had grown up around. "I remember thinking those guys probably have the same stories," he said, "but you never hear much from those guys, because they had a whole different mindset of, 'I'm going to go home to my family and tuck this away.' You can kind of see that in people, and I saw a lot of it that night."

Few would have expected the Opry to appear in *GQ* magazine that summer, but there it was: an eight-page spread written by alt-country performer Robbie Fulks. An observant and sly writer, Fulks chronicled the deep history, the larger-than-life characters, and of course the biggest challenges facing the Opry just before its seventy-eighth birthday. Of their predicament, Fulks wrote, "While many of these midcentury figures are still in good form, their ranks are rapidly thinning, and they have no obvious heirs. When they die, the Opry will die with them, unless it allies itself with fresh talent and somehow broadens its appeal without sacrificing its identity."

Over the next two years, the Opry did exactly that.

The show brought on its first-ever musical director when Pete Fisher hired guitarist Steve Gibson in 2002. Gibson grew up listening to the Opry in his father's 1955 Buick; they would sometimes take family trips from Peoria, Illinois, to watch the show at Ryman Auditorium. Gibson moved to Nashville in 1972, at nineteen years old, and embedded himself in the local recording scene over the next thirty years. Upon joining the Opry staff, he was tasked with elevating the show's audio standards, strengthening the relationship between the musicians and artists, and preparing the fragmented audio archives for digitization. Gibson would spend the next sixteen years at the Opry, with an unrivaled front-row seat for a new generation of country artists, including Trace Adkins, Terri Clark, and Dierks Bentley.

Possessing a masculine swagger and singing in a resonant bass, Trace Adkins's music quickly gained a foothold on the chart. For his 1996 debut at the Opry, he chose to perform his first two singles, "There's a Girl in Texas" and "Every Light in the House Is On." During his set, he also planned to ask his girlfriend to marry him. The stage manager asked Adkins if he was going to play his own guitar; Adkins said all that was already taken care of. But when the stage manager wondered if that meant Adkins would be singing a cappella, it became apparent there had been a breakdown in communication.

"The Opry thought I was bringing my band, and my management company thought that the Opry staff band was learning my stuff. Neither of those things happened," Adkins said. "So, ten minutes

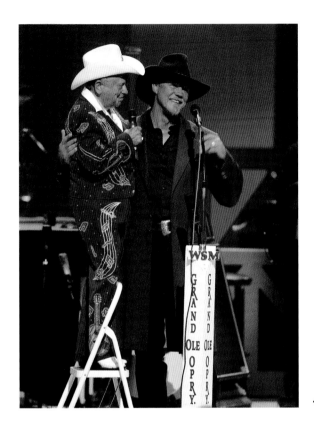

before I'm supposed to walk out onstage, my friend ran out to his truck and got a copy of my album and came back in, gave it to [Opry band guitarist] Jimmy Capps, and they charted those two songs in about five minutes. Didn't even go over them. We went onstage, and they played them just like it sounded on the record."

After he left the stage, relieved that the band had played his songs perfectly and that his girlfriend had accepted his marriage proposal, Adkins took two people from his management team into his dressing room and closed the door. "That's the only time that I know of that the door to Mr. Acuff's dressing room was ever closed," Adkins

Little Jimmy Dickens uses a stepladder to deliver Trace Adkins's Opry invitation, June 14, 2003.

added, "but the things that I needed to say . . . that door had to be closed."

On June 14, 2003, just weeks before the release of a *Greatest Hits* album, Adkins accepted his Opry invitation from Little Jimmy Dickens, who carried a stepladder to the stage, perched himself at the top, and asked, "Just how bad would you like to become a member of our Grand Ole Opry family?" Shocked, amused, and humbled all at the same time, Adkins managed to reply, "I want it pretty bad." Twenty years later, Adkins relives that moment frequently; it's the only career-related photo he displays in his home.

Two months after Adkins joined the cast, blue-grass star Del McCoury followed on October 25, 2003. McCoury, who first played the Opry as a member of Bill Monroe's band, grew up listening to the radio show with his family on Saturday nights. His brother taught him to play guitar at nine years old, but Del switched to banjo at eleven, as soon as he heard Earl Scruggs.

In 1963, Monroe walked into a Baltimore bar where McCoury was playing in a band with his friend Jack Cooke, a guitarist who'd been in Monroe's Blue Grass Boys in the late fifties. Monroe needed a guitarist and a banjo player for a gig in New York City; Cooke and McCoury agreed to go. Afterward, Monroe offered McCoury a job, but he declined. A friend talked him into reconsidering and even drove him to Nashville, where Monroe was prepared to audition him. Another banjo player named Bill Keith landed the job, but Monroe asked McCoury if he would play guitar and sing lead instead.

"I thought, 'Oh man, I didn't come down here for this.' But I didn't say anything to him because

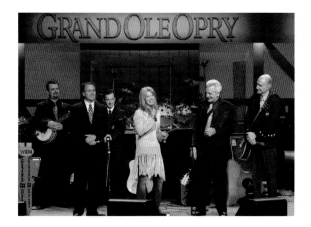

McCoury toured with Monroe for a year, moved briefly to California, then returned to his home state of Pennsylvania to work as a logger. Touring on weekends, he developed a following in the 1970s with his own band, the Dixie Pals. By the 1990s, the ensemble encompassed his two sons and evolved into the Del McCoury Band. He received his Opry invitation from Ricky Skaggs and Sonny Osborne on October 2, 2003, during the International Bluegrass Music Association Awards in Louisville, Kentucky. The surprising moment marked the first public invitation to be made away from the Opry stage.

The Opry's next inductee, Terri Clark, had her eye on the wooden circle since she was a teenager in Medicine Hat, Alberta, Canada. A card-carrying member of Reba McEntire's fan club, Clark improved her guitar playing by picking along with Ricky Skaggs records. In 1987, when she crossed the Canadian border into the United States with her mother and a family friend, Pat, the border guard spotted the guitar among the suitcases. When he asked where they were going. Pat looked at Terri and responded, "We're going to the Grand Ole Opry!" What the guard didn't know was that the eighteen-year-old passenger wouldn't be making the return trip.

he's the chief and I was up for the challenge," McCoury said. "I thought, 'Well, I'll try it.' He said, 'You'll like this job better,' and, of course, in my mind, I thought, 'He's wrong there.' Actually, I don't know if I liked it better, but when I did quit [touring with] him and it was time for me to get my own band, it worked so much better if I was to be the guitar player and the lead singer . . . He proved himself right there. I'm still doing it that way."

"I knew all about the Opry when I moved to Nashville," Clark said. "We couldn't necessarily pick up WSM in Medicine Hat, Alberta, but I watched all the country music shows I could. I watched *This Week in Country Music* and the Barbara Mandrell show, and [listened to] all the radio shows, like the country countdown on my local station. I bought *Country Rhythms* magazine and *Country Song Roundup* and read every bit of literature and biography and

autobiography about country music and country music artists. The Opry, of course, is the Holy Grail. It's the top of the mountain that everybody wants to get to, and I was no different. The first time I came to Nashville as a tourist, this was on the list the first day we got here, I said, 'We have to go watch the Grand Ole Opry. I just want to say I sat in that seat and watched the show.'"

After playing daytime gigs at Tootsie's and getting rejected by pretty much every label in town, Clark broke through in 1994 with her debut single, "Better Things to Do," and rarely strayed from her country leanings. Just one month before releasing a *Greatest Hits* collection, Clark became the first Canadian woman to join the Opry cast on June 12, 2004.

OPPOSITE, FROM TOP: Steve Wariner helps Linda Clark surprise her daughter Terri with an Opry membership invitation on May 15, 2004; Patty Loveless and George Hamilton IV welcome Del McCoury to the Opry cast on October 25, 2003. ABOVE: Dierks Bentley shares the stage with his dog Jake as he accepts his membership into the Grand Ole Opry, October 1, 2005.

Although Clark had been obsessed with the Opry for years, Dierks Bentley hadn't even heard of it when he moved to Nashville in 1994 as a Vanderbilt University transfer student. He listened to country stations growing up in Arizona, but received his true musical education by tuning in to WSM 650, where he discovered artists like Jimmy Dickens, Connie Smith, and Porter Wagoner, and by catching shows at the Station Inn, an unassuming bluegrass club where he befriended some of the city's young pickers. One of his new friends, Terry Eldredge, played guitar with the Osborne Brothers and invited him to the Opry as his guest.

"Being backstage at the Opry House with those guys and seeing what goes on behind the scenes, bringing people onstage, the banter in between songs and the commercials and the audience—there's the history of it all. You just feel it when you're backstage. I remember thinking, 'This is cool.' I know a lot of people my age probably thought it wasn't that cool. They maybe thought it was an older thing, or more of a historical thing, but for me I sensed it right away. This is cool. This is the roots of the music. The fans that come here to see this recognize the authenticity of it as well. It's just something I wanted to be around as much as possible," Bentley said.

From that night on, playing the Opry became Bentley's primary ambition. He took a day job at TNN working in the tape library and helping producers find archived performance clips for network shows. While looking through tapes, he became intrigued by vintage television series like the 1950s Purina-sponsored shows and *Pet Milk Grand Ole Opry*.

The Opry always reserved a few spots on its backstage list for TNN executives to bring clients or VIPs, and while Bentley didn't fall into any of those categories, he routinely added his name to the list after work on most Friday afternoons. He'd start the night at the Opry, then go to the Lower Broadway honky-tonks.

Associate producer Gina Keltner, who'd joined the Opry staff in September 1999 as Pete Fisher's assistant, started noticing a pattern. "We had an arrangement with TNN to let them have an allotment of backstage guests every weekend, and that was intended for their sponsors and VIPs that they were socializing with that weekend, and I noticed that they had turned in Dierks's name. It was like, 'Well, I guess that's OK this time,' but then his name started appearing on every list that they would turn in," she said.

Because the Opry staff didn't get backstage privileges, let alone TNN employees, Keltner said she decided that Bentley needed to scale back his visits. She emailed his boss as well as TNN's executive assistant to suggest limiting his backstage visits to once a month.

"That hurt," Bentley admitted, "but it was good motivation to get my own backstage pass, as far as getting a chance to play it for real, and not just be snooping around and watching." To stay focused, he changed all his internet passwords to "Petefisher." He once cut short a Saturday night date, feeling that he should be at the Opry House instead. He handed out homemade CDs to Opry staff, even telling Keltner that it would be her lifetime backstage pass to any of his shows.

All was forgiven when Bentley signed a record deal and made his Opry debut on April 18, 2003. Coming offstage after performing his rowdy first single, "What Was I Thinkin'," he was amazed that Sonny Osborne had watched the segment at the side of the stage. After all, Bentley had spent thousands of hours listening to the Osborne Brothers and studied the harmonies on their records. With a good-natured laugh, he recalled Osborne's terse comment: "Could you hear *anything*?!"

On a hit streak at twenty-nine years old, Bentley snagged an Opry invitation from Marty Stuart onstage at the House of Blues in Los Angeles on July 26, 2005; Bentley brought along his parents and his dog, Jake, to the induction ceremony on October 1, 2005. Just seven weeks later, he collected a CMA Award for Best New Artist at Madison Square Garden in New York City. While that annual ceremony had taken place at the Opry House since 1974, the Country Music Association reasoned that getting country music in front of the Manhattan advertising industry might prove lucrative. With the Opry turning eighty years old in 2005, Gaylord executives decided to make the trip, too. They brought the Opry to Carnegie Hall for the first time since 1961 and staged it the night before the CMA Awards with an all-star cast.

"I think that any time you can take country music to a place that you might not have expected to hear it, it elevates our genre," said Trisha Yearwood, one of eleven Opry members to perform that night. "I came along in the nineties, so we were already in a place where country music was becoming more mainstream. I didn't have

OPPOSITE, FROM TOP: Vince Gill and Little Jimmy Dickens share the Carnegie Hall stage, November 14, 2005; Bill Anderson and Brad Paisley at Carnegie Hall

to have the fight that some of the people that came before me had, of 'Oh, it's all about hay bales' and whatever. It's really a global music. Carnegie Hall to me was one more benchmark of 'We belong here.' It was an honor to be a part of that."

Then the Opry took a moment to catch its breath. No new members joined in 2006, even as rising talents such as Eric Church, Taylor Swift, and Chris Young made their Opry debuts. That same year, seventy-seven-year-old Opry member Billy Walker, his wife Betty, and two band members were killed when their van wrecked outside of Montgomery, Alabama. A regular in the Opry lineup, and a frequent segment host, Walker was remembered for his genial smile and gentle spirit in the Opry hallways.

Since 2000, the Opry family had lost a significant number of cast members, including Bashful Brother Oswald, Bill Carlisle, Skeeter Davis, Don Gibson, Jim McReynolds of bluegrass duo Jim & Jesse, Johnny Paycheck, Johnny Russell, and Teddy Wilburn. By the end of the decade, Ernie Ashworth, Hank Locklin, Del Reeves, and Charlie Walker had also passed on. But with Porter Wagoner's death in October 2007, the Opry mourned perhaps its most prominent ambassador.

Five months before Wagoner's passing, Dolly Parton returned to the Opry stage to serenade him with "I Will Always Love You," a ballad closely associated with Whitney Houston, who made it a Grammy Award–winning pop smash in 1992. However, Parton had written it as a farewell to Wagoner in 1973 as she made the

decision to step away from his television show and touring group. Their emotional onstage reunion coincided with Wagoner's fiftieth anniversary as an Opry member.

"I knew I had to do that. Although we had gone our separate ways, Porter and I had made up our differences. We had a few little legal problems and all that stuff, but life goes on and you can't live with that. I thought, 'I want to go back, and I want to be with Porter.' I wanted to show him that I appreciated him. We kind of got started there, so it was only right that I help him celebrate his fiftieth year on the Opry because that was a big deal to him. That was the least I could do, and I was happy to do it," Parton said.

In a 2011 interview, Eddie Stubbs recalled going to see Wagoner in the hospital the day before the singer entered hospice care. Wagoner spoke weakly: "That new boy they're putting on the show this weekend to make a member . . ."

"Josh Turner," Stubbs responded.

"Yeah, Josh Turner," Wagoner replied, slowly. "The Opry's really getting a good singer. They're really getting a good man."

Born and raised in South Carolina, Turner started singing as a kid at church. Because his grandmother loved bluegrass gospel, well-worn albums by the Stanley Brothers and the Osborne Brothers were the soundtrack of his childhood. A few months after earning a bachelor of music degree from Belmont University in 2001, Turner landed a record deal with MCA Nashville.

Dolly Parton sings "I Will Always Love You" to Porter Wagoner in their last appearance together, May 19, 2007. Left to right: Marty Stuart, Buck Trent, Parton, Wagoner, and Harry Stinson

Although he was still completely unknown, without a single or a promotional photo, he tracked down Pete Fisher's email address and begged for a slot on the Opry. Though Fisher was skeptical, he offered a one-song appearance on December 21, 2001, late in the show on the Friday before Christmas. Turner brought along a demo of a gospel-tinged country song he'd written and recorded in college called "Long Black Train" for the band to learn. Bill Anderson introduced him to the stage.

"It was one of the most high-pressure situations I'd ever been in," Turner recalled. "The first time through, I did the song like I was supposed to do it. So that part of it wasn't the problem. But when I had gotten through the first verse, people just started standing up out in the crowd. It just really unnerved me. I'd never had that happen before, not that I had done a lot of shows prior to that. But I was at the Opry. I was at the Ryman Auditorium. I was on the stage where Hank Williams had gotten six or seven encores of his debut of 'Lovesick Blues.' I'm looking up at the same balcony he looked up at . . . I was nowhere near finished with the song but people, one at a time, they would start popping up and clapping and hollering and stomping their feet. Somehow or another I made it through the first round of that song, and by the time I had finished, the whole crowd was on their feet. They were so loud."

Turner waved to the audience and walked offstage, overwhelmed by the response but also oblivious to the stage manager's shouts for his attention. Finally realizing that Anderson was calling him back for an encore, Turner obliged but scrambled up the lyrics while trying to get hold of his emotions.

"I remember vividly after that second round of it, I went back up to the dressing room and fell down into the couch, trying to figure out what just happened," Turner adds. "Shortly after that, Pete came up to the dressing room and he said, 'Josh, you're welcome to come back anytime.' Which was great, but at the time, I was just thinking, 'Man, I don't know if I can handle this again!'"

Four years after introducing "Long Black Train," and with a couple of chart-topping hits to his name, Turner was inducted into the Opry on October 27, 2007. Wagoner died of lung cancer the next day.

For Turner and Bentley, the Opry invitation came relatively quickly. In contrast, some of the most established artists in country music were kept waiting. Mel Tillis, who was tapped for the cast in 1969 but didn't stay, returned in 2007 at age seventy-four. Charlie Daniels signed on in 2008 at age seventy-one. Both men were staples of seventies country radio, with Tillis's "Coca Cola Cowboy" and Daniels's "The Devil Went Down to Georgia" reaching number one in back-to-back weeks in 1979. Although their commercial peak had passed, their familiarity

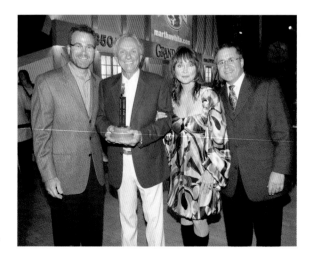

made them instant Opry favorites, despite the belated invitations.

Presiding over her father's induction ceremony on June 9, 2007, Pam Tillis happily remarked, "All week long, people have been coming up to me and saying, 'I can't believe your dad wasn't already a member.' I guess that's because you belong here. And I just want to say that the best thing about going in here before you is the fact that I get to be the one to induct you."

Charlie Daniels received his Opry invitation from Martina McBride on November 19, 2007, at Ryman Auditorium, where he was hosting his annual Christmas 4 Kids concert. As Daniels recovered from the moment, the curtain at the back of the stage lifted to reveal the Opry backdrop. A stagehand swiftly placed Daniels's microphone into an Opry microphone stand.

"It was almost surreal. It was almost like a dream," Daniels said in 2011. "We had played the Opry. They have always been very kind about letting us play the Opry. If we're going to have a Saturday night off and we wanted to play, we'd call and they'd say, 'Come on out!' And we did it so many times, but I was getting to the point I thought, 'Well, maybe the membership part will never happen.' The reason that was important is because this has been such a big part of my life for so long . . . And to think about my name being included [among] every name that has been something like a cornerstone in country music–the Ernest Tubbs, the Eddy Arnolds, the Roy Acuffs, the Hank Williamses–to be included in the same company as that was something very special to me, and something I take very much to heart."

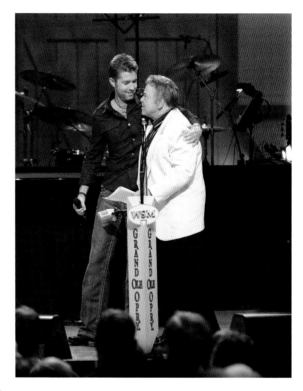

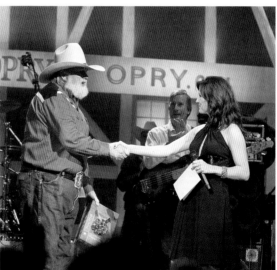

OPPOSITE: Mel Tillis receives his Opry Member Award from his daughter Pam Tillis on November 19, 2007. Left to right: Steve Buchanan, Mel Tillis, Pam Tillis, Pete Fisher. TOP: Roy Clark invites Josh Turner to be the newest Opry member, September 29, 2007. BOTTOM: Martina McBride surprises Charlie Daniels on the Ryman stage, November 19, 2007.

Like Patsy Cline before her in 1957, Carrie Underwood captured America's attention on a network television talent show. Underwood grew up in Checotah, Oklahoma, the same small town where Opry member Mel McDaniel was born. As a young girl, whenever her parents played McDaniel's classic hit "Baby's Got Her Blue Jeans On," Underwood would race to her room to put on her jeans. She'd seen the Opry on TNN at her grandparents' house and spotted the Opry House from Briley Parkway on a family trip as a young girl. After taking the next exit and following the signs, Underwood and her family drove toward the Opry House to get a closer look. However, she never actually saw the inside of the venue until her debut on June 10, 2005, mere weeks after winning *American Idol* and in the chaos of CMA Music Festival, when thousands of country fans from around the world descend upon Nashville.

"I think at the time, I was just having so much fun and excited to just be in it, whatever it was," Underwood recalled. "I was like, 'I don't know where this is going. Just on God's good graces.' And it could have been my first and last time at the Opry or doing all the crazy things in Nashville but instead, it was the beginning of a lot."

Underwood's climb to superstardom was breathtaking. Nearly three years after that debut performance, she'd sold millions of albums, charted five number one singles at country radio, and won nearly every industry award imaginable. Still, after delivering a rendition of Randy Travis's "I Told You So" on the Opry stage on March 15, 2008, she was stunned when Travis himself extended an Opry invitation. Her

performance was serviced to CMT and other outlets as a music video.

"It was such a wonderful moment that we did want to share," she said. "If we want to think long-term and make sure the Opry stays around for as long as possible, we need people to come see it. It is important for those of us who are involved to put as many eyes on it as possible. I feel like making that music video helped. Maybe some people saw it that weren't ever exposed to the Grand Ole Opry and would want to come visit in person."

If Carrie Underwood's Opry invitation seemed inevitable, the opposite could be said for Craig Morgan. Raised just outside Nashville in Kingston Springs, Tennessee, Morgan didn't long for country stardom. Occasionally, he'd get dragged to the Opry House as a kid because his father played bass for a couple of TV shows that were filmed in a smaller studio inside the complex. Morgan remembers seeing George Jones and Tammy Wynette having a quarrel in the parking lot, then singing harmoniously for the cameras, but he acknowledges that he didn't pay much attention to his surroundings as a kid.

At age ten, Morgan sang "The Star-Spangled Banner" at a school field trip; Minnie Pearl happened to be in the audience and told him, "Son, someday you're going to be a famous singer." But instead of getting into the music industry, Morgan joined the army and served for seventeen years. While stationed abroad, he started working on his songwriting, thinking that maybe he could get some songs recorded by country artists to supplement his income. Once he returned home, he cut some demos to pitch his songs. A major label liked what they heard

GRAND OLE OPRY.

WELCOMES ITS NEWEST MEMBER

CARRIE UNDERWOOD
MAY 10, 2008

©.2008 HATCH SHOW PRINT JGB

CLOCKWISE FROM TOP LEFT: Carrie Underwood kisses her Opry Member Award, May 10, 2008; recent *American Idol* winner Carrie Underwood makes her Opry debut, June 10, 2005; Carrie Underwood cries after Randy Travis surprises her with an invitation to join the Opry during a performance of his song "I Told You So" on March 15, 2008; Hatch Show Print celebrating Carrie Underwood's induction

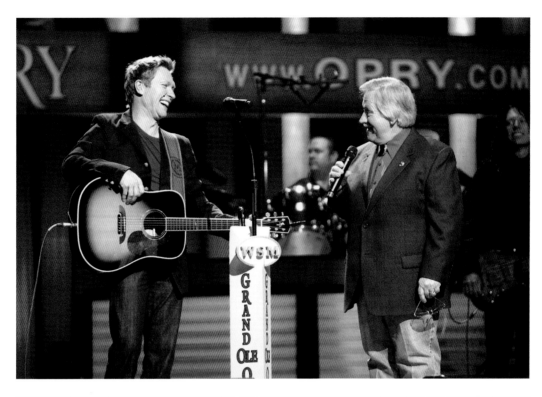

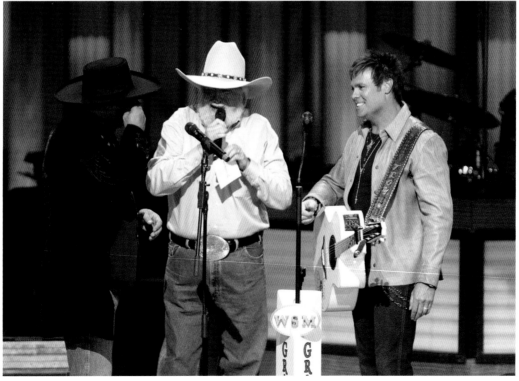

and signed Morgan to a record deal. Country radio barely responded; the Opry, however, took a chance.

On April 21, 2000, Morgan was introduced to the Opry stage by one of his musical idols, John Conlee. With his career getting a slow start, Morgan was frequently available for guest spots on the Opry. Finally in 2003, after signing to an independent label, Morgan climbed into the Top 10 with "Almost Home." In March 2005, he joined Ricky Skaggs, Trace Adkins, and the Oak Ridge Boys for the Opry's first telecast on Armed Forces Television, with live feeds to and from soldiers stationed in Iraq. A sentimental ballad that would become the biggest hit of his career, "That's What I Love About Sunday," had just started its ascent to number one. By then, Morgan was practically begging to join the Opry.

"I played the Opry almost two hundred times before they made me a member," Morgan said. "I was a brand-new artist, so it ain't like I was out making money, so every chance I got to play the Grand Ole Opry, I did it. And I *loved* it! After a couple of years of that, I started saying, 'What do I have to do to be a member?' I'm not saying that I deserve it, but I want to know. If I need to do something, I want to check the box."

The moment finally arrived—but not on the Opry stage. On September 19, 2008, Conlee shocked Morgan with an Opry invitation in the middle of a performance at Fort Bragg, North Carolina, the military base where Morgan had served from 1990 to 1992. After Conlee formally inducted Morgan

OPPOSITE, FROM TOP: John Conlee inducts Craig Morgan into the Grand Ole Opry, October 25, 2008; Charlie Daniels invites Montgomery Gentry to join the Opry cast, May 26, 2009.

into the Opry cast on October 25, 2008, they sang Conlee's hit "Rose Colored Glasses" together.

Another curveball invitation arrived on June 23, 2009, when Charlie Daniels emerged from the audience and marched directly to the stage with an offer of Opry membership for his good friends in the duo Montgomery Gentry. Rowdy and relatable, Eddie Montgomery and Troy Gentry's reputation as entertainers had been established through playing clubs around Lexington, Kentucky. When they started picking up an impressive run of country hits, their everyman demeanor onstage and off remained exactly the same. The invitation could be seen as a passing of the torch from Daniels, who charted his last Top 10 hit in 1988, to Montgomery Gentry, who'd just earned their fifteenth one a few weeks earlier.

"Me and T just lost it," Montgomery said. "To get introduced to the Opry by Charlie Daniels, it don't get no better than that, man. And then Little Jimmy was there and Marty Stuart was there when we got inducted. I get cold chills thinking about it right now. We got to meet a lot of our legends and heroes who have passed now. And we got to do songs with them. We got to do records with them. I hate that for a lot of the young artists now, because they're gonna miss a lot of them guys that were characters."

The fact that country stars from three different eras—Little Jimmy Dickens, Charlie Daniels, and Marty Stuart—welcomed Montgomery Gentry into the Opry illustrated how the vision for a multigenerational cast had taken root over the prior decade. But not even the most seasoned Opry star could have foreseen the disaster waiting around the bend.

THE RIVER

ABOVE: Opry stage door, May 3, 2010. OPPOSITE, TOP: Flood waters in the Opry Plaza, May 3, 2010. OPPOSITE, BOTTOM: Minnie Pearl's Mary Jane shoes, Roy Acuff's fiddle, and Marty Robbins's cowboy hat were some of the artifacts rescued from rising flood waters by Opry staff. FOLLOWING SPREAD: Grand Ole Opry House stage and pews covered by flood waters, May 3, 2010

THE GRAND OLE OPRY HOUSE SITS ALONG A CURVE OF THE CUMBERLAND RIVER. And that river was rising fast in May 2010.

For two days, the rain wouldn't let up. Saturday was distressing, but the relentless downpour that continued on Sunday, May 2, 2010, decimated areas of Nashville. Sunday ultimately set the record for the city's wettest calendar day ever, reaching 7.25 inches of rain. Adding in Saturday's rainfall, that figure rose to a devastating 13.57 inches.

Steve Buchanan had been in touch that Sunday with Sandy Liles, who oversaw the Opry's video archive. Security tipped her off that the water levels were rising. Buchanan grabbed his waders and drove to the Opry property. He walked through the water to the archive and started moving things to an upper floor. With Liles and fellow Opry employees Debbie Ballentine and Rex England also on hand, Buchanan turned his attention to rescuing file drawers. Behind him, he could see the water rising along the glass pane of an exit door. With the fear of being trapped or electrocuted, the staffers scrambled out of the building.

Buchanan and the others met up with Brenda Colladay, Sally Williams, and Williams's husband, Brad Bissell, to save what they could in the second tape library in the former TNN building. Then they headed to the Grand Ole Opry Museum. Colladay, the museum's curator, hustled to move as many artifacts as possible to a mechanical room in an attic space, including Roy Acuff's fiddle and Minnie Pearl's Mary Jane shoes. Williams, who was Ryman Auditorium's general manager at the time, remembered the rescue effort almost like a factory line, with everyone grabbing whatever they could and putting it as high as possible, as quickly as possible. When it became unsafe for staff to remain on property, Buchanan drove to a nearby grocery store to buy food for the Opryland Hotel guests who had been evacuated to a high school down the road.

On Monday, the Opry's front-of-house engineer, Tommy Hensley, met Pete Fisher with a canoe at the security gate adjacent to Briley Parkway, right where the floodwater ended. They rowed toward the backstage artist entrance and saw that the water had risen to about ten inches below the awning. They needed to find another way in.

"So we went around the other side and managed to get a door open," Fisher recalled. "Then we floated the canoe down the hallway between the back section of pews and the main pews. And if you were in the front row, the water would have been seven feet over your head, because the water was almost four feet onstage, and the stage was elevated by forty inches. So it was devastating. You could smell our liquid propane tanks that had overflowed, and your eyes would burn, and of course there was no power in the building."

After that, Fisher and Colladay took the canoe to the Acuff House, where staff had moved the file cabinet drawers that stored the Opry's photograph archive up from the basement. Fisher and Colladay tied their canoe to the balcony on the second floor and stepped over the railing. The flood had surpassed all predictions—on the main floor, they found the photo collection underwater. They returned to the boat and paddled across the plaza to the museum, where they tried to enter—unsuccessfully, due to the building's electronic locks. When they rowed back to their vehicles at the security gate, they were greeted by a diminutive figure smoking a cigarette. Jimmy Dickens wanted to get his stage costumes. Fisher had to break the news that there was no way to save anything that day. Then, thinking about the residual propane in the water, Fisher politely asked Dickens to extinguish his cigarette.

To keep the show going, Buchanan wanted to go to one of the Opry's historical homes; however, the Ryman (which was not damaged in the flood) already had a concert on the books for Tuesday night. He called Brent Hyams, a former marketing colleague at the Ryman who now oversaw operations at War Memorial Auditorium, which was in the middle of a renovation.

"I immediately started writing down all the history of the Opry and making sure that every dressing room had the history in it, so that the artists would read it. Then they would, one, feel at home because we were a former home and the Opry had never been back, and two, they would be able to say things that were accurate," Hyams noted. "From a marketing

250

ABOVE, FROM TOP: Grand Ole Opry Museum, May 3, 2010; Kevin Reinen, Opry chief technical engineer, holds a "halo" over the head of WSM-AM chief engineer Jason Cooper, who successfully harnessed the AT&T 3G signal that enabled the Grand Ole Opry to broadcast live from War Memorial Auditorium on May 4, 2010. Cooper recalled, "It was a miracle to be on the air." OPPOSITE, FROM TOP: Performing "Will the Circle Be Unbroken" onstage at War Memorial Auditorium during the Opry's first broadcast after the flood are, left to right: Tim Atwood, Hoot Hester, Chris Young, Jimmy C. Newman, Kerry Marx, Jeannie Seely, Suzy Bogguss, Connie Smith, Mark Beckett, Marty Stuart, Jim Ed Brown, Michele Voan Capps (music librarian), Steve Gibson, Jack Greene, Restless Heart (Larry Stewart, John Dittrich, Greg Jennings, and Dave Innis), and Jimmy Capps, May 4, 2010; Charlie Daniels performs on the Opry at Two Rivers Baptist Church on May 15, 2010.

standpoint, it's like people have memories, but they don't have the exact memory. It was my job to make sure that they got it right."

From the security guards to the box-office attendants to the gift shop cashiers, Opry employees showed up with a determination to make the show come together. Leading up to the live broadcast, WSM-AM engineer Jason Cooper couldn't locate any working phone or ISDN lines in the venue. When the crew found a faint 3G signal outside the building, they opened a window and set up the remote unit, atop an apple box, on a window ledge. The announcer's podium, salvaged from the Opry House and still bearing mud stains, was hauled onto the War Memorial Auditorium stage.

As the evening's announcer, Eddie Stubbs informed the audience that Bill Monroe, Minnie Pearl, and Ernest Tubb had been inducted into the Opry inside this very building. Marty Stuart offered words of consolation and sang "Let the Church Roll On." Tennessee senator Lamar Alexander performed "The Tennessee Waltz" on piano. At the close of the night, Opry stars Jim Ed Brown, Jack Greene, Jimmy C. Newman, Jeannie Seely, Connie Smith, and Marty Stuart joined guest artists Suzy Bogguss, Restless Heart, and Chris Young to sing "Will the Circle Be Unbroken," one of country's anthems of solace.

Seely, whose home was extensively damaged in the flood, recalled, "It never, ever entered my mind not to go to the Opry. When I went in and they were like, 'What are you doing here?' my first comment was, 'Well, it wasn't like I could stay home and watch TV.' I didn't have a home, TV, nothing to sit on. But it just simply never entered my mind not to come to the Opry. It's your job, it's where your heart is, and like I said, I'm wanting to see everybody."

Addressing perhaps the most pressing question, the *Tennessean* reported that the historic circle from the Opry House stage was saved and preserved; a thick coat of varnish protected it from irreversible damage. However, the rest of the stage floor would be replaced, as would the backstage lockers, the walls in the dressing rooms, the soundboard, and nearly everything else the water had touched. In the lobby, the water rose to twenty inches; backstage, it reached an astonishing forty-six inches. Within days, the Opry House was stripped to its concrete foundation.

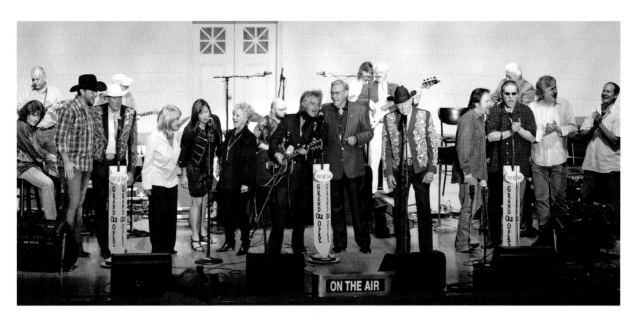

"Everyone's office was flooded, so we set up camp in the corporate building in a conference room," Buchanan said. "I made a sign for the door that said it was the Opry World Headquarters. That's where we worked for the next however many weeks. The first six weeks were really hard because you're dealing with the destruction. And then it was more about the phoenix rising and the rejuvenation."

For the Ryman shows on May 7, 8, and 11, Opry members Brad Paisley, Alan Jackson, George Jones, Martina McBride, Joe Diffie, and John Conlee confirmed appearances. After that, the Opry traveled. On May 14 and 15, the show set up at Two Rivers Baptist Church on the other side of Briley Parkway. The May 25 show at the Ryman raised funds for Middle Tennessee flood relief, with music from Vince Gill, Brad Paisley, Ricky Skaggs, and Steve Wariner.

In June, Tennessee Performing Arts Center's Andrew Jackson Hall and David Lipscomb University's Allen Arena staged Opry shows for the first time. During the CMA Music Festival, the Opry moved back into Municipal Auditorium for a night, just as it did during the 1975 flood. That all-star lineup included Bill Anderson, Little Jimmy Dickens, Josh Turner, Carrie Underwood, and Trisha Yearwood.

"It was fun to go back down to the Municipal and do the Opry again, I will say that," recalled Tim Thompson, the Opry's longtime stage manager. Two Rivers Baptist Church might

have been the easiest venue, he added, but it was still a chore to deal with load-in and load-out of the barn backdrop, the podium, the microphones, and everything else the show needed to run efficiently.

Sally Williams, who offered multiple nights at Ryman Auditorium during the ongoing flood repairs, observed, "Being able to do the Opry shows in other locations . . . it was terrible. No one would ever have wished that. But I think a bit of a blessing in that is that we were able to show that the Opry is really the people and it's the show. It's not the building. And everybody did what they needed to do for as long as they needed to do it."

Flood repair costs were soaring across Nashville, with an estimated $2 billion in damage done to the city. Twenty-six people in the region died in the storm's aftermath; roughly ten thousand others were displaced. A report in July estimated that $20 million would be needed to renovate the Opry House, with $170 million necessary for all of Gaylord's properties, including Opryland Hotel. Colin V. Reed, Chairman and CEO of Gaylord Entertainment since 2001, faced the adversity with an investment. The Opry allocated more than $1.7 million to restore and digitize the video archive, plus roughly $650,000 for the restoration of damaged artifacts, instruments (including those that belonged to Opry members and the museum collection), and photograph collections. Reed recalled that he fast-tracked more than $250 million in repairs and enhancements to the Gaylord properties. A ten-foot-high flood wall and perimeter flood protection system were completed in 2012 at a cost of $17 million.

"Whenever you get turmoil in an industry or turmoil in a business, look for the green shoots, look for the opportunities. That was what we did with the Opry back then," Reed said. "Steve Buchanan had come to me prior to the flood and basically said, 'We need to spend some money backstage because it looks pretty awful.' Then we had the flood, and then my view was, 'Well, why not blow the backstage completely up and tell the story of the eighty-five years of history?' And that's what we did. We spent a lot of money redoing every one of those dressing rooms to different themes, different standards, to honor the people who had stood in those dressing rooms beforehand."

Today, the dressing rooms memorialize Opry legends such as Roy Acuff and Porter Wagoner, and illustrate themes like bluegrass, patriotism, cowboy singers, and the women of country, to name a few. The centrally located greenroom is a welcoming hub, decorated with photos of notable Opry moments spanning decades. Musicians and tourists mingle in the hallways. Bags of bright yellow popcorn are stuffed into baskets for visitors to enjoy. A mural-size print of a painting by Archie Campbell adds a nostalgic element to the mix. An unassuming metal marker next to the coffee station reminds passersby just how high the floodwater rose.

"I heard somebody at some point describe the Opry before the flood as looking like a high school. The fluorescent light and the bare walls. It was very sterile. I remember those days, but you didn't really focus on that as much as you focused on the experience and the artists that were here," Josh Turner said. "But after the flood, when they rebuilt and designed everything, and every room had a theme, and you walk in and it kind of feels like a museum . . . I felt like it did the Opry a huge service because it has a story to tell, and this is a cool way to tell the story."

At an August press conference, Brad Paisley and Little Jimmy Dickens helped construction workers replace the wooden circle at center stage. Dark Brazilian teak stage flooring now surrounded the lighter circle, and the planks first installed fifty-nine years earlier at the Ryman stood out brightly under the stage lights. Calls went out to Opry members for a September 28 reopening celebration. As the new curtain slowly rose, its motor sputtered and failed just before reaching the top. While all eyes were on the procession of Opry stars, a stagehand carefully climbed into the rafters and manually cranked the curtain the rest of the way.

After five agonizing and exhausting months, a feeling of fellowship and a sense of anticipation filled the Opry pews. Backstage, dressing room doors stayed open all night as friends and artists hugged tightly and wept in relief. With this joyous night of homecoming, and television camera operators ready for their cue, the Opry picked up right where it had left off.

OPPOSITE: The Opry House undergoes extensive remediation and renovation following the Nashville flood in 2010. ABOVE: Brad Paisley and Little Jimmy Dickens unveil and reinstall the Opry circle after the 2010 flood, August 25, 2010.

COUNTRY COMES HOME

2019

n September 28, 2010, the Grand Ole Opry House raised its curtain for the first time in five months, and Brad Paisley fought back tears to sing "Will the Circle Be Unbroken" with his friend Jimmy Dickens by his side. They were joined onstage by more than thirty Opry members, as well as a handful of guest artists, including Jason Aldean, Blake Shelton, and Keith Urban. Viewers tuning in to the Great American Country broadcast, titled *Country Comes Home: An Opry Celebration*, were able to catch a glimpse of the new dressing rooms, watch interviews with people affected by the flood, and, of course, see the circle at center stage.

"It's good to be back. It's good to be home," Trace Adkins told the crowd during his segment.

"I've had people ask me, as we travel around the country doing shows this year, did I lose anything during the flood? Was I affected personally? And I always answer that question 'yes,' because when the water was this deep on this stage, it hurt me in my soul. So, yeah, it affected me personally."

The occasion called for a few special duets, too. Martina McBride sang "Once a Day" with Connie Smith, Lorrie Morgan joined Josh Turner on "Golden Ring," Dierks Bentley and Del McCoury Band played Bill Monroe's "Roll On Buddy, Roll On," and Charlie Daniels and Montgomery Gentry teamed up for "The Devil Went Down

PREVIOUS SPREAD: Opry Announcer Eddie Stubbs greets Blake Shelton before a performance, April 11, 2017. OPPOSITE: Little Jimmy Dickens and Brad Paisley open the Opry on the first show back at the Grand Ole Opry House following the 2010 Nashville flood, September 28, 2010. BELOW: Opry members pose for a photo on September 28, 2010, celebrating the return to the Opry House.

to Georgia." Near the end of the show, Shelton brought out Adkins to sing their hit collaboration, "Hillbilly Bone." In an Opry first, Adkins pulled out his phone and read him a tweet from @opry: "@blakeshelton, you're invited to join the Grand Ole Opry. See you on 10/23/2010!"

"Man, that takes a long time!" Shelton said after embracing Adkins. "I know a lot of guys that want this as bad as I have wanted it, and, uh . . . forget them for now!" Amid audience laughter, he added, "I don't know what I ever did in the last year or so to finally turn Nashville's head a little, but whatever I did, man, I'm loving this! This right here, this moment right here, is hands down the highlight of my career."

Looking back on that milestone, Shelton recalled, "Boy, that was a really incredible night. It was the opening after the flood. People had been waiting a long time to get back in there. They sent me a tweet—it was when social media was really starting to become the new thing, even in music. I was addicted to Twitter at the time and they knew it, so they invited me with a tweet on the big screen. But that's not the big deal for me. The big deal for me was that my brother Trace Adkins is the one who walked out there and made the official invite. That's the thing that I hold the dearest."

A lifelong fan of country music, Shelton grew up in the small town of Ada, Oklahoma, watching the Opry on television. "They would scroll the opening and you would see the audience and it just seemed like a big deal. It seemed like an award show every Saturday night to us," he remembered. By the time of his Opry invitation, Shelton had been on the country charts for about a decade, though he was still a year away

from finding television stardom as a coach on NBC's *The Voice*. To a network audience of millions, he would appear completely at ease. At the Opry, however, he admitted to getting a little jumpy.

"For me, I'm always extra nervous because I like to have a quiet moment before I go onstage," Shelton said. "But that's next to impossible at the Grand Ole Opry because there's always so many friends and family and other bands and people backstage. And you can't help it, on the way you want to stop and say hi. Next thing you know,

ABOVE: Trace Adkins uses Twitter to invite Blake Shelton to become an Opry member, September 28, 2010. OPPOSITE: The Oak Ridge Boys pose with their name plaque displayed on the Opry member gallery wall, August 8, 2011.

you end up in an in-depth conversation with somebody, and then they're announcing your name from the stage, and you haven't even had a minute to get in the zone. So it's already nerve-racking enough when you go out there. But when you have to be thinking as you're walking out, 'Oh my God, what song are we even doing first?' That's where my brain is every time. That's why I sneak drinks into the Grand Ole Opry."

For the next three invitations, Opry management selected artists with a proven track record. The Oak Ridge Boys had remained crowd favor-ites in country music since the seventies, while Rascal Flatts and Keith Urban had shown stay-ing power on the charts for more than a decade with no sign of fading. To bring them into the

Opry fold, Little Jimmy Dickens and Vince Gill led the charge.

The Oak Ridge Boys had evolved from the Oak Ridge Quartet, the gospel group founded by Wally Fowler in the 1940s. Fowler later sold rights to the band's name to another member, who modified it to the Oak Ridge Boys. None of the ensemble's members from that time were in place by 1973, when the Oak Ridge Boys solidi-fied a lineup of Duane Allen, Joe Bonsall, Richard Sterban, and William Lee Golden (except from 1987 to 1995, when Golden stepped away from the group).

Golden, who grew up in tiny Brewton, Alabama, said, "I remember before we had electricity, we

had these battery radios. The Grand Ole Opry would come alive in these little shacks out there in the middle of a cotton field. On Saturday night, it was amazing. It seemed like you were transported to being in the auditorium there with it coming alive. It was always exciting."

At a July 8, 2011, appearance, after singing "Y'all Come Back Saloon," the Oak Ridge Boys noticed that a miniature version of William Lee Golden had situated himself in the circle. As everyone in the band was cracking up, Little Jimmy Dickens spoke through his costume beard: "All my life I have wanted to be a little bitty Oak Ridge Boy." The quartet's ongoing laughter turned to shock when Dickens announced, through his beard, that they would soon be the newest members of the Grand Ole Opry.

Exhausted after the group's induction ceremony on August 6, 2011, Allen joined his bandmates at the back of their tour bus. "Richard started trying to talk," Allen recalled. "Richard loves baseball. He said, 'This is like getting inducted into the Baseball Hall of Fame,' and he started crying. I've never seen Richard cry. It was so touching to me, and we all just hugged. Big old tears flowing. It was so touching to me to see Richard that emotionally touched by what had just happened—us becoming members of the Grand Ole Opry."

Vince Gill surprised Rascal Flatts with their invitation on September 27, 2011. In his remarks, Gill commented on the trio's impressive run of commercial hits, which by this time included "I'm Movin' On," "Bless the Broken Road," and "What Hurts the Most." When Dickens presided over their induction on October 8, 2011, he told the group that he'd been a fan from the very beginning and that he'd never heard one bad word spoken about them.

Away from the Opry stage, at Nashville's Bridgestone Arena, Keith Urban's invitation arrived on April 10, 2012. Nearing the end of an all-star show called All for the Hall, which raised money for the Country Music Hall of Fame and Museum, Urban was about to bring out Merle Haggard as an unannounced guest. Gill, who founded the event in 2005, had other plans. A large duffel was placed at Urban's feet as Gill, Diamond Rio, the Oak Ridge Boys, Rascal Flatts, and Opry announcer Eddie Stubbs gathered nearby. Urban unzipped it to find an Opry microphone stand, instantly recognizable, with red letters on its white wooden cover proclaiming WSM GRAND OLE OPRY. Eleven days later, Urban—who was born in New Zealand and raised in Australia—became the first-ever Opry member born outside of North America.

Urban started playing guitar at six years old, encouraged by parents who loved country music. Influenced by singular creative voices such as Dolly Parton and Ricky Skaggs, Urban moved to Nashville in 1992 to pursue a country career. Five years later, his band the Ranch backed Australian country star Slim Dusty at the Opry, but Urban's solo career didn't take off until 2000. Although he quickly rose from promising newcomer to superstar status, it didn't faze Urban to wait a dozen years for the Opry invitation.

"Because I come from a small town, I know that way of being. You have to watch out for carpetbaggers. You have to watch out for the people that are coming with not good intentions. They just want to walk in, change things,

and if it doesn't work, then leave," he said. "I think this town, certainly when I moved here, had a silent way of making sure you were there for the right reason. You had to be patient, persistent, and show the community that you're part of the community. Deeply, deeply part of the community, and you've got to be there for the community. And I felt that early on, and I understood that, and I understood why it took a long time to be accepted in the town. But that invite into the Opry family was absolutely extraordinary."

On the night of his induction, at the end of a press conference, a reporter yelled out a question about Urban's favorite Opry star. "My favorite Opry star . . ." Urban repeated with a laugh. "There's too many that aren't Opry members, I'd say firstly, but for color and character, it's got to be Jimmy. Little Jimmy. I love the fact that he's still as strongly present and prevalent as he is on the Opry. I've got to send a big shout-out to Vince Gill because he's really like a spiritual brother to me. There's just something about Vince that really moves me, so I'm gonna say Vince."

Six months later, Gill and Dickens welcomed Darius Rucker into the Opry. Rucker's path to the Opry circle started as a boy in Charleston, South Carolina. On Saturday nights, he said, "The Opry came in clear as the day, and I would just sit and listen to whoever was on that night." With the ambition to be a musician himself, he loved tuning in to *Hee Haw* because it was one of the few shows where he could see music being played.

TOP: Keith Urban performs at the Opry early in his career, September 29, 2000. LEFT: Trace Adkins inducts Keith Urban into the Grand Ole Opry, April 21, 2012.

"All my life I have wanted to be a little bitty Oak Ridge Boy," Little Jimmy Dickens exclaims before inviting the Oak Ridge Boys to join the Opry, July 8, 2011.

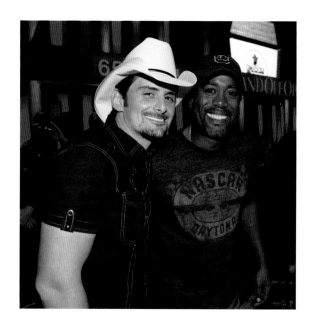

As a Black youth in the 1970s and 1980s, Rucker assumed that few of his friends or family members shared his appreciation for country music. One day in middle school, when his aunt Jeanette picked him up to take him to football practice, Rucker realized she was listening to Willie Nelson's *Red Headed Stranger*, one of her favorite albums. Suddenly, he discovered that someone in his family enjoyed country music as much as he did.

"That became a bond between us because she was like me. She didn't let anybody tell her, 'You have to listen to this,' or 'Why are you listening to that?' 'I'm listening to it because I like it,' that's what she'd always say. And I stood by that. That helped me. That was one of the things that helped me just chase the dreams I wanted to chase, when I knew they weren't what people were going to tell me I should be chasing."

By his early twenties, Rucker still harbored country music aspirations, especially after hearing Radney Foster's 1992 album, *Del Rio, TX 1959*. However, he put his Nashville plans on hold when his band, Hootie & the Blowfish, exploded on the pop charts with the 1994 album *Cracked Rear View*. Even though the band didn't have country crossover potential, they begged for years for an Opry slot. But every time they were offered a date, the band was already booked elsewhere.

Rucker would finally land a solo Opry debut on July 15, 2008, just as he was launching a country

TOP: Brad Paisley and Darius Rucker pose together following the show where Paisley surprised Rucker from the audience with an invitation to join the Opry, October 2, 2012. LEFT: Hatch Show Print poster celebrating Darius Rucker's induction, October 16, 2012. OPPOSITE: Darius Rucker performs "Wagon Wheel" with Old Crow Medicine Show, July 6, 2012.

career with "Don't Think I Don't Think About It." Although some country radio programmers directly told him that their audiences wouldn't accept a Black artist, Rucker proved them wrong with five platinum singles reaching number one. Inducted by Gill on October 16, 2012, Rucker became the third Black artist to be an Opry member and the first in nineteen years.

"You're about to get me," Rucker said, remembering that night. "The memory that really tears me up every time I talk about it is, we finished playing and they're having a party for me. I'm walking down the hall to go to the party. And Little Jimmy Dickens comes up to me and he turns me around and looks me in the eye and says, 'Don't ever let them tell you that you don't belong.' I'll never forget that."

If any song from the modern era hearkened back to the abiding spirit of the Grand Ole Opry, it would have to be "Wagon Wheel." And if any contemporary old-time string band had a shot of getting the Opry's attention, it would be Old Crow Medicine Show.

While growing up in Harrisburg, Virginia, the band's cofounders Ketch Secor and Chris "Critter" Fuqua bonded over Bob Dylan. They stayed in touch when Secor attended boarding school in New England, where he learned to play banjo and discovered old-time music. On a family trip to London, Fuqua bought a multi-CD set of Dylan bootlegs and sent it to Secor, who especially liked the feel of "Rock Me Mama," an unfinished outtake recorded in 1972. Secor wrote three verses to support Dylan's chorus,

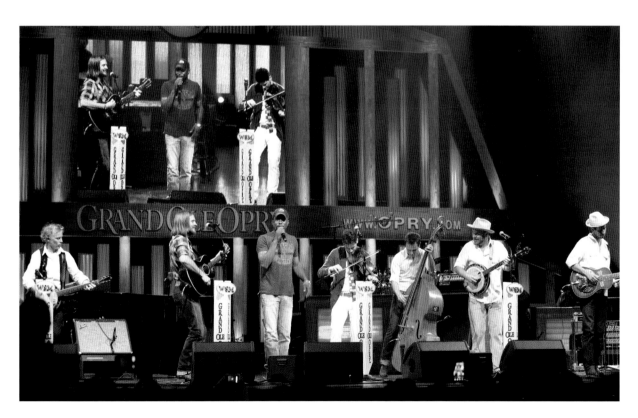

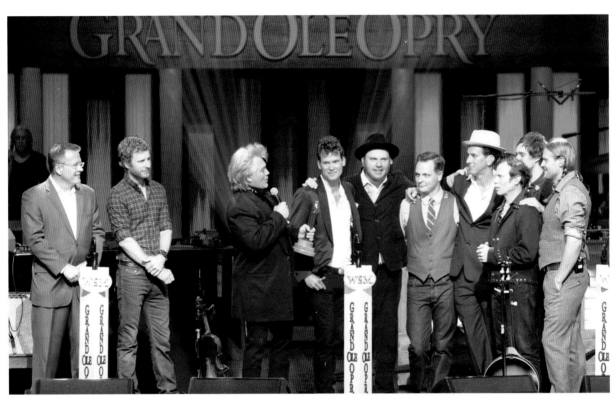

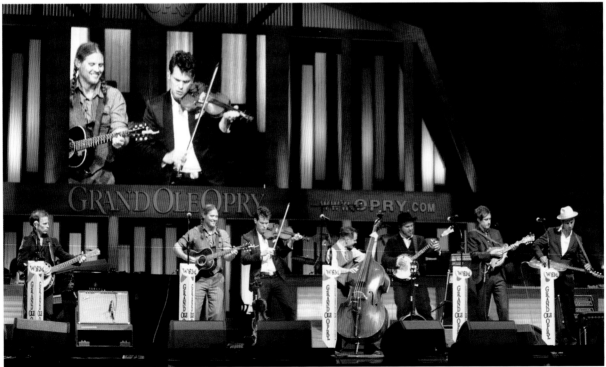

which coalesced into "Wagon Wheel," now a staple of Old Crow's repertoire.

Once the Old Crow Medicine Show lineup gelled in New York state, the band drove across the Canadian highways, over to the Pacific Northwest, and eventually to Western North Carolina. A chance encounter with folk guitarist Doc Watson in Boone led to a slot at his music festival, MerleFest, in the spring of 2000. Old Crow didn't get much response from their official afternoon set, so they casually set up by a fountain and began to draw a crowd. Sally Williams, then a relative newcomer to the Opry staff, was in the audience. With the Opry's seventy-fifth birthday looming, she'd been tasked with scouting bands to entertain crowds in front of the Opry House before the show. Old Crow accepted the offer to play these free Opry Plaza Parties throughout the summer; once the Opry got underway, the band would go downtown to busk.

On January 13, 2001, Old Crow brought their show indoors, making their debut on the Opry stage during Marty Stuart's segment. The band subsequently played the Opry dozens of times, but more often than not, they would forgo "Wagon Wheel" to perform something they had learned from Uncle Dave Macon or DeFord Bailey. "We wanted to play the music of the early Grand Ole Opry on the Grand Ole Opry," Secor explained.

"Wagon Wheel," meanwhile, took on a life of its own. The band signed to a label and filmed a music video at a rural Tennessee fair. Busking went by the wayside as their popularity soared.

TOP LEFT: Marty Stuart inducts Old Crow Medicine Show as the newest members of the Grand Ole Opry, joined by Pete Fisher and Dierks Bentley, September 17, 2013. BOTTOM LEFT: Old Crow Medicine Show performs on the night of their Opry induction.

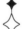

In the years to come, the band played countless festivals, collected a gold-certified single for "Wagon Wheel," and weathered a couple of lineup changes. When Darius Rucker made an Opry appearance on July 6, 2012, he sang "Wagon Wheel" with Old Crow and tweeted that he'd just recorded it.

On October 2, 2012, Rucker performed "Wagon Wheel" again, right after Brad Paisley stood up in the Opry audience and invited him to become a member. Released as a single in 2013, Rucker's version became so inescapable that some honky-tonks with live music started posting signs by the stage: NO WAGON WHEEL. In the middle of a show in Cleveland, Ohio, Old Crow Medicine Show received their Opry invitation from Marty Stuart on August 16, 2013. They were inducted by Stuart and Dierks Bentley on September 17, 2013.

"When we became members of the Opry, it really felt that there was something about the song that had helped to make it all possible," Secor said. "Even though we had put our time in at the Opry and had been repeat performers, I felt like 'Wagon Wheel' was really the thing that the Opry wanted out of an Old Crow membership of the Opry. They wanted a band that seemed to care a lot about the Opry and seemed to represent the roots of the Opry, and also had a hit. And that we shared that hit with another Opry member sweetened the deal, too."

Little Big Town, a harmony-driven vocal group known for radio hits like "Boondocks" and "Little White Church," jumped into the parade of bands joining the Grand Ole Opry, on the heels of Rascal Flatts, the Oak Ridge Boys, and Old Crow Medicine Show. All four band members came from families who revered the Opry; in 1999, the

group gave its first-ever public performance in the Opry circle, filling in for a last-minute cancellation. They'd placed a respectable number of radio hits over the years, but nothing close to 2012's feel-good single "Pontoon" and its irresistible hook: "Mmmm, motorboatin'." During their Opry set on October 3, 2014, they suddenly heard a fifth voice singing "motorboating" in their ear monitors. When Reba McEntire strolled onstage from the wings of the Opry, it dawned on them that the moment had arrived.

Vince Gill and Little Jimmy Dickens welcomed Little Big Town into the Opry family on October 17, 2014. It would serve as Dickens's final induction ceremony. He died on January 2, 2015, at the age of ninety-four.

Craig Morgan, part of the cast since 2008, had befriended Dickens during the annual Opry duck hunt gatherings, a long-standing tradition for members to spend a few days together off the grid. After coming in from the hunt, artists would dine together, swapping stories and songs late into the night. Years later, Morgan can still hear Dickens's response after a young artist made a comment at dinner about singing at sparsely attended shows.

"The artist was saying how difficult it is to do shows when there's not a lot of people there. And he was talking about how he's getting started, and then sometimes he goes out and they're expecting a big crowd and there's not a lot of people," Morgan recalled. "I'll never forget Little Jimmy got up and he walked around [the table]; he was standing up and he was still right

in the face of the guy sitting down. And he got real close, like awkwardly close, and he said, 'Listen, son, you need to remember something. We don't play for the people who aren't there. We play for the people who are.'"

In the show's ninetieth year, Opry executives found creative ways to market the Opry to a wide array of audiences. Opry Entertainment, alongside ABC Studios and Lionsgate Television, produced the popular dramatic prime-time series *Nashville*; in May 2015, ABC announced the show would return for a fourth season. A theatrical film titled *American Saturday Night: Live from the Grand Ole Opry* arrived in December 2015. The project received a Grammy nomination in the category of Best Music Film, marking the Opry's first time on the Grammy ballot.

Nashville tourism was booming, and the Opry's expanding offerings accommodated the influx of visitors. Fans could now get a ticket for Tuesday, Wednesday, Friday, or Saturday night. *Opry Country Classics*, staged at the Ryman during spring and fall months, offered another option on Thursdays. The increased availability paid off. The *Tennessean* reported an attendance of 650,000 visitors to the Opry in 2016, an increase of 150,000 from just four years earlier.

OPPOSITE: Reba McEntire crashes a performance of "Pontoon" to invite Little Big Town to become members of the Grand Ole Opry, October 3, 2014. ABOVE: Chris Carmack, Sam Palladio, Chaley Rose, Jonathan Jackson, Charles Esten, Clare Bowen, and Will Chase perform during a concert featuring stars of the television drama *Nashville* in New York City, May 6, 2014.

As Opry attendance grew, so did the cast. On November 15, 2016, Carrie Underwood surprised country legend Crystal Gayle with her Opry invitation after they sang "Don't It Make My Brown Eyes Blue" together. With more nights to appear and a less demanding tour schedule, Gayle started coming to the Opry more frequently in the early 2000s. As the youngest sibling of Loretta Lynn, she'd roamed the Ryman hallways with the other Opry members' children in the early sixties. One night, she and her sister-in-law climbed the lighting trusses and tossed a wadded piece of paper at Jim Reeves. He opened it up, read their song request scrawled inside, and sang it on the Opry stage. On another visit, she watched Roy Rogers and Dale Evans make a rare appearance on the Opry.

"Of course, I stayed away but I wanted to run up there and bug them a little bit!" Gayle remembered. "That was a neat night and the excitement was just incredible. It was just a time that . . . it's hard to put into words because it was part of my life. Because I grew up with my sister singing in the business, being at the Opry, it was home to me. Even though I was not a member, I was not singing on the stage, it was part of me as well. I felt like I was OK to be there."

At sixteen years old, Gayle debuted on the Opry singing "Ribbon of Darkness," a country hit for both Marty Robbins and Connie Smith. Loretta had fallen ill that night, so Mooney Lynn persuaded management to offer the vacant slot to Crystal. Fifty years later, Loretta Lynn and Peggy Sue Wright presided over their sister's Opry induction on January 21, 2017, with obvious pride. After joking about how she gave Crystal her stage name (partially inspired by Krystal hamburgers), Loretta noted, "All kidding aside,

tonight is a special night for her, because the greatest moment in my life is when they made me a member of the Grand Ole Opry in '62."

Her sister's induction was Lynn's final appearance on the Opry. She died in her sleep on October 4, 2022, at the age of ninety. Keeping with tradition, a public memorial was held at the Opry House.

"She didn't appear all that often, but when she did, it was so important to her and you could really get the sense that she missed it," said Steve Buchanan, who retired as president of Opry

ABOVE: Crystal Gayle performs for the Grand Ole Opry's fifty-third birthday celebration, October 9, 1978. OPPOSITE, TOP: Sisters Loretta Lynn, Peggy Sue Wright, and Crystal Gayle perform together on the Grand Ole Opry, February 24, 1990. OPPOSITE, BOTTOM: Crystal Gayle is joined by her sisters Loretta Lynn and Peggy Sue Wright to celebrate her Opry induction, January 21, 2017.

Entertainment Group in 2018. "There were a lot of complications in her life and being pulled in a lot of different directions, but I always got this sense of how much she loved it and the appreciation. I always felt like whenever she was leaving, she was just thinking about wanting to come back. That's not always what you get from an artist, but she was of that generation that felt like the Opry was really instrumental in the development of their career."

Underwood remembered her first encounter with Loretta Lynn, which took place backstage at the Opry. "I was standing off to the

side talking to Vince Gill. I don't even remember what we were talking about," Underwood recalled. "And somebody came up behind me and smacked me on the bum! Initially I was on my way to getting offended because I'm all dressed up talking to Vince Gill and somebody comes and smacks my rear. I turn around and then she's just scooting off down the hall in her sparkly dress. And I'm like, 'OK, that's kind of perfect.'"

The Opry sneaked in one last invitation for the year on December 30, 2016, for Dailey & Vincent, the charismatic duo of Jamie Dailey and Darrin Vincent, who had built a sizable audience of bluegrass, classic country, and gospel fans.

As a little boy in the early seventies, Vincent traveled everywhere with his family's band, the

ABOVE: Loretta Lynn remembrance during the Opry's ninety-seventh birthday celebration, featuring Ranger Doug and Woody Paul of Riders in the Sky, Bill Anderson, Deana Carter, Vince Gill, Ricky Skaggs, Steve Wariner, and Chapel Hart, October 8, 2022
OPPOSITE: Marty Stuart surprises Dailey and Vincent with an Opry invitation, December 30, 2016.

Sally Mountain Show. He's been told that when the group played the *Midnite Jamboree* radio show at the Ernest Tubb Record Shop, the Texas Troubadour himself walked the narrow hallway to get backstage. "They had a guitar case laying there," Vincent said. "I had gotten sleepy at five or six years old, so I went and curled up and fell asleep in that guitar case. I guess when Ernest got off the bus, he was walking down through there and he looked down there and saw me laying there, and he said, 'The little feller's tuckered out. Just leave him alone.' And he tiptoed off his boots past me and went onstage to do the *Midnite Jamboree*."

"But what I see when I heard that," Dailey added, "I see an elder statesman Opry member that's looking down at a baby in a case that's going to be a future Opry member. I just think that's one of the most interesting stories and really sweet stories that I've heard."

Prior to forming their own unit, Dailey played guitar and sang lead tenor and baritone with award-winning bluegrass group Doyle Lawson & Quicksilver, and Vincent played bass and sang harmony for Ricky Skaggs & Kentucky Thunder. On the advice of their manager, Don Light, the duo turned down every offer to perform as Dailey & Vincent until after they made their Opry debut on December 29, 2007. Light suggested that if Dailey & Vincent's first show was at the Opry, it would be a memory they could cherish.

Nine years and ninety-nine guest appearances after Dailey & Vincent's debut, the Opry encouraged the duo to bring along special guests for a thirty-minute segment at their one hundredth show. Dailey's father and Vincent's mother, who also played music, accepted their offer, but

everybody else said they were too busy. When Marty Stuart told the Ryman crowd about the milestone, the duo figured somebody would be wheeling out a cake for a photo op. Instead, the houselights came up to reveal all the friends and family who'd pretended to be out of town. After Stuart sprung the invitation on them, Dailey burst into tears and Vincent crumbled to the floor.

Just as other bluegrass performers on the Opry have done, Dailey & Vincent charted their own course in acoustic music without losing sight of the sounds that inspired them. Sixteen years after the duo's Opry debut, Dailey observed, "We do feel the pressure of, 'OK, we've got to hold some of this sound together by also putting our foot in some new stuff, too, and not losing track of the future. I do believe that if you're going to be an Opry member, you certainly need to respect the traditions. But you also need to be open to the versatility and awareness of what's going on in the world around you. And be open-minded to it, like, 'Hey, there's a spot for you, and there's a spot for you . . .' And everybody's welcomed around

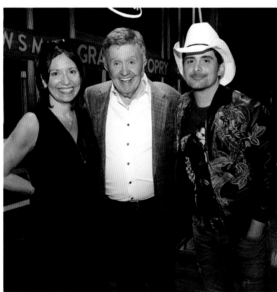

TOP: Pete Fisher's final show as Opry GM, January 20, 2017. Fisher is flanked by Opry music director Steve Gibson, Steve Wariner, and Opry band member Randy Hart. BOTTOM: New Opry general manager Sally Williams poses with Bill Anderson and Brad Paisley, April 14, 2017. OPPOSITE, TOP: Chris Janson's Opry debut, February 15, 2013. OPPOSITE, BOTTOM: Chris Young installs his own Opry member plaque backstage at the Opry House, October 17, 2017;

us. It's certainly how I look at it, and I know a few other Opry members do, too."

Pete Fisher announced in March 2017 that he would be leaving his role as Opry GM. After seventeen years, he accepted an offer to lead the Academy of Country Music in Los Angeles. Stepping away, he said, was a "lifestyle decision." In addition to keeping office hours, he'd been working about eighty percent of weekends every year, along with most Opry shows during the week. As for his legacy at the Opry, Fisher said he would like to be remembered as "a catalyst and a connector."

When asked how the experience of working for the Opry was different from his initial expectations, he replied, "The thing that probably surprised me the most was more associated with what is truly, truly extraordinary about the Opry. And that is the people. Just the incredible caliber of employees who work here, and the incredible caliber of members who perform here, and the incredible caliber and quality of musicians and technicians. I mean, although I don't miss the work and the schedule associated with the Grand Ole Opry, I miss the people."

To replace Fisher, the Opry named Sally Williams as senior vice president of programming and artist relations for Opry Entertainment, and general manager of the Grand Ole Opry. She became the first woman to hold that position. Williams had held the general manager role at Ryman Auditorium since 2008, after seven years of managing concerts and other events at the Opry's properties. In addition, she was chairman of the board at the Country Music

Association at the time she was hired to lead the Opry. The Grand Ole Opry staff, cast, and crew were well acquainted with her; in turn, she understood the Opry's inner workings, onstage and behind the scenes.

Williams, like Fisher before her, made it a priority to develop new artists. Although the Opry had been featuring guest artists essentially from the start, debut performances would now be given significantly more attention. Camera crews would often follow newcomers as they walked the halls backstage or awaited their name being called from the announcer's podium. Audience members, who probably hadn't ever heard of the artist, were primed by an effusive Opry announcer to expect a historic moment.

With the proliferation of competition shows like *American Idol*, *The Voice*, and *Nashville Star*, the talent pool of new artists was overflowing. For Chris Young, winning *Nashville Star* in 2006 did not translate to overnight success, although he did earn a recording contract and a very rare prize: an Opry debut. On June 10, 2006, Young walked to his assigned dressing room, figuring that somebody would give him further directions as showtime approached. The house band already knew his songs, so he killed time by tuning his guitar.

"I don't know what the rules are. I haven't done this before," Young recalled. "I'm here. I'm ready to go. But I'm like, 'Do I go find somebody? Am I supposed to tap someone on the shoulder?' [There's a] knock on the door. The door opens before I can even open it. 'All right, you're up!' I'm like, 'What?' And they're like, 'Yeah, go that way.' And then you're onstage getting introduced. So it's crazy the very first

time you do it, and it's still awesome every time I get to do it now."

Young's first few singles made minor impressions, but enough *Nashville Star* viewers purchased his debut album for him to keep his contract. His second album, *The Man I Want to Be*, ushered in a thriving career. Young continued to make himself available to the Opry, singing at the first show after the flood, redesigning a dressing room with Little Jimmy Dickens for a cable TV series, and performing with one of Keith Whitley's guitars. When Vince Gill delivered an Opry invitation on August 29, 2017, Young impulsively gave him a bear hug and lifted him a few feet off the ground. Brad Paisley, another of his musical heroes, presided over the induction on October 17, 2017.

Like Chris Young, Chris Janson grew up consumed by country music. Right after high school graduation in 2004, Janson moved from Perryville, Missouri, to make it in Nashville. He spent his first evening in town walking up and down Lower Broadway, hoping that one of the honky-tonks would let him play. Not one of them did. "When I moved here, it was still in the cleanup phase, if you will, of Lower Broadway. So, it was kind of dangerous," he recalled. "I mean, it was hustlers on the street, and I've always sort of been a hustler myself, so I fit right in."

Around midnight, he circled back to Tootsie's and begged the doorman for just one song. Finding out that Janson was underage, the doorman physically lifted him from the sidewalk to the stage. After performing "Folsom Prison Blues" (but, as he described it, "way more punk rock style"), Janson was asked to not only finish out the night, but to come back in the morning.

Janson said all-day and all-night shifts were not out of the ordinary for him at the time.

"I'd never had a morning gig," Janson said. "So I showed up at ten o'clock the next morning and started playing ten to two, then two to six, then six to ten, then ten to two. And I did that for one year until I got discovered, really."

Mainstream success came incrementally, however. Janson slept in his Monte Carlo until he could find a place to live. A single on a small label provided enough traction to earn an Opry

OPPOSITE: Hatch Show Print poster celebrating Chris Janson's induction, March 20, 2012. ABOVE, FROM TOP: Bobby Bare and Bobby Bare Jr. on the Opry stage at Ryman Auditorium, March 9, 1974; Bobby Bare and Bobby Bare Jr. share an Opry moment during the senior Bare's second induction, April 7, 2018.

debut in 2013. A few years later, Janson notched an independent hit with "Buy Me a Boat," which captured his irreverent personality and led to a major label contract. During a headlining show at the Ryman, he accepted his Opry invitation from Keith Urban on February 6, 2018. When Garth Brooks inducted him on March 20, 2018, it was Janson's 114th Opry appearance.

"The Grand Ole Opry helped me pay my bills and really stay afloat," Janson said. "If it weren't for the Grand Ole Opry, I maybe wouldn't have had a gig when I needed one. So, I really appreciate them having me on as often as they did, and because it's kind of rare. Most new artists who aren't members don't get to play pretty much anytime they want to. I was always wanting to, and I always got to."

Following the inductions of Chris Young and Chris Janson, both in their early thirties, the Opry welcomed back Bobby Bare on April 7, 2018, which happened to be his eighty-third birthday. Bare originally joined the Opry in 1965, but his membership lapsed about a decade later when he couldn't maintain the number of shows required of members at that time. At this performance, Bare sang "I Drink" with songwriter Mary Gauthier, and his 1970 Top 10 hit "Come Sundown" with his son, Bobby Bare Jr. Afterward, he paused and asked, "I think we're going to a commercial, aren't we?" Jeannie Seely, who was hosting the segment, responded: "Yeah, Bobby, you remember how this goes. This is radio!"

Before Bare's final song of the night, Seely brought unannounced guest Garth Brooks to the stage. Explaining to Bare and the audience that the Opry is a family, Brooks inducted him on the spot. Sally Williams presented the Opry

Member Award, which Bare joyfully raised above his head. Caught completely off guard, he said, "I gotta tell you, this was quite a surprise. See, I was a member of the Opry for ten years, and then I drifted away. And now that it's all new and it's all family again, I'm back!"

When Bare first joined the Opry, a clear channel AM radio broadcast could attract a national listening audience. But now, a crowded media landscape made it harder than ever to draw attention to a ninety-three-year-old radio show. In her role as GM, Williams sought new ways to convey the Opry's significance. She recognized that this new generation didn't gather around a radio on Saturday nights or watch the Opry with their grandparents on TNN. "For me," she said, "it was, how do we get the Opry into as many places where there are fans of music?"

Williams scheduled a meeting with Ashley Capps, an independent concert promoter who cocreated and produced Bonnaroo Music & Arts Festival in a sprawling field near Manchester, Tennessee. Capps had already developed a working relationship with Williams through her role at the Ryman, so conversations started naturally: How do we bring the Opry to Bonnaroo? On June 10, 2018, they did just that, with a Sunday night Opry set to close out the festival.

The carefully curated lineup delivered a genuine Opry experience: bluegrass from the Del McCoury Band, clogging by the Opry Square Dancers, country legend Bobby Bare singing "Marie Laveau," Riders in the Sky harmonizing

ABOVE: Cast of the 2018 Bonnaroo Opry, including performers Del McCoury Band, Bobby Bare, Old Crow Medicine Show, Riders in the Sky, Lucie Silvas, LANCO, Nikki Lane, and Joshua Hedley. OPPOSITE: 2019 Bonnaroo poster with Grand Ole Opry at the top of the bill

JUNE 13-16, 2019

MANCHESTER, TENNESSEE

bonnaroo
MUSIC & ARTS FESTIVAL

THURSDAY, JUNE 13 **GRAND OLE OPRY** FEATURING SPECIAL GUESTS

SABA · SPACE JESUS B2B EPROM B2B SHLUMP · 12TH PLANET · SUNSQUABI · ALL THEM WITCHES
MAGIC CITY HIPPIES · THE NUDE PARTY · ROLLING BLACKOUTS COASTAL FEVER · THE COMET IS COMING
JACK HARLOW · EPROM · CAROLINE ROSE · DONNA MISSAL · PEACH PIT · HEKLER · DORFEX BOS

PHISH CHILDISH GAMBINO FRIDAY, JUNE 14
SOLANGE THE AVETT BROTHERS BROCKHAMPTON GRIZ RL GRIME

BEACH HOUSE · GRIZ SUPERJAM · NGHTMRE · GOJIRA · COURTNEY BARNETT · GIRL TALK · AJR
CATFISH AND THE BOTTLEMEN · K.FLAY · ANOUSHKA SHANKAR · NAHKO & MEDICINE FOR THE PEOPLE · LIQUID STRANGER
DEAFHEAVEN · PARQUET COURTS · RIVAL SONS · IBEYI · JADE CICADA · LAS CAFETERAS · CHERRY GLAZERR
THE TESKEY BROTHERS · MEDASIN · TYLA YAWEH · DUCKY · MONSIEUR PERINÉ · MERSIV · CROOKED COLOURS

SATURDAY, JUNE 15 POST MALONE ODESZA
HOZIER KACEY MUSGRAVES THE NATIONAL THE LONELY ISLAND ZHU

JUICE WRLD · JOE RUSSO'S ALMOST DEAD · GUCCI MANE · JOHN PRINE · JIM JAMES (FULL BAND) · MAREN MORRIS
GRAMATIK · SHOVELS & ROPE · UNKNOWN MORTAL ORCHESTRA · QUINN XCII · CLAIRO · BISHOP BRIGGS
HIPPO CAMPUS · SPACE JESUS · TOKIMONSTA · CHELSEA CUTLER · THE RECORD COMPANY · SNBRN
RUSTON KELLY · WHIPPED CREAM · RUBBLEBUCKET · LITTLE SIMZ · MEMBA · DEVA MAHAL · DJ MEL

PHISH (2 SETS) THE LUMINEERS SUNDAY, JUNE 16
CARDI B BRANDI CARLILE ILLENIUM WALK THE MOON

MAC DEMARCO · KING PRINCESS · LIL DICKY · G JONES · TRAMPLED BY TURTLES · THE WOOD BROTHERS
HOBO JOHNSON & THE LOVEMAKERS · PRINCESS (FEATURING MAYA RUDOLPH & GRETCHEN LIEBERUM)
THE SOUL REBELS · THE LEMON TWIGS · TWO FEET · AC SLATER · CID · DOMBRESKY
BOMBINO · FAYE WEBSTER · RIPE · KIKAGAKU MOYO · IGLOOGHOST

BACARDÍ PayPal

Neighborhood of Good
StateFarm asics BAREFOOT

like cowboys, and Old Crow Medicine Show closing the show with "Wagon Wheel." Guest performers Joshua Hedley, LANCO, Nikki Lane, Maggie Rose, and Lucie Silvas offered their interpretations of country music, which incorporated a renegade spirit not often found on the FM dial. Bill Cody emceed the show, which was broadcast on WSM 650.

When the Opry returned as an opening night headliner in 2019, the phrase GRAND OLE OPRY FEATURING SPECIAL GUESTS topped the list of artists on the festival's official T-shirt. Having the show's name in a marquee position, rather than simply listing the artists who played on its behalf, was especially meaningful for Williams. "That was exactly what I wanted because, for me, it's not so much about the headliner," she said. "It's not about the A-level artists. If you love music, if you love heart and story and Americana, you're going to love this experience. The best experiences at Bonnaroo are the ones where you're in a tent, and it feels like the roof is going to blow off because of the energy. And that's how it was. I wanted music fans to see [the Opry] is a place for what you love."

Tullahoma, Tennessee, with a population of roughly nineteen thousand people, lies about fifteen miles from where Bonnaroo takes place. Dustin Lynch grew up there, watching the Opry on television and picking up lessons on how to entertain. As a teenager, he went with his girlfriend to a local truck dealership for a meet-and-greet with Trace Adkins.

"We stood in line for a long time, and he was drinking a black cup of coffee," Lynch recalled.

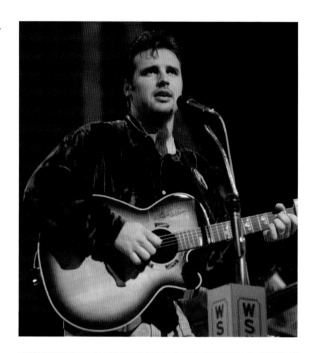

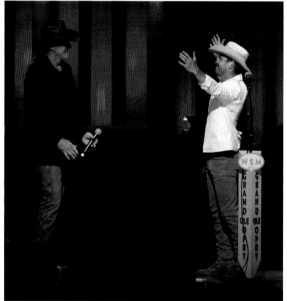

TOP: Mark Wills performs at the Grand Ole Opry early in his career, c. late 1990s. BOTTOM: Trace Adkins invites Dustin Lynch to become a member of the Grand Ole Opry, August 21, 2018. OPPOSITE, TOP: Mark Wills performs on the Ryman stage backed by Bill Anderson, Connie Smith, Jeannie Seely, and Vince Gill on the night of his Opry invitation, December 21, 2018. OPPOSITE, BOTTOM: Dustin Lynch and Reba McEntire the night of Lynch's Grand Ole Opry induction, September 18, 2018

"I had my girlfriend at the time, and I walked up. I was like, 'Mr. Adkins, great to meet you. I'd love to take a picture with you and my girlfriend.' And he looked at me, looked at her, looked at me, looked at her and goes, 'You're dating this shrimp?' As a sixteen-year-old, that was the first country artist that I'd ever met and soul-crushing. So I was like, 'Ouch, man.' Life's funny, right? I mean, the fact that that guy goes on to invite me to be a member of the Opry, you can't write it better than that."

After earning five consecutive number one singles, Lynch joyously wrapped his arms around the towering country star when the invitation was presented on August 21, 2018. Making a surprise appearance, Reba McEntire formally inducted him on September 18, 2018, as both artists choked back tears.

There was more crying when Mark Wills received his long-awaited Opry invitation on December 21, 2018, after 265 guest appearances. A native of Blue Ridge, Georgia, who kept his home base in Atlanta, Wills first arrived on the country charts in 1996 with "Jacob's Ladder," a feel-good love story that fit perfectly within the nineties country landscape. Thriving at country radio for the remainder of the decade, Wills had a way with sentimental material, whether on ballads like "Don't Laugh at Me" or upbeat smashes such as "19 Somethin'," a six-week number one hit in 2002.

"If in 1998, the Grand Ole Opry had approached me and said, 'Hey, we want you to be the newest member of the Opry,' after we had our first number one, or even our second number one, it wouldn't have meant as much to me," Wills said. "I came in here and I got to meet Bill, and I got to meet Jim Ed, and I got to meet Little Jimmy, and I got to meet Porter. I got to meet all of these greats, and I loved being around them. I loved coming out here and just experiencing what the Opry was.

"I think that what happened to me in 2005, '06, '07, '08 was, I craved that. I wanted to be around those guys," he continued. "I wanted to immerse myself into the Opry culture. And I got to be friends with several of those people. And then we would lose one. I would drive up from Atlanta four hours away and go to the funeral and try and drive four hours back home. That

gave you a lot of time to think about where your career was, what you would be remembered for. And for each one of those times that we were asked to come up and do something, my standard answer for the Opry was always yes."

In 2018, Wills asked if he could take part in a salute to Jimmy Capps, the guitarist in the Opry's house band. The special show commemorated the sixtieth anniversary of Capps's Opry debut when he was backing the Louvin Brothers. Vince Gill asked Wills to close out the night–and much to Wills's shock, to become an Opry member. Overcome with emotion, Wills gathered himself to perform "Don't Laugh at Me." Behind him, shoulder to shoulder, stood Capps, Gill, Bill Anderson, Jeannie Seely, Connie Smith, Marty Stuart, and others who'd come from the wings to sing together and share the moment.

Seeing so many longtime Opry members together onstage served as a subtle reminder of the artists who had passed on. In 2011 alone, Opry members grieved the losses of Wilma Lee Cooper, Billy Grammer, Charlie Louvin, and Mel McDaniel. Troy Gentry of Montgomery Gentry lost his life in a 2017 helicopter crash just before a concert date in New Jersey. In

addition to Dickens's death, the Opry had also mourned long-established stars Jim Ed Brown, Roy Clark, Jack Greene, George Hamilton IV, George Jones, Jimmy C. Newman, Jean Shepard, Ralph Stanley, and Mel Tillis by the end of the decade. The legacy artists who dutifully honored the commitment to appearing at the Opry were slipping away. Perhaps more than ever, the Opry needed to pinpoint the guest artists who could maintain that same longevity.

Opry management rose to the occasion by asking Little Big Town to deliver an invitation to Kelsea Ballerini, a vivacious singer-songwriter from East Tennessee. Her father worked at a country radio station in Knoxville, though her parents listened to all kinds of music. Her mother especially liked Josh Turner, so when Kelsea was thirteen years old, they planned a weekend getaway to the Opry to see him play. Even at a young age, she said she realized the show felt different from the concerts she saw in Knoxville, and she knew the Opry would be part of her bucket list somehow.

Ballerini moved to Nashville for college but took classes only three days a week; she used the rest of her time to pursue a career as a songwriter and artist. Shortly after signing to an independent label, she made her first Opry appearance on Valentine's Day in 2015, the same week that her debut single, "Love Me Like You Mean It," cracked the Top 40 on country radio. As her career took off, she would return to the Opry to perform a new song along with a country classic, such as "Make the World Go Away" or "Ghost in This House." Carrie Underwood formally welcomed Ballerini into the Opry family on April 16, 2019, just four years after her debut.

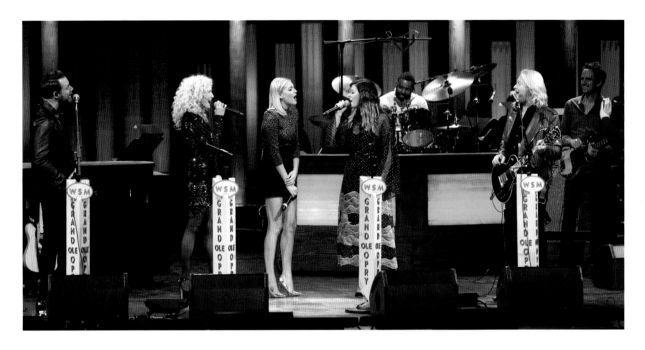

"Every time I play, in between songs I'll ask, 'Is it anyone's first time here?' And I love watching moms with young daughters raise their hand, or people that are here in town on a bachelorette trip that are carving this night out," Ballerini said. "I get to watch from the stage people have the experience that I had when I was thirteen, and what a gift to know what that feels like on both sides."

OPPOSITE: On December 21, 2018, the Opry band rehearsal space was named in honor of musician Jimmy Capps, the longest-tenured member of the Opry band, who first appeared on the Opry in 1958. Left to right: Eddie Stubbs, Vince Gill, Gina Keltner, Kerry Marx, Randy Hart, Michele Capps, Eamon McLoughlin, Jimmy Capps, Larry Paxton, Sally Williams, Marty Stuart, Mark Beckett, and Dan Rogers. TOP: Little Big Town performs "Girl Crush" with Kelsea Ballerini. On the last verse, they changed the lyrics to "Kelsea Ballerini, do you want to be a member of the Opry?" March 5, 2019. BOTTOM: Kelsea Ballerini was overwhelmed when Little Big Town asked her to become the newest member of the Opry.

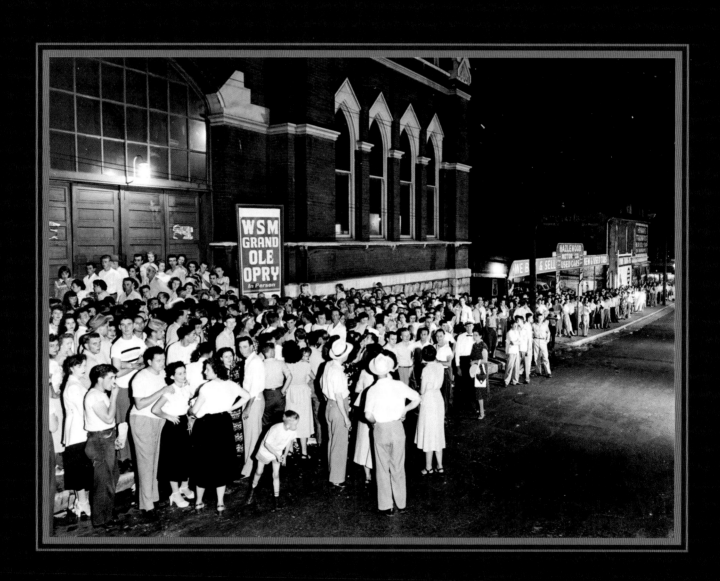

Y'ALL COME

OF ALL THE CHARACTERS IN THE GRAND OLE OPRY STORY, PERHAPS THE MOST IMPORTANT ARE THE FANS. After all, the dedication of the fans transformed a local radio show into a globally recognized entertainment icon, where they and the artists create an experience like no other. Important milestones and life events are part of the show each week, when announcers recognize folks in the audience celebrating honeymoons, wedding anniversaries, or other special moments. Family reunions, bachelorette parties, and veteran gatherings frequently include the Opry as part of the special occasions.

Members of the military are respectfully recognized at each show, allowing audiences to express their gratitude with applause. The tribute is one representation of the indelible bond between the Grand Ole Opry and America's armed forces that was forged during World War II with performances at military bases and broadcasts via the Armed Forces Radio Service. Opry members continue to treasure the opportunity to support and entertain fans who wear or have worn the uniform.

Also during World War II, Minnie Pearl realized that fans were hungry to learn more about their favorite Opry stars, so she launched the *Grinder's Switch Gazette*, a monthly paper published between 1944 and 1946. Nashville's first country music publication, it included features about Opry members, photos of their families, and a column where fans' submitted questions were answered.

One of country music's signature events was, in part, the result of enthusiastic fans making a trek to Nashville for the annual music industry gathering organized around WSM's birthday. Because fans kept popping up at these business functions, the Grand Ole Opry and the Country Music Association created International Country Music Fan Fair in 1972. The family-friendly festival beckoned fans to Nashville

OPPOSITE: Crowds line up outside Ryman Auditorium for the Grand Ole Opry, March 24, 1955. ABOVE: Minnie Pearl's newspaper, the *Grinder's Switch Gazette*, April 1946

ABOVE: Fans hold Marty Robbins signs as Robbins performs for his twentieth Opry anniversary, January 27, 1973. OPPOSITE, FROM TOP: Carl Smith signs autographs for fans, 1956; Hank Snow performs for troops in Korea during the Korean War, 1953.

to meet their favorite stars and watch them perform. The annual all-star event, now known as CMA Fest, continues to attract country music listeners from all fifty states and more than fifty different countries. Opryland USA also provided even more meet-and-greet opportunities after it opened in May 1972, with Opry legends such as Roy Acuff, Bill Anderson, and Porter Wagoner often found mingling and posing with visitors.

Sometimes an Opry fan goes above and beyond in their commitment to the show. For forty-two years, beginning in June 1972, Paul Eckhart attended the Opry every weekend. His dedication eventually earned him his own backstage parking space, a name plaque on his chosen seat in the Opry House pews, and a special sendoff when, at age eighty-three, he decided it was time to end the streak. His wife approved of his long-standing Saturday night dates with the Opry, because it left her free for her bingo night. Eckhart explained to the Associated Press, "We made a promise, and we've kept that promise all these years, that I will go with her at least a half dozen times a year, but not on Saturday night, and she will go with me to the Grand Ole Opry—but not on Saturday night. We've had a great marriage."

Glen Thompson, another of the Opry's most ardent fans, achieved his dream of moving to the Nashville area from Wisconsin after retiring from the City of Kenosha after twenty-eight years as the superintendent of the waste department. Proud of having been born on November 28, 1945, exactly twenty years after the broadcast that launched the Grand Ole Opry radio show, Thompson created a Grand Ole Opry fan club in 1987 and maintained it for twenty-three years. His 2020 obituary observed, "He purchased his front row Opry tickets three years in advance for as long as he could, and in 1980, secured tickets for the 100th Anniversary Celebration in 2025." Thompson is buried next to Uncle Jimmy Thompson, the Opry's first performer, in Wilson County, Tennessee.

In the 1990s, the show became an obsession for a twelve-year-old boy from Grenada, Mississippi, named Charlie Worsham. Not long after winning the title of Junior National Banjo Champion in 1998, Worsham was invited to perform on the Opry stage by banjo player Mike Snider. Worsham's mother wrote a thank-you letter to public relations director Jerry Strobel, saying, "Imagine practicing for hours and

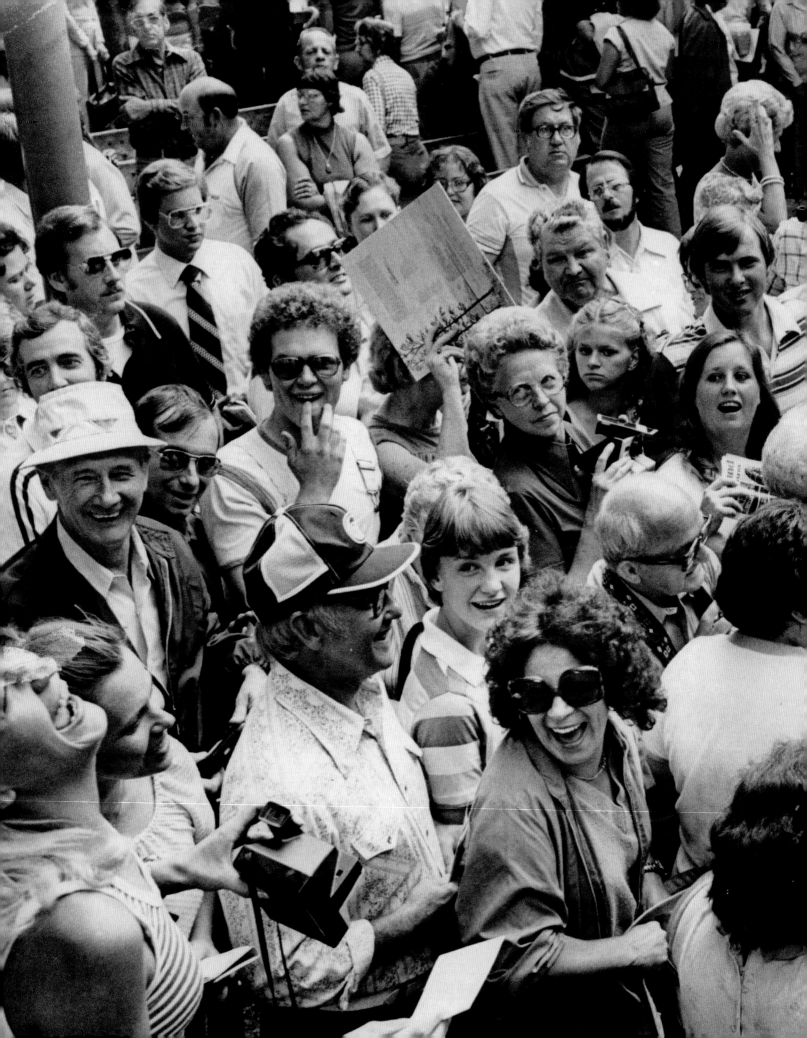

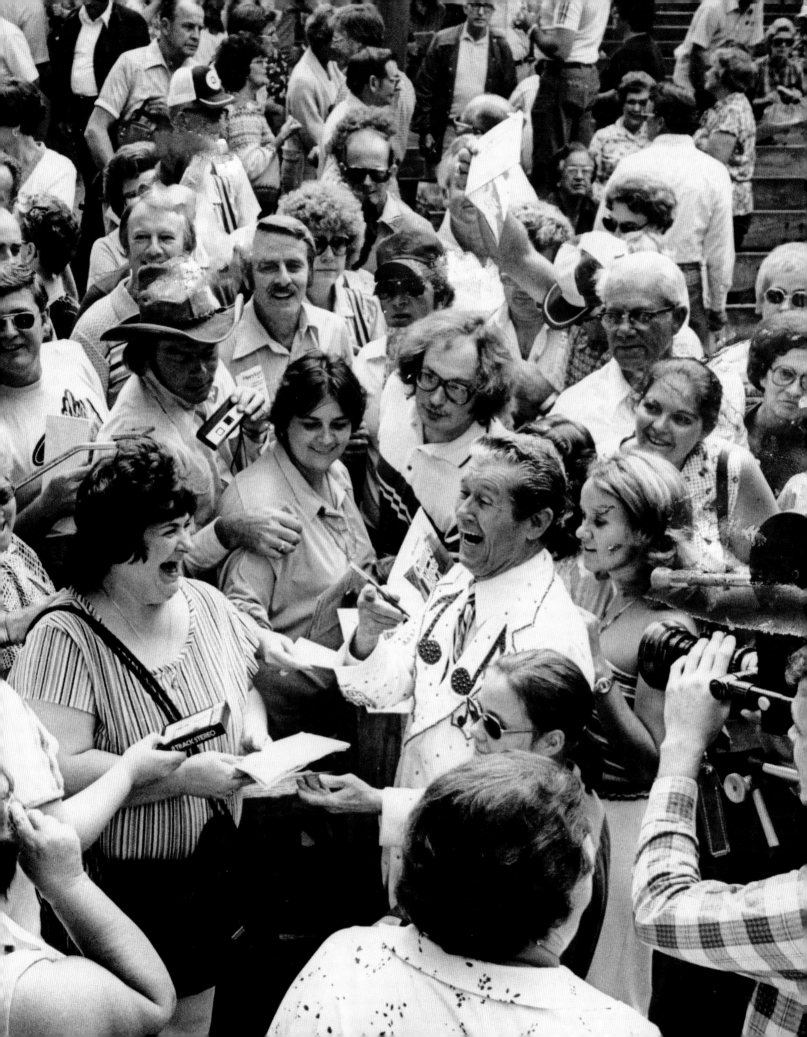

GRAND OLE OPRY
★ *Fan Club* ★

PREVIOUS SPREAD: Roy Acuff is mobbed by fans at the Opryland USA theme park, 1979. THIS PAGE, CLOCKWISE FROM TOP LEFT: Van Warden fulfills his dream of working at the Opry, greeting guests and taking tickets, July 22, 2011; Craig Morgan poses for a selfie with an audience member during an Opry show; fans wait in line to meet Alan Jackson at Fan Fair, 1990; Carrie Underwood signs autographs from the Opry stage on June 7, 2013; Charlie Worsham makes his Opry debut.

hours over a period of years and then getting rewarded with a chance to play in that circle for a packed house and a standing ovation! It has greatly influenced his life." More than twenty-five years later, with several major-label albums to his credit, Worsham is now a regular guest performer on the Opry stage.

While it seems natural for fans to dream of playing the Opry, Van Warden of Austin, Texas, decided that he wanted to be employed by the show after seeing his father, songwriter Monte Warden, perform there in 2005. When Opry GM Pete Fisher learned of the young man's dream, Van was invited to greet guests and take their tickets during Monte's guest appearance in 2011. Van, who has Down syndrome, wore his own name tag and uniform for the special day. When Monte introduced his son from the stage and Van's face was shown on the big screen, the auditorium erupted in applause. Fisher told the family that it was the only time an usher had received a standing ovation at the Grand Ole Opry.

While backstage passes in other venues may be hard to come by, visitors to the Grand Ole Opry are welcomed behind the curtain before, during, and after Opry performances. Following the destruction from the flood of 2010, the entire backstage area was reimagined as a showcase for the Opry's fascinating history, keeping the focus on the fans as well as the performers. Since then, millions of visitors have taken advantage of the opportunity for a behind-the-scenes tour. Guests especially like to linger at one of the building's original features, the old-fashioned mailboxes where Opry members can pick up their fan mail sent from around the world. Meanwhile, the new Circle Room provides ticket holders with a high-tech experience and a history lesson in the moments just before the show begins. And when the red curtain rises at the Opry today, first-time guests and longtime enthusiasts share the anticipation that has thrilled fans for one hundred years.

FROM TOP: The plaque honoring Paul Eckhart and his dedication to the Opry after having never missed a weekend show in forty-two years, June 28, 2014; country music–loving nuns at Fan Fair, 1976; longtime Opry fan Elaine Sledge was presented with a poster celebrating her five hundredth visit to the Grand Ole Opry on April 26, 2024.

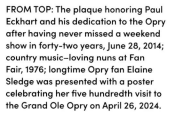

2019–

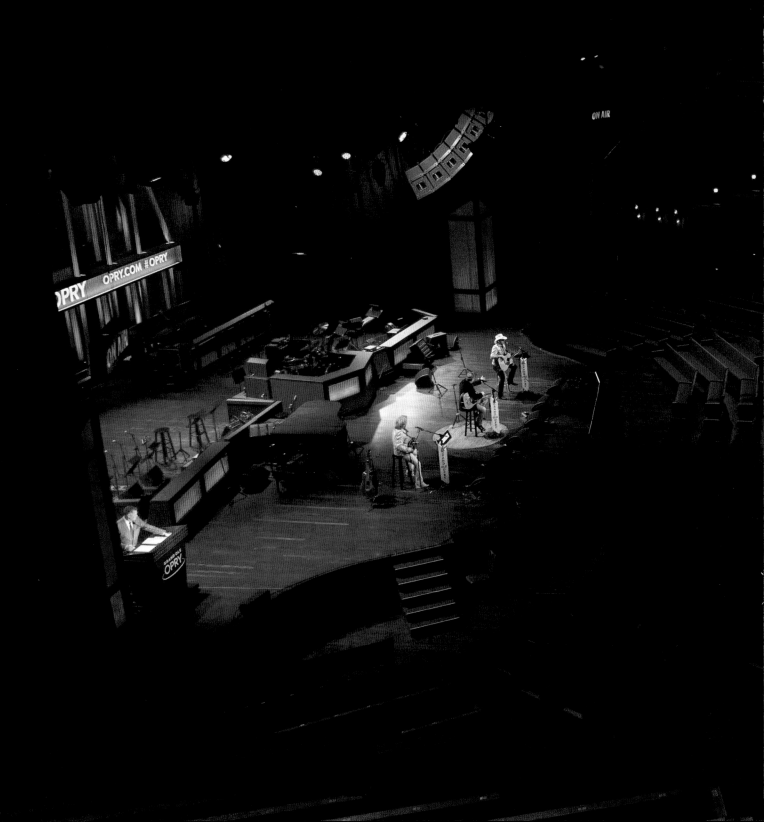

Between a traffic jam on the interstate and dealing with car trouble, a then-unknown Luke Combs didn't make it to the Grand Ole Opry on his first attempt in the spring of 2013. Combs and his college roommate were supposed to pick up their tickets at will call, but the box office was already closed by the time they reached the Opry House. Instead, they headed to Opry Mills mall to watch the Duke-Carolina basketball game. Combs pulled out his phone and tweeted that he wished he could have seen Ashley Monroe, who was a guest on the Opry that night. To his surprise, Monroe tweeted back and invited him to her album signing in the Opry gift shop.

"That was my first experience with the Opry," Combs said. "The fact that an artist was willing to do that for me, and go out of their way to say, 'Hey, sorry you weren't able to make the show,' speaks volumes to what the Opry is, and the kind of people who are performing there."

Just one year after that first visit, Combs moved to Nashville and would sometimes go to the Opry to see Eric Church, or to support friends who were making their Opry debut. Nobody could have guessed what the future held when the momentum from Combs's debut single, "Hurricane," carried him to his own Opry debut on October 29, 2016. As his career grew to superstar status, Combs continued to return to the circle, occasionally bringing along a few of his favorite songwriters for in-the-round performances, so they could experience the Opry, too.

On June 11, 2019, during his sixteenth Opry appearance, a shocked and emotional Combs accepted an Opry invitation from John Conlee,

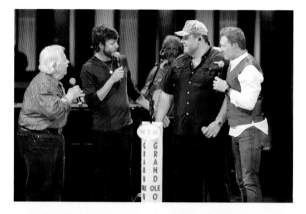

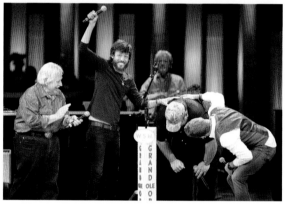

Chris Janson, and Craig Morgan. "It really was an incredible night, a landmark moment in my career," Combs said. "It was just everything that you could have ever wanted it to be. It really was a perfect night."

Vince Gill and Joe Diffie presented Combs with his Opry Member Award on July 16, 2019, cheered

PREVIOUS SPREAD: Marty Stuart, Vince Gill, and Brad Paisley prepare to perform to an empty auditorium as host Bobby Bones introduces the show to a remote audience during the COVID-19 pandemic, March 21, 2020. ABOVE, FROM TOP: John Conlee, Chris Janson, and Craig Morgan surprise Luke Combs with an invitation to become the next member of the Grand Ole Opry, June 11, 2019; Luke Combs doubles over in shock at being invited to become the next Opry member, June 11, 2019. OPPOSITE, FROM TOP: Early appearance by country music legend Gene Watson on the Opry stage, June 10, 1977; Vince Gill surprises Gene Watson with an invitation to become a member of the Grand Ole Opry on January 17, 2020.

on by the Gatlin Brothers, Chris Janson, Dustin Lynch, Craig Morgan, and Mark Wills. Behind the scenes that summer, Opry stars were also applauding Dan Rogers, who was promoted in August from his executive role in marketing to vice president and executive producer of the Grand Ole Opry. Like Sally Williams, who announced her departure a few weeks prior, Rogers brought two decades of Opry experience to the position. His unwavering enthusiasm for promoting the Opry led WSM radio personality Bill Cody and country music columnist Hazel Smith to start calling him "Opry Dan." The nickname stuck.

In the new role, Rogers would guide the process of selecting new members. Because he'd been part of the Opry fold for more than twenty years, he had a keen sense of who would take the commitment of an Opry membership seriously. Invitations soon materialized for country traditionalist Gene Watson and bluegrass star Rhonda Vincent.

On January 17, 2020, during an Opry show at Ryman Auditorium, Vince Gill surprised Watson with the long-awaited invitation. It was a full-circle moment, as Watson made his Opry debut fifty-five years earlier at the Ryman as a special guest of the Wilburn Brothers. Then working as an auto body technician and just a few years into a music career, Watson received an unexpected standing ovation for his rendition of Hank Williams's "I Can't Help It (If I'm Still in Love with You)." However, ten years would pass before the Texas native truly stepped into the national spotlight with his sensual 1975 single, "Love in the Hot Afternoon." After seven consecutive decades of guesting on the Opry stage, Watson composed himself enough to sing his signature hit, "Farewell Party."

"All I know is that I love the thought of being a member, and I knew every time I played it, I'd love to be a member, but it didn't look like I was going to be," Watson said. "And if there's anybody in the world that holds the flag for country music up, it's me. Ray Price even told me, he said, 'If anybody can keep our kind of country going, it's you.' I got to thinking about that, and that's a pretty good load to carry around on your back. I don't know if I can carry the flag or not, but I'll tell you what, I'm going to keep plugging at it."

As for Rhonda Vincent, given the many ways that the Opry had woven through her life and career, her membership seemed preordained. As a child, her family visited the Grand Ole Opry and stood in line for hours outside Ryman Auditorium. Her father, Johnny Vincent, walked with a cane after a severe car accident in 1964, so a stranger hoisted Rhonda on his shoulders to see the long line to the door. Once inside, they saw Stringbean, whose unusual stage costume would have made an impression on any four-year-old.

PREVIOUS SPREAD: Shock and elation as Rhonda Vincent receives an Opry invite from Jeannie Seely, February 28, 2020. ABOVE: The Sally Mountain Show, including future Opry members Darrin Vincent (far left) and Rhonda Vincent (center), performs on the Grand Ole Opry stage, October 12, 1982. OPPOSITE: Colin V. Reed, chairman and CEO at Ryman Hospitality Properties, is the lone audience member as Bill Anderson performs at the Grand Ole Opry House, Saturday, March 14, 2020 (© Alan Poizner—USA TODAY NETWORK)

Johnny Vincent kept the family's band, the Sally Mountain Show, active on the road, particularly on the bluegrass festival circuit. In the late 1970s, they were hired as staff musicians at Silver Dollar City, a quaint theme park in Branson, Missouri. On one occasion, dealing with a day of downpouring rain, Johnny Vincent insisted the band still needed to play, even if it meant singing to empty chairs. Rhonda and her brother Darrin (later of Dailey & Vincent) complained but did as they were told. A week later, Opry GM Hal Durham called Johnny Vincent out of the blue to book the Sally Mountain Show; he'd been tucked away nearby that Silver Dollar City stage with his family, riding out the storm and listening to the band.

The Sally Mountain Show returned to the Opry multiple times, well into the 1980s. After Vincent won TNN's *You Can Be a Star* in 1985, Jim Ed Brown hired her for his touring ensemble. As a segment host at the Opry one night, Brown surprised her with an opportunity to sing, marking her solo Opry debut. She returned to the Opry as an aspiring nineties country artist and, later, an award-winning bluegrass entertainer. Finally, on her 215th Opry appearance, Vincent was extended an invitation by Jeannie Seely. Her stunned response: "Are you serious?!"

"In my mind, I came to peace with the idea that I would never be an Opry member," Vincent recalled. "I said, 'It's never going to happen.' And I had absolutely no warning. I had no clue . . . But you talk about a very thankful moment. This is what I've always dreamed of. Dreams really do come true. God gives us the desires of our heart, and I don't know of a greater desire that was in my heart than to be a member of the Opry that I love so very much, and I love being a member."

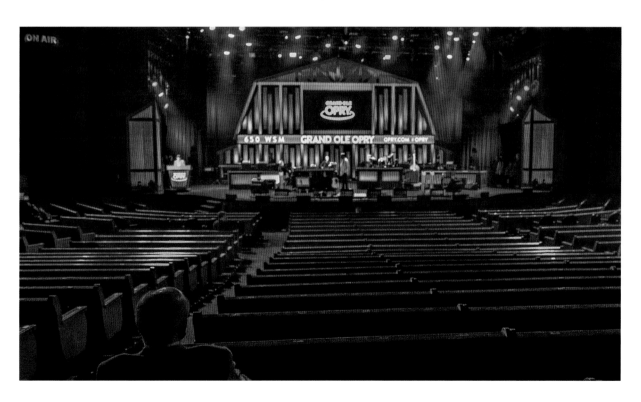

CLOCKWISE FROM TOP LEFT: Bill Anderson rehearses for the first empty house caused by the COVID-19 pandemic, March 14, 2020; Kelsea Ballerini, and Keith Urban perform during the pandemic, May 16, 2020; Luke Combs and Craig Morgan perform on April 25, 2020 (the show would not return to full capacity until March 2021); Vince Gill and Reba McEntire perform to an empty house, July 18, 2020; production staff wear masks during the broadcast of *Opry Live* during the pandemic, April 4, 2020; Opry producer Martin Fischer wears a mask during the broadcast of *Opry Live* during the pandemic, April 4, 2020; Mandy Barnett performs to an empty auditorium during the Opry's first live COVID-19 Grand Ole Opry broadcast, March 14, 2020.

Vincent's invitation happened on February 28, 2020, with her induction planned for March 24, 2020. Little did anyone know that the Opry—and the world—was headed toward a lockdown. Just two weeks after Vincent's invitation, there was no longer an audience in the Opry House. But there was a show.

———

On Friday, March 13, as the COVID-19 pandemic took hold, the Opry announced that all Tuesday- and Friday night performances would be canceled through April 4. However, the world's longest-running radio show would continue with its Saturday night broadcast. Hearkening back to 1925, the Opry would temporarily take place without an in-person audience. The following night, the lineup consisted of members Bill Anderson, Jeannie Seely, and Connie Smith, alongside the evocative singer Mandy Barnett, bluegrass band Michael Cleveland & Flamekeeper, and newcomer Sam Williams, the grandson of Hank Williams. Mike Terry handled the announcement duties. Rather than warm hugs and cordial handshakes, artists stayed six feet apart, mostly keeping to themselves in dressing rooms. There was no applause.

"I said, 'Nothing unusual for me. I've been playing to empty auditoriums all my life,'" Anderson recalled with a laugh. "It was weird. I mean, to be in that building and that hall and see those seats out there with nobody sitting in them, it was pretty strange. But it had to be done and we did it."

For the second Saturday night broadcast without an audience, the Opry aired live on the

Circle Network even as other venues around the world were silenced. Vince Gill, Brad Paisley, and Marty Stuart, socially distanced on the Opry stage, traded songs and offered encouragement.

"It was so great to have a Grand Ole Opry to come to, because we were the only show on the

FROM TOP: Terri Clark, Ashley McBryde, and Lauren Alaina rehearse in the backstage parking lot in order to comply with COVID-19 protocol before appearing on the Opry show, April 4, 2020; the album *Opry Unbroken* features performances that took place during the pandemic. The record was released exclusively on vinyl in June 2021.

air throughout the nation at that moment," Stuart said. "And our job, the way I saw that night, was if we could touch one heart out there and say, 'Come on, we've got to keep one foot in front of another. There's a back door somewhere to this thing.' It was an awesome responsibility, but an awesome opportunity and a privilege to be able to do that."

"You know what that was for me? It made me feel like fiddling Jimmy Thompson," Gill added, referencing the first-ever musician to play on the radio show that became the Grand Ole Opry. "We were playing just to the radio, which is how this place started. I thought, 'Now, that's pretty cool.' What was neat was you didn't have to play to an audience, not that that's preferable. It's different, but it changes things. So, then you're the three guys that were up there, taking turns singing songs, and keeping the Opry going. And it was kind of beautiful."

When April 4 rolled around, the Opry House doors remained closed to ticket holders. On the Opry stage, however, Terri Clark swapped songs with guest artists Lauren Alaina and Ashley McBryde; they rehearsed their harmonies earlier that day, safely spread out in the Opry's parking lot. "The whole experience was really eerie, but I'm so grateful to have gotten to be a part of history," Clark said. "I think I looked at Ashley and Lauren at one point and I said, 'You know, this is a part of history. What we're doing here tonight is unprecedented.'"

Opry members continued to heed the call. Ricky Skaggs and Dailey & Vincent collaborated on April 18; Luke Combs and Craig Morgan appeared on April 25. Trisha Yearwood, who played a set on May 2 with Garth Brooks,

observed, "I think that the Opry saying, 'OK, how do we keep this going?' and 'Here's a way we could do it' was really smart. When the world turns upside down, to have something that is that stable, something that continues, that is normal in the face of everything not being normal, is important."

At the end of June, *Variety* reported that an average of two million people were tuning in to the Opry each week across a variety of platforms. For one of the highest-rated installments, Vince Gill and Reba McEntire teamed up for a July 18 show, bringing along just three backing musicians. In an interview prior to an appearance at the Opry in 2023, McEntire said she immediately flashed back to that moment during sound check.

"It was just surreal that we had been through that time when nobody was at the Opry," she said. "But we kept the music going. The lights were on. That's huge. What a dedication. I'm so proud to be a part of the Opry family for a lot of reasons, and that's one of them."

The Opry received a ninety-fifth birthday gift in October when a limited audience of five hundred fans, or roughly eleven percent of the venue's capacity, returned to the Opry House, even though capacity restrictions would remain in place until the spring of 2021. If there was a silver lining, it's that the Opry reconnected with its viewing audience through live streaming. Circle Network's one-hour *Opry Live* show reached more than fifty million views across fifty countries, making it the most-watched live musical performance series of the pandemic.

Although precautions were still in place, the Opry threw itself a belated ninety-fifth birthday party on January 21, 2021. Brad Paisley and Blake Shelton hosted the all-star show, which aired as a two-hour NBC special on Valentine's Day. Kane Brown made his Opry debut without a live audience; later, Darius Rucker invited Lady A to join the Opry, effective immediately. The award-winning trio had made numerous guest appearances since their 2007 debut.

"It was such a blessing to have that moment, especially during the pandemic. There was just nothing positive happening, it felt like, and to have such a special moment and honor, we were over the moon," said Lady A member Charles Kelley. "It was such a highlight of what had been a really hard year, and the timing couldn't have been more perfect for us. And that was one of

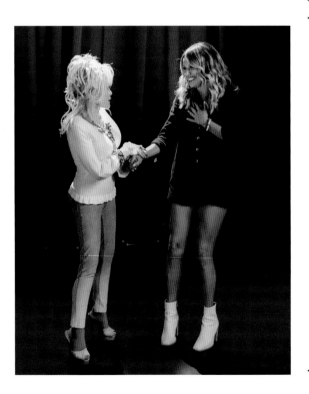

the only stages where we were able to perform during the pandemic."

"The Grand Ole Opry is not a fair-weather friend," added band member Hillary Scott. "I feel like they've walked through the ups and downs of artists' very hard times, very great times, and been consistent and loving and welcoming, which is what a good, healthy family does. I'm very, very grateful for that. And I would love to be on the committee of how people get asked, because that would be so much fun to just plan surprises all the time. I would love that job!"

"I remember our debut was so fun. That was so special to get to do that for the first time," added band member Dave Haywood. "That first time, we got to meet Vince Gill; he was backstage. It's imprinted on my mind the very first time Bill Anderson introduced us, and his voice is just iconic. I mean, his voice will live on for generations."

After nearly a year of waiting, Rhonda Vincent finally received her Opry Member Award on February 6, 2021, as the audience gradually returned and grew in size. In May, the Grand Ole Opry House returned to its full capacity. For fans and artists alike, seeing the Opry find a way to go on through the pandemic, as it had when displaced by the flood in 2010, gave a sense of comfort and normalcy during times that were anything but normal. On the other side of the crisis, deeper bonds among the members and renewed respect for the institution spurred a period of appreciable growth as Opry invitations were soon bestowed upon Carly Pearce, the Isaacs, Mandy Barnett, Lauren Alaina, and Jamey

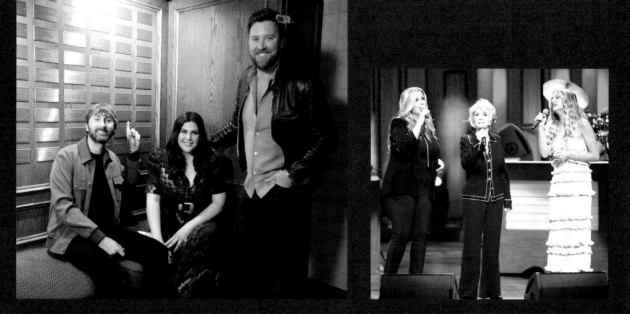

OPPOSITE: Dolly Parton surprises Carly Pearce with an Opry invitation during a contrived commercial taping for Dollywood. THIS PAGE, CLOCKWISE FROM TOP LEFT: Lady A—Dave Haywood, Hillary Scott, and Charles Kelley—pose with their Opry member plaque; left to right: Trisha Yearwood, Carly Pearce, and Jeannie Seely perform the Kitty Wells classic "Making Believe" following Pearce's Opry induction on August 2, 2021; during the taping of the Opry's ninety-fifth birthday celebration, Darius Rucker surprises Lady A with the news that they are the newest members of the Opry cast; Ricky Skaggs and the Whites welcome new Opry members the Isaacs, September 14, 2021.

TOP: Connie Smith invites Mandy Barnett to become a member of the Grand Ole Opry, September 28, 2021. BOTTOM: Mandy Barnett holds her Opry Member Award the night of her induction, November 2, 2021.

Johnson. All five artists had been regulars at the Opry for years.

In June 2021, Carly Pearce was tricked into believing she was filming a television spot for Dollywood, the East Tennessee theme park where she performed as a teenager. During the shoot, when she saw Dolly Parton walking her way, she got excited because she thought Parton might be in the commercial, too. Instead, Parton offered an invitation for Pearce to join the Opry. When Pearce crumbled into sobs, Parton quipped, "Well, you can't do it sitting down. Get up!"

Pearce sat in the Opry audience as a kid on a family vacation, but she declined a spot on the backstage tour. She'd already decided that she wanted to be an artist before she ever stepped on the stage. Trying to catch a break after moving to Nashville, she found Opry GM Pete Fisher's email address online and sent him a message in 2014 about being on the show. Fisher agreed to meet for coffee and took an interest in her slow-building career. A year later, on May 30, 2015, she made her Opry debut; offstage, she was still making ends meet by cleaning vacation rentals. Two years would pass before she signed a record deal and landed a major hit with a song she co-wrote, "Every Little Thing."

"I remember feeling maybe worthy because I had worked so hard, but also maybe unworthy because nobody knew any of my songs," Pearce recalled. "My entire life has changed and the trajectory of my career from that moment to now is just . . . it's crazy. The Opry believed in me before the town believed in me, or before anybody knew who I was."

Ricky Skaggs, an Opry member for nearly forty years by this time, joyously invited the Isaacs, a family gospel group with a strong country and bluegrass influence, on August 10, 2021. He returned alongside the Whites on September 14, 2021, to induct their close family friends.

Lily Isaacs and her children, Sonya, Becky, and Ben, had been making guest appearances at the Opry since 1993. Porter Wagoner, who loved their a cappella song "I Have a Father Who Can," initially brought them to the Opry stage after inviting them to sing at his birthday party. On another night in the mid-nineties, Sonya and Becky were harmonizing in their Opry dressing room when Vince Gill, who was Sonya's favorite singer, popped in. Even though he'd never met them, he complimented their voices and asked if they'd join him on "Go Rest High on That Mountain" that night. Sonya also remembered the emotional response when the Isaacs and Alison Krauss delivered an exquisite rendition of "It Is Well with My Soul" on the Opry stage in 2018.

The induction ceremony was especially momentous for Ben, who'd grown up blasting Ricky Skaggs albums on his bedroom speakers. Founding member Joe Isaacs, who left the group after his divorce from Lily in 1998, was also welcomed to the stage for a song. As a member, Lily said she relishes being called "mom" not just by her kids, but by the Opry staff and crew.

"We are a Jewish family, and my parents are Holocaust survivors. So, my parents lived through a nightmare," she said. "I came to America when I was two years old, became citizens with my parents when I was nine. My kids are firstborn Americans. I love to say we're living the American dream. The honor of the

TOP: Lauren Alaina performs for her Opry debut, June 10, 2011. BOTTOM: Trisha Yearwood invites a stunned Lauren Alaina to become a member of the Grand Ole Opry.

diversity in this family of Grand Ole Opry members is huge."

Connie Smith wept when she received the call asking if she would invite her longtime friend Mandy Barnett to be the Opry's next inductee. She surprised Barnett with a birthday card on the Opry stage on September 28, 2021, along with a long-awaited offer to join. Twenty-seven years had passed since Barnett's debut, yet she'd been part of the community since she was a kid.

Growing up in Crossville, Tennessee, Barnett would get asked to sing at fair openings or political rallies. Because of her booming voice, some folks referred to her as "Little Kate Smith," alluding to the torch singer famous for belting out "God Bless America." When Barnett was eight, she started singing along with country and gospel "soundtracks" (similar to a modern-day karaoke track) on a truck bed at the Wilson County flea market. The woman who sold the soundtracks was the sister of Ralph and Melvin Sloan, who headed up the square dancers at the Opry. Melvin Sloan took Barnett to the Opry for the first time when she was ten years old. She sang for Roy Acuff in his dressing room, mingled with a bunch of Opry stars, and met Charlie Dick, Patsy Cline's widower, who happened to be backstage that night.

Cline holds an integral place in Barnett's life story, even though the iconic singer had been dead for two decades by the time Barnett discovered that powerful, versatile voice. Barnett first played the Opry in 1994, dressed up as Patsy Cline shortly after landing the title role of a new theatrical production at the Ryman titled *Always, Patsy Cline*. Through its run, and even

after the show closed, Barnett returned to the Opry regularly as a guest.

As her appearances swelled, eventually surpassing five hundred visits to the Opry stage, she held out hope for her own invitation, though she had privately accepted that it might not ever happen. Looking back on it, she said she never felt any animosity or bitterness from elder members in the late nineties and early 2000s, when up-and-coming artists were sometimes met with skepticism.

"If I was, I never knew it, and it didn't last because I really feel like I had a lot of support,"

ABOVE: Jamey Johnson performs on the Opry stage, June 16, 2023. OPPOSITE, TOP TO BOTTOM: Don Schlitz performs one of his hit songs the night of his Grand Ole Opry induction; Vince Gill invites Charlie McCoy to become a member of the Opry; Charlie McCoy and Don Schlitz pose with Vince Gill after being invited to become members of the Grand Ole Opry.

Barnett noted. "Maybe they realized that I wanted to preserve country music, too. And the music that I loved was what they loved. I felt a lot of support from Opry members. I know many of them stuck out their neck for me and went to management and asked for me to become a member of the Opry. Ranger Doug did multiple times. I know George Hamilton IV did, Jean Shepard, Jimmy C. Newman, I knew Porter and Little Jimmy Dickens did. There were a lot of people. I had a lot of great support and that's what I thought about when they asked me to become a member: 'Gosh, I wish they could have seen it.'"

Just before Christmas, Lauren Alaina received her invitation from Trisha Yearwood, a close friend and mentor. As a teenager, Alaina auditioned for *American Idol* on the Ryman stage, made it to Hollywood, and placed second overall. She made her Opry debut on June 10, 2011, as did that year's *Idol* winner, Scotty McCreery. Brooks and Yearwood inducted Alaina on February 12, 2022, following a congratulatory video from Dolly Parton. At last, her photo hangs on the wall of a dressing room dedicated to the women in the Opry cast. Before being invited to join, Alaina would stick her head in an open spot in the room's framed photo display and take a selfie; frequently it would end up on social media.

"I probably did that twenty times. There are a bunch of those photos," Alaina said. "I couldn't have sent a letter in the mail any louder to say, 'Hey, this really would mean a lot to me.' But everything happens when it's supposed to, genuinely. I think it worked out so great that I wanted it for so long because I really didn't see it coming at all. I knew it would happen

eventually. I really believed it in my being, but I didn't think it was happening that night. So that was pretty cool. And now I don't have to stick my head anywhere. I just get to look at myself. I'm like, 'Hey, what's up, Lauren? Good to see you!'"

Jamey Johnson felt a similar pull to the Opry. Born in Enterprise, Alabama, Johnson and his family lived in the small town of Troy for about three years before relocating to Montgomery. As Johnson started discovering country music, the songwriting of Hank Williams fascinated him, not only because of the Montgomery connection but for the remarkable legacy that Williams left despite his short career. After two years in college and eight years in the US Marine Corps, Johnson moved to Nashville on January 1, 2000.

Supporting his career-launching single, "The Dollar," Johnson made his Opry debut on September 10, 2005. Though he rarely granted interviews and maintained some sense of mystery, his profile in the Nashville music industry continued to rise. He won several awards as a cowriter of George Strait's 2006 hit "Give It Away" and staked out his own place on the chart in 2008 with a nostalgic ballad, "In Color." Johnson estimated that he played the Opry five or six times a year after that, but there was never any indication that he was being considered for membership.

Johnson's dream was finally realized on March 19, 2022, during a songwriting round on the Opry stage with his frequent cowriters, Bill Anderson and Buddy Cannon. Between songs, Anderson stood at center stage and informed Johnson that this would be his last guest appearance; Johnson quipped, "I've been kicked out of

a whole lot of places in my life!" With a voice full of emotion, Anderson then revealed to the audience that Johnson would be the newest member of the Opry cast. Anderson also presided over the induction on May 14, 2022.

"I asked Bill one time, a long time ago, 'When's the Opry going to add a member that really wants to play the Opry?'" Johnson remembered. "And I didn't mean anything by it. I wasn't trying to smack nobody around, but I

think all I meant was how much I would appreciate being a member. And it probably came out wrong. I thought there might've been some grievance with me over having voiced it that way, but evidently not."

———

When Charlie McCoy and Don Schlitz were asked to join the Opry on June 11, 2022, it was the first time that the audience got to see two performers receive an invitation on the same night. Even though McCoy thought it might be nice to be a member, he never saw his Opry invitation coming. He got his break as a teenager when Mel Tillis heard him playing rock 'n' roll guitar at a Florida club. After moving to Nashville in 1960, McCoy became a first-call session harmonica player and released a few albums of his own. In later years, he worked on *Hee Haw and TNN's Music City Tonight*, and made guest appearances at the Opry at the request of both Pete Fisher and Sally Williams. McCoy was eighty-one years old when he joined the cast on July 13, 2022, and his affection for the Opry was palpable.

"I can't tell people how great this band is. They are absolutely overwhelmed with having four or five shows a week. It's crazy, but they're so good," he said. "Plus, it's the greatest audience in the world, and it's always different. That's a good thing. I love it all. I'm friends with all the stagehands, the sound people; they all really care about this and it's part of a team."

Don Schlitz was twenty and mending a broken heart when he moved from Durham, North Carolina, to Nashville in 1973. He had eighty dollars to his name and was trying to find his footing as a songwriter. He worked the graveyard

shift as a computer operator at Vanderbilt University but spent about half of his eight-hour shift thinking about rhyme and meter. On a lark, he auditioned with a funny song for a contest held at the Ryman, figuring that would be his one and only time on the Opry stage.

That wasn't the case. In 2017, when Vince Gill asked him to come along to the Opry after dinner one night, Gill unexpectedly brought him out for a song; after that, Schlitz started getting the call to appear as a guest. At first playing solo, and later incorporating the Opry's house band and singers into his set, Schlitz had no shortage of songwriting credits to share: Randy Travis's

ABOVE: Carlos DeFord Bailey , the grandson of the Opry's "Harmonica Wizard," DeFord Bailey, poses with new Opry member Charlie McCoy. OPPOSITE, TOP TO BOTTOM: Ashley McBryde makes her Opry debut, June 16, 2017; Ashley McBryde performs for her Opry induction, December 10, 2022.

FROM TOP: Wendy Moten's Opry debut, April 20, 2019; Mickey Guyton performs on the Opry June 6th, 2022. OPPOSITE: Marty Stuart announcing Henry Cho and Gary Mule Deer's Opry invitation, January 6, 2023. The invitation took place earlier in the evening during a Facebook Live stream.

"Forever and Ever, Amen," Kenny Rogers's "The Gambler," Reba McEntire's "One Promise Too Late," and Keith Whitley's "When You Say Nothing at All," to name a few. When Gill offered the invitation, Schlitz replied, "I'm gonna be a member of the Grand Ole Opry! Can I bring my songs with me?"

"That was smarter than I could have imagined," Schlitz said about his impromptu remark that night. "Because what it's turned out to be for me as a songwriter, and I think the first and only songwriter that's been invited–it's the songs that got invited. I mean, Kenny Rogers cannot be here tonight. Alison Krauss is out working and doing other things. Keith Whitley cannot be here tonight. Randy Travis cannot be here tonight. Their songs deserve to be out there. And when I start singing them, and giving the backstory of being a song, the audience is agreeing with me, those songs should be here. They're all Opry-quality songs."

The unconventional approach to invitations didn't stop there. On October 6, 2022, while promoting a new album on the New York set of *CBS Mornings*, Ashley McBryde teared up when Garth Brooks was patched in from the Opry stage to extend the invitation on network television. Inducted by Terri Clark, McBryde joined the cast on December 10, 2022.

Even though McBryde had come to the Opry as a kid on a family vacation, she had never stepped backstage until June 16, 2017, the night of her debut. Fighting back tears, she nailed her performance of "Girl Goin' Nowhere," earning a standing ovation for a self-written song about believing in yourself when others don't.

"I think the Opry is sacred as long as we treat it sacred. And it's a priority as long as we make it clear that it is," McBryde said. "So, if we want future generations of whoever is on country radio, whoever's in the genre, even if they're not on country radio at the time, we have to keep making it important and be loud about it and visible about it. Because again, if you're not playing at the Opry, you're not doing the whole thing."

In recognition of Black History Month in 2023, the Opry reiterated an apology from the prior summer addressing the hurt from past decisions, including the dismissal of DeFord Bailey in 1941 and the use of blackface in the Opry's first three decades. The statement concluded: "More recently, the Opry has worked towards positive change. We are committed to growing, listening, and learning. While the Opry cannot change the mistakes of the past, we acknowledge them. We are sorry for the hurt those decisions caused then and now and we vow to be a leader in creating a welcoming and inclusive future for country music."

Dan Rogers, now the Opry's senior vice president and executive producer, said, "You can't change history, but if you can do something that might make someone somewhere feel better, and might make people around the globe realize they really are welcome—that the doors are open to lots of different people, beliefs, styles—why not? It's important. This place benefits from all those things; it shouldn't just be about different generations, which it is, but it should be about different styles, viewpoints, histories, where people have come from."

Rogers confirmed that the emphasis on diversity was an intentional decision by Opry

management. To view the Opry experience through another lens, Rogers and his colleagues personally reached out to artists of color to learn more about their experiences at the Opry.

One of those artists, Memphis native Wendy Moten, adored *Hee Haw* and *Soul Train* as a kid. She worked at the local theme park Libertyland as a teenager, thinking she'd parlay that into a gig at Opryland USA. Her career took a different turn, though, when she signed with EMI Records in 1992 and earned an international R&B hit with "Come in Out of the Rain." A few years later, Julio Iglesias hired her as his touring duet partner.

When she heard that Vince Gill needed a singer in his band, Moten did a deep dive into country music, studying the techniques of the women in country music in the sixties and seventies. Impressed with her voice and noticing that she'd done the homework, Gill hired her. On his twenty-fifth anniversary as an Opry member in 2016, Gill brought Moten to the circle to sing one of his ballads, "Faint of Heart." Since that night, the Opry has welcomed her back to the stage dozens of times. At first, she called Gill to ask if he was involved in those bookings; he replied that he had nothing to do with it.

"I used to wonder, 'Why am I so comfortable here? And why are they so comfortable with me, considering the history?'" Moten said. "And it's like, 'You've always been a bridge.' So, I hope to be that bridge for everyone else that is maybe not white, or whatever, that dreams about this place. They see me and I create safe passage. Come this way. There's love here. Nothing is perfect, but here it's more open, more welcoming. I

hope if my presence does that, then yeah, I want that for people."

On February 11, 2023, Henry Cho became the Opry's first Asian American inductee, and the first comedian in fifty years, to join the cast. Cho made his Opry debut in 2011 and performed more than a hundred stand-up sets before being asked to join. He'd been friends with Gary Mule Deer for at least thirty-five years, making the double invitation from Marty Stuart an especially rewarding experience. Both comedians were in-house favorites for years, especially among stagehands and the Opry staff band.

"The band doesn't have to play me on and off, but they do. And I love them back there," Cho said. "They've heard a lot of these jokes over a hundred times because I found out what works at the Opry. When I first started doing it, I would try to do a different set because as a comedian, that's kind of how we roll. And Vince Gill told me, 'Hey, man, I've been singing the same three songs all month. Little Jimmy Dickens told the exact same joke verbatim every night. Just crush it.' And so that's my goal, is to go out and crush it."

Being around the entertainment business since the 1970s, Gary Mule Deer knew quite a few Opry members personally. His closest friend is Randy Hart, the keyboard player in the Opry band. They met in 1977 when Hart was Roger Miller's bandleader and Mule Deer was opening the shows in Las Vegas. Mule Deer made his Opry debut at the request of Roy Acuff, who'd seen the comedian's set on TNN. Inducted on March 10, 2023, at the age of eighty-three, Mule Deer said he's seen his royalty checks from old comedy albums increase tenfold, which he attributes to his Opry

exposure. In contrast to Henry Cho, Mule Deer usually takes a stab at new material:

"Here's a joke. I'm going to try this tonight for the first time on the Opry. A couple of months ago, my wife yelled down to me from upstairs and said, 'Do you ever get shooting pains in your chest and all over your body, to make you feel like maybe somebody made a voodoo doll and they're punching you with stuff?' And I said, 'No.' And she said, 'How about now?'"

———

Amid so many membership milestones, the Opry and its extended family continued to

OPPOSITE: Left to right: Opry members Dustin Lynch, Connie Smith, John Conlee, Jeannie Seely, and Chris Young celebrate five thousand Saturday night broadcasts of the Grand Ole Opry on October 30, 2021. ABOVE: Jon Pardi poses with Opry senior vice president and executive producer Dan Rogers and Guy Fieri after being invited to be a member of the Grand Ole Opry.

COUNTERCLOCKWISE FROM TOP: Bill Anderson celebrated his sixtieth Opry anniversary on July 17, 2021, with the Opry audience and backstage with cake. As of 2024, Anderson, who joined in 1961, is the longest-serving Grand Ole Opry member; Opry senior vIce president and general manager Dan Rogers and associate producer Gina Keltner honor Jeannie Seely on her fifty-fifth Opry anniversary. Seely holds the record for the most Grand Ole Opry appearances by any Opry member in history; OPPOSITE, LEFT TO RIGHT: Sara Evans celebrates her Opry induction; Scotty McCreery smiles after receiving his Opry invitation.

set records. Thirteen cast members marked the five thousandth Saturday night broadcast on October 30, 2021. In September 2022, Jeannie Seely celebrated her achievement as the member with the most Opry appearances, reaching and easily surpassing five thousand shows. Bill Anderson commemorated his sixty-second year as an Opry member in July 2023, breaking the record set by Herman Crook for the longest tenure.

Also in 2023, for the first time in more than twenty years, the Opry set earned a major upgrade to the tune of $4 million. The classic barn backdrop remains, though it is structured within a high-resolution video wall; among the new impressive lighting effects, a luminescent halo now surrounds the famous circle of wood.

Alongside these joyous occasions, the Opry family mourned numerous members since 2020,

including Joe Bonsall of the Oak Ridge Boys, Joe Diffie, Jan Howard, Stonewall Jackson, Hal Ketchum, Jesse McReynolds, Bobby and Sonny Osborne, Ray Pillow, and Charley Pride. Yet the cast continued to grow with the addition of Jon Pardi, Sara Evans, Scotty McCreery, and T. Graham Brown. Because the Opry strives to catch an artist by surprise when the big moment comes, none of these invitations arrived during a typical Saturday night show.

Pardi's invitation arrived during his set at Stagecoach Festival in Indio, California, when Alan Jackson popped up on a massive screen and delivered the good news. The first California native to join the Opry, Pardi got a rough start with the show when a member of the staff band fumbled through Pardi's Opry debut in 2012. Frustrated, Pardi decided to only play acoustic at the Opry after that, though his appearances were sporadic.

When he bumped into Dan Rogers and his colleague, Jordan Pettit, at a social event, they asked him why he didn't play the Opry often. He gave them the truthful answer: that he'd love to play it if he could bring his band. "Long story short, the band was invited, and it was never the same again," said Pardi.

He further bonded with the Opry during the pandemic, when there was no in-person audience and only two band members played with him. "That's when I really got to soak it up," he added. "I walked through every dressing room. I saw every picture. I went and toured the Opry House. That was when I really fell in love, and it felt like home. I guess it was a healing thing. We're all trying to get over being shut down from the pandemic, and the Opry was one of the first places I played, getting back to playing music. That's what started the whole Opry partnership and becoming a member."

Twenty-five years after her 1998 debut, Sara Evans also felt a disconnect in her relationship with the Opry. Emotions would get the best of her when she wondered why she hadn't yet been invited after selling millions of records and scoring number one hits such as "Born to Fly," "Suds in the Bucket," and "A Real Fine Place to Start."

"I felt that I deserved it, and then I would go into that dressing room where they have all the pictures of the women, and there would be people like Kelsea Ballerini. Nothing against them, but they were just way later than me," she said. "I would cry because I would hear about how Ashley McBryde became a member of the Opry, and I'm like, 'She just came out!' It started to become an issue where I was

thinking somebody at the Opry doesn't like me, but I had no idea. I just had to accept it and just be patient."

Finally, Evans received her invitation on the Ryman stage, during a twentieth-anniversary concert of her bestselling album, *Restless*. Bill Anderson, Carly Pearce, and Lady A shared the moment with the sold-out crowd. Evans was formally inducted on October 7, 2023, during the Opry's ninety-eighth birthday celebration. Her photo now hangs in the Women

of Country dressing room next to that of her idol, Reba McEntire.

One more crowd favorite received an invitation by year's end. Scotty McCreery made his Opry debut at seventeen years old, right after winning *American Idol* in May 2011. Just a few months after turning thirty, he accepted his surprise invitation from Garth Brooks, who brought out a wrapped gift during a Christmas-themed Opry on a Sunday night, December 3, 2023.

Asked about his emotions at that moment, McCreery responded, "Shock and disbelief first. Why the heck is Garth Brooks here? I didn't see him on the bill. It's just the honor of a lifetime, and it's always been such a huge goal, if not *the* goal, for me. Every emotion, every memory, every day of hard work just came flooding back. I've been working toward this a long time."

Entering the Opry's ninety-ninth year, T. Graham Brown was probably at the top of every Opry fan's wish list to receive the next invitation. Brown had been coming to the Opry regularly since 1985, singing hits like "Tell It Like It Used to Be" and "Hell and High Water." His music often leaned more toward R&B and soul than traditional country, though his amiable demeanor onstage transcended genres.

During a February 20, 2024, interview on Brown's SiriusXM radio show, in front of a live audience, his buddy Vince Gill caught him off guard with an Opry invitation. Brown broke down in tears, finally realizing a dream he'd held for nearly forty years. He said he and his wife, Sheila, had decided years ago that he would never ask to be a member. "I just figured

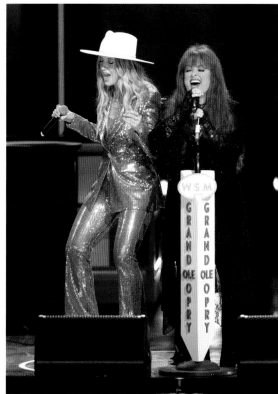

OPPOSITE: T. Graham Brown was shocked by Vince Gill with an invitation to join the Grand Ole Opry live on Sirius XM radio, February 20, 2024. ABOVE, FROM TOP: Lainey Wilson performing following her Opry induction on June 7, 2024; Lainey Wilson performing "Refugee" with Wynonna Judd the evening of Wilson's Opry induction.

if it's meant to be, it'll be," he said. "I didn't want to be that guy to put any kind of pressure on anybody."

Brown stood onstage alongside Bill Anderson, spanning the newest and the longest-serving Opry members, when the Grand Ole Opry House turned fifty on March 16, 2024. Connie Smith and Jeannie Seely, who took part in the Opry House's grand opening, also returned for the occasion. Just as it was in 1974, the anniversary show opened with a performance of "Wabash Cannonball," this time performed by members of the cast. Near the end of the night, Anderson surprised the audience by singing "I Wonder If God Likes Country Music" while the voice of Roy Acuff, taken from vintage performance footage of the pair's duet, rang through the Opry House.

Brown formally joined the Opry on May 3, 2024, with Vince Gill doing the honors. Just five weeks later, another much-anticipated invitation arrived over the airwaves. This time, Reba McEntire offered an Opry membership to Lainey Wilson on the season finale of *The Voice*.

Wilson grew up in a small town in Louisiana and set her sights on performing on the Opry after her first visit on a family vacation when she was nine years old. In 2011, at the age of nineteen, she moved to Nashville and lived in a camper trailer while trying to make her way into the music industry. Eighteen months after signing a record deal, she debuted on the Opry on February 14, 2020, and frequently returned to the circle as her star swiftly ascended. Within the twelve months leading up to the invitation, she placed a number one hit with "Watermelon Moonshine," graced the cover of *Billboard* magazine, earned Entertainer

of the Year awards from the Academy of Country Music and the Country Music Association, and collected her first-ever Grammy for her album *Bell Bottom Country*. Fittingly, Wilson selected a fashionable pair of golden bell bottoms and a matching jacket for her induction ceremony on June 7, 2024.

Asked how she feels before stepping into the circle of wood, Wilson told reporters, "I keep thinking that eventually I'm not going to be as nervous. I'm nervous every time, every single time. I try to make sure I channel that nervousness into excitement. But when you're standing in that circle of wood, it's hard not to think about the people who have stood on the same plank. You think about Hank Williams, and you think about Loretta, you think about Patsy, you think about everybody who had a similar dream to yours. It's definitely a presence. It's an energy and I'm very thankful. I feel like they're smiling down on me tonight, too."

———

The Grand Ole Opry has carried on for a century by taking chances and embracing new sounds. What started as a barn dance broadcast from an insurance office in downtown Nashville is now a celebrated global destination. Patrick Moore, CEO of Opry Entertainment Group, observed, "This milestone is both a testament to our rich history and a springboard into our exciting future. Our vision for the next century is bold. Like those who came before us, we are committed to honoring the legacy while embracing innovation and expanding our reach to new generations of music fans, and we are poised to reach a global audience as the undisputed cultural home of country music."

Dan Rogers, now senior vice president and executive producer of the Grand Ole Opry, noted, "I truly believe that with the power of everyone who has performed on or been a fan of the Opry over the course of its first one hundred years, the future of the Opry is bright. With each passing year, new generations become more intentional about making their own marks on this unique show and this incredible community of music lovers. Some of the true hallmarks of the Grand Ole Opry—great music, impeccable storytelling, authenticity, laughter, family, and friendship—will never go out of style."

Looking to new horizons, NASA astronaut Butch Wilmore and his flight crew sang "Rocky Top" live for the Opry audience from the International Space Station on July 20, 2024. A Tennessee native, Wilmore also became the first Opry announcer to participate from beyond planet Earth. Watching the Opry from the other side of the world, let alone having astronauts participating in the show from space, would have been unimaginable in 1925. Even amid such wondrous advances in technology, the Grand Ole Opry can still be tuned in on WSM 650 AM. The storied radio station relocated from Gaylord Opryland Resort & Convention Center to Roy Acuff's former home next to the Grand Ole Opry House in July 2024. A picture window allows passersby to peek at the action inside.

Approaching its centennial celebration, the world's longest-running radio show is thriving. Several nights a week, the Grand Ole Opry House pews are filled with more than four thousand fans, eager for the one-of-a-kind experience that only the Opry can provide. It can be staggering to think that for one hundred years,

no Grand Ole Opry show has ever been the same. Of course, spontaneity keeps the show fresh, even when it feels as comfortable as a family reunion.

With its growing and committed cast, the Opry's future is assuredly in good hands. Country music as a genre is also stronger than ever, which means that audiences are traveling to Nashville in record numbers. To meet demand, Grand Ole Opry performances are sometimes presented five nights a week. As it has since its inception, the Opry will embrace every emerging means of communication to expand its reach and make new fans, worldwide.

Lauren Alaina, a member since 2022, concluded, "You'd be hard-pressed to tell somebody about the Grand Ole Opry that doesn't know about it. But I want to expand that and represent the younger generation and inspire little girls out there right now, like Trisha Yearwood did for me. I want to represent the family well, and I want to wear the title well, and I want to bring people here that may not have been brought here before. It means so much to me, and I want to help make it live on forever."

INTO THE CIRCLE

ARTISTS MAKING THEIR OPRY DEBUT
OFTEN LEAVE A NOTE BEHIND TO
COMMEMORATE THE SPECIAL OCCASION.

Most little girls dream about their wedding day, beautiful dresses, & walking down the aisle. Well this is the day I've been dreaming about. I finally stepped foot into the Grand Ole Opry circle.
Lainey Wilson
2/14/20

Heritage, Tradition and Musical Memories of a Lifetime!!
Leslie Jordan

Grand Ole Opry,
Words can not express how honored I am to have been on that stage tonight. I thank you to everyone involved in making the best night of my life happen. I love you so much, and I'm the happiest man alive. I may or may not be the first to shit his pants out of nerves and excitement.
I LOVE YOU. goodnight.
- Post Malone

I'm living proof that miracles happen. Keep dreaming, keep creating, keep making art.

CLOCKWISE: Leslie Jordan, May 22, 2021, Lainey Wilson, February 14, 2020, Dionne Warwick, December 6, 2019, Carín León, February 24, 2024, Tyler Childers, September 5, 2023, Ashley McBryde, June 16, 2017, Lukas Nelson, September 12, 2017, Rita Wilson, October 23, 2018, Post Malone, August 14, 2024

323

WHAT AN INCREDIBLE HONOR TO WALK ON THE STAGE OF ABSOLUTE LEGENDS.

THANK YOU

I felt Good when I walked into the circle. Thanks for one of the best moments of my life!

CAPTN LEON

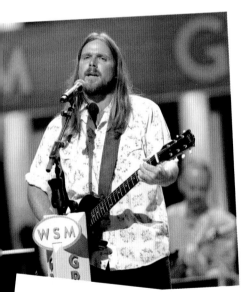

Dear Opry,
Thank you for having me...
Love you!

I told you I would.
And I'm about to.
I can't believe I'm about to play the Opry!
Not bad for a girl goin' nowhere.

Ashley McBryde

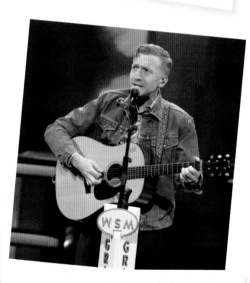

Wherever you're at, there ya are.
Honor to be here.

324

LITERALLY ONE OF THE BEST NIGHTS OF MY LIFE. DREAMS COME TRUE!! MINE DID ON Nov 9th 2021! Jelly Roll

Writing this 2 hours later & Im still freaking out... A dream come true ♡ Thank you —Megan

The War and Treaty

Tay I can't believe that this is happening

WE ARE Now OPRY FAMILY —Mike—

CLOCKWISE: Megan Moroney, February 11, 2023, Jelly Roll, November 9, 2021, Zach Top, July 27, 2022, Billy Strings, March 2, 2019, Breland, November 5, 2021, Jordan Davis, May 12, 2018, The War and Treaty, April 2, 2019

This was a dream come true. Such an honor to stand there and sing where most all of my heroes stood before me!

What an honor to stand in the circle, may it never be broken.

— Billy Strings

I'll never forget tonight... Such an honor... Thank You

5/12/18

Breland

My Opry debut was ELECTRIC! The crowd was so warm and inviting. WOW. I'll be back soon.

EPILOGUE

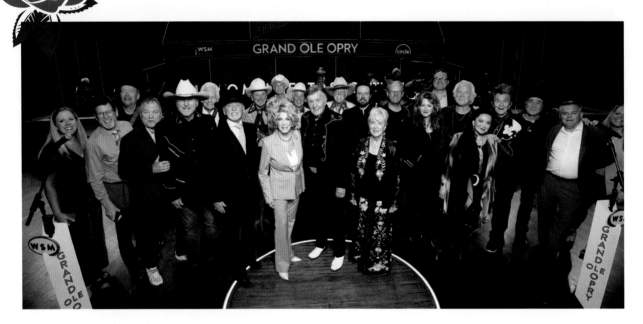

I'VE ASKED MYSELF NUMEROUS TIMES OVER THE PAST QUARTER CENTURY WORKING AT THE GRAND OLE OPRY, AND HAVING HAD A FRONT-ROW SEAT TO ITS HISTORY-IN-THE-MAKING, WHY I LOVE THIS SHOW AS MUCH AS I DO. I'm just one of thousands of past and present staff members, artists, and fans who have heard the Opry's siren song and made their way to Nashville to play a part in this show, about which there's so much I find personally fulfilling and universally appealing.

For starters, I love the Opry's family ties, both for me and among all who embrace it. My first memories of the Opry are sitting between my mom and dad in a pickup truck riding down southern Illinois highways and dark country roads, listening to its stars on Saturday nights through the pop, crackle, and static of 650 AM WSM radio. I have been fortunate to attend the Opry in person with my parents, my paternal grandparents, and my maternal grandmother, Winnie, watching the show we listened to on the radio unfold before our eyes. Like the family farm on which I was raised, the Opry passes its ways of life down from generation to generation. Patsy Cline famously reached out her hand in friendship to Loretta Lynn,

who reached out hers to Trisha Yearwood, who did the same for Lauren Alaina, and so on. It's amazing to walk the Opry's backstage hallways, look at the photos of those who have come before us, and think of the torches that have been passed and the legacies being built with each show we produce.

I also love the Opry's heart. It's the show on which just a few weeks ago Vince Gill wore one of his father's shirts for the anniversary of his passing, and performed a set list exclusively inspired by his dear old dad. Everyone listened intently on the side of the stage and in the auditorium, as I am sure was also the case for fans tuned in around the world. The Opry's heart was also front and center when Ms. Connie Smith's voice broke as she invited her longtime friend Mandy Barnett to become an official Opry member after Mandy had played the show magnificently more than five hundred times. And heart no doubt rang loud and clear across the radio airwaves when Ashley McBryde sang the words "Not bad for a girl goin' nowhere" on the night of her Opry debut. Perhaps among those listening was the teacher who'd inspired Ashley's words by advising her to pursue a life other than that of a songwriter or

recording artist. Performances such as those, filled with heart, happen so often on the Opry. It's a stage that seems to draw the very best out of those who step into its circle.

The excitement of the unexpected is something else I absolutely love about our hundred-year-old show. While we have a general plan for the show when the big red curtain goes up each night, every single show unfolds differently. There might be surprise onstage collaborations, or someone might be inspired to sing a song they've just penned. The Opry is well planned but also informal enough to allow magic to happen onstage and off. Some of my most memorable Opry moments have been the times when a superstar makes a surprise appearance and wows fans who've already seen a great show. I can almost hear them telling their friends back home about the experience after they've returned from Music City.

It's also important to share that my appreciation for the Opry comes from its proverbial open doors. The words on a backstage welcome mat, taken from a Dierks Bentley tune, ring true night after night: "This is still the place that we all call home." One of the show's monikers we've developed through the years is "the show that made country music famous," but some of my favorite nights at the Opry have been those that featured the best in today's country and country classics, alongside those in bluegrass, comedy, and other genres standing tall in the Opry's widening circle.

But of course, I'm enamored by the Opry's rich history. Everyone who works with, performs on, or is a fan of the Opry today stands on the shoulders of those who came before them, including those who, way back in 1925, embraced the then-new concept of AM radio. Naturally as we look back through the lens of one hundred years of history, we've found moments we'd change if we could—but we also acknowledge that every Opry performance and every fan interaction of the past ninety-nine years has led to the centennial we celebrate in 2025.

I don't just love the promise of the future at the Opry; I am energized by it. I hear the Opry's future both in

the strong voices of artists making Opry debuts and when I hear live performances of tunes such as "The Gambler" and "Don't It Make My Brown Eyes Blue" that'll be played in the circle long after I'm gone. I see the Opry's future in the eyes of young audience members looking up at the stage, perhaps wondering if they'll one day fill the shoes of Opry members such as Luke Combs, Scotty McCreery, and Lainey Wilson. Fans of the future can also be seen in online comments from around the world as young music aficionados share that they are tuned in to livestreams on Saturday nights (or in some cases Sunday mornings in their corner of the world), watching some of their favorite artists in Nashville.

It's probably obvious by now I could go on and on with my love letter to the Grand Ole Opry and my confidence in its future success, but I'll simply say I'd bet my last dollar that one hundred years from now, the Opry will still be honoring country music's past, present, and future.

If you've visited us in Nashville before, I hope you'll come back again and again. If you've never been to the Opry, you've now read all about its first hundred years. Please come be a part of its second century!

Grand Ole Opry: Long may she live!

DAN "OPRY DAN" ROGERS
Senior Vice President & Executive Producer, 2019–Present

ABOVE: Five-year-old Dan Rogers visits the Grand Ole Opry House.

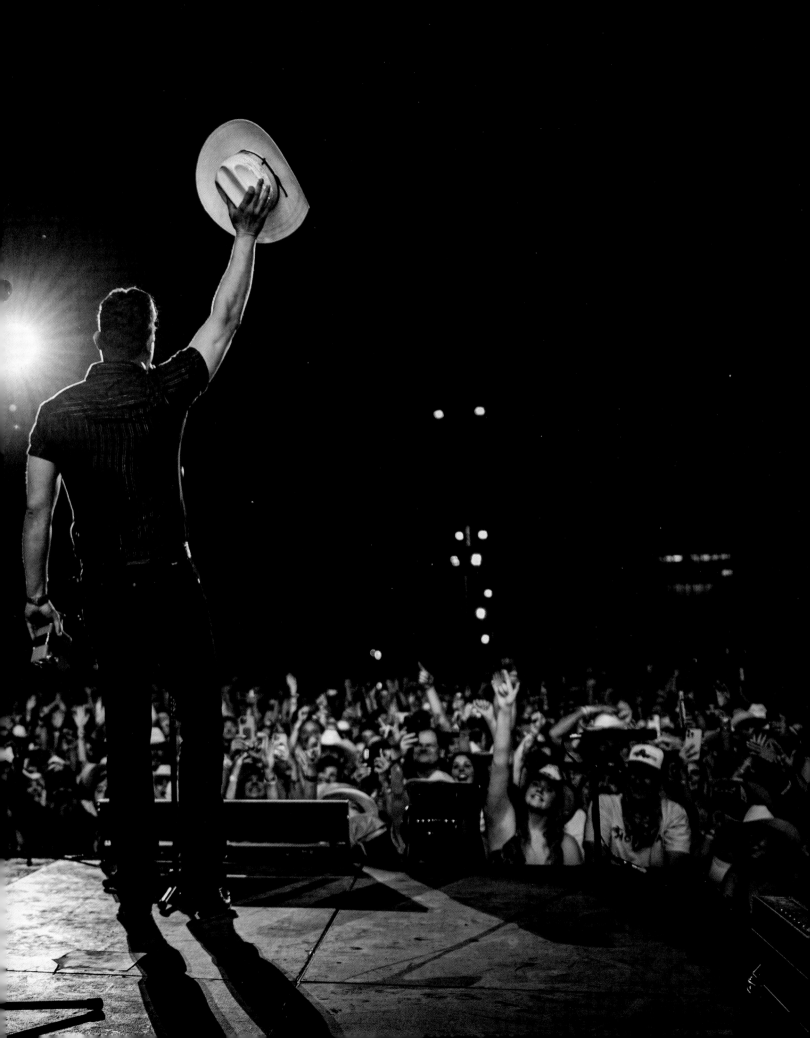

THE OPRY CAST

Roy Acuff
FEBRUARY 19, 1938

Trace Adkins
AUGUST 23, 2003

David "Stringbean" Akeman
FALL 1945; 1956

Lauren Alaina
FEBRUARY 12, 2022

Bill Anderson
JULY 15, 1961

The Andrews Brothers
FEBRUARY 18, 1939

Eddy Arnold
SUMMER 1943

Ernest Ashworth
MARCH 7, 1964

Chet Atkins
JUNE 1950

The Bailes Brothers
DECEMBER 1944

DeFord Bailey
JUNE 5, 1926

Kelsea Ballerini
APRIL 16, 2019

Henry Bandy
MARCH 13, 1926

Bobby Bare
AUGUST 7, 1965; APRIL 7, 2018

Mandy Barnett
NOVEMBER 2, 2021

Bashful Brother Oswald
JANUARY 21, 1995

Dr. Humphrey Bate and His Possum Hunters
JANUARY 2, 1926

Dierks Bentley
OCTOBER 1, 2005

Binkley Brothers' Dixie Clodhoppers
NOVEMBER 13, 1926

Clint Black
JANUARY 10, 1991

Margie Bowes
1959

Boxcar Willie
FEBRUARY 21, 1981

Rod Brasfield
JULY 1944

Garth Brooks
OCTOBER 6, 1990

T. Graham Brown
MAY 3, 2024

The Browns / Jim Ed Brown
AUGUST 10, 1963

Carl Butler / Carl and Pearl Butler
JULY 19, 1958; 1962

The Cackle Sisters
OCTOBER 1944

Archie Campbell
EARLY 1959

Bill Carlisle
NOVEMBER 14, 1953

Martha Carson
APRIL 26, 1952

June Carter
1958

Mother Maybelle & the Carter Sisters
JUNE 1950

Johnny Cash
JULY 7, 1956

Cedar Hill Square Dancers
BY 1952

Steven Curtis Chapman
NOVEMBER 1, 2024

Lew Childre
JANUARY 1945

Henry Cho
FEBRUARY 11, 2023

Roy Clark
AUGUST 22, 1987

Terri Clark
JUNE 12, 2004

Zeke Clements
1932; 1934; 1939

Kitty Cora Cline
MARCH 24, 1928

Patsy Cline
JANUARY 9, 1960

Jerry Clower
OCTOBER 27, 1973

Luke Combs
JULY 16, 2019

John Conlee
FEBRUARY 7, 1981

Wilma Lee & Stoney Cooper
MARCH 2, 1957

Cowboy Copas
1946

Cousin Jody
1955

The Crook Brothers
JULY 24, 1926

Dailey & Vincent
MARCH 11, 2017

Charlie Daniels
JANUARY 19, 2008

Skeeter Davis
AUGUST 1959

Lazy Jim Day
APRIL 21, 1946

The Delmore Brothers
APRIL 29, 1933

Diamond Rio
APRIL 18, 1998

Little Jimmy Dickens
BY SEPTEMBER 1948; FEBRUARY 8, 1975

Joe Diffie
NOVEMBER 27, 1993

Annie Lou & Danny Dill
1947

Clyde & Marie Dilleha
1943

The Dixieliners
APRIL 2, 1932

Jimmy Driftwood
MARCH 31, 1962

Roy Drusky
JUNE 1959

The Duke of Paducah
MARCH 1943

Holly Dunn
OCTOBER 14, 1989

Milton Estes
1946

Sara Evans
OCTOBER 7, 2023

The Everly Brothers
JUNE 1, 1957

Lester Flatt
MARCH 22, 1969

Flatt & Scruggs
SUMMER 1955

Red Foley
APRIL 6, 1946

The Four Guys
APRIL 22, 1967

Wally Fowler
SEPTEMBER 8, 1945

Curly Fox & Texas Ruby
AUGUST 1937; MAY 1944

Lefty Frizzell
JULY 21, 1951

The Fruit Jar Drinkers
DECEMBER 17, 1927

Larry Gatlin &
the Gatlin Brothers
DECEMBER 25, 1976

Crystal Gayle
JANUARY 21, 2017

The Georgia Peach
Pickers
DECEMBER 1942

Don Gibson
APRIL 12, 1958;
SEPTEMBER 13, 1975

Vince Gill
AUGUST 10, 1991

Tompall & the
Glaser Brothers
APRIL 1960

Billy Grammer
FEBRUARY 28, 1959

Jack Greene
DECEMBER 23, 1967

The Gully Jumpers
DECEMBER 24, 1927

Theron Hale &
Daughters
OCTOBER 30, 1926

Tom T. Hall
JANUARY 8, 1971;
MARCH 29, 1980

George Hamilton IV
FEBRUARY 6, 1960; MAY 8, 1976

The Happy Valley Boys
BY APRIL 1945

Sid Harkreader
JULY 3, 1926

Emmylou Harris
JANUARY 25, 1992

Hawkshaw Hawkins
JUNE 1955

Goldie Hill
AUGUST 1953

Hilltop Harmonizers
JANUARY 4, 1936

David Houston
AUGUST 12, 1972

Jan Howard
MARCH 27, 1971

Paul Howard
BY MAY 1942

Ferlin Husky
SUMMER 1954

The Isaacs
SEPTEMBER 14, 2021

Alan Jackson
JUNE 7, 1991

Stonewall Jackson
DECEMBER 1, 1956;
MAY 10, 1969

Sonny James
OCTOBER 27, 1962

Jamup & Honey
JANUARY 7, 1939

Chris Janson
MARCH 20, 2018

Jim & Jesse / Jesse
McReynolds
MARCH 7, 1964

John Daniel Quartet
BY MAY 1942

Johnnie & Jack
SPRING 1947; BY JANUARY 1952

Jamey Johnson
MAY 14, 2022

George Jones
AUGUST 11, 1956; JANUARY 11,
1969; MARCH 31, 1973

Grandpa Jones
MARCH 16, 1946;
JULY 1952

The Jordanaires
APRIL 1950

Rusty & Doug Kershaw
BY NOVEMBER 1957

Hal Ketchum
JANUARY 22, 1994

Bradley Kincaid
JANUARY 1946

Pee Wee King
JUNE 26, 1937

Alison Krauss
JULY 3, 1993

The La Dell Sisters
1956

Lady A
JANUARY 21, 2021

The Lakeland Sisters
JANUARY 23, 1937

Lasses & Honey
APRIL 21, 1934

Little Big Town
OCTOBER 17, 2014

Hank Locklin
NOVEMBER 12, 1960

Lonzo & Oscar
1947

Bobby Lord
NOVEMBER 1960

The Louvin Brothers /
Charlie Louvin
FEBRUARY 26, 1955; JUNE 1959

Patty Loveless
JUNE 11, 1988

Bob Luman
AUGUST 21, 1965

Robert Lunn
MARCH 31, 1934

Dustin Lynch
SEPTEMBER 18, 2018

Loretta Lynn
SEPTEMBER 29, 1962

Uncle Dave Macon
APRIL 10, 1926

Rose Maddox
OCTOBER 1956

Barbara Mandrell
JULY 8, 1972

Uncle Joe Mangrum &
Fred Shriver
JUNE 30, 1928

Benny Martin
SUMMER 1955

Martina McBride
NOVEMBER 30, 1995

Ashley McBryde
DECEMBER 10, 2022

Del McCoury
OCTOBER 25, 2003

Charlie McCoy
JULY 13, 2022

Scotty McCreery
APRIL 20, 2024

Mel McDaniel
JANUARY 11, 1986

Reba McEntire
JANUARY 14, 1986

Sam & Kirk McGee
1932

Ronnie Milsap
FEBRUARY 6, 1976

Minnie Pearl
NOVEMBER 1940

The Missouri
Mountaineers
FEBRUARY 2, 1935

Bill Monroe
OCTOBER 28, 1939

Montgomery Gentry /
Eddie Montgomery
JUNE 23, 2009

Clyde Moody
NOVEMBER 1944

Craig Morgan
OCTOBER 25, 2008

George Morgan
SEPTEMBER 25, 1948

Lorrie Morgan
JUNE 9, 1984

Gary Mule Deer
MARCH 10, 2023

Moon Mullican
APRIL 1951

Nap & Dee
MARCH 31, 1934

Willie Nelson
NOVEMBER 28, 1964

Jimmy C. Newman
AUGUST 4, 1956

Norma Jean
JANUARY 9, 1965

The Oak Ridge Boys
AUGUST 6, 2011

Old Crow Medicine
Show
SEPTEMBER 17, 2013

Old Hickory Singers
NOVEMBER 1943

The Osborne Brothers /
Bobby Osborne
AUGUST 8, 1964

Brad Paisley
FEBRUARY 17, 2001

Jon Pardi
OCTOBER 24, 2023

Dolly Parton
JANUARY 11, 1969

Johnny Paycheck
NOVEMBER 8, 1997

Carly Pearce
AUGUST 3, 2021

Stu Phillips
JUNE 17, 1967

The Pickard Family /
Obed Pickard
MAY 8, 1926

Webb Pierce
SEPTEMBER 13, 1952

Ray Pillow
APRIL 30, 1966

The Poe Sisters
JUNE 17, 1944

Poplin-Woods
Tennessee String Band
DECEMBER 17, 1927

Ray Price
JANUARY 1952

Charley Pride
MAY 1, 1993

Jeanne Pruett
JULY 21, 1973

Pete Pyle
1945

Rascal Flatts
OCTOBER 8, 2011

Del Reeves
OCTOBER 14, 1966

Jim Reeves
OCTOBER 22, 1955

Riders in the Sky
JUNE 19, 1982

Tex Ritter
JUNE 12, 1965

Marty Robbins
JANUARY 24, 1953

Darius Rucker
OCTOBER 16, 2012

Ford Rush
OCTOBER 7, 1939

Johnny Russell
JULY 6, 1985

Sarie & Sally
JANUARY 26, 1935

Don Schlitz
AUGUST 30, 2022

Jeannie Seely
SEPTEMBER 16, 1967

Blake Shelton
OCTOBER 23, 2010

Ricky Van Shelton
JUNE 10, 1988

Jean Shepard
NOVEMBER 1955

Asher & Little Jimmie
Sizemore
SEPTEMBER 10, 1932

Ricky Skaggs
MAY 15, 1982

Melvin Sloan Dancers
MARCH 22, 1980

Ralph Sloan & the
Tennessee Travelers
JULY 5, 1952

Ben Smathers & the
Stoney Mountain
Cloggers
1958

The Smith Sisters
JULY 1943

Arthur Smith
JULY 23, 1927

Carl Smith
JULY 1950

Connie Smith
AUGUST 21, 1965

Homer Smith
JULY 23, 1927

Mike Snider
JUNE 2, 1990

Hank Snow
JANUARY 7, 1950

Red Sovine
1955

The Stacey Sisters
DECEMBER 1939

Ralph Stanley
JANUARY 15, 2000

Marty Stuart
NOVEMBER 28, 1992

The Tennessee Valley Boys
MAY 7, 1938

B.J. Thomas
AUGUST 7, 1981

Hank Thompson
1949

Uncle Jimmy Thompson
NOVEMBER 28, 1925

Mel TIllis
JANUARY 11, 1969; JUNE 9, 2007

Pam Tillis
AUGUST 26, 2000

Mazy Todd
APRIL 3, 1926

Merle Travis
1961

Randy Travis
DECEMBER 20, 1986

Travis Tritt
FEBRUARY 29, 1992

Ernest Tubb
FEBRUARY 13, 1943

Justin Tubb
SEPTEMBER 10, 1955

Josh Turner
OCTOBER 27, 2007

Carrie Underwood
MAY 10, 2008

Keith Urban
APRIL 21, 2012

The Vagabonds
SEPTEMBER 5, 1931

Leroy Van Dyke
OCTOBER 20, 1962

Rhonda Vincent
FEBRUARY 6, 2021

Porter Wagoner
FEBRUARY 23, 1957

Billy Walker
JANUARY 1960

Charlie Walker
AUGUST 19, 1967

Steve Wariner
MAY 11, 1996

Gene Watson
FEBRUARY 7, 2020

Kitty Wells
SEPTEMBER 1952

Dottie West
AUGUST 8, 1964

Willie "Cousin Wilbur" Wesbrooks
SPRING 1945

The Whites
MARCH 2, 1984

Slim Whitman
OCTOBER 29, 1955

The Wilburn Brothers / Teddy Wilburn
NOVEMBER 10, 1956

Don Williams
APRIL 23, 1976

Hank Williams
JUNE 11, 1949

The Williams Sisters
SEPTEMBER 1940

The Oklahoma Wranglers / Willis Brothers
1946; SPRING 1960

Mark Wills
JANUARY 11, 2019

Lainey Wilson
JUNE 7, 2024

Del Wood
NOVEMBER 1953

Marion Worth
FEBRUARY 2, 1963

Tammy Wynette
MAY 17, 1969; MARCH 31, 1973

Trisha Yearwood
MARCH 13, 1999

Chris Young
OCTOBER 17, 2017

Faron Young
JUNE 14, 1952

Opry membership is a concept that evolved over time, and pinpointing the date an entertainer first performed as an Opry member can be difficult, especially in the pre-1960s era. Newspaper program listings were not always up to date and often incomplete. Determining who would have been considered a member in the early days is an imperfect exercise. Very little information remains in the Grand Ole Opry Archives, press releases were not always published in a timely manner, and souvenir Opry program rosters were subject to change. This list represents the best available information from documentation that is contemporary to artist "inductions" (a term first used in the 1980s to describe becoming a regular cast member) found in newspapers and trade magazines, Grand Ole Opry publicity materials and publications, Grand Ole Opry show recordings, photographic records, and WSM program logs documented by Dr. Charles K. Wolfe. Some information contradicts long-stated induction dates.

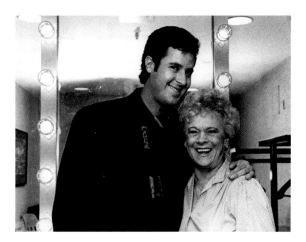

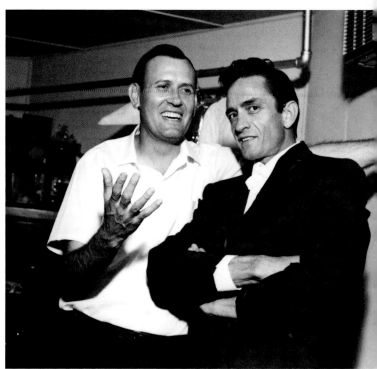

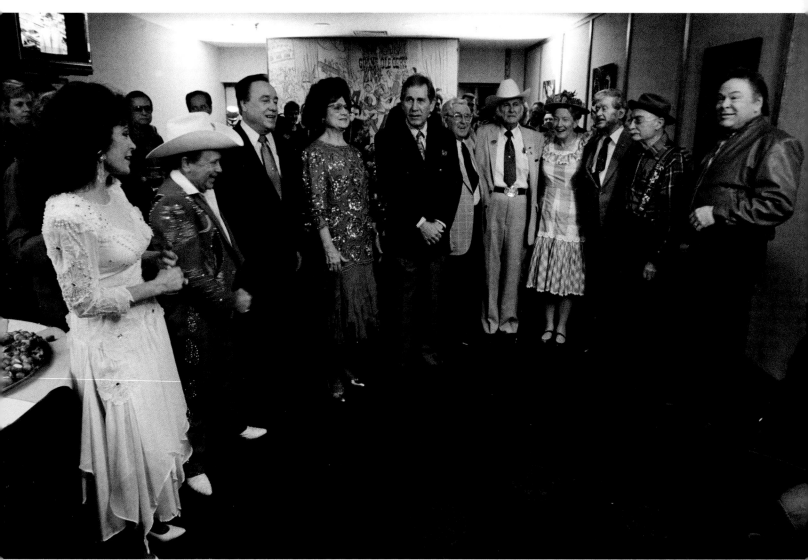

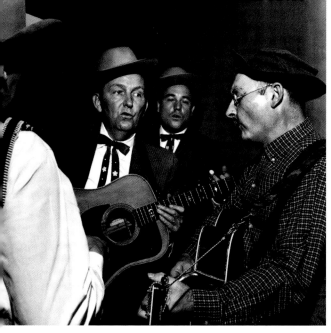

CLOCKWISE FROM TOP LEFT: Vince Gill and Jean Shepard, August 10, 1991; Jimmy C. Newman and Johnny Cash, July 23, 1966; Lester Flatt, Earl Scruggs, and Grandpa Jones, March 11, 1961; Jan Howard and Bill Anderson, April 26, 1975; Reba McEntire and Barbara Mandrell, January 7, 1988; Roy Acuff and George Jones, 1980s; Vice President George H. W. Bush, Little Jimmy Dickens, and Stonewall Jackson, May 18, 1985; posing backstage at the Grand Ole Opry House during the taping of the show's sixty-fifth anniversary television special are, from left to right: Loretta Lynn, Little Jimmy Dickens, Earl Scruggs, Kitty Wells, Chet Atkins, Pee Wee King, Bill Monroe, Minnie Pearl, Roy Acuff, Grandpa Jones, and Roy Clark.

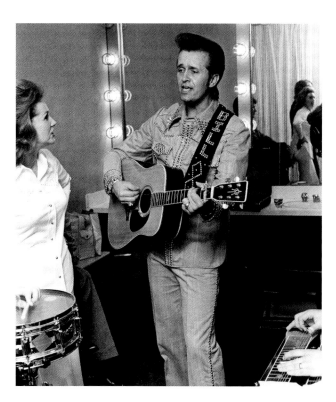

BIBLIOGRAPHY

Unless otherwise noted, quotes from and descriptions of Grand Ole Opry performances were obtained from video recordings in the Grand Ole Opry Archives. Chart positions referenced in the text are from *Billboard* chart history, compiled in Joel Whitburn's *Top Country Singles, 9th Edition, 1944-2017* and on Billboard.com. Personal correspondence and press releases noted in the text are from the Grand Ole Opry Archives.

JUST SO PROUD TO BE HERE (1925–1940)

Havighurst, Craig. *Air Castle of the South: WSM and the Making of Music City*. Urbana: University of Illinois Press, 2007.

Nashville Banner. "Congratulations Showered Upon Radio Station WSM." October 6, 1925.

Tennessean. "Messages Flood Studio Praising WSM Dedication." October 6, 1925.

Los Angeles Times. "WLS Announcer Awarded Prize of Popularity." September 28, 1924.

Nashville Banner. "WSM Engages George D. Hay." November 2, 1925.

Wolfe, Charles K. *A Good-Natured Riot: The Birth of the Grand Ole Opry*. Nashville: The Country Music Foundation Press and Vanderbilt University Press, 1999.

Hay, George D. *A Story of the Grand Ole Opry*. Nashville: self-published, 1945.

Nashville Banner. "Station WSM Will Increase Service." November 22, 1925.

Tennessean. "WSM to Feature Old Time Tunes.", December 27, 1925.

Doubler, Michael. *Dixie Dewdrop: The Uncle Dave Macon Story*.

Champaign: University of Illinois Press, 2018.

Nashville Banner. "Will Broadcast Music at Fair." September 19, 1926.

Tennessean. "WSM Station to Be Silent Month." December 5, 1926.

Morton, David C., with Charles K. Wolfe. *DeFord Bailey: A Black Star in Early Country Music*. Champaign: University of Illinois Press, 2023.

Beasley, Alcyone Bate, interview by Bill Williams, March 5, 1970, Object ID OH284, Oral History Collection, Country Music Hall of Fame and Museum, Nashville, TN. https://digi.countrymusichalloffame.org/digital/collection/oralhistory/id/2476/rec/1.

Escott, Colin. *Grand Ole Opry: The Making of an American Icon*. New York: Hachette Book Group, 2006.

Tennessean. "Damrosch to Be Radio Feature." November 4, 1927.

Atlanta Journal. "Locomotive Is Inspiration for RCA's Symphony Hour." November 12, 1927.

Tennessean. "Radio by the Clock." November 12, 1927.

Indianapolis Star. "The Microphone." November 12, 1927.

Tennessean. "WSM to Present Symphony Today." December 11, 1927.

Nashville Banner. "Joins WSM Staff." January 22, 1928.

Porterfield, Nolan. "Hey, Hey, Tell 'Em 'Bout Us: Jimmie Rodgers Visits the Carter Family." In *Country: The Music and the Musicians*, edited by Paul Kingsbury and Alan Axelrod, 13–41. New York: Abbeville Press, 1988.

Nashville Banner. "Al Smith Talk to Be Broadcast." August 19, 1928.

AllMusic. "Theron Hale & Daughters Biography by AllMusic." https://www.allmusic.com/artist/theron-hale-daughters-mn0000492993#biography.

Tennessean. "WSM to Dedicate New Power Station Night of November 12." October 30, 1932.

Kingsbury, Paul, Michael McCall, and John Rumble, eds. *Encyclopedia of Country Music, Second Edition*. New York: Oxford University Press, 2012.

Tennessean. "Premier MacDonald's Speech Friday Will Be Heard over WSM." November 4, 1934.

Tennessean. "Fisk Singers Appear in New York Today, Broadcast to WSM." November 18, 1934.

Radio Wave. "WSM." November 7, 1935.

Pellettieri, Vito, and Kathryn Pellettieri, interview by Dorothy Gable, May 24, 1968, Object ID OH356, Oral History Collection, Country Music Hall of Fame and Museum, Nashville, TN. https://digi.countrymusichalloffame.org/digital/collection/oralhistory/id/3357/rec/1.

Stephenson, Frances M. Letter to the editor, *Nashville Banner*, May 26, 1935.

Tennessean. "Revival Will Open at Tabernacle on Sunday." March 23, 1934.

Tennessean. "Solemn Ol' Judge, Absent 14 Months, Returns to Radio." March 4, 1938.

Nashville Banner. "The Week in Radio." August 1, 1937.

Hall, Wade. *Hell-Bent for Music: The Life of Pee Wee King*. Lexington: The University Press of Kentucky, 1996.

Acuff, Roy, with William Neely. *Roy Acuff's Nashville: The Life and Good Times of Country Music*. New York: The Putnam Publishing Group, 1983.

St. Louis Post-Dispatch. "Here and There on the Air." October 8, 1939.

Ewing, Tom, ed. *The Bill Monroe Reader*. Champaign: University of Illinois Press, 2000.

Streissguth, Michael. *Eddy Arnold: Pioneer of the Nashville Sound*. New York: Schirmer Books, 1997.

McNeil, Glenn. "Hollywood Didn't Make Roy Acuff a Bit Different—He's Still Hillbilly." *Knoxville News-Sentinel*, July 7, 1940.

Minnie Pearl with Joan Dew. *Minnie Pearl: An Autobiography*. Nashville: Opryland and Richards & Southern, 1980.

COUNTRY CLUB

Whittaker, Bob, interview with the author, August 15, 2023.

Hay, George D. *A Story of the Grand Ole Opry*. Nashville: self-published, 1945.

Wolfe, Charles K. *A Good-Natured Riot: The Birth of the Grand Ole Opry*. Nashville: The Country Music Foundation Press and Vanderbilt University Press, 1999.

Eipper, Laura. "Opry Adds its 60th Star—Hobo Boxcar Willie." *Tennessean*, February 23, 1981.

Oermann, Robert K. "Johnny Russell Fulfills a Dream." *Tennessean*, July 5, 1985.

Minnie Pearl with Joan Dew. *Minnie Pearl: An Autobiography*. Nashville: Opryland and Richards & Southern, 1980.

Oermann, Robert K. "Opry Welcomes Reba with Open Arms." *Tennessean*, November 29, 1985.

Havighurst, Craig. "Brad Paisley Joins Opry Cast." *Tennessean*, February 18, 2001.

MOVING TO THE MOTHER CHURCH (1941–1952)

Maddux, Rachael, "A Pleasant Catastrophe." *Oxford American*, June 1, 2021.

Minnie Pearl with Joan Dew. *Minnie Pearl: An Autobiography*. Nashville: Opryland and Richards & Southern, 1980.

Escott, Colin. *Grand Ole Opry: The Making of an American Icon*. New York: Hachette Book Group, 2006.

"Acuff vs. Sinatra." *Minnie Pearl's Grinder's Switch Gazette* 1, no. 9 (May 1945): 6.

Russell, Fred. "A New Japanese Cheer." *Nashville Banner*, June 13, 1945.

Schlappi, Elizabeth. *Roy Acuff: The Smoky Mountain Boy*. 2nd ed. Gretna, LA: Pelican, 1993.

Robesonian. Advertisement, "Coming: The Grand Ole Opry." September 22, 1941.

Ewing, Tom, ed. *The Bill Monroe Reader*. Champaign: University of Illinois Press, 2000.

Smith, Richard D. *Can't You Hear Me Callin': The Life of Bill Monroe Father of Bluegrass*. New York: Little, Brown and Company, 2000.

Morton, David C., with Charles K. Wolfe. *DeFord Bailey: A Black Star in Early Country Music* by Champaign: University of Illinois Press, 2023.

Pugh, Ronnie. *Ernest Tubb: The Texas Troubadour*. Durham, NC: Duke University Press, 1994.

"Curley Williams and His Georgia Peach Pickers." *Minnie Pearl's Grinder's Switch Gazette* 1, no. 5 (January 1945): 2. https://digi.countrymusichalloffame.org/digital/collection/Printed/id/2999/rec/5.

Kingsbury, Paul, Michael McCall, and John Rumble eds. *Encyclopedia of Country Music*. 2nd ed. Oxford University Press, 2012.

Minnie Pearl, interview by Joan Dew, date unknown, Tape 29, Object ID RS.2018.1358, Bob Pinson Recorded Sound Collection, Country Music Hall of Fame and Museum, Nashville, TN. https://digi.countrymusichalloffame.org/digital/collection/musicaudio/id/13500/rec/1.

Eiland, William U., with Craig Havighurst and F. Lynne Bachleda. *Nashville's Mother Church: The History of Ryman Auditorium*. 2nd revised ed. Nashville: Grand Ole Opry LLC, 1992.

Webb, William S. "Newspaper Man Visits, Talks to Stars of Grand Ole Opry." *Rutherford Courier*, June 23, 1942.

Cusic, Don. *Eddy Arnold: I'll Hold You in My Heart*. Nashville: Rutledge Hill Press, 1997.

Hagood, Taylor. *Stringbean: The Life and Murder of a Country Music Legend*. Champaign: University of Illinois Press, 2023.

"Clyde Moody." *Minnie Pearl's Grinder's Switch Gazette* 1, no. 6 (February 1945): 5.

"Pete Pyle." *Minnie Pearl's Grinder's Switch Gazette* 1, no. 9 (May 1945): 4.

Belvidere Daily Republican. Radio program listings. December 30, 1944.

"WSM Opry Cancelled for First Time." *Minnie Pearl's Grinder's Switch Gazette* 1, no. 9 (May 1945): 2.

Jones, Louis M. "Grandpa" with Charles K. Wolfe. *Everybody's Grandpa: Fifty Years Behind the Mike*. Knoxville: University of Tennessee Press, 1984.

Tennessean. "Nation Hears 'Opry' Strains from Showboat." January 23, 1946.

Simon, John Roger. *Cowboy Copas*. Ashland, KY: Jesse Stuart Foundation, 2008.

Eipper, Laura. "Danny Dill's Travels: The Opry to the Exit/In." *Tennessean*, September 14, 1977.

Trott, Walt. *The Honky Tonk Angels*. Nashville: Nova Books, 1987, 1993.

Nashville Banner. "Rod Brasfield, Star of Opry Dies." September 13, 1958.

Billboard. "Hillbilly Bash in Carnegie Perks Stem Interest." September 27, 1947, 3–34.

O'Donnell, Red. *"Top O' the Mornin'."* *Tennessean*, September 20, 1947.

Times Herald. "Tennessee Society to Attend Folk Music Performance Here." October 19, 1947.

Evening Star. "Truman to Get Album from Cast of Show." October 30, 1947.

Circleville Herald. "On the Air," November 29, 1947.

Robbins, Peggy. "Candy Kisses Turn to Silver." *Nashville Tennessean Magazine*, May 1, 1949, 36.

Little Jimmy Dickens, interview with Florentine Films, November 15, 2012, Object ID FV.2019.2640, video recording, Country Music Hall of Fame and Museum, Nashville, TN. https://digi.countrymusichalloffame.org/digital/collection/movingimage/id/5977/rec/1.

Escott, Colin, with George Merritt and William MacEwen. *Hank Williams: The Biography*. New York: Little, Brown and Company, 1994.

Sippel, Johnny. "Rustic Rhythm Reaps $$ Reward." *Billboard* Special Disk Jockey Supplement, October 22, 1949, 97.

South Gate Daily Press-Tribune. "'Opry' Will Make European Tour." November 12, 1949.

St. Louis Post-Dispatch. "Grand Ole Opry Show from Europe Saturday." November 13, 1949.

Snow, Hank, with Jack Owenby and Bob Burris. *The Hank Snow Story.* Urbana: University of Illinois Press, 1994.

Kosser, Michael, and Alan Stoker. *The Jordanaires: The Story of the World's Greatest Backup Vocal Group as Told by Gordon Stoker.* Essex, CT: Backbeat Books, 2023.

Cash, June Carter. *Among My Klediments.* Grand Rapids, MI: Zondervan, 1979.

Cash, Johnny, with Patrick Carr. *Cash: The Autobiography.* San Francisco: HarperSanFrancisco, 1997.

Cunniff, Alfred. "Muscle Behind the Music: The Life and Times of Jim Denny, Part 1." *Journal of Country Music* 11, no. 1 (1986): 39–48.

Davidson, Bill. "Thar's Gold in in Them Thar Hillbilly Tunes." *Collier's*, July 28, 1951, 34–45.

Nashville Banner. "WSM President Puts TV on Air." September 30, 1950.

Cooper, Daniel. *Lefty Frizzell.* New York: Little Brown and Company, 1995.

Fort Worth Star Telegram. "Once Over Nightly." September 18, 1951.

O'Donnell, Red. *"Top O' the Mornin'."* *Tennessean*, March 25, 1952.

Cunniff, Alfred. "Muscle Behind the Music: The Life and Times of Jim Denny, Part 2." *Journal of*

Country Music 11, no. 2 (1986): 26–59.

Barker, George. "Big Wheel on the Band Wagon." *Nashville Tennessean Magazine*, March 3, 1963, 8–9, 16.

HIGH LONESOME SOUND

Ewing, Tom, ed. *The Bill Monroe Reader.* Champaign: University of Illinois Press, 2000.

Smith, Richard D. *Can't You Hear Me Callin': The Life of Bill Monroe Father of Bluegrass.* New York: Little, Brown and Company, 2000.

Kingsbury, Paul, Michael McCall, and John Rumble, eds. *Encyclopedia of Country Music.* 2nd ed. New York: Oxford University Press, 2012.

THE GOLDEN ERA (1952–1967)

Sippel, Johnny. "Artists' Activities." *Billboard*, April 12, 1952, 34.

Diekman, Diane. *Live Fast, Love Hard: The Faron Young Story.* Champaign: University of Illinois Press, 2012.

Billboard. Webb Pierce Decca Records advertisement. September 5, 1962, 63.

Kingsbury, Paul, Michael McCall, and John Rumble, eds. *Encyclopedia of Country Music.* 2nd ed. New York: Oxford University Press, 2012.

Trott, Walt. *The Honky Tonk Angels.* Nashville: Nova Books, 1987, 1993.

Diekman, Diane. *Twentieth Century Drifter: The Life of Marty Robbins.* Champaign: University of Illinois Press, 2012.

Jones, Eddie. "Assignment Nashville." *Nashville Banner*, November 6, 1953.

Guralnick, Peter. *Last Train to Memphis: The Rise of Elvis Presley.* New York: Little, Brown and Company, 1994.

Jackson, Wanda, with Scott B. Bomar. *Every Night Is Saturday Night: A Country Girl's Journey to the Rock & Roll Hall of Fame.* Los Angeles: BMG Books, 2017.

Sachs, Bill. "Folk Talent and Tunes." *Billboard*, January 29, 1955, 50.

Green, Ben A. "Everly Bros. (Don-Phil) Become Opry 'Regulars'" *Nashville Banner*, May 29, 1957.

Lay, Slim. "Slim Lay's Party Line," *Huntsville Times*, June 19, 1955.

Tennessean. "Justin Tubb Signs Song Tour of West." September 10, 1955

Lay, Slim. "Slim Lay's Party Line," *Huntsville Times*, September 11, 1955.

Wichita Eagle. "Big Hillbilly Wedding Set for Forum." November 20, 1960.

Green, Ben A. "Johnny Cash Achieves 'Life's Ambition,' Wins Opry Hearts." *Nashville Banner*, July 16, 1956.

Green, Ben A. "Jimmy Newman Achieves Lifetime Goal at Opry." *Nashville Banner*, January 19, 1957.

Cashbox. "WSM Signs George Jones." September 1, 1956, clipping.

Cunniff, Alfred. "Muscle Behind the Music: The Life and Times of Jim Denny, Part 2." *Journal of Country Music* 11, no. 2 (1986): 26–59.

Green, Ben A. "Kilpatrick Succeeds as Opry Manager." *Nashville Banner*, September 25, 1956.

Nashville Banner. "W. D. Kilpatrick, Opry Head Who

Doesn't Sing or Play, No. 1 in Music." September 29, 1956.

Whiteside, Jonny. *Ramblin' Rose: The Life and Career of Rose Maddox.* Nashville: The Country Music Foundation Press and Vanderbilt University Press, 1997.

Evening Sun. "Unusual Group on Air." August 2, 1940.

Green, Ben A. "Wilburns Bring Cheers." *Nashville Banner*, November 12,1956.

Green, Ben A. "Stonewall Jackson Checks In." *Nashville Banner*, October 22, 1956.

Green, Ben A. "Country Music for Everybody." *Nashville Banner*, November 12, 1956.

Eng, Steve. *A Satisfied Mind: The Country Music Life of Porter Wagoner.* Nashville: Rutledge Hill Press, 1992.

Green, Ben A. "Porter Wagoner, Cooper Clinch Clan to Join Opry." *Nashville Banner*, February 20, 1957.

Green, Ben A. "Country Music for Everybody." *Nashville Banner*, November May 14, 1957.

Maples, Bill. "Music City Beat." *Tennessean*, November 17, 1957.

Maples, Bill. "La Dells Hit the Movies." *Tennessean*, December 8, 1957.

Dolly Parton, interview with Florentine Films, November 1, 2016, Object ID FV.2019.2644, video recording, Country Music Hall of Fame and Museum, Nashville, TN. https://digi.countrymusichalloffame.org/digital/collection/movingimage/id/5980/rec/1.

Parton, Dolly, interview with the author, September 27, 2023.

O'Donnell, Red. "'Round the Clock." *Nashville Banner*, March 26, 1958.

O'Donnell, Red. "The Watching Machine." *Nashville Banner*, July 23, 1958.

Maples, Bill. "Big Carl Has 1 Aim: Do What He's Doin'." *Tennessean*, August 3, 1958.

O'Donnell, Red. "The Watching Machine." *Nashville Banner*, February 28, 1959.

Nashville Banner. "Kilpatrick To Leave WSM, Open Agency." May 12, 1959.

O'Donnell, Red. "Dial Tones." *Nashville Banner*, May 13, 1959.

WSM Public Relations Department. "Roy Drusky." Press release, July 3, 1961.

Sullivan, Phil. "Longbow Joining Opry." *Tennessean*, March 25, 1962.

WSM Public Relations Department. Draft press release announcing that Billy Walker joined the Opry cast, February 4, 1960.

Acuff-Rose Artists Corporation, "Bobby Lord Joins Grand Ole Opry." Press release, November 23, 1960.

WSM Public Relations Department. "Tompall and the Glaser Brothers." Press release, May 17, 1961.

Davis, Skeeter. *Bus Fare to Kentucky: The Autobiography of Skeeter Davis*. New York: Carol Publishing Group, 1993.

Hamilton, George IV, interview with Florentine Films, September 20, 2013. Object ID 2013.V.2019.2786, video recording, Country Music Hall of Fame and Museum, Nashville, TN. https://digi.countrymusichalloffame.org/digital/collection/movingimage/id/6035/rec/1.

Bego, Mark. *I Fall to Pieces: The Music and the Life of Patsy Cline*. Holbrook, MA: Adams Media Corporation, 1995.

Nassour, Ellis. *Honky Tonk Angel: The Intimate Story of Patsy Cline*. Chicago: Chicago Review Press, 1993, 2008

Anderson, Pat. "George IV Reverses a Trend." *Tennessean*, February 14, 1960.

WSM Public Relations Department. press release announcing that Hank Locklin joined Opry cast, November 9, 1960.

Bill Anderson, interview with the author, September 30, 2023.

Anderson, Bill, with Peter Cooper. *Whisperin' Bill Anderson: An Unprecedented Life in Country Music*. Athens: University of Georgia Press, 2016.

Country Music Hall of Fame and Museum. *Bill Anderson: As Far as I Can See*. Nashville: Country Music Foundation Press, 2021.

Lynn, Loretta, interview with Florentine Films, November 17, 2014. Object ID FV.2019.2641, video recording, Country Music Hall of Fame and Museum, Nashville, TN. https://digi.countrymusichalloffame.org/digital/collection/movingimage/id/5983/rec/1.

Sullivan, Phil. "Grand Ole Opry Adds 2 Stars." *Tennessean*, October 28, 1962.

O'Donnell, Red. "The Watching Machine." *Nashville Banner*, February 2, 1963.

Brinton, Larry, and Clay Hargis. "4 Opry Stars Die in Crash." *Nashville Banner*, March 6, 1963.

Stringer, Don. "Opry's Fans, Stars Mourn for Its Dead." *Nashville Banner*, March 8, 1963.

Jean Shepard, interview with Florentine Films, June 22, 2013. Object ID FV.2020.0101, video recording, Country Music Hall of Fame and Museum, Nashville, TN. https://digi.country

musichalloffame.org/digital/collection/movingimage/id/6176/rec/1.

Sullivan, Phil. "Jean Shepard Goes Back to the Opry." *Tennessean*, May 5, 1963.

Ritter, Frank. "Texas Ruby Dies in Fire." *Tennessean*, March 30, 1963.

O'Donnell, Red. "The Watching Machine." *Nashville Banner*, August 6, 1963.

Billboard. "Bonnie Brown Move Brings Break-Up of Browns' Act." July 8, 1967, 48.

Sullivan, Phil. "3 More Stars for the Opry!" *Tennessean*, March 15, 1964.

Thompson, Jerry, and Frank Sutherland. "Reeves Found Crash Victim." *Tennessean*, August 3, 1964.

Berryhill, Judy, and Frances Meeker. *Country Sunshine: The Dottie West Story*. Nashville: Eggman Publishing, 1995.

Sullivan, Phil. "Music City Beat." *Tennessean*, September 6, 1964.

Nelson, Willie, interview with Florentine Films, November 17, 2015. Object ID FV.2019.2643, video recording, Country Music Hall of Fame and Museum, Nashville, TN. https://digi.countrymusichalloffame.org/digital/collection/movingimage/id/5953/rec/1.

Hieronymus, Clara. "Grand Ole Opry Drops 12 Top Entertainers for 1965." *Tennessean*, December 6, 1964.

Knoxville News-Sentinel. "Ritter Joins Opry." May 12, 1965.

Sawyer, Kathy. "Nashville Inherits a Real Legend." *Tennessean*, June 27, 1965.

Escott, Colin. *Grand Ole Opry: The Making of an American Icon.*

New York: Hachette Book Group, 2006.

Bare, Bobby, interview with Florentine Films, June 24, 2013. Video recording, Country Music Hall of Fame and Museum, Nashville, TN.

Smith, Connie, interview with Florentine Films, June 25, 2013. Video recording, Country Music Hall of Fame and Museum, Nashville, TN.

Smith, Connie, interview with the author, September 15, 2023.

Daughtrey, Larry. "Connie Smith Could Be Cinderella Over Again." *Tennessean*, April 11, 1965.

Tennessean. "Bob Luman May Join Opry Stars." July 12, 1965.

Seely, Jeannie, interviews with the author, June 20, 2023, and September 15, 2023.

Hieronymus, Clara. "Blondes in the Spotlight at RCA's Opry Breakfast." *Tennessean*, October 22, 1967.

YOU'RE LOOKIN' AT COUNTRY

Tennessean. "Fisk Singers Appear in New York Today, Broadcast to WSM." November 18, 1934.

Hay, George D. *A Story of the Grand Ole Opry*. Nashville: self-published, 1945.

Escott, Colin. *Grand Ole Opry: The Making of an American Icon*. New York: Hachette Book Group, 2006.

George-Warren, Holly, and Michelle Freedman. *How the West Was Worn*. New York: Harry N. Abrams, 2001.

Carrie Underwood, interview with the author, August 18, 2023.

THE CIRCLE (1968–1977)

King, Larry L. "Inside Grand Ole Opry." *Reader's Digest*, condensed from *Harper's Magazine*, October 1968, 96–100.

Escott, Colin. *Grand Ole Opry: The Making of an American Icon.* New York: Hachette Book Group, 2006.

Tennessean. "Dr. King Slain in Memphis." April 5, 1968.

Tennessean. "E. W. Wendell New Opry Chief." April 6, 1968.

Gillem, Tom. "Curfew Closes Opry Program." *Tennessean*, April 7, 1968.

Martin, Harris. "Curfew Cuts Country Capers . . . but the Roy Acuff Show Goes On." *Music City News.* May 1968. https://digi .countrymusichalloffame.org /digital/collection/Printed/id /33580/rec/1.

Tennessean. "Waugh Sees 'No Changes' At WSM." February 21, 1968.

Opry Memories Panel Discussion with Mark Wills, Bill Anderson, E. W. "Bud" Wendell, and Jeannie Seely, moderated by Paul Kingsbury, September 16, 2023. Object ID FV.2023.0371, video recording, Country Music Hall of Fame and Museum, Nashville, TN. https://digi.countrymusic halloffame.org/digital/collection /movingimage/id/7518/rec/17.

Nashville Tennessean Magazine. "Bud Wendell: He Can't Pass the Buck!" October 13, 1968.

Tennessean. "Opryland U.S.A. To Offer Facilities 'Like No Other.'" October 14, 1969.

Kingsbury, Paul, Michael McCall, and John Rumble, eds. *Encyclopedia of Country Music.* 2nd ed. New York: Oxford University Press, 2012.

Sawyer, Kathy. "Grand Ole Opry Adds 4 Stars." *Tennessean*, December 31, 1968.

Parton, Dolly, interview with the author, September 27, 2023.

Hurst, Jack. "Scared or Not, She Made It!" *Tennessean*, March 28, 1971.

Hall, Tom T., interview by Florentine Films, June 21, 2013. Video recording, Country Music Hall of Fame and Museum, Nashville, TN.

Hurst, Jack. "Song Writer Tom T. Hall Joins Opry." *Tennessean*, January 10, 1971.

Bailey, Jerry. "Tom T. Hall Quits Opry Over 'Policy.'" *Tennessean*, June 22, 1974.

Eipper, Laura. "Tom T. Hall's 'Homecoming' Delights Opry Fans, Stars." *Tennessean*, March 31, 1980.

Hurst, Jack. "Japan Hillbilly 'Persuades' Opry." *Tennessean*, August 14, 1972.

Mandrell, Barbara, interview with the author, January 30, 2024.

Tennessean. "Mandrell Has Debut on Opry." July 9, 1972.

Mandrell, Barbara, with George Vecsey. *Get to the Heart: My Story.* New York: Bantam Books, 1990.

Loveless, Patty, interview with Michael McCall, August 26, 2023. Object ID FV.2023.0319, video recording, Country Music Hall of Fame and Museum, Nashville, TN. https://digi.countrymusic halloffame.org/digital/collection /movingimage/id/7479/rec/1.

Allen, Bob, "Patty Loveless: The Time is Right." *Country Music*, January 19, 1988, 52–53.

Loveless, Patty, interview with the author, December 2, 2023.

Stuart, Marty, interview with the author, August 1, 2023.

Stuart, Marty. *Country Music: The Masters.* Nashville: self-published, 2008.

Wariner, Steve, interview with the author, December 5, 2023.

Gray, Michael. "Childhood Dreams No Longer Out of Place as Wariner Awaits Opry Induction," *Nashville Banner Backbeat*, May 9, 1996.

Lorrie Morgan, interview with the author, October 10, 2023.

The Tennessean. "Ryman? It's Moving, Too." March 21, 1971.

Weaver, William C. "'Little Church' To Keep Legacy of Ryman Alive." *Tennessean*, January 14, 1973.

Huxtable, Ada Louise. "Only the Phony Is Real." *New York Times*, May 13, 1973.

Tennessean Sunday Showcase. "Newest." July 29, 1973.

Bontemps, Alex. "He Whooped, Hollered Way to Opry Cast." *Tennessean*, October 29, 1973.

Hagood, Taylor. *Stringbean: The Life and Murder of a Country Music Legend.* Champaign: University of Illinois Press, 2023

Thompson, Jerry. "Opry Stars Now Under New Pressure." *Tennessean*, November 12, 1973.

Thomas, Patrick. "Skeeter Davis Blames Police in Opry Curb." *Tennessean*, December 15, 1973.

Thomas, Patrick. "Skeeter Davis: Grand Ole Opry Suspends a Star." *Rolling Stone*, January 31, 1974, clipping.

Tennessean. "Hal Durham New Opry Manager." January 20, 1974.

Bailey, Jerry. "Porter, Dolly Singing Team Breaking Up." *Tennessean*, February 20, 1974.

Morton, David C., with Charles K. Wolfe. *DeFord Bailey: A Black Star in Early Country Music.* Champaign: University of Illinois Press, 2023.

Zibart, Eve. "'Old Timers' Take Place on Grand Ole Opry Stage Again." *Tennessean*, February 25, 1974.

Tennessean. "DeFord Bailey Comes Home to the Opry." December 14, 1974.

Keillor, Garrison. "Onward and Upward with the Arts: At the Opry." *New Yorker*, May 6, 1974, 46–70.

Welch, Pat. "Nixon, Pat Here Today for Opry House Debut." *Tennessean*, March 16, 1974.

Anderson, Bill, interview with the author, September 30, 2023.

Rogers, Dan, and Brenda Colladay. *Backstage at the Grand Ole Opry.* Nashville: Grand Ole Opry, 2013.

Tennessean. "Ryman Still Open." March 24, 1974.

Harvey, Lynn. "Water Edges Opry House Stage; 'Damage in Millions.'" *Tennessean*, March 15, 1975.

Williams, Bill. "WSM's Grand Ole Opry Projects Nashville Role." *Billboard*, September 6, 1975, 32.

Tennessean. "Paul & Linda Visit Opry." July 1, 1974.

Sawyer, Kathy. "Pointers' Sounds No Hand-Me-Downs!" *Tennessean*, October 24, 1974.

"Space Crews 'Touch Down' Here Today." *Tennessean*, October 24, 1975.

Varley, Nancy. "Tennessee-Style Hospitality Reigns." *Tennessean*, June 8, 1976.

Milsap, Ronnie, interview with the author, October 17, 2023.

341

Tennessean. "New at Opry." February 9, 1976.

Harvey, Lynn. "Williams Opry's Newest." *Tennessean*, April 24, 1976.

Tennessean. "Larry Gatlin Joins Opry." January 2, 1977.

Gatlin, Larry, interview with author, December 14, 2023.

Gatlin, Steve, interview with author, December 14, 2023.

Gatlin, Rudy, interview with author, December 14, 2023.

Bailey, Jerry. "Artists Organize New Group, Want Country to Stay 'Country.'" *Tennessean*, November 13, 1974.

Seely, Jeannie, interview with the author, June 20, 2023.

Thrasher, Sue. "Pure Country: Wilma Lee & Stoney Cooper." *Southern Exposure* 5, no. 2/3 (Summer/Fall 1977): 90–96.

McEntire, Reba, interview with the author, November 4, 2023.

OPRY ON-SCREEN

Jordan, Turner. "Grand Ole Opry Stars in Hollywood for Film but Troupe Carries On." *Birmingham News*, April 27, 1940.

Hay, George D. *A Story of the Grand Ole Opry.* Nashville: self-published, 1945.

Schlappi, Elizabeth. *Roy Acuff: The Smoky Mountain Boy, Second Edition.* Gretna, LA: Pelican, 1993.

Doubler, Michael. *Dixie Dewdrop: The Uncle Dave Macon Story.* Champaign: University of Illinois Press, 2018.

Billboard. "'Opry' Artists Yodel on Color TV Film." November 6, 1954, 1–13.

Jones, Eddie. "Grand Ole Opry Goes on TV Nationally At 6 p.m. from Ryman Auditorium." *Nashville Banner*, October 15, 1955.

Alexander, Alice. "The Opry at 50: TV Anniversary." *Tennessean*, October 8, 1975.

Brown, Mary Jane. "Saturday Night's Telecast of Opry by WDCN a First." *Nashville Banner*, March 2, 1978.

Carter, Walter. "Opry Show Withdrawal Upsets PBS Officials." *Tennessean*, December 31, 1981.

Eipper, Laura. "Hard Work and Television Magic Bring Grand Ole Opry to 'Life.'" *Tennessean*, June 15, 1980.

Eipper, Laura. "Ryman Reborn for Film." *Tennessean*, April 11, 1979.

WHO'S GONNA FILL THEIR SHOES (1978–1990)

Brown, Mary Jane. "Saturday Night's Telecast of Opry by WDCN a First." *Nashville Banner*, March 2, 1978.

Carter, Walter. "Fiddle Before Politics Senator's Preference." *Tennessean*, March 3, 1979.

Eipper, Laura. "Wonder-ful." *Tennessean*, September 8, 1979

Wagoner, Porter, interview by John Lomax III, March 16, 1983, Object ID RS.2020.0445, Bob Pinson Recorded Sound Collection, Country Music Hall of Fame and Museum, Nashville, TN. https://digi.countrymusichalloffame.org/digital/collection/musicaudio/id/11939/rec/2.

Escott, Colin. *Grand Ole Opry: The Making of an American Icon.* New York: Hachette Book Group, 2006.

Edwards, Joe. "Country Songstress Speaks Out." *Capital Times*, September 15, 1979.

Conlee, John, interview with the author, August 8, 2023.

Cackett, Alan. "John Conlee Keeps His Country Music 'Pure and Honest.'" *Country Music People*, November 1982, 31–33.

Eipper Hill, Laura. "John Conlee to Join the Grand Ole Opry." *Tennessean*, January 29, 1981.

Eipper Hill, Laura. "Opry Adds its 60th Star—Hobo Boxcar Willie." *Tennessean,* February 23, 1981.

Kingsbury, Paul, Michael McCall, and John Rumble, eds. *Encyclopedia of Country Music.* 2nd ed. New York: Oxford University Press, 2012.

Thomas, B. J. *Home Where I Belong.* Waco, TX: Word, Incorporated, 1978.

Hill, Laura. "Joining the Opry Brings B. J. Thomas Full Circle." *Tennessean*, August 7, 1981.

Tessier, Denise. "B. J. Thomas Is Aiming to Get His Fans Back." *Albuquerque Journal*, September 11, 1983.

Skaggs, Ricky, interview with the author, August 31, 2023.

Skaggs, Ricky, with Eddie Dean. *Kentucky Traveler: My Life in Music.* New York: HarperCollins, 2013.

Whiteside, Jonny. "Ricky Skaggs: Corporate Country." *LA Weekly*, December 11, 1986.

Riders in the Sky, interview with the author, June 28, 2023, and August 15, 2023.

White, Sharon, and Cheryl White, interview with the author, August 23, 2023.

Pond, Neil. "'White Girls' Branch Out." *Music City News*, April 1981.

Tennessean. "The Whites Now Members of the Opry Family." March 2, 1984.

Country News. "The Whites . . . It's a Family Affair." October 1983, 6.

Robinson, Steven M. "The Whites: Living in the Name of Love." *Bluegrass Unlimited*, June 1986, 14–19.

Oermann, Robert K. "Lorrie Morgan to Be Newest Opry Member." *Tennessean*, June 8, 1984.

Taylor, Rick. "Lorrie Morgan Sings Dad's Praises." *Country Weekly*, date unknown, 55–57.

Thompson, Tim, interview with the author, June 27, 2023.

Tyler Morning Telegraph. "Insurance Merger Gains FCC Approval." November 5, 1982.

Bartley, Diane, and Robert K. Oermann. "Nashville Network Makes Cable History." *Tennessean*, March 8, 1983.

Berg, Eric N. "Grand Ole Opry Finds a Buyer." *New York Times*, July 2, 1983.

Cason, Albert. "$250 Million Reported Tab for Opryland." *Tennessean*, July 2, 1983.

Pratt, James. "Opryland Complex in Family." *Tennessean*, July 2, 1983.

Watts, Cindy. "The Protector of All Things Opry." *Tennessean*, February 2. 2014.

Buchanan, Steve, interview with the author, June 20, 2023.

Tennessean. "Acuff Enjoys New Home." July 20, 1983.

Lewis, Jim. "Grand Ole Opry Endures, Celebrates 60th Anniversary." UPI Archives, October 3, 1985.

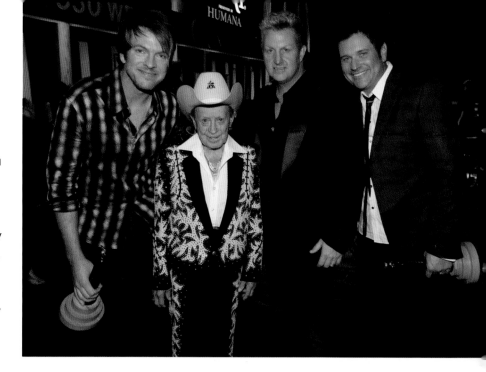

CLOCKWISE FROM TOP LEFT: Rascal Flatts, October 8, 2011; Charley Pride and Sara Evans, June 7, 2018; Eddie Stubbs, Jim Ed Brown, Ricky Skaggs, January 10, 1998; Larry Gatlin and Jamey Johnson, August 31, 2018; Connie Smith and Martina McBride, mid-1990s; Bill Anderson and Dustin Lynch, April 3, 2018; Randy Travis, Charley Pride, and Jan Howard, June 16, 2000; Old Crow Medicine Show, December 13, 2019; Alison Krauss, Joe Diffie, and Bill Monroe, November 27, 1993; Duane Allen, Blake Shelton, and Joe Bonsall, June 7, 2018; Trace Adkins and Loretta Lynn, January 20, 2008

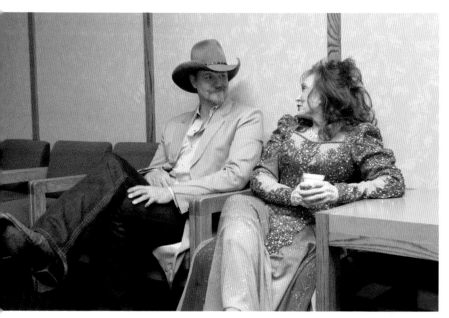

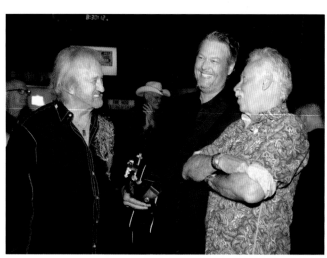

Oermann, Robert K. "CBS-TV Opry Taping a Night of Grandeur." *Tennessean*, November 22, 1985.

Dougherty, Steve, with Gerry Wood. "Winners." *People*, November 10, 1986, clipping.

Travis, Randy, with Ken Abraham. *Forever and Ever, Amen: A Memoir of Music, Faith, and Braving the Storms of Life.* Nashville: Thomas Nelson, 2019.

Goldsmith, Thomas. "Randy Travis 62nd Member of the Opry." *Tennessean*, December 19, 1986.

Tennessean. "Roy Clark to Join Opry Tomorrow." August 21, 1987.

Tennessean. "Opry's Legend Herman Crook, 89, Dies." Jun 11, 1988.

Hurst, Jack. "Ricky Van Shelton, a Not So Wild-eyed Dream." *Chicago Tribune*, January 11, 1987.

Roland, Tom. "Shelton Has Opry Stage All to Himself First Time." *Tennessean*, April 15, 1994.

Loveless, Patty, interview with the author, December 2, 2023.

Allen, Bob, "Patty Loveless: The Time Is Right." *Country Music*, January 19, 1988, 52–53.

Hurst, Jack. "Golden Opry-tunity." *Chicago Tribune*, July 3, 1988.

Goldsmith, Thomas. "Mandolins: To Leaders, From Opry." *Tennessean*, July 7, 1990.

Goldsmith, Thomas. "Holly Dunn to Join the Opry." *Tennessean*, October 13, 1989.

Opry Observer. "Holly Dunn Joins Opry Family." November 1989.

Snider, Mike, interview with the author, August 17, 2023.

Neese, Sandy. "Friendly Little Gleason, Tenn., Yields National Banjo Champ." *Tennessean Showcase*, October 23, 1983.

Neese, Sandy. "Opry Invites New Player's Hometown." *Tennessean*, January 1, 1984.

Neese, Sandy. "Uproar! Most of Hometown Sees Debut on Opry." *Tennessean*, January 22, 1984.

COMEDY IN THE SPOTLIGHT

Wolfe, Charles K. *A Good-Natured Riot: The Birth of the Grand Ole Opry.* Nashville: The Country Music Foundation Press and Vanderbilt University Press, 1999.

Hay, George D. *A Story of the Grand Ole Opry.* Nashville: self-published, 1945.

Escott, Colin. *Grand Ole Opry: The Making of an American Icon.* New York: Hachette Book Group, 2006.

Kingsbury, Paul, Michael McCall, and John Rumble, eds. *Encyclopedia of Country Music.* 2nd ed. New York: Oxford University Press, 2012.

Schlappi, Elizabeth. *Roy Acuff: The Smoky Mountain Boy, Second Edition.* Gretna, LA: Pelican, 1993.

Minnie Pearl with Joan Dew. *Minnie Pearl: An Autobiography.* Nashville: Opryland and Richards & Southern, 1980.

Dowling, Marcus K. "Gary Mule Deer, Henry Cho invited to join Grand Ole Opry." *Tennessean*, January 7, 2023.

Mule Deer, Gary, interview with the author, August 8, 2023.

THE NEW TRADITION (1990–1999)

Brooks, Garth, interview with the author, October 14, 2023.

Oermann, Robert K. "Garth Brooks Becomes Opry's 65th." *Tennessean*, October 5, 1990.

Black, Clint, interview with the author, December 11, 2023.

Thompson, Tim, interview with the author, June 27, 2023.

Werner, Laurie. "Fast Track Jackson." *USA Weekend*, October 5–7, 1990.

Inside Opryland USA. "Alan Jackson Proved Nice Guys Finish First." July 1991.

Opry Observer. "Alan Jackson Joins Opry Family." August 1991.

Jackson, Alan, submitted self-interview, March 11, 2024.

Goldsmith, Thomas. "Stroke Hospitalizes Minnie Pearl." *Tennessean*, June 21, 1991.

Mandrell, Barbara, interview with the author, January 30, 2024.

Gill, Vince, interview with the author, July 25, 2023.

Oermann, Robert K. "Vince Gill Finally Gains Own Spotlight." *Tennessean*, July 28, 1990.

Roland, Cindy, "Crash Injures Dottie West." *Tennessean*, August 31, 1991.

Seely, Jeannie, interview with the author, September 15, 2023.

Thomas, Karen. "Dottie West Dies During Surgery." *USA Today*, September 5, 1991.

Eiland, William U., with Craig Havighurst and F. Lynne Bachleda. *Nashville's Mother Church: The History of Ryman Auditorium.* 2nd revised ed. Nashville: Grand Ole Opry, 1992.

Nelson Baxter, Emme. "Opryland to Start Ryman Facelift Within 3 Weeks." *Tennessean*, February 1, 1989.

Goldsmith, Thomas. "Ryman Goes 'Onstage' for Six-Day TNN Taping." *Tennessean*, April 13, 1991.

Oermann, Robert K. "'A Sense of Awe.'" *Tennessean*, May 17, 1992.

Harris, Emmylou, and the Nash Ramblers. *At the Ryman.* Reprise Records 9 26664-2, 1992, compact disc.

Rogers, Joe. "Stars to Mark 100 for Ryman." *Tennessean*, May 1, 1992.

Ippolito, Mark. "The Ryman's Revival Complete." *Tennessean*, June 2, 1994.

East, Jim. "Auditorium Reopens to Keillor's Act." *Tennessean*, June 4, 1994.

Buchanan, Steve, interview with the author, June 20, 2023.

Kingsbury, Paul, Michael McCall, and John Rumble, eds. *Encyclopedia of Country Music.* 2nd ed. New York: Oxford University Press, 2012.

Stuart, Marty, interview with the author, August 1, 2023.

Folkart, Burt A. "Roy Acuff, First Superstar of Country Music, Dies." *Los Angeles Times*, November 24, 1992.

Anderson, Bill, interview with the author, September 30, 2023.

Pride, Charley, with Jim Henderson. *Pride: The Charley Pride Story.* New York: William Morrow and Company, 1994.

Krauss, Alison, interview with the author, September 5, 2023.

Mansfield, Brian. "Alison Krauss Fiddles her Way into Grand Ole Opry." *Tennessean*, June 30, 1993.

Himes, Geoffrey. "Alison Krauss: Music That's Timeless." *Country Music*, April 1994, 48–50.

Moir, Al. "Alison Krauss." *Country Music People*, August 1999, 18, 20–21.

Roland, Tom. "Diffie: A 'Dream' to Join Opry." *Tennessean*, November 22, 1993.

Roland, Tom. "The Opry's Power Awes Ketchum." *Tennessean*, January 14, 1994.

Moore, Linda A. "'The Best Job of Any in the World.'" *Tennessean*, March 8, 1992.

Whittaker, Bob, interview with the author, August 15, 2023.

Wood, Tom. "Backstage at the Opry." *Tennessean*, September 14, 1995.

Roland, Tom. "At 83, Brother Oswald the Grand Ole Opry's Oldest New Member." *Tennessean*, January 14, 1995.

Tillis, Pam, interview with the author, October 10, 2023.

Pond, Neil. "I'm Little, But I'm Loud." *Country Music People*, September 1997, 61–64.

Roland, Tom. "Martina McBride Is Latest to Join Grand Ole Opry." *Tennessean*, November 11, 1995.

Holden, Stephen. "Minnie Pearl Is Dead at 83; Star of 'The Grand Ole Opry.'" *New York Times*, March 6, 1996.

Wariner, Steve, interview with the author, December 5, 2023.

Gray, Michael. "Childhood Dreams No Longer Out of Place as Wariner Awaits Opry Induction," *Nashville Banner Backbeat*, May 9, 1996.

Oermann, Robert K. "'An Instrumental Success.'" *Tennessean*, May 11, 1996.

Skaggs, Ricky, interview with the author, August 31, 2023.

Rogers, Joe. "Opry Likes Hitmakers of Any Age." *Tennessean*, May 11, 1996.

Carey, Bill. "Opry's Guiding Hand to Retire Next Month." *Tennessean*, October 15, 1996.

Carey, Bill. "Gaylord's Griscom to Retire." *Tennessean*, November 5, 1996.

Roland, Tom. "Westinghouse Buys New Clout." *Tennessean*, February 11, 1997.

Hartman, Stacey. "Gaylord 'Still Country' Despite Sale of Networks." *Tennessean*, February 11, 1997.

Domeier, Robin Hall. "New CMT, TNN Owners Plan to Stick with What Works." *Tennessean*, February 11, 1997.

Roland, Tom. "Wendell Loves Country, Associates Note." *Tennessean*, April 11, 1997.

Roland, Tom. "Mandrell's Finale Quite a Show." *Tennessean*, October 24, 1997.

Schmidt, Brad. "Opry Asks Paycheck to Join Cast." Brad About You, *Tennessean*, September 21, 1997.

Pinkston, Will. "Death of a Theme Park: Opryland Shifts to Retail." *Tennessean*, October 30, 1997.

Roland, Tom. "Opry May Discontinue Late Shows on Fridays." *Tennessean*, July 17, 1996.

Roland, Tom. "Country's Grandpa Dies." *Tennessean*, February 20, 1998.

Pinkston, Will. "Opry's New Horizon." *Tennessean*, May 31, 1998.

Loveless, Patty, interview with the author, December 2, 2023.

Orr, Jay. "Diamond Rio First Band Since '84 to Join Opry." *Tennessean*, March 15, 1998.

Roe Marty, and Dana Williams, interview with the author, October 10, 2023.

Diamond Rio with Tom Roland. *Beautiful Mess: The Story of Diamond Rio*. Nashville: Thomas Nelson, 2009.

Orr, Jay. "Buchanan Takes Lead at Gaylord." *Tennessean*, September 12, 1998.

Orr, Jay. "'Grand Ole Opry' Comes Home." *Tennessean*, January 16, 1999.

Orr, Jay. "Opry Stage Greets New Member Yearwood." *Tennessean*, January 17, 1999.

Orr, Jay. "Yearwood Joins Cast of Greats as Opry's 71st Member." *Tennessean*, March 14, 1999.

Yearwood, Trisha, interview with the author, October 16, 2023.

WELCOME TO THE FUTURE

Colin Reed, interview with the author, August 15, 2023.

Steve Buchanan, interview with the author, June 20, 2023.

Nashville Convention & Visitors Corp. "Research & Hospitality Stats." https://www.visitmusic city.com/research

Carly Pearce, interview with the author, June 28, 2023.

COMPETING TO BE HEARD (2000–2009)

Schmidt, Brad. "Bluegrass Legend Ralph Stanley joins 'Opry' Cast." Brad About You, *Tennessean*, January 17, 2000.

Cooper, Peter. "Tillis Accepts 'Overdue' Invite, Becomes Newest Opry Member." *Tennessean*, June 25, 2000.

Longino, Miriam. "www.opry. com: At 75, Nashville's Shrine of Country Music Gets Wired, Gets Global." *Atlanta Journal-Constitution*, October 15, 2000.

Cooper, Peter. "'Grand Ole Opry' Closes Door on Barn Backdrop." *Tennessean*, June 10, 2000.

Cooper, Peter. "Opry Veterans Give New Set Good Reviews." *Tennessean*, June 11, 2000.

Flippo, Chet. "Peter Fisher To Run Grand Ole Opry as Its First Full-Time GM." *Billboard*, June 19, 1999, 38.

Orr, Jay. "Fisher to Manage 'Grand Ole Opry.'" *Tennessean*, June 3, 1999.

Fisher, Peter, interview with the author, June 9, 2023, and June 13, 2023.

Orr, Jay. "Old-timers on 'Opry' Shown the Door. *Tennessean*, November 5, 1999.

Seely, Jeannie, interview with the author, June 20, 2023.

Gill, Vince, interview with the author, July 25, 2023.

Cooper, Peter. "Young Artists Squeezing Out Opry legends." *Tennessean*, October 13, 2000.

Skaggs, Ricky, interview with the author, August 31, 2023.

Brown, Jim Ed, interview with Florentine Films, September 17, 2013. Object ID FV.2019.2785, video recording, Country Music Hall of Fame and Museum, Nashville, TN. https://digi. countrymusichalloffame.org/ digital/collection/movingimage/ id/5992/rec/32.

Havighurst, Craig, and Peter Cooper. "Opry Traditions Shine On." *Tennessean*, October 15, 2000.

Havighurst, Craig. "America Sees Only the Starry Tip of Country Music on Television, Making an Industry Revival Difficult." *Tennessean*, October 15, 2000.

Rogers, Dan, and Brenda Colladay. *Backstage at the Grand Ole Opry*. Nashville: Grand Ole Opry, 2013.

Cooper, Peter. "'A Sentimental Journey.'" *Tennessean*, January 4, 2001.

Cooper, Peter. "O Brother, What a Show!" *Tennessean*, November 8, 2001.

Havighurst, Craig, and Brad Schmidt. "WSM Could Face Changes, Gaylord Says." *Tennessean*, December 21, 2001.

Lawson, Richard, and Craig Havighurst. "WSM Keeps Classic Country." *Tennessean*, January 15, 2002.

Reed, Colin, interview with the author, August 15, 2023.

Cooper, Peter. "Veteran 'Opry' Members Fuming Over Changes." *Tennessean*, September 29, 2002.

Havighurst, Craig. "Opry Options: Techno-savvy, Tried and True." *Tennessean*, January 16, 2002.

Cooper, Peter. "Wagoner, Carlisle to Join Hall." *Tennessean*, August 11, 2002.

Worley, Darryl, interview with the author, July 2, 2023.

Fulks, Robbie. "Sex, Heartbreak and Blue Suede." *GQ*, July 2003.

Gerome, John. Associated Press. "Adkins First New Opry Member in Two Years," *LeafChronicle*, August 24, 2003.

Wilson, Mandy. "Trace Adkins." *CMA Close Up*, February 1998.

Adkins, Trace, interview with the author, August 23, 2023.

Cooper, Peter. "Bluegrass Star McCoury Asked to Join the 'Opry' Cast." *Tennessean*, October 3, 2003.

Gray, Michael. "Del McCoury Gives Voice to the Bluesy Side of Bluegrass." *Nashville Banner Backbeat*, January 23, 1997.

McCoury, Del, interview with the author, July 18, 2023.

Brown, John. "Better Things to Do." *American Cowboy*, September/October 1998, 34–37.

Clark, Terri, interview with the author, August 8, 2023.

Schmidt, Brad. "Terri's Got No Better Thing to Do June 12." Brad About You, *Tennessean*, May 16, 2004.

Bentley, Dierks, interview with the author, February 26, 2024.

Schmidt, Brad. "Bentley Surprised by 'Proposal' from the Opry." Brad About You, *Tennessean*, July 28, 2005.

Gerome, John. "Bentley to Join Grand Ole Opry," *Knoxville News-Sentinel*, July 28, 2005.

Keltner, Gina, interview with the author, March 1, 2024.

Gerome, John. "The Opry at 80: Where Country Was, Is and Will Be." *Los Angeles Times*, April 29, 2005.

Schmidt, Brad. "Nashville, New York Sounds to Come Together." *Tennessean*, November 6, 2005.

Parales, Jon. "Rhinestones and Cowboy Hats as the Opry Turns 80." *New York Times*, November 14, 2005.

Yearwood, Trisha, interview with the author, October 16, 2023.

Cooper, Peter. "Opry's Billy Walker, 77, Dies in Crash." *Tennessean*, May 22, 2006.

Keel, Beverly. "In Silvery Sparkles, Porter Marks Golden Anniversary on Opry." *Tennessean*, May 20, 2007.

Parton, Dolly, interview with the author, September 27, 2023.

Turner, Josh, interview by Eddie Stubbs, RFD-TV, *Reflections from the Circle*, November 27, 2011.

Turner, Josh, interview with the author, December 5, 2023.

Keel, Beverly. "Josh Turner Surprised with Invite to Join Opry." *Tennessean*, September 30, 2007.

Keel, Beverly. "Mel Tillis to Join Daughter as 'Opry' Member in June." *Tennessean*, May 13, 2007.

Keel, Beverly. "Daniels Is Buzzing Over His Invitation to Join the 'Opry.'" *Tennessean*, November 21, 2007.

Underwood, Carrie, interview with the author, August 18, 2023.

Keel, Beverly. "Invitation to Join the 'Opry' Surprises Carrie Underwood." *Tennessean*, March 16, 2008.

Morgan, Craig, interview with the author, June 21, 2023.

Montgomery, Eddie, interview with the author, July 11, 2023.

THE RIVER

Rodgers, D. Patrick. "Looking Back, a Decade After Nashville's Historic Flood." *Nashville Scene*, April 30, 2020.

Buchanan, Steve, interview with the author, June 20, 2023.

Fisher, Peter, interview with the author, June 9, 2023.

Hyams, Brent, interview with the author, June 13, 2023.

Seely, Jeannie, interview with the author, June 20, 2023.

Cooper, Peter. "Opry House, Circle Intact, Looks to Reopening." *Tennessean*, May 8, 2010.

Cooper, Peter. "Workers Try to Save 'Opry' Treasures." *Tennessean*, May 14, 2010.

Watts, Cindy. "Relocated 'Opry' Show Goes On." Around Music City, *Tennessean*, May 5, 2010.

Thompson, Tim, interview with the author, June 27, 2023.

Williams, Sally, interview with the author, June 13, 2023.

Rau, Nate. "Dean Sets Aside Millions for Opry." *Tennessean*, July 9, 2010.

Reed, Colin, interview with the author, August 15, 2023.

Turner, Josh, interview with the author, December 5, 2023.

Talbott, Chris. "Paisley, Dickens Help Install Circle in Opry Stage." *Washington Post*, August 25, 2010.

COUNTRY COMES HOME (2010–2019)

Shelton, Blake, submitted self-interview, April 3, 2024.

Schmidt Relations. "Oak Ridge Boys Invited to Join Grand Ole Opry." Press release, July 8, 2011.

Watts, Cindy, "Bush Helps Welcome Oaks as Newest 'Opry' Members." *Tennessean*, August 8, 2011.

Allen, Duane, and William Lee Golden, interview with the author, September 14, 2023.

Watts, Cindy. "This Time, Surprise Is on Urban." *Tennessean*, April 11, 2012.

Urban, Keith, interview with the author, December 6, 2023.

Cooper, Peter. "Hootie's Rucker Fishes for Place in Country Music." *Tennessean*, September 18, 2008.

Rucker, Darius, interview with the author, July 12, 2023.

Gold, Adam. "So, the Story Behind That 'Wagon Wheel Song Is Kinda Cray." *Nashville Scene*, November 8, 2013.

Hight, Jewly. "Old Crow Medicine Show Has Managed to Become an Elusive, Entertaining Institution and Stay Hungry." *Nashville Scene*, August 21, 2014.

Bledsoe, Wayne. "Old-time's New Dawn." *Knoxville News-Sentinel*, October 20, 2006.

Secor, Ketch, interview with the author, June 27, 2023.

Watts, Cindy. "Little Big Town Invited to Join 'Opry.'" *Tennessean*, October 4, 2014.

Morgan, Craig, interview with the author, June 21, 2023.

Nicholson, Jessica. "Grand Ole Opry Earns First Grammy Nomination." *Music Row*, December 7, 2016.

Rau, Nate. "Coming Soon: A Better Opry." *Tennessean*, October 16, 2017.

Gayle, Crystal, interview with the author, August 11, 2023.

Buchanan, Steve, interview with the author, June 20, 2023.

Underwood, Carrie, interview with the author, August 18, 2023.

Dailey & Vincent, interview with author, July 11, 2023.

Fisher, Pete, interview with the author, June 13, 2023.

Williams, Sally.\, interview with the author, June 13, 2023.

Young, Chris, interview with the author, July 11, 2023.

Janson, Chris, interview with the author, August 22, 2023.

Watts, Cindy. "Watch: Keith Urban Shocks Chris Janson with an Invite to Join Grand Ole Opry." *Tennessean*, February 5, 2018.

Watts, Cindy, "Brooks' Birthday Gift to Bare: Membership Back into Opry." *Tennessean*, April 9, 2018.

Paulson, Dave. "Grand Ole Opry Reveals Bonnaroo Plans, Lineup." *Tennessean*, May 3, 2018.

Paulson, Dave. "The Grand Ole Opry Came to Bonnaroo, and it was weird and wonderful." *Tennessean*, June 11, 2018.

Rau, Nate. "Taste of Home Cooking." *Tennessean*, June 13, 2019.

Lynch, Dustin, interview with the author, August 18, 2023.

Wills, Mark, interview with the author, August 4, 2023.

Ballerini, Kelsea, interview with the author, April 16, 2024.

Y'ALL COME

Minnie Pearl with Joan Dew. *Minnie Pearl: An Autobiography*. Nashville: Opryland and Richards & Southern, 1980.

Johnson, Lucas L. II, Associated Press, "'Opry' Set to Honor Longtime Fan Tonight." *Tennessean*, June 28, 2014.

Obituary for Glen Sterling Thompson. *Kenosha News*, January 10, 2021.

Warden, Monte, email to the author, September 9, 2024.

UNBROKEN (2019–2025)

Watts, Cindy. "Luke Combs Stunned with Request to Join Opry." *Tennessean*, June 14, 2019.

Combs, Luke, interview with the author, February 21, 2024.

Rogers, Dan, interview with the author, December 14, 2023.

Music City News. "Gene Watson Is What You Get." August 1977.

Watson, Gene, interview with the author, July 18, 2023.

Vincent, Rhonda, interview with the author, July 2, 2023.

Anderson, Bill, interview with the author, September 30, 2023.

Stuart, Marty, interview with the author, August 1, 2023.

Gill, Vince, interview with the author, July 25, 2023.

Clark, Terri, interview with the author, August 8, 2023.

Brooks, Garth, interview with the author, October 14, 2023.

Mansfield, Brian. "Grand Ole Opry Finds New Purpose Amid Pandemic, Playing to Empty Houses and a New TV Audience." *Variety*, June 30, 2020.

McEntire, Reba, interview with the author, November 4, 2023.

Skates, Sarah. "'Opry Live' Notches No. 1 on Year-End Livestreamers Chart." *Music Row*, December 16, 2020.

Lady A, interview with the author, October 24, 2023.

Pearce, Carly, interview with the author, June 28, 2023.

The Isaacs, interview with the author, July 7, 2023.

Barnett, Mandy, interview with the author, June 28, 2023.

Alaina, Lauren, interview with the author, June 20, 2023.

Johnson, Jamey, interview with the author, July 22, 2023.

McCoy, Charlie, interview with the author, August 15, 2023.

Schlitz, Don, interview with the author, September 15, 2023.

McBryde, Ashley, interview with the author, December 5, 2023.

Moten, Wendy, interview with the author, July 2, 2023.

Cho, Henry, interview with the author August 18, 2023.

Mule Deer, Gary, interview with the author, August 8, 2023.

Pardi, Jon, interview with the author, January 29, 2024.

Evans, Sara, interview with the author, January 29, 2024.

McCreery, Scotty, interview with the author, December 3, 2023.

Brown, T. Graham, interview with the author, February 20, 2024.

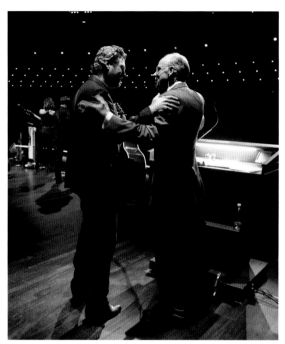

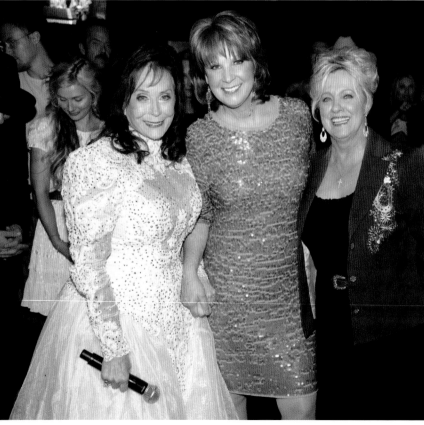

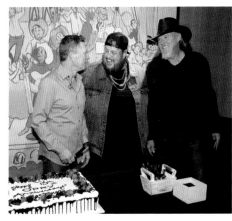

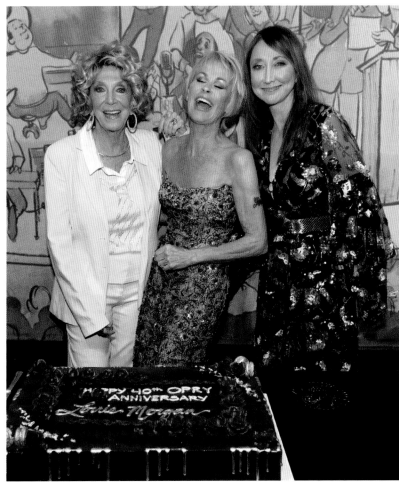

CLOCKWISE FROM TOP LEFT:
Blake Shelton and Eddie Stubbs,
April 11, 2017; Steve Gatlin, Larry
Gatlin, and Rudy Gatlin, December
12, 2021; Diamond Rio, April 18, 1998;
Craig Morgan, Jelly Roll, and Trace
Adkins, October 25, 2023; Jeannie
Seely, Lorrie Morgan, and Pam Tillis,
June 8, 2024; Bill Cody and Charley
Pride, June 7, 2018; Dierks Bentley
and band, June 25, 2013; Buck White
and Jesse McReynolds, March 2,
2018; Loretta Lynn, Patty Loveless,
and Connie Smith, June 15, 2013

PHOTOGRAPHY CREDITS

Alan Poizner – USA TODAY NETWORK: 299

Alan Mayor: 261 (top), 343 (bottom left)

Alexa Campbell: 304, 328–329 (full spread)

Annamaria DiSanto: 53 (top right)

Beth Banks: 250 (bottom)

Bill Kingsley: 53 (bottom), 241 (bottom)

Chris Hollo: 4, 8–9 (full spread), 14 (bottom left, bottom right), 15 (top right), 16–17 (full spread), 51 (middle), 52 (top right, bottom right), 87 (all), 124 (bottom), 125 (bottom right, bottom left), 126 (left, bottom right), 127 (bottom right, bottom left, middle right, top left), 128 (top left), 129 (top, bottom right), 160, 189 (all), 221 (top), 222 (top, bottom), 223 (all), 226, 228, 230, 233, 234 (all), 235, 237 (top), 239, 240, 241 (bottom), 243 (top left, top right), 244 (all), 246, 247 (all), 248–249 (full spread), 250 (top), 251 (top), 252 (all), 253, 256, 257, 258, 259, 261 (bottom), 262–263 (full spread), 264 (top), 265, 266 (all), 268, 269, 271 (bottom), 272, 273, 274 (all), 275 (bottom), 277 (bottom), 278, 280 (bottom), 281 (all), 282, 283 (all), 290 (top right), 291 (top, bottom), 296 (all), 297 (bottom), 298 (bottom), 300–301 (all), 302 (top), 305 (all), 306 (all), 307 (bottom), 308, 309 (all), 310 (bottom), 311, 312 (all), 313, 314, 316 (all), 317 (all), 319 (all), 322 (top right, middle, bottom right), 323 (top left, top right, bottom left, bottom right),

324 (all), 325 (all), 342 (top left, middle left, middle right, bottom left), 343 (top left, middle right, bottom right), 348 (top left, top right, bottom left, middle right, bottom right), 349 (top right, bottom left, bottom right)

Courtesy of Dan Rogers: 327

Courtesy of Monte Warden and Family: 292 (top left)

Courtesy of the Country Music Hall of Fame® and Museum: 139 (top, bottom right), 264 (bottom), 276 (top right)

Chris Hilbun: 241 (bottom)

Dale Ernsberger: 288–289 (full spread)

Dan Loftin: 126 (top right), 217 (top)

Donnie Beauchamp: 51 (bottom), 52 (bottom left), 181, 182, 194, 198–199 (full spread), 201 (top), 202 (bottom), 202, 206 (all), 207, 210 (bottom left, top right, bottom right), 213, 214, 217 (bottom), 219 (all), 220 (all) 271 (top), 280 (top), 290 (middle right), 334 (bottom), 342 (bottom right), 343 (top right), 349 (top left)

Elmer Williams: 90, 94 (all), 97, 98 (bottom), 99, 100–101 (all), 103, 128 (bottom left), 188 (top, middle left)

Gordon Gillingham: 69 (bottom), 73 (top left), 80 (bottom), 82, 86 (bottom), 91, 92, 93, 95, 98 (top), 102, 128–129 (top middle), 158 (bottom), 186 (bottom), 188 (bottom), 287 (top)

Jim McGuire: 2–3 (full spread), 15 (bottom left) 125 (top right), 129 (bottom left), 132–133 (full spread), 138, 170

Jody Domingue: 315

Joe Horton: 36 (top)

Joel Dennis: 222 (second from the top, second from the bottom), 251 (bottom), 256, 262–263 (full spread), 275 (top), 290 (bottom right), 307 (top)

John E. Hood: 42 (bottom), 47, 63 (top right), 66, 72 (right), 84, 187 (bottom right)

John Schweikert: 241 (top)

Judy Mock: 62 (top left)

Mark Mosrie: 294–295 (full spread)

Ken Spain: 75, 79

Les Leverett: 14 (top left, top right), 15 (top left) 69 (top), 86 (top left, top right), 104 (top, bottom), 110, 111 (top, bottom), 112 (top, bottom), 114, 115, 120, 121 (all), 122 (all), 123, 124 (top), 124–125 (middle), 134, 135, 137 (all), 139 (bottom left), 141, 143, 146, 147 (all), 148, 149, 150 (all), 151 (all), 153, 154, 157, 159 (middle), 164–165 (full spread), 167 (all), 168 (all), 169, 171 (all), 173, 174, 175, 179 (all), 184 (top), 185, 186 (top), 187 (middle left, bottom left), 194–195 (full spread), 197 (top right), 201 (bottom), 202 (top), 208–209 (full spread), 210 (top left), 270, 277 (top), 286, 291 (middle), 297 (top), 298 (top), 334 (top left, top right), 335 (top left, top right, bottom left)

N/A: 10, 22, 25 (top), 29, 35, 38 (top, bottom), 48–49 (all), 50 (top left), 65 (top left), 78 (bottom left), 85, 107, 108, 119 (top left), 136, 145 (top right), 150 (top left), 158 (top), 159 (bottom), 161 (top, bottom), 167 (top left), 184 (bottom right), 190–191 (all), 203 (top right), 205 (bottom), 218, 279, 285 (right), 290 (top), 302 (bottom)

Official White House Photo by Pete Souza: 221 (bottom)

Rachael Black: 310 (top), 318 (top, bottom), 323 (bottom middle)

Steve Lowry: 205 (top)

Tim Davis: 51 (top)

Unknown: 6–7 (full spread), 15 (middle right, bottom), 20, 21, 24 (top, bottom), 26 (top, bottom), 27, 28, 30, 31 (top, bottom), 32, 34, 36 (bottom), 41, 42 (top), 45, 46, 52 (top left), 56–57 (full spread), 58, 59 (top, bottom), 60–61 (full spread), 66–67 (full spread), 70–71 (full spread), 72 (top left), 73 (top right), 76 (top left, top right), 77, 80 (top), 83, 84 (top), 96, 116 –117 (all), 118, 119 (bottom), 159 (top), 187 (top left, top right), 284, 287 (bottom), 335 (middle left, bottom right), 343 (middle left)

Video still: 53 (top left)

ACKNOWLEDGMENTS

The author wishes to thank the Grand Ole Opry team, specifically Dan Rogers and Emily Frans, for this opportunity. For more than a year, interviews were conducted at the Grand Ole Opry House. It was always a pleasure to work with the Opry talent, administration, and production teams, including Gina Keltner, Jenn Tressler, Anna Lemme, Samantha Kane, Brooke Stuart, Nicole Judd, Jim Schermerhorn, Martin Fischer, Richmond Chaffin, and Patrick Sheehan. In the archives, assistance from Aaron Scott, Mal Nieten, and Cameron Knowler was invaluable. Tim Davis deserves special recognition for selecting and organizing the incredible photographs that beautifully illustrate this book from the Opry's vast collection. Shannon Sullivan provided helpful guidance and feedback. A special thank-you to Steve Buchanan, Pete Fisher, Colin V. Reed, Tim Thompson, Bob Whittaker, and Sally Williams. The Grand Ole Opry has greatly benefited from your guidance. Special thanks to Byron Fay for sharing his Opry knowledge.

More than sixty Opry members generously shared their memories and their time for this project. This book is dedicated to them. Thank you to Jeff Kleinman and Steve Troha at Folio Literary Management for your support and persistence, to Kathi Whitley for the introduction and friendship, and to Zack Knoll at Abrams Books for unwavering professionalism and excellent feedback. Thanks as well to Diane Shaw, Lisa Silverman, Alison Gervais, and Ruby Pucillo at Abrams.

The contributions of Brenda Colladay to this book are innumerable. Thank you for the historical insight, the careful editing, and the tenacity required to complete such an assignment. The encouragement of Scott and Cheryl Shelburne, Marcus Davis, and many dear friends helped this manuscript get delivered in time for the Opry's centennial celebration. The author also wishes to express his gratitude to the industry leaders who have opened so many doors.

Editor: Zack Knoll
Designer: Diane Shaw
Managing Editor: Lisa Silverman
Production Manager: Alison Gervais

Library of Congress Control Number: 2024940959

ISBN: 978-1-4197-7360-0
eISBN: 979-8-88707-279-1

Text copyright © 2025 OEG HoldCo, LLC dba Opry Entertainment Group
Photography credits can be found on page 350

Jacket © 2025 Abrams

Printed and bound in China
10 9 8 7 6 5 4 3 2 1

Abrams books are available at special discounts when purchased in quantity
for premiums and promotions as well as fundraising or educational use.
Special editions can also be created to specification.
For details, contact specialsales@abramsbooks.com or the address below.
Abrams® is a registered trademark of Harry N. Abrams, Inc.

ENDPAPERS: Front: George Jones, November 1, 1968; back: Opry Cast photo, September 8,
1956. PAGES 2-3: Staff remove Grand Ole Opry signage after the final show at Ryman
Auditorium, March 15, 1974. PAGE 4: Darius Rucker performs for his fifth anniversary as an
Opry member, September 20, 2017. PAGES 6-7: Roy Acuff and His Smoky Mountain Boys
perform on the War Memorial Auditorium stage while Opry founder George D. Hay blows
his steamboat whistle to open a performance of the Grand Ole Opry, early 1940s. PAGES
8-9: Carly Pearce greets the audience after receiving her Opry membership invitation,
June 22, 2021. PAGE 10: Grand Ole Opry program cover from 1974, before the move to the
Opry House. PAGES 16-17: The Opry cast performs on the newly renovated stage during
the first show back at the Opry House following the 2010 Nashville flood, September 28,
2010. PAGE 351: Marty Stuart plays mandolin during an RCA Records Fan Fair showcase at
Municipal Auditorium, June 14, 1974.

ABRAMS The Art of Books
195 Broadway, New York, NY 10007
abramsbooks.com

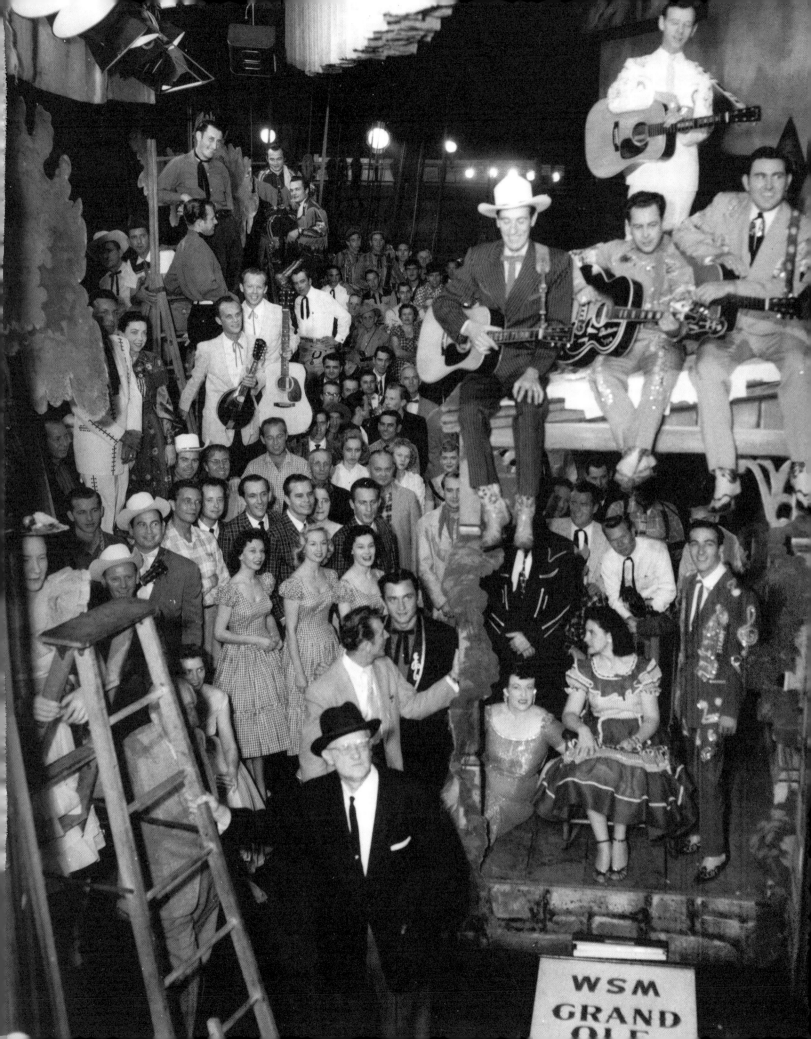